Visual Thinking

Visual Thinking

RUDOLF ARNHEIM

University of California Press

Berkeley and Los Angeles

University of California Press
Berkeley and Los Angeles, California
University of California Press, Ltd.
London, England
Copyright © 1969, by
The Regents of the University of California
Library of Congress Catalog Card Number: 71–76335
Printed in the United States of America

Preface

This book is an attempt to proceed from earlier studies of art to a broader concern with visual perception as a cognitive activity—a reversal, one might say, of the historical development that led in the philosophy of the eighteenth century from *aisthesis* to aesthetics, from sensory experience in general to the arts in particular.

My earlier work had taught me that artistic activity is a form of reasoning, in which perceiving and thinking are indivisibly intertwined. A person who paints, writes, composes, dances, I felt compelled to say, thinks with his senses. This union of perception and thought turned out to be not merely a specialty of the arts. A review of what is known about perception, and especially about sight, made me realize that the remarkable mechanisms by which the senses understand the environment are all but identical with the operations described by the psychology of thinking. Inversely, there was much evidence that truly productive thinking in whatever area of cognition takes place in the realm of imagery. This similarity of what the mind does in the arts and what it does elsewhere suggested taking a new look at the long-standing complaint about the isolation and neglect of the arts in society and education. Perhaps the real problem was more fundamental: a split between sense and thought, which caused various deficiency diseases in modern man.

There was no way of approaching so vast a problem without getting involved uncautiously in numerous branches of psychology and philosophy, the arts and the sciences. An overview was needed, a tentative confrontation, requiring ideally a professional competence in all these fields of knowledge. But to wait for the ideal meant to leave the urgent task undone. To undertake it meant to do it incompletely. I could not hope to survey all the pertinent material nor even be sure that I would discover the most telling evidence in any one

v

area. Fortunately, since the problem had attracted me darkly for several decades, I had by now accumulated boxes filled with references, from which a start could be made. With a bit of beginner's luck I could hope to establish my case sufficiently.

It is in the nature of such an enterprise that it suggests connections where distinctions are cherished by many. Among those who cultivate the senses — especially among artists — not a few have come to distrust reasoning as an enemy or at best an alien, and practitioners of theoretical thought like to think that their operations are beyond the senses. Therefore, both parties view the reunion of sense and reason with diffidence. I could not go along with the view that the arts are to be kept locked up in a sacred precinct, privileged with their own exclusive purposes, laws, procedures. Rather I am convinced that art cannot exist anywhere unless it is a property of everything perceivable. I also must expect many an experimentalist to feel uncomfortable with the idea that productive thinking ignores the property lines between the aesthetic and the scientific. But this is what will be presupposed in the following.

If one asserts that productive thinking in philosophy or science consists in the shaping of images, one may seem to cling naively to the primitive beginnings of human reasoning, when theories were derived from the sensory form of what was perceived or imagined. But although there may be a difference in principle between those early explorations of nature and the techniques of processing data in our time, this difference may not be relevant for the crucial thought operations of discovery and invention.

On the other side of the property line, the assertion that art is an instrument of reasoning will hardly convince those who would use it as a means of withdrawing from rational order and from the challenge of problems. Therefore I will state from the outset that this book concentrates on the truly creative aspects of the mind and has little to say about other uses to which the instruments of art and science are put, legitimately and inevitably, in studios, studies, or laboratories.

Perceptual thinking quite in general needs to be considered. Nevertheless I have limited this book to the sense of sight, which is the most efficient organ of human cognition and the one I know best. More comprehensive accounts will have to deal with the specific powers and weaknesses of the other sensory modalities and with the intimate cooperation among all the senses. Such a fuller treatment

of the subject will also show how widely human beings and animals explore and comprehend by acting and handling rather than by mere contemplation, which is after all a rare stance.

In the chapters dealing with the general psychology of perception I refer only briefly to facts that are discussed with more leisure in *Art and Visual Perception*. A few earlier essays, recently collected in *Toward a Psychology of Art*, laid some of the groundwork for the present book, notably those on perceptual abstraction, on abstract language, symbols of interaction, and "The Myth of the Bleating Lamb."

A grant from the Arts and Humanities Program of the United States Office of Education for a study of visual factors in concept formation enabled me to supplement the bibliographic research from which the present study developed. To a fellow psychologist, Dr. Alice B. Sheldon of George Washington University, I owe more thanks than anybody should owe to a friend and colleague. Dr. Sheldon has scrutinized everyone of my many and often long sentences; she has checked on some of the facts, improved structure and logic, and sustained the author's morale by her faith in the ultimate reasonableness of what transpired from his efforts. Wherever the reader stumbles, she is likely not to have had her way.

As I said, I wish that the theoretical assertions of this book were more fully documented. I regret even more that the book remains so theoretical. If its thesis is sound, it has tangible consequences, particularly for education in the arts and sciences. But to spell out these practical applications more fully would have meant to extend the end of the book beyond all proportion. I can only say that the din of classroom and laboratory and the smell of the studio, barely perceivable in these pages, are remote neither from the mind of the author nor from the subject he tries to treat.

Harvard University R. A.
Carpenter Center for the Visual Arts
Cambridge, Massachusetts

Contents

1. *Early Stirrings*

Reasoning, says Schopenhauer, is of feminine nature: it can give only after it has received. Without information on what is going on in time and space the brain cannot work. However, if the purely sensory reflections of the things and events of the outer world occupied the mind in their raw state the information would be of little help. The endless spectacle of ever new particulars might stimulate but would not instruct us. Nothing we can learn about an individual thing is of use unless we find generality in the particular.

Evidently then the mind, in order to cope with the world, must fulfill two functions. It must gather information and it must process it. The two functions are neatly separate in theory, but are they in practice? Do they divide the sequence of the process into mutually exclusive domains as do the functions of the woodcutter, the lumber yard, and the cabinetmaker, or those of the silkworm, the weaver, and the tailor? Such a sensible division of labor would make the workings of the mind easy to understand. Or so it seems.

Actually, as I shall have occasion to show, the collaboration of perceiving and thinking in cognition would be incomprehensible if such a division existed. I shall suggest that only because perception gathers types of things, that is, concepts, can perceptual material be used for thought; and inversely, that unless the stuff of the senses remains present the mind has nothing to think with.

1

Perception torn from thinking

Nevertheless we find ourselves saddled with a popular philosophy that insists on the division. Not that anybody denies the need of sensory raw material. The Sensualist philosophers have reminded us forcefully that nothing is in the intellect which was not previously in the senses. However, even they considered the gathering of perceptual data to be unskilled labor, indispensable but inferior. The business of creating concepts, accumulating knowledge, connecting, separating, and inferring was reserved to the "higher" cognitive functions of the mind, which could do their work only by withdrawing from all perceivable particulars. From medieval philosophers, such as Duns Scotus, the rationalists of the seventeenth and eighteenth centuries derived the notion that the messages of the senses are confused and indistinct and that it takes reasoning to clarify them. Ironically enough, Alexander Baumgarten, who gave the new discipline of aesthetics its name by asserting that perception, just as reasoning, could attain a state of perfection, continued nevertheless the tradition of describing perception as the inferior of the two cognitive powers because it supposedly lacked the distinctness that comes only from the superior faculty of reasoning.

This view was not limited to the theory of psychology. It had application and support in the traditional exclusion of the fine arts from the Liberal Arts. The Liberal Arts, so named because they were the only ones worthy of being practiced by a free man, dealt with language and mathematics. Specifically, Grammar, Dialectic, and Rhetoric were the arts of words; Arithmetic, Geometry, Astronomy, and Music were based on mathematics. Painting and sculpture were among the Mechanical Arts, which required labor and craftsmanship. The high esteem of music and the disdain of the fine arts derived, of course, from Plato, who in his *Republic* had recommended music for the education of heroes because it made human beings partake in the mathematical order and harmony of the cosmos, located beyond the reach of the senses; whereas the arts, and particularly painting, were to be treated with caution because they strengthened man's dependence on illusory images.

Today, the prejudicial discrimination between perception and thinking is still with us. We shall find it in examples from philosophy and psychology. Our entire educational system continues to be based on the study of words and numbers. In kindergarten, to be

sure, our youngsters learn by seeing and handling handsome shapes, and invent their own shapes on paper or in clay by thinking through perceiving. But with the first grade of elementary school the senses begin to lose educational status. More and more the arts are considered as a training in agreeable skills, as entertainment and mental release. As the ruling disciplines stress more rigorously the study of words and numbers, their kinship with the arts is increasingly obscured, and the arts are reduced to a desirable supplement; fewer and fewer hours of the week can be spared from the study of the subjects that, in everybody's opinion, truly matter. By the time the competition for college placement becomes acute, it is a rare high school that insists on reserving for the arts the time needed to make their practice at all fruitful. Rarer still is the institution at which a concern with the arts is consciously justified by the realization that they contribute indispensably to the development of a reasoning and imaginative human being. This educational blackout persists in college, where the art student is considered as pursuing separate and intellectually inferior skills, although any "major" in one of the more reputable academic areas is encouraged to find "healthy recreation" in the studio during some of his spare hours. The arts for which the bachelor and the master are certified do not yet include the creative exercise of the eyes and hands as an acknowledged component of higher education.

The arts are neglected because they are based on perception, and perception is disdained because it is not assumed to involve thought. In fact, educators and administrators cannot justify giving the arts an important position in the curriculum unless they understand that the arts are the most powerful means of strengthening the perceptual component without which productive thinking is impossible in any field of endeavor. The neglect of the arts is only the most tangible symptom of the widespread unemployment of the senses in every field of academic study. What is most needed is not more aesthetics or more esoteric manuals of art education but a convincing case made for visual thinking quite in general. Once we understand in theory, we might try to heal in practice the unwholesome split which cripples the training of reasoning power.

Historians can tell us how this curious distinction originated and how it persisted through the ages. On the Hebrew side of our tradition, the story of a long hostility against graven images begins with the destruction of a piece of sculpture, that golden calf which Moses

burnt in the fire, and ground to powder, and strewed upon the water, and made the children of Israel drink of it. To trace the whole story in this book would mean to rewrite a major part of the history of European philosophy. I shall limit myself to a few examples of how the problem was reflected in the writings of some Greek thinkers.

The senses mistrusted

At early stages of refinement, the human mind tends to take psychological phenomena for physical things or events. Thus the split I am talking about was located by the early thinkers not in the mind but in the outside world. The Pythagoreans believed that there was a difference in principle between the realm of the heavens and existence on earth. The course of the stars was permanent, predictable in the lawful recurrence of the Same. Simply shaped bodies rotated along geometrically perfect paths. It was a world governed by basic numerical ratios. However, the sublunar world, in which the mortals dwelt, was the disorderly setting of unpredictable changes. Was it the purity of the shapes and the reliability of the events observed in astronomy and mathematics that made the Pythagoreans conceive of a dichotomy between the heavenly and the terrestrial worlds? Were they still under the influence of the notion, found in primitive thinking everywhere, that the happenings in nature and human existence are governed by individual causes rather than by general laws? But the Greek philosophers of the sixth century were not primitives, and they did possess the concept of lawful order in their astronomy.

Nor can it be said that the world of the senses presents itself inevitably as a spectacle of disorder and irrationality. For example, the Chinese thinkers of the taoistic and the yin-yang schools at roughly the same time and perhaps at a similar stage of their culture saw the world of the senses pervaded throughout by the interplay of cosmic forces, which ruled the stars and the seasons as well as the smallest thing and action on earth. Faulty conduct could produce discord and strife, but the infant was born nearest to the Tao, and underlying human fumbling there was the law of All. Thus, Arthur Waley writes in his book on the Tao Te King:

The wheelwright, the carpenter, the butcher, the bowman, the swimmer, achieve their skill not by accumulating facts concerning their art, nor by the energetic use either of muscles or outward senses, but through utilizing the fundamental kinship

which, underneath apparent distinctions and diversities, unites their own Primal Stuff to the Primal Stuff of the medium in which they work.

Even in the West, however, the separation of the physical world into two qualitatively different realms did not prevail. Eventually, the visible difference between the calculable order of the heavens and the endless variety of earthly shapes and events was imputed to the instruments of observation, namely, to the human senses, which provided the information. Perhaps what the eyes reported was not true. After all, Parmenides, the Eleatic philosopher, had insisted that there was no change or movement in the world although everybody saw the opposite. This meant that sensory experience was a deceptive illusion. Parmenides called for a definite distinction between perceiving and reasoning, for it was to reasoning that one had to look for the correction of the senses and the establishment of the truth:

For never shall this be proved, that things that are not are; but do thou hold back thy thought from this way of enquiry, nor let custom, born of much experience, force thee to let wander along this road thy aimless eye, thy echoing ear or thy tongue; but do thou judge by reason the strife-encompassed proof that I have spoken.

Examples were easily found to show that perception could be misleading. A stick dipped into water looked broken, a distant object looked small; a person ill with jaundice saw things yellow. Democritus had taught that since honey tasted bitter to some, sweet to others, there were no such things as bitter and sweet in themselves. The sensations of warm and cold or of color existed only by convention whereas in reality there was nothing but atoms and the void. Emphasis on the unreliability of the senses served the Sophists to support their philosophical skepticism. But it surely helped at the same time to establish the notion of an undivided physical world, united by natural law and order. The chaotic variety of the terrestrial world could now be attributed to a subjective misreading.

Undoubtedly, Western civilization has greatly profited from the distinction between the objectively existing world and the perception of it. It is a distinction that established the difference between the physical and the mental. It was the beginning of psychology. Psychology, as it came to be practiced, has cautioned us not to identify innocently the world we perceive with the world that "really" is; but it has done so at the risk of undermining our trustful familiarity

with the reality in which we are at home. The first great psychologists of the West, after all, were the Sophists.

The Greek thinkers were subtle enough not to simply condemn sensory experience but to distinguish between the wise and the unwise use of it. The criterion for how to evaluate perception was supposed to come from reasoning. Heraclitus had warned that "barbarian souls" cannot correctly interpret the senses: "Evil witnesses are eyes and ears for men, if they have souls that do not understand their language." Thus, the split overcome in the conception of the physical world was now introduced into that of the mind. Just as the realm of order and truth had been beyond the range of life on earth, so it was now beyond the realm of the senses in the geography of the inner world. Sensory perception and reasoning were established as antagonists, in need of each other but different from each other in principle.

By no means, however, were the Greek philosophers unaware of the problem this distinction created. They were unwilling to exalt reason dogmatically at the price of deprecating the senses. Democritus seems to have faced the dilemma most directly. He distinguished the "dark" cognition of the senses from the "bright" or genuine cognition by reasoning but had the senses address reason scornfully as follows: "Wretched mind, do you, who get your evidence from us, yet try to overthrow us? Our overthrow will be your downfall."

Plato of two minds

In Plato's dialogues, an ambiguous attitude expresses itself in two quite different approaches which coexist uneasily. According to one of them, the stable entities of objective existence are approached by what we would call logical operations. The wise man surveys and connects widely scattered forms (*ideas*) of things and discerns intuitively the generic character they have in common. Once he has collected these forms he also distinguishes them from each other by defining the particular nature of each. We note that, according to Plato, this procedure calls for more than the skill of manipulating concepts. The common character is not found by induction, that is, by mechanically tracking down elements shared by all species and by subsequently compounding these elements to a new whole. Rather, in order to find it one must discern the totality of that generic form in each particular *idea*, as one makes out a figure in an unclear image. Furthermore, this operation refers to generic forms only, not

to the particular instances perceived by the senses. There remains the question of how these forms come to be known since sensory experiences can deceive us.

Plato's attempt to arrive at stable generalities through logical thought operations is complemented and perhaps contradicted by his deep belief in the wisdom of direct vision. Here, then, we have a second approach, which is expressed in the parable of the underground den. The prisoners, formerly limited to the sight of the passing shadows, are "released and disabused of their error." They are made to look at the objects of true reality and they are dazzled by them as though by a strong light. Gradually they become accustomed to facing and accepting them.

When Plato tells this story of initiation he is not merely speaking figuratively. The grasp of reality by direct vision is concretely acknowledged in the doctrine of anamnesis. In the *Meno*, Socrates demonstrates that "all enquiry and all learning are but recollection." The soul, being immortal and having been born many times

and having seen all things that exist, whether in this world or in the world below, has knowledge of them all; and it is no wonder that she should be able to call to remembrance all that she ever knew about virtue, and about everything; for as all nature is akin, and the soul has learned all things, there is no difficulty in her eliciting, or as men say learning, out of a single recollection all the rest . . .

Plato is not speaking here of what he usually means by "knowing from experience." He speaks of "gazing upon truth," that is, "the very being with which true knowledge is concerned: the colorless, formless, intangible essence, visible only to mind, the pilot of the soul." This is purified perception of purified objects—but it is perception nevertheless. In the *Phaido*, Socrates speaks characteristically of blindness, of "losing the eye of his mind" when he warns against the danger of trusting the senses. It is a case of renouncing one kind of perception in order to save another.

One hardly furthers one's understanding of Plato's position if one tries to eliminate the "contradiction" between his two approaches. The modern reader can soften his uneasiness by assuming that the dilemma derives from the difference between the views of Plato himself and those of Socrates, his protagonist; or that Plato's convictions shifted in the course of his life; or that he spoke of direct vision not literally but only metaphorically. Such attempts to adapt the Greek philosopher to the tidy alternatives of modern thinking can only

obscure our understanding of this complex figure — a man impressed
by a first glimpse of the power of logical manipulations and affected
by the suspicion against the senses while at the same time close
enough to the primary experience of knowing by seeing.

It is not necessary for our purpose to decide to what extent
the split in Plato's view of the world was still Pythagorean, that is,
ontological and to what extent it was already psychological in the
manner of Protagoras, the Sophist. Did Plato hold that the individual
objects accessible to the senses are in themselves "imperfect," that
is, inconstant, unreliable, and therefore responsible for the inferiority
of the images received through the senses? Or did he believe that the
stability of the objectively existing archetypes reaches all the way
down to those particular entities from which the senses derive their
information and that the deplorable distortion of reality occurs only
in the process of perception? Whichever the answer, what matters
is that the mistrust of ordinary perception marks Plato's philosophy
profoundly. He went so far as to exclude the sensory images entirely
from the hierarchy that leads from the broadest generalities to the
tangible particulars. The tree of logical differentiations ended,
for him, at the level of the species. The sensory images were dim
reflections outside of the system of reality. In order to profit from
what the senses offer one had to follow the example of the mathe-
maticians, who make use of the visible shapes and reason about
them although "they are thinking not of these but of the ideas which
they resemble." True vision is described in a passage in which it is
referred to as an illustration of how the soul should behave toward
the Supreme Good:

And the soul is like the eye: when resting upon that on which truth and being
shine, the soul perceives and understands and is radiant with intelligence; but
when turned towards the twilight of becoming and perishing, then she has opinion
only, and goes blinking about, and is first of one opinion and then of another, and
seems to have no intelligence.

Aristotle from below and from above

A similarly complex attitude towards sensory experience is found
in Aristotle's thinking. On the one hand it is he who introduces the
notion of induction — in the modern sense of knowledge gained
through the collection of individual instances. There are animals, he
says, who can remember what their senses have perceived, and

among these animals there are some species endowed with the "power of systematizing" sensory experiences as they recur frequently. This systematizing, he says, operates like the stopping of a rout during a battle: first one man makes a stand and then another, until the original formation has been restored. Through induction, then, which "proceeds through an enumeration of all the cases," we arrive at the conception of the higher genera by means of abstraction. Abstraction removes the more particular attributes of the more specific instances and thereby arrives at the higher concepts, which are poorer in content but broader in range. This sounds familiar and modern enough. It introduces the notion of abstraction as involving an increasing distance from immediate experience. It supplies the emptied generalizations which have made modern science possible. These generalizations limit themselves to what all instances of a family of cases have in common and ignore everything else. They are the very opposite of the Platonic genera, which become fuller and richer the higher they are located in the hierarchy of "ideas."

Yet to see in Aristotle nothing but the progenitor of modern scientific abstraction would be most misleading. His curious example of the battle rout is significant enough. It describes induction as the restoration of an "original formation," that is, as a way of attaining access to a pre-existing entity, to which the individual cases relate as do the parts to a whole. It is true that Aristotle was the first thinker to recognize that substance is nowhere but in individual objects. He thereby furnished the basis for our knowledge that nothing exists beyond individual existences. However, the individual case was by no means abandoned to its particular uniqueness, from which only generalizing thought could redeem it. Immediately after describing the procedure of induction Aristotle writes the remarkable sentence:

When one of a number of logically indiscriminable particulars has made a stand, the earliest universal is present in the soul: for though the act of sense-perception is of the particular, its content is universal—is man, for example, not the man Callias.

In other words, there is no such thing as the perception of the individual object in the modern sense. "Perception as a faculty," Aristotle says elsewhere, "is of 'the such' and not merely of a 'this somewhat,'" i.e., we always perceive, in the particulars, *kinds* of

thing, general qualities, rather than uniqueness. Therefore, al-
though under certain conditions events can be understood only
when their repeated experience leads to generalization by induction,
there are also instances in which one act of vision suffices to termi-
nate our enquiry because we have "elicited the universal from
seeing." We see the reason of what we are trying to understand
"at the same time in each instance and intuit that it must be so in
all instances." This is the wisdom of the *universale in re,* as it was to
be called later, the universal given within the particular object
itself—a wisdom which our own theorizing is struggling to recover
in its concern with *Wesensschau,* i.e., the direct perception of es-
sences.

Aristotle is rightly credited with having impressed the need for
empirical research upon the occidental mind. But this demand is
correctly understood only if one remembers at the same time that
he saw this approach "from below" as only one side of the task, to
be complemented symmetrically by the opposite approach "from
above." Abstraction must be complemented with definition, which
is the determination of a concept by deriving it deductively from
the higher genus and pinpointing it through its distinguishing at-
tribute (differentia). In fact, when Aristotle talked about thinking
he referred to the syllogism, that is, to the art of making a state-
ment on a particular case by consulting a higher generality. This
again was deduction. Characteristically enough, in the nineteenth
century the syllogism was accused of begging the question by
presenting as a new piece of knowledge what was already contained
in the major premise. This accusation presupposed that the gen-
erality of the major premise had come about through induction,
that is, the diligent collection of all individual instances, of which
indeed the case of the minor premise would have been one. We can
be confident that Aristotle's acute mind would have spotted such
a flaw himself. If the difficulty did not arise it is probably because for
him the universal ("that which is of such a nature as to be predicated
of many subjects") was not necessarily *derived from* those many
subjects by collection. For instance, using a physician to illustrate
his point, Aristotle states that if he "has the theory without the
experience, and recognizes the universal but does not know the
individual included in this, he will often fail to cure." With all due
respect for induction, the universal was "what is always and every-
where," and the term *cath'holou* (catholic), which Aristotle used,

was based on a root signifying "whole" and carried no connotation of a sum of particulars.

This was still thoroughly Platonic, of course; but Aristotle went beyond Plato in demanding a more active relation between *ideas* and sensible things, between universals and particulars. In Plato's version of this relation, the immutable entities and sensory appearance had coexisted rather statically. Aristotle asserted that in order for any perceivable object to come about a universal had to impress itself upon the medium or substance, which in itself was shapeless and inert, except for its desire to be thus impressed. This generative process by which the possible form acquired actual existence was called by Aristotle *entelechy*, a word which implied the bringing about of a state of perfection. It was a thought that gave a new vitality to the ontological status of the universals. They became creators. The world of substantial objects was generated as a sculptor imposes shape upon inert matter, and the perceivable things contained the universals not only through the intuition of the observer but embodied them actually, through the nobility of their birth.

This is not to say that Aristotle simply returned to the senses a dignity which Plato had taken away from them. The "static co-existence" of the transcendental ideas and sensory appearance in Plato's doctrine was after all a relation between prototype and image, imperfect though the image was considered to be. This relation was, to some extent, replaced by the genetic connection which Aristotle postulated between universals and particulars — a connection which did not deny the image function of sensory appearance but made it less exclusive. The son is the product of the father, not merely his effigy.

Aristotle not only established the universal as the indispensable condition of the individual thing's existence and as the very character of the perceivable object; in doing so he also rejected and avoided the arbitrary choice of the attributes that can serve as the basis of a generalization when induction is intended in its strict, mechanical sense. Strictly, any common attribute, relevant or not, could be used for this purpose if the generalization depended simply on similarities which someone happened to discover and single out. Instead, the generality within the particular case was to Aristotle an objectively determined fact. The qualities an object shared with others of its kind were not an incidental similarity but the very

essence of the object. What was general in an individual was the form impressed upon it by its genus. Therefore, this generality was not defined as what the individual shared with others but as what "mattered" about it. The double meaning of our word "matter" is significantly present in Aristotle's thought: matter is that which matters. Or, to use another term often resorted to by the translators, "substance" is that which is "the substance of" a thing, its essence. Being, then, was not defined — the way we are taught to do it — as a property of just anything endowed with material substantiality. An object existed only to the extent of its essence since the being of the object was nothing but what had been impressed upon the amorphous raw material by its form-giving genus. The object's accidental properties were mere impurities, the inevitable contribution of the raw material. The form lost some of its purity by embodying itself; but the resulting impurities did not belong to the being of the object. They did not matter.

This noble conception is not usable for us in its metaphysical formulation. But most relevant is the basic experience and conviction which it expresses. Aristotle asserts that an object is real to us through its true and lasting nature, not through its accidental, changeable properties. Its universal character is directly perceived in it as its essence rather than indirectly collected through the search of common elements in the various specimens of a species or genus. And when a perceptual generalization is to be made, it can only be done by recognizing the common essence of the specimens. Shared accidentals cannot serve as the basis for a genus.

Although the Greek philosophers conceived the dichotomy of perceiving and reasoning, it cannot be said that they applied this notion with the rigidity the doctrine assumed in recent centuries of Western thought. The Greeks learned to distrust the senses, but they never forgot that direct vision is the first and final source of wisdom. They refined the techniques of reasoning, but they also believed that, in the words of Aristotle, "the soul never thinks without an image."

2.

The Intelligence of Visual Perception (i)

Perception as cognition

The title of this chapter may seem to contain an obvious contradiction. How can there be intelligence in perception? Is not intelligence a matter of thought? And does not thought begin where the work of the senses ends? Precisely these assumptions will be questioned in what follows. My contention is that the cognitive operations called thinking are not the privilege of mental processes above and beyond perception but the essential ingredients of perception itself. I am referring to such operations as active exploration, selection, grasping of essentials, simplification, abstraction, analysis and synthesis, completion, correction, comparison, problem solving, as well as combining, separating, putting in context. These operations are not the prerogative of any one mental function; they are the manner in which the minds of both man and animal treat cognitive material at any level. There is no basic difference in this respect between what happens when a person looks at the world directly and when he sits with his eyes closed and "thinks."

By "cognitive" I mean all mental operations involved in the receiving, storing and processing of information: sensory perception, memory, thinking, learning. This use of the term conflicts with one to which many psychologists are accustomed and which excludes the activity of the senses from cognition. It reflects the distinction I am trying to eliminate; therefore I must extend the meaning of the terms "cognitive" and "cognition" to include perception.

13

Similarly, I see no way of withholding the name of "thinking" from what goes on in perception. No thought processes seem to exist that cannot be found to operate, at least in principle, in perception. Visual perception is visual thinking.

There are good reasons for the traditional split between seeing and thinking. In the interest of a tidy theoretical model it is natural to distinguish clearly between the information a man or animal receives through his eyes and the treatment to which such information is subjected. The world casts its reflection upon the mind, and this reflection serves as raw material, to be scrutinized, sifted, reorganized, and stored. It is tempting to say that the organism supplements a passive capacity to receive with a separate active power of elaboration.

Such a view seems well supported by elementary facts. Examining the extirpated eye of a man or animal, one can see on its retinal background a small, but complete and faithful image of the world toward which the eye is turned. This image turns out not to be the physical equivalent of what perception contributes to cognition. The mental image of the outside world is known to differ importantly from the retinal projection. Therefore it seems natural enough to attribute these differences to manipulations taking place after the sense of vision has done its work.

However, a difference between passive reception and active perceiving is contained even in elementary visual experience. As I open my eyes, I find myself surrounded by a given world: the sky with its clouds, the moving waters of the lake, the wind-swept dunes, the window, my study, my desk, my body — all this resembles the retinal projection in one respect, namely, it is given. It exists by itself without my having done anything noticeable to produce it. But is this awareness of the world all there is to perception? Is it even its essence? By no means. That given world is only the scene on which the most characteristic aspect of perception takes place. Through that world roams the glance, directed by attention, focusing the narrow range of sharpest vision now on this, now on that spot, following the flight of a distant sea gull, scanning a tree to explore its shape. This eminently active performance is what is truly meant by visual perception. It may refer to a small part of the visual world or to the whole visual framework of space, in which all presently seen objects have their location. The world emerging from this perceptual exploration is not immediately given. Some of

its aspects build up fast, some slowly, and all of them are subject to continued confirmation, reappraisal, change, completion, correction, deepening of understanding.

Perception circumscribed

Does the view presented here really differ from what most people take for granted? Few would deny or even be surprised to learn that the cognitive operations enumerated above are applied to perceptual material. And yet they might insist that thinking, which processes the output of perception, is non-perceptual in itself. Thinking, they may say, consists of intellectual operations performed on cognitive material. This material becomes non-perceptual from the moment in which thinking has transformed the raw percepts into concepts. The abstractness of these concepts is supposed to somehow disrobe them completely, to free them from their visual character and thereby to make them suitable for intellectual operations. It is conceded that perception and thinking, although studied separately for the purpose of theoretical understanding, interact in practice: our thoughts influence what we see, and vice versa. But is it really obvious that such interaction can take place among two media supposedly so different from each other?

A reference to an issue to be discussed soon in greater detail may illustrate the point. A person's view of the size of an object does not commonly correspond to the relative size of the projection of that object on the retina—so that, for example, a distant car whose optical projection on the retina is smaller than that of a letterbox close to the observer, appears to have the normal size of cars. One can explain this by saying, as Helmholtz did in the nineteenth century, that the faulty image is corrected by an unconscious judgment based on facts available to the observer. It makes all the difference whether such a theory is meant to suggest that the percept obtained from the retinal projection is as distorted as that projection itself and that this misleading perceptual raw material is interpreted in a manner better fitted to the facts by inferences drawn from the observer's knowledge; or whether the theory says that the given perceptual situation itself contains aspects that assign to the image of the car a relative size different from the one it has in the retinal projection. In the latter case, the cognitive feat is accom-

plished within perception itself; in the former it is tackled after perception has delivered a rather deficient message.

The difference here at issue is not easily made clear in words because "perception" means different things to different people. Some take the term very narrowly to describe only what is received by the senses at the time when they are stimulated by the outer environment. This definition is too narrow for the purpose of this book because it excludes the imagery present when a person, with eyes closed or inattentive, thinks of what is or could be. Others broaden the term to include any kind of knowledge obtainable about some subject of the outer world. For example, the ill-sounding phrase "person perception" can be taken to embrace all the complex processes by which one person comes to know another, that is, not only what he sees, hears, smells, etc. but also what he finds out about the person's principles, habits, possessions, and actions and by the inferences he draws from circumstantial evidence. Some of these ways of obtaining knowledge may not be thought of as operations taking place within the perceptual realm, and yet they are incorporated under perception by gerrymandering. A person using the term in this broader fashion may assert that, of course, he includes thinking in perception, and he may thereby hide the whole problem of visual thinking for himself and for others.

As one more point of general strategy I should mention that for the following discussion of cognitive processes it makes no difference in principle whether they are carried out consciously or unconsciously, voluntarily or automatically, by the higher brain centers or by mere reflexes. They may be actions initiated by a particular creature or inherent in the structure of an organ and as such an accomplishment of biological evolution rather than of any one individual. I am concerned here with abilities that are not the late product of the refined human mind but a steady trait of the organism in its groping for information about the outer and the inner world, present in the lowly beginnings of animal life and by no means dependent upon consciousness or even the presence of a brain.

To speak of "intelligence" with regard to elementary biological responses is, no doubt, risky, especially when no firm definition of intelligence is offered. Even so, it may be permissible to say, for example, that the use of information about the environment makes

for more intelligent conduct than does total insensitivity. In this simplest sense, an inbuilt tropism by which an insect seeks or avoids light has something in common with a person who watchfully observes the happenings in the world around him. The vigilance of a lively human mind is the latest display of the struggle for survival that made primitive organisms responsive to changes in the environment.

Exploring the remote

Sensory responsiveness as such can be said, therefore, to be intelligent. More particular traits distinguish the intelligence of the various senses. One of them is the capacity to obtain information about what is going on at a distance. Hearing, vision, smell are among the distance senses. Jean Piaget has said that

... the entire development of mental activity, from perception and habit to representation and memory, as well as to the higher operations of reasoning and formal thinking is a function of the gradually increasing distance of the exchanges, that is, of the balance between the assimilation of more and more remote realities to pertinent action and an accommodation of this action to those realities.

It is not far-fetched to relate the ability to sense across distances to what we call the farsightedness of an intelligent person.

The distance senses not only give a wide range to what is known, they also remove the perceiver from the direct impact of the explored event. To be able to go beyond the immediate effect of what acts upon the perceiver and of his own doings enables him to probe the behavior of existing things more objectively. It makes him concerned with what is, rather than merely with what is done to him and with what he is doing. Vision, in particular, is, as Hans Jonas has pointed out, the prototype and perhaps the origin of *teoria*, meaning detached beholding, contemplation.

The senses vary

Intelligent behavior in a particular sensory area depends on how articulate are the data in that medium. It is necessary but not sufficient that the data offer a rich variety of qualities. All the senses can be said to do that, but if these qualities cannot be organized into definite systems of shape they give scant leverage to intelligence.

Although the senses of smell and taste, for example, are rich in nuances, all this wealth produces — at least for the human mind — only a very primitive order. Therefore, one can indulge in smells and tastes, but one can hardly think in them. In vision and hearing, shapes, colors, movements, sounds, are susceptible to definite and highly complex organization in space and time. These two senses are therefore the media *par excellence* for the exercise of intelligence. Vision is helped by the sense of touch and the muscle sense, but the sense of touch alone cannot vie with vision, mainly because it is not a distance sense. Dependent upon immediate contact, it must explore shapes inch by inch and step by step; it must laboriously build up some notion of that total three-dimensional space which the eye comprehends in one sweep; and it must forever do without those many changes of size and aspect and those overlappings and perspective connections that enrich the world of vision so vastly and are available only because visual images are obtained from distant objects by optical projection.

In the universe of audible sounds, each tone can be given a definite place and function with regard to several dimensions in the total system. Music, therefore, is one of the most potent outlets of human intelligence. But while thinking of the highest level takes place in music, it is thinking about and within the musical universe. It can refer to the physical world of human existence only indirectly and hardly without the help of the other senses. This is so because audible information about that world is quite limited. Of a bird it gives us little more than its song. It is limited to the noises things make. Among them are the sounds of language, but they acquire their meaning only by reference to other sensory data. Thus music by itself is hardly thinking about the world. The great virtue of vision is that it is not only a highly articulate medium, but that its universe offers inexhaustibly rich information about the objects and events of the outer world. Therefore, vision is the primary medium of thought.

The facilities of the sense of vision are not only available to the mind; they are indispensable for its functioning. If perception were nothing better than the passive reception of information, one would expect that the mind would not be disturbed by being left without such input for a while and might indeed welcome the repose. The experiments on sensory deprivation have shown, however, that this is not so. When the visual, auditory, tactile and kinesthetic senses are reduced to unpatterned stimulation — nothing but diffuse light

for the eyes and a steady buzz for the ears – the entire mental functioning of the person is upset. Social adjustment, serenity, and capacity for thought are profoundly impaired. During the monotonous hours of the experiment, the subject, finding himself unable to think, replaces the outer stimulation of the senses by reminiscing and by conjuring up imagery, which soon becomes insistent and uncontrollable, independent of the person's will as though it were an impingement from the outside. This imagery can develop into genuine hallucination; (in mental hospitals, patients are found to hallucinate more readily in bare environments offering little stimulation). So real are these visions that after the experiment some subjects admit that they are now more willing to believe in supernatural apparitions. These desperate attempts of the mind to replace the missing stimulation indicate that instead of a mere facility for reception, the activity of the senses is an indispensable condition for the functioning of the mind in general. The continuous response to the environment is the foundation for the working of the nervous system.

Vision is selective

In order to interpret the functioning of the senses properly, one needs to keep in mind that they did not come about as instruments of cognition for cognition's sake, but evolved as biological aids for survival. From the beginning they aimed at, and concentrated on, those features of the surroundings that made the difference between the enhancement and the impediment of life. This means that perception is purposive and selective. I have already pointed out that vision is experienced as a most active occupation. To quote a formulation I gave elsewhere:

In looking at an object we reach out for it. With an invisible finger we move through the space around us, go out to the distant places where things are found, touch them, catch them, scan their surfaces, trace their borders, explore their texture. It is an eminently active occupation. Impressed by this experience, early thinkers described the physical process of vision correspondingly. For example, Plato, in his *Timaeus*, asserts that the gentle fire that warms the human body flows out through the eyes in a smooth and dense stream of light. Thus a tangible bridge is established between the observer and the observed thing, and over this bridge the impulses of light that emanate from the object travel to the eyes and thereby to the soul.

This view was derived from spontaneous experience. However, as it became clear that the optical recording in the eye is largely a

passive process, the same was assumed by extension to be true for the psycho-physical process of vision as a whole. This change of view was slow and hesitant. Around 500 A.D., the Roman philosopher, Boethius, wrote: "for sight is common to all mortals, but whether it results from images coming to the eye or from rays sent out to the object of sight is doubtful to the learned, though the vulgar are unaware that such doubt exists." And a thousand years later, Leonardo da Vinci wrote a confutation against

. . . those mathematicians, who say that the eye has no spiritual power which extends to a distance from itself, since, if it were so, it could not be without great diminution in the use of the power of vision, and that though the eye were as great as the body of the earth it would of necessity be consumed in beholding the stars: for this reason they maintain that the eye takes in but does not send forth anything from itself.

There was much evidence to the contrary:

. . . the snake called lamia is seen daily by the rustics attracting to itself with fixed gaze, as the magnet attracts iron, the nightingale, which with mournful song hastens to her death. . . . the ostrich and the spider are said to hatch their eggs by looking at them.

Not to mention the maidens, who "are said to have power in their eyes to attract to themselves the love of men."

Active selectivity is a basic trait of vision, as it is a trait of any other intelligent concern; and the most elementary preference to be noted is that for changes in the environment. The organism, to whose needs vision is geared, is naturally more interested in changes than in immobility. When something appears or disappears, moves from one place to another, changes its shape or size or color or brightness, the observing person or animal may find his own condition altered: an enemy approaching, an opportunity escaping, a demand to be met, a signal to be obeyed. The most primitive organ of sight, the light-sensitive spot or nerve fiber in a clam or a barnacle, will limit information to changes of brightness and thereby permit the animal to withdraw into its shell as soon as a shadow interrupts the sunlight. To contemplate immobile parts of the surroundings is more nearly a luxury, useful at most to spot the locations of possible future changes or to view the context in which events take place.

Change is absent in immobile things but also in things repeating the same action over and over or persevering in it steadfastly. Psy-

chologists discussing satiation and adaptation point out that animals, even quite primitive ones, will stop reacting when a given stimulus reaches them again and again. The constant factors of a visual setting, e. g., the particular color of ever present sunlight will vanish from consciousness, just as a constant noise or smell will. When a person is forced to stare at a given figure he will use any opportunity to change it by varying it: he may reorganize the grouping of its parts or make a reversible figure switch from one view to the other. A color looked at steadily tends to bleach, and if the eye is made to fixate a pattern without the small scanning movements that are never absent otherwise, that pattern will disappear from sight after a short while. These reactions to monotony go all the way from conscious defense to the purely physiological wearing off of impulses generated in the brain by a static situation. They are an elementary form of intelligent contempt for indiscriminate attention. Noticed and attended to is only what matters. One refuses to be bored.

Practically useful though this selective attention to change is, it also has its drawbacks. It makes it difficult to become aware of the constant factors operative in life. This weakness shows up when the thinker or scientist needs to consider agents lying beyond those that display observable change. In physical as well as in psychological or social matters, the constant aspects of a situation are most easily overlooked, hardest to be understood. The characteristics of perception not only help wisdom, they also restrict it.

The eyes are movable within their sockets, and their selective exploration is amplified by the movements of the head and indeed of all of the beholder's body. Even the recording processes going on within the eyeball are highly selective. For example, since the early years of the last century there have been good reasons to assume that the retina, in informing the brain about color, does not record each of the infinitely many shades of hues by a particular kind of message but limits itself to a few fundamental colors, or ranges of color, from which all the others are derived. This assumption, by now confirmed experimentally and anatomically, means to us that the photochemistry of the eye proceeds by a similar kind of abstraction by which, at the level of conscious perception, we see colors as variations and combinations of a few primaries. Through this ingenious simplification vision accomplishes with a few kinds of transmitters a task that would otherwise require an unmanageably large number of them.

One might say that even physiologically vision imposes a conceptual order on the material it records.

What is known about color may turn out to be true for shape also. It is beginning to look as though the lightning speed with which animals and humans react to movement, be it ever so small or so distant from the center of attention, is made possible by a short-cut that distinguishes motion from immobility even at the retinal level. We were accustomed to believe that the retinal receptors know of no such distinction. All they could do was supposedly to register qualities of color and shape, so that it was left to the brain to infer the presence of movement from a computation of changes occurring in masses of point-sized spots. By now, the retina of the frog's eye is known to contain at least four types of receptors, responding each to one special kind of stimulus and remaining unimpressed by all others. Among them are the "bug-detectors," which react immediately and exclusively to small crawling things, naturally of particular interest to frogs. Others are geared to respond only to the movement of, or encounter with, edges or to the onset or end of illumination. In order to accomplish these reactions, large groups of receptors must cooperate as a team because only in that way can the shapes or motions of extensive stimuli be apprehended. This means that even at the retinal level there is no mechanical recording of elements. The research paper, *What the Frog's Eye Tells the Frog's Brain* by Lettvin, Maturana, McCulloch, and Pitts, concludes:

The operations thus have much more the flavor of perception than of sensation if that distinction has any meaning now. That is to say that the language in which they are best described is the language of complex abstractions from the visual image.

It is true, however, that like all screening, this one expedites the processing of the material but also limits operations to what remains available after the screening. When a frog starves in the presence of dead, immobile flies, which would make perfectly good food, he reminds us of the blindness of a man whose mind is "made up" and therefore incapable of responding to unforeseen opportunities. Those are the wages of economy.

Such inbuilt selectivity is useful not only because it avoids the wasting of effort but also because, by restricting the choice, it makes reactions faster and surer. Therefore, in relatively simple creatures,

which have stable needs and can rely on dwelling in a fairly stable environment, vital functions of sustenance, procreation, and defense tend to be limited to standardized reactions, which are geared to fixed signals. Striking examples of such highly selective behavior have been described by ethologists, notably Konrad Lorenz and N. Tinbergen. Since animals cannot tell us what they see, we cannot be sure to what extent the selection takes place in their perception itself or rather in their responses to what they perceive. In any case, no stimulus can be reacted to, unless it is distinguished in perception. Most probably, this distinction is not a matter of specifically primed categories of retinal receptors like those making the frog respond to crawling bugs, but a selective reaction of the nervous system to particular features of the visual field transmitted by the eyes. The responses to these signals, or "releasers," are bred into the species. The yellow bill of the herring gull has developed a red spot at the end of the lower mandible. It is this red spot that makes the newly hatched chick peck at the tip of the parent's bill. When the red spot is absent, the chick does not peck; when the chick does not peck, the parent does not deliver the food. Signals of this kind meet two essential prerequisites: they are clearly identifiable by their pure color and simple shape, and they are sufficiently distinct from what else is commonly visible in the environment.

The perception of these animals must be geared to their highly selective responses. Their visual fields are likely to be hierarchic rather than homogeneous, in the sense that certain perceptual features stand out because of the needs to which they relate. The animal could not respond to them unless they were distinguished perceptually. This is an early instance of abstraction, in so far as the animal is fitted to a type or category of essential signals — e.g., all instances of a red spot in the right place — but the abstraction is performed by the species rather than the individual; it is inbred.

Fixation solves a problem

As long as such mechanisms are built in by heredity, they rigidly apply to the species as a whole. At biologically higher levels, the choice of stimuli and the reactions to them are increasingly controlled by the individual. The eye movements that help to select the targets of vision are somewhere between automatism and willful response. They must direct the eyes in such a way that the area of the visual

field to be scrutinized comes within the narrow range of sharpest vision. Sharpness falls off so rapidly that at a deviation of ten degrees from the axis of fixation, where it is at a maximum, it is already reduced to one fifth. Because retinal sensitivity is so restricted, the eye can and must single out some particular spot, which becomes isolated, dominant, central. This means taking up one thing at a time and distinguishing the primary objective from its surroundings. An object may be selected for attention because it stands out against the rest of the visual world and/or because it responds to needs of the observer himself. At early organic levels, the stimulus compels the reaction. When a strong light enters the visual field, the infant turns toward it as though directed by an outer controlling power, just as a plant turns towards the light or a cat towards the slightest motion somewhere. This is the prototype of a cognitive response unconditionally surrendered to the object of attention. The response is steered by the stimulus rather than by the initiative of the observer.

How is ocular fixation accomplished? An act of fixation can be described as a move from tension to tension reduction. The stimulus enters the visual field eccentrically and thereby opposes the field's own center with a new and alien one. This conflict between the intruding outer world and the order of the inner world creates a tension, which is eliminated when a movement of the eyeball makes the two centers coincide, thus adapting the inner order to the outer. The relevant item of the outer order is now centrally placed in the inner.

Here we have an elementary example of still another aspect of cognitive behavior, namely, problem solving. All problem solving requires a restructuring of a given problem situation. In ocular fixation, the restructuring needed is of the simplest kind; it is nothing more than a shift of the center of orientation, not requiring any reorganization of the perceptual pattern itself.

I shall soon give examples of problem solving by much more complex restructuring. But even this simple example shows why problem solving should not be assumed to be the cognitive level at which perception and thinking part company. Such a distinction, based on a precise criterion, would be agreeable to the theorist. Perception, one might be tempted to say, is the direct exploration of what is out there. Thinking, on the contrary, begins with the task, different in principle, of modifying a given order for the purpose of making it fit the requirements of the solution to a given problem.

Köhler defines intelligent behavior in this fashion, but does not seem inclined to acknowledge examples of it in the elementary mechanisms of perception. He asserts that we do not speak of behavior as being intelligent when human beings or animals attain their objective by a direct route which derives naturally from their own perceptual organization. But we tend to speak of "intelligence" when, circumstances having blocked the obvious course, the human being or animal takes a roundabout path, so meeting the situation. The mechanism of fixation does arise naturally out of the organization of the human being or animal. And yet the shifting of the center of vision to the center of interest seems to me to involve, at an elementary level, the same kind of restructuring that, in Köhler's examples, reveals that the desired goal can be reached by a detour. In both cases, the structural connections within the given perceptual pattern are changed in a way that yields the solution of the problem.

The simple example of ocular fixation serves also to illustrate another point of more general relevance. It shows that the observer's attention is searching to find its objective in a perceptual field that has an order of its own. The stimulus of the light entering the infant's range of vision gives a definite, objective structure to that field. The field has a center, with regard to which the infant's focus of attention is eccentrically oriented. This discrepancy produces the tension to which the child reacts by adapting his fixation to the structure of the outer situation. Such an interplay between the structure of the given field and the demands of the observer's needs and interests is characteristic of the psychology of attention. William James, writing about attention, suggested the opposite when he wrote that without selective interest experience would be an utter chaos. But truly chaotic or otherwise unstructured situations are not typical, and when they prevail they make it all but impossible for selective interest to take hold of a target. When the field is homogeneous, as in total darkness, or when nothing can be seen but a repetitious pattern of, say, a checkered surface the gaze will roam about aimlessly, trying to impose some sort of shape on that which has none. This sort of situation is not characteristic of cognitive processes.

I have shown that the need and opportunity to select a target exists in cognition even at the retinal level. Since acute vision is limited to a narrow area, an objective must be selected from the total range of the given field. This limitation, far from being a handicap, protects

the mind from being swamped with more information than it can, or needs to, handle at any one time. It facilitates the intelligent practice of concentrating on some topic of interest and neglecting what is beside the point of attention.

Discernment in depth

Selectivity also obtains in the depth dimension. Only a narrow range is in focus at any moment. If the close-up view is sharp, the background is blurred, and vice versa. This selectiveness is contributed by the crystalline lenses of the eyes, and visual cognition profits from it the same way in which a photograph or painting can guide the beholder's attention by throwing certain limited ranges of depth into sharp focus. The accommodation of the eye lenses is an elementary aspect of selective attention. It gives visual stringency to an observer's concentration on what happens at a particular distance.

The depth dimension contributes, in addition, to cognitive factors of quite a different nature. It makes the size of objects variable and thereby adaptable to the needs of the observer. This is so because the object of perception does not enter the eye bodily, although this is what was believed at early stages of the theory of vision. Democritus, for example, held that in perception a sort of decal of the object's outer surface enters the eye through the opening of the pupil — which posed the problem of how a large object could shrink sufficiently to accomplish such a feat. We know now that what the eye receives is not a part of the object itself but an equivalent of it. The size of the projective image depends on the distance of the physical object from the eye. Therefore, by choosing the proper distance, the observer can make the image as large or small as his purpose requires. In order to be comfortably visible the relevant portion of the visual field must be large enough to be sufficiently discernible in its detail and small enough to fit into the field. Furthermore, the size of the critical area also determines how much of its surroundings will be contained in the visual field at the same time. The smaller the area, the more of the environment will appear, that is, the more the object will be shown in context. Inversely, with increasing size of the object, its context will move out of sight. The proper choice depends on the nature of the cognitive task. How much detail is relevant? What distance is needed to bring out the

larger structural features, otherwise hidden by too much detail? How much of the context is pertinent to the understanding of the matter under scrutiny? Here again the correct selection at the elementary perceptual level is an important part and reflection of broader cognitive strategy. To find the appropriate range of a problem is almost tantamount to finding its solution. This strategy of thought may be hampered at its very foundation when the visual range of the situation to be contemplated is incorrectly chosen. In practice this means, for example, that the visual aid offered by an illustration or a television image may be severely impaired simply because the size and range of the portrayed objects are inappropriate. Since reasoning about an object starts with the way the object is perceived, an inadequate percept may upset the whole ensuing train of thought.

Shapes are concepts

In the perception of shape lie the beginnings of concept formation. Whereas the optical image projected upon the retina is a mechanically complete recording of its physical counterpart, the corresponding visual percept is not. The perception of shape is the grasping of structural features found in, or imposed upon, the stimulus material. Only rarely does this material conform exactly to the shapes it acquires in perception. The full moon is indeed round, to the best of our viewing powers. But most of the things we see as round do not embody roundness literally; they are mere approximations. Nevertheless the perceiver does not only compare them with roundness but does indeed see roundness in them. Perception consists in fitting the stimulus material with templates of relatively simple shape, which I call visual concepts or visual categories. The simplicity of these visual concepts is relative, in that a complex stimulus pattern viewed by refined vision may produce a rather intricate shape, which is the simplest attainable under the circumstances. What matters is that an object at which someone is looking can be said to be truly perceived only to the extent to which it is fitted to some organized shape. In addition, there generally is an amount of visual noise, accompanying and modifying the perceived shape with more or less vague detail and nuances, but this contributes little to visual comprehension.

I do not mean to suggest that the mind, and hence the brain, contains a set of pre-established shapes transmitted by heredity and lying in wait for stimulus material. There are known to be inbred responses to certain shapes, colors, or movements, for example, to the so-called visual releasers, which regulate much instinctual animal behavior. But these mechanisms presuppose rather than explain shape perception. The red spot at the mandible of the sea gull must be apprehended as such before it can be reacted to. The same would hold for Jungian "archetypes," allegedly geared to certain geometrical figures. It is true that the above-cited discoveries about the frog's sense of vision imply that some organization into larger units exists even at the retinal level. If the smallest initiator of the stimulation is not a dot but an object, such as a crawling bug or a moving edge, then a large panel of receptors must cooperate in identifying the stimulus and mobilize all pertinent single nerve fibers. A dot cannot report about an extended object. In other words, even in the eye, long before impulses reach the brain, there seem to be responses to shape rather than mere recordings of elements. But responses to shape do not necessarily imply conscious perception of it; and even in the higher vertebrates similar mechanisms are likely to be too rigid to amount to more than a kind of shorthand abbreviation of sensory recording. In order to account for the complexity and flexibility of shape perception, it seems preferable to assume that the decisive operations are accomplished by field processes in the brain, which organize the stimulus material on its arrival according to the simplest pattern compatible with it.

The shape patterns perceived in this fashion have two properties enabling them to play the role of visual concepts: they have generality and they are easily identified. Strictly speaking, no percept ever refers to a unique, individual shape but rather to the kind of pattern of which the percept consists. There may be only one object to fit that pattern or there may be innumerable ones. Even the image of one particular person is a view of a particular pattern of qualities, of that kind of person. There is, therefore, no difference in principle between percept and concept, quite in keeping with the biological function of perception. In order to be useful, perception must instruct about kinds of thing; otherwise organisms could not profit from experience.

If a perceptual pattern is simply organized and differs clearly

from its environment, it has a correspondingly good chance of being easily recognized. The biological releasers can serve here again as illustration. They tend to be simple, distinct colors, shapes, or movements, developed in evolution as signs, on whose clear-cut identity the instinctual responses of animals could be built. Identification, then, presupposes an identifiable pattern. One cannot recognize something as a thing known, expected, or to be reacted to unless it is discriminated by its sharply defined character.

I am describing the perception of shape as the grasping of generic structural features. This approach derives from gestalt psychology. There are other theories, notably the traditional view that the sense of vision mechanically records the elements of stimulation, which are then suitably conglomerated into shapes on the basis of the perceiver's past experience. It is not necessary here to explain again why such a theory is inadequate; but one of its consequences is relevant. If the theory were true, shape perception would be quite inferior cognitively. It would be limited to the automatic gathering of incoming material. If, on the other hand, the view I am presenting is correct, shape perception operates at the high cognitive level of concept formation.

Perception takes time

Much recent discussion of shape perception would lead one to believe that what matters most for its explanation is whether it occurs spontaneously, without preparation, or whether it is made possible by a gradual process of learning. Actually, this is not the issue at all, for it makes little difference for the nature of the cognitive process here described whether it occurs quickly or slowly. Most organic accomplishments go through a phase of learning and biological maturation. What matters is what kind of learning is involved. Is an initial incapacity to see shape due to the lack of similar experience with which a present stimulus can be compared? Or is it the art of grasping the structure of a visual pattern that takes time to perfect? Perceptual acquisition in the latter sense was the subject of studies by German psychologists on what they called *Aktualgenese*. One of their approaches was to reconstruct the elusive and often all too rapid process by presenting a pattern insufficiently, e.g., for a split second only, so that observers arrived

at a complete grasp only gradually, through repeated exposure. Under such conditions, perception tends to start with a diffuse, undifferentiated whole, which is progressively modified and elaborated. In order to show how little these processes resemble a mechanical recording of stimuli, I will translate the summarizing statement of one of these researchers, Gottfried Hausmann:

The experimental situation conveyed to the observers the clear conviction that what we popularly call perceptual cognition cannot be described as a simple, immediate, purely sensory mirroring. Instead, it originates in a process of manifold, mutually intertwined, selective, abstractive and even creative acts of formation. The course taken by such a process may be either organically consequent or intricate, ambiguous and meandering. Sometimes fancy will leave the given data behind, but when the process runs organically, it leads through a sequence of phases and qualities, deriving from each other but at the same time specific and organized within themselves, to the goal demanded by the task.

Similarly, in the earliest statement on gestalt psychology, von Ehrenfels insisted on the "effort" it takes to put a gestalt together. Gestalt psychologists, while pointing out that the capacity to see shapes is not brought about merely by repeated exposure to the stimuli, have no reason to suggest that a gestalt shows up with automatic spontaneity.

What is true of shape, also holds for color. I mentioned earlier that physiologically the many wavelengths of light corresponding to different shades of hue are dealt with by a few types of receptor, each sensitive to one color or a range of colors, from which particular nuances are obtained by combination. In the psychological realm, color vision is based on a few pure, elementary qualities, by no means necessarily or simply related to the physiological types of receptor. Just as perceived shapes are more or less complex elaborations of simple shapes, so color patterns are seen as elaborations of the elementary, pure qualities of yellow, red, blue. Here and there, these qualities are encountered in their purity, but most of the time there are mixtures, which are understood perceptually as combinations of the underlying primaries. Some of these combinations are sufficiently precise in themselves to function as visual concepts in their own right, e.g., orange, green, or purple. In the system of colors, as we find it applied, for example, in a painting, these secondary concepts serve as transitional links between the primaries, which are the fundamentals of the system. It is a hier-

archic system, similar to that of traditional logic, in which a multitude of more particular concepts derives from a basic few, thereby creating an order, which defines the nature of each element through its place in the whole.

There is considerable evidence to indicate that the graspability of shapes and colors varies, depending on the species, the cultural group, the amount of training of the observer. What is rational for one group, will be irrational for another, i.e., it cannot be grasped, understood, compared, or remembered. There are differences in this respect between different species of animals, between man and animal, and between various kinds of people. A rat does not seem to perceive the difference between a circle and a square. For some persons, a pentagon is a perfectly graspable visual figure whereas it is a roundish thing of uncertain angularity for others. Children have trouble with the identification of certain colors, which have a clear character of their own for adults. Some cultures do not put green and blue under separate perceptual headings. Within limits, training will refine the categories accessible to an individual.

How machines read shape

Perhaps the particular nature of shape perception can be clarified best when it is compared with recent research on pattern recognition by machine. The task is that of developing devices that can read such shapes as letters or numbers, not just in a standardized version but over a large range of variations, encountered when different persons write the same numbers or when printing is done from different fonts. What is invariant about a 3 or a B must be picked out, regardless of the particular shape it takes. The machine starts out by doing exactly what the eye does: it cuts up the continuous stimulus pattern into a mosaic of discontinuous bits, each recorded by a separate photoelectric cell. This is an act of so-called digital coding, which transforms the stimulus into an assembly of discrete units, each reporting the presence or absence of a particular perceptual quality. The mosaic preserves or indicates no pattern whatsoever, except that the dots are not scattered at random but maintain their particular location relative to their neighbors.

One can try to derive shape from such a mosaic by fusing groups of adjacent positive impulses into continuous masses or by making

continuous lines out of uninterrupted chains of impulses. Putting all similar elements together and separating them from dissimilar ones, the machine obtains a rough pattern, which then it can be asked to clean up by eliminating small irregularities, dropping isolated particles, straightening out almost straight lines, etc. This is the sort of blind fitting together of pieces which does not go beyond discovering similarity or dissimilarity among adjacent elements and in which the resulting shape comes as a surprise—rather as though a child were to draw a line along numbered dots and find that it adds up to the outline of a rabbit.

In this procedure shape is derived from the analysis of the stimulus. But the machine can also be handed certain shapes of whole or part figures and asked to find out which of them fits the stimulus. This sort of codification works by analogue, that is, it compares shape with shape. Here a pre-established concept is rigidly identified with one particular realization, for example, the concept of the letter A is identified with one individual A-template of defined size, shape, proportion. It is a method that works well when the task is limited to the reading of a standardized set of shapes, for instance, numbers printed from one and the same font of type in one size only. The system will allow for a certain amount of broadmindedness in that the machine can be made to measure the amount of area which a given stimulus has in common with a given template. In this way, some deviation from the norm can be taken care of.

The perceptual concept of the machine can be made more intelligent when it is not limited to one particular shape but covers the whole range of variation along certain dimensions. Change of size is one of these dimensions; change of proportion, that is, the ratio between horizontal and vertical, is another. When allowance is made for rotation in space, a diamond may be recognized as a square turned 45°. A more radical transformation is the tilt that changes the angles, or one that allows even for bending, stretching, and twisting. Such flexibility makes it possible for the machine to isolate the "topological" properties—such as crossing, touching, or surrounding—left invariant by the distortions.

By allowing for variability along such dimensions the machine can concentrate upon the task of identifying structural features, which are not bound to any one individual realization but common to a large set of possible instances. Such structural features can refer

to overall characteristics, for example, the symmetry or asymmetry of a pattern, which will distinguish letters like A, H, W from B, G, or R, or front face from profile in the picture of a person or animal.

When the task calls for nothing better than identification by whatever means, it can be accomplished by a machine or organism that is largely blind for the true character of the object. We may identify a person by nothing more than the ring he is wearing or by his name. Rats seem to identify some patterns by simply discovering a certain corner in a particular location. A scanning machine may slide a narrow slit across a black shape and thereby identify it through a sequence of slices of changing length without any realization that the pattern is the profile silhouette of a human head. A brain-injured person suffering from agnosia may identify a rectangle by counting the number of corners. For most practical tasks, however, it is necessary to understand the overall visual structure of an object to be handled, and for the purpose of the scientist or artist a grasp of the object's visual character is essential.

In principle, pattern recognition can be applied to the most complex and crazy shapes, but the simpler the pattern, the easier the task. Chinese ideographs are a greater challenge than the Roman alphabet. In practice, however, the figures to be read tend to be simple. Numerals and letters, for example, have evolved historically as the results of the search for sets of shapes simple enough to be easily produced, perceived, and remembered, yet as clearly distinct from each other as possible. Nature accommodates this need for simple shapes essentially in two ways. They come about in evolution as signals for organisms endowed with the sense of sight. Quite independently from sight, the tendency towards tension reduction in the physical world will produce the simplest shapes available under the circumstances and thereby assist vision incidentally. Even so, most of the shapes and combinations of shapes presented to the eyes by nature are much more complicated than letters, numbers, or other signs devised by human vision for human vision.

Completing the incomplete

One of the complications arising under natural conditions is the overlap by which one object prevents another behind it from being seen completely. In many such instances, vision, instead of contenting

itself with the visible section completes the object. A box, partly covered by a flowerpot, is seen as a complete cube partly hidden. This means that perceptual organization does not limit itself to the material directly given but enlists invisible extensions as genuine parts of the visible. Similarly, objects are often perceived as three-dimensionally complete although only a frontal part of their surface is directly given. What happens here is not that the beholder completes by non-visual knowledge the fragment he actually sees. No, a cylindrical pot is *seen* as a complete, all-around thing; an incomplete cylinder looks quite different. Here again invisible parts of the object supplement the visible ones in order to produce a complete shape. The distinction between complete and incomplete shape as well as the pertinent rounding off take place within perception itself.

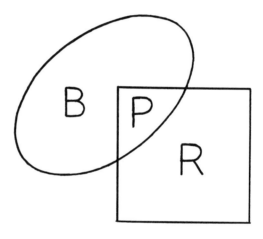

Figure 1

The cognitive feat involved in such a process consists in rejecting the wholeness of a shape that presents itself and in re-interpreting it instead as a part of a larger and structurally better whole. Examples of similar procedures in scientific problem solving and everyday reasoning will come readily to mind.

A particularly striking example of shrewd restructuring by completion in perception can be found in the phenomenon of transparency. Suppose a pattern consists of three shapes, a red one, a blue one, and between them a purple one (Figure 1). If the shapes are such that a simpler overall pattern is obtained when two mutually overlapping shapes—an oval and a square—are seen rather than

three adjacent ones, the following perceptual problem situation presents itself. The distribution of colors suggests an order based on three separate, contiguous units. The character of the shapes suggests two overlapping units. How can this intrinsic conflict be brought to a satisfactory solution? If the color of the central unit is reasonably accommodating, i.e., an approximate mixture of the other two colors, the unitary sensation of purple will split up into its components, red and blue. It will be seen as two colors, one behind the other—a transparency effect. By spotting and using the particular relation between the three colors, namely, $P = B + R$, the mind restructures the unitary central color in such a way that a superposition of two colors is seen where one color would be seen otherwise. This ingenious solution adapts the order of the colors to the order of the shapes. In this case the perceptual solution of the problem tends to present itself with great immediacy, and there can be no question but that the intelligent rearrangement of an unsatisfactory stimulus organization occurs in the act of perception itself and not in some secondary elaboration of the perceptual product.

Under natural conditions, vision has to cope with more than one or two objects at a time. More often than not, the visual field is overcrowded and does not submit to an integrated organization of the whole. In a typical life situation, a person concentrates on some selected areas and items or on some overall features while the structure of the remainder is sketchy and loose. Under such circumstances, shape perception operates partially.

It is in works of art, for example, in paintings, that one can observe how the sense of vision uses its power of organization to the utmost. When an artist chooses a given site for one of his landscapes he not only selects and rearranges what he finds in nature; he must reorganize the whole visible matter to fit an order discovered, invented, purified by him. And just as the invention and elaboration of such an image is a long and often toilsome process, so the perceiving of a work of art is not accomplished suddenly. More typically, the observer starts from somewhere, tries to orient himself as to the main skeleton of the work, looks for the accents, experiments with a tentative framework in order to see whether it fits the total content, and so on. When the exploration is successful, the work is seen to repose comfortably in a congenial structure, which illuminates the work's meaning to the observer.

More clearly than any other use of the eyes, the wrestling with a work of visual art reveals how active a task of shape-building is involved in what goes by the simple names of "seeing" or "looking." The experience of searching a given image rather helplessly and then finding the key to what looked at first like a mere accumulation of shapes is common in good art appreciation work. Such an experience is the purest and strongest example of that active exploration of shape and visual order which goes on when anybody looks at anything.

3.

The Intelligence of Visual Perception (ii)

Visual perception, I tried to show, is not a passive recording of stimulus material but an active concern of the mind. The sense of sight operates selectively. The perception of shape consists in the application of form categories, which can be called visual concepts because of their simplicity and generality. Perception involves problem solving. Next I shall discuss a somewhat more subtle perceptual operation.

The size of a retinal projection varies, as I noted earlier, with the distance of the physical stimulus object from the observer. Therefore, as far as the object by itself is concerned, the distance dimension distorts the information. For example, an object actually maintaining its size may be reported to the eye as changing it during movement. The same is true for shape. The retinal projection of an object varies depending on its location relative to the observer. There are other such perceptual modifications. The brightness and the color of an object depend in part on the brightness and color of the source illuminating it and on the spatial location of the object relative to light source and observer.

Subtracting the context

The mind meets here, at an elementary level, a first instance of the general cognitive problem that arises because everything in this world presents itself in context and is modulated by that context.

37

When the image of an object changes, the observer must know whether the change is due to the object itself or to the context or to both, otherwise he understands neither the object nor its surroundings. Intertwined though the two appear, one can attempt to tease them apart, especially by watching the same object in different contexts and the same context acting on different objects.

The object under observation must, then, be abstracted from its context. This can be done in two fundamentally different ways. The observer may wish to peel off the context in order to obtain the object as it is and as it behaves by itself, as though it existed in complete isolation. This may seem to be the only possible way of performing an abstraction. However, the observer may also wish to find out about the object by observing all the changes it undergoes and induces because of its place and function in its setting. Here the abstraction, while singling out the object, does not relinquish the effects of the context but relies on them for an indispensable part of the information. The two procedures serve different purposes, but for both of them it is necessary to tell object and context apart.

In the psychology of perception the generally accepted view is that the mind aims at, and achieves, abstraction in the first of these two meanings. It wishes to peel off all the influences of the context, and it succeeds in doing so. In spite of retinal variations and environmental influences, the mind's image of the object is constant, at least approximately so: the object has and maintains its own — and only — size, shape, brightness, color. There seems to be widespread agreement on this, although there is some controversy on how the feat is accomplished. Nevertheless this view is quite restricted and one-sided.

Granted, it is of the greatest practical importance that constant things should be seen as constant and that change should be attributed to them only when they themselves do the changing. This is evidently true for the size of objects. Since biological orientation requires a stable world in which objects preserve their identity, the organism profits greatly from abstracting a true or constant size from the bewildering variety of projected sizes. There is, however, more than one way of fulfilling this need.

Most of the psychological discussions have started from the notion of what I, too, just called "the bewildering variety of projected sizes." This, however, is a piecemeal approach, according to which any one physical object appears in the visual world as a multiplicity

of separate and static images, each of a different size. If perception is assumed to start with this medley of particulars, how is "constant size" abstracted from it? Does the mind perhaps average all the projections statistically and settle for a median size? Surely not, because in that case a pad of writing paper would be seen roughly the size of a building since on the average the projections of both kinds of object occupy a similar amount of space in the visual field. In fact, all objects would converge toward one average size because, as I mentioned earlier, one tries to look at any thing from the distance at which it offers an image of convenient size, not too large and not too small.

Perceived size is related rather to perceived distance. No matter how large or small the physical projection on the retina, an object will be perceived as relatively large when it is seen far away in visual space, and small when it is seen close by. However, when one scrutinizes objects in their surroundings one is not aware of performing any such adjustment of projective size to distance, and therefore the processes that establish the so-called constancy of size must be inferred. Helmholtz maintained that the effect was brought about by what he called "unconscious judgment." The primary percept, he assumed, contains all the distortions of projection, but judgment intervenes and corrects them. The theory has been attacked on three grounds. First, Helmholtz assumed that these corrections are based mainly on knowledge previously acquired and imported into the perceptual situation by the observer. This assumption seems to me untenable, but there is no need to argue the point here. Second, Helmholtz has been blamed for postulating the existence of "primary" percepts which nobody has ever experienced. This argument has lost its force since we have come to realize how much perception takes place below the level of awareness. The kind of reactive computation and correction, needed to straighten out the retinal distortions, is well within the capacity of the nervous system and rather similar to many other mechanisms that keep the organism going without conscious awareness or intervention.

Third, Helmholtz's recourse to "judgment" seemed objectionable. Was it permissible to assume that the highest mental processes are involved in elementary perception? Actually, Helmholtz had no intention of intellectualizing perception. Instead he believed, very much in keeping with what I am trying to demonstrate here, that the kind of process observed in logical thinking occurs at the perceptual

level also. "There appears to me to be in reality only a superficial difference between the 'conclusions' of logicians and those inductive conclusions of which we recognize the result in the conceptions we gain of the outer world through our sensations."

Brightness and shape as such

Most noteworthy is the awesome complexity of the cognitive processes that must be performed in order to make adequate perception possible. The properties of any part of the visual field must be seen in constant relation to corresponding properties of the field as a whole. The perceived brightness of, say, a piece of paper is derived from its place on the scale of brightness that reaches from the brightest to the darkest value visible in the field. What is being received is not an absolute but a relative value. I must repeat here what I said in discussing the perception of shape: it does not seem to me to make much difference how much of this complex feat of organization can be performed spontaneously and early in life on the basis of innate mechanisms. Quite likely it takes time to learn to see things in relation. What matters is that the cognitive process which produces the so-called constancies is of a very high order of intelligence since it must evaluate any particular entity in relation to an intricate context, and that this feat is performed as an integral part of ongoing perception.

The accomplishment is spectacular enough when a given range of brightness holds good for the total field and determines the appearance of any object, regardless of where in the field it is located. Quite often, however, this range varies along a spatial gradient so that the same amount of reflected light is perceived as a relatively bright object in a dark setting in one corner of the field and a relatively dark object in a bright setting in another corner. This sort of situation is brought about by uneven illumination, for example, in a room brightly lit by a window or lamp on one side and increasingly darker at a distance from the source. Perception has to cope here, one might say, with relativity to the second degree.

Perceived size, too, depends on its place on a scale, in this case a distance scale. The farther away an object is seen, the more its size counts. At the same time, the range of the distance gradient as a whole will determine the size value of each location. This range does not necessarily equal the objective and physical one; it has been

shown, for example, that observers judge sizes as though the horizon were only from fifty to three hundred feet away. But whether or not the outcome is correct is a question that does not touch the intelligence of the perceptual performance. Notice here also that as distance determines size, so size determines distance. Distance in depth has no direct equivalent in the two-dimensional projection of the retinal image. The image registers only a gradient of diminishing sizes, and size is one of the factors determining depth perception. Such observation by indirection is an ingenious device, also used more consciously in order to measure the inaccessible through some correlated variable, for example, in physics, when temperature is measured by the length of a mercury column.

In the retinal projection, then, the image of an object derives from the contributions of the physical object itself as well as from those of the object's environment, an important part of which is the observer. The two components, united in the image, can be separated in perception because, and to the extent to which, context as well as object are organized wholes rather than mere conglomerations of pieces. Only because the brightness or color values of a given context are perceived as an organized scale can the brightness or color of an object be assigned a place in it, and the same is true for the spatial gradients. Similarly, only because an object has a graspable shape in itself can this shape be distinguished from the deformations that an equally well organized system of perspective imposes upon it. The less clearly organized are the context and the object in themselves, the less clearly can they be separated perceptually. In other words, perception can abstract objects from their context only because it grasps shape as organized structure, rather than recording it as a mosaic of elements.

I said earlier that there are two different ways of describing the outcome of a perceptual abstraction. So far I have treated the so-called constancies as though perception stripped the object of the "contaminations" to which it is subjected by its surroundings, and showed it in isolation. According to such a description, the object is reduced to its invariants, the context and its effects drop out of sight, and constancy means invariability of appearance. The great variety of shapes, sizes, brightness and color values and so on, displayed by the image in the retinal projection is supposed to be replaced by a frozen, immutable thing.

To be sure, any theory must admit that originally the organism

receives full information on the contextual variations of the stimulus since what is not received cannot be processed; but according to textbooks of psychology, this rich information is overruled and ignored in conscious experience as thoroughly as possible, in the interest of a stable world populated by stable objects. I suggest that such stability is compatible with a much richer perceptual experience than that envisaged by rigid "constancy." For the moment I shall use size as an example of what is also true for the other aspects of perception.

First of all, the variety of object sizes is not a lawless assortment of separate items, scattered at random through space and time. On the contrary, as object and observer move around in space, the retinal projection goes through a gradual, perfectly organized modification of size, and the continuity of this process preserves the identity of the object in spite of the change of size. James J. Gibson has strongly emphasized this fact, and William H. Ittelson, following a lead of Koffka's, has pointed out that in actual experience "continuity is the rule, and constancy, as traditionally investigated, merely represents a sample picked out for study from the more general experienced continuity." In other words, the primary physical facts, from which the sense of sight takes off, are not a bewildering spread of random samples but highly consistent processes of change. What is more, the size variations of each object are not only organized within themselves but also related in an orderly fashion to other similar variations going on elsewhere in the field at the same time. For example, when the observer moves through an environment, the projective sizes of all of its constituents change in accord. The setting as a whole is subjected to a unified and consistent modification of size.

Identity, then, does not have to be extrapolated from a random scattering of appearances. Instead, the permanent character of an object can be established when and because the setting is pervaded by orderly perceptual gradients, to which the object conforms. Now it is quite true that under ordinary living conditions the contextual modifications of the object remain largely unobserved: its size, shape, color are constant. This typical lack of awareness, however, should not be considered a universal trait inherent in the nature of perception. Instead it is, I believe, a special instance of a broader rule of cognition, according to which the generality of concepts is not differentiated beyond necessity, i.e., concepts remain as generic

as their application permits. To perceive an object as immutable is to abstract it at the highest level of generality, and that level is appropriate for all those many situations in which vision is used for the purpose of handling objects physically. In the physical world the contextual modifications observed in perception either do not exist or do not matter. But a person who needs the awareness of size differences — a painter, for example — will readily leave the level of maximum generality and proceed to the necessary refinement of perception.

Three attitudes

Experimental findings on the "constancies" have not been as clear-cut as the usual psychological treatment of the subject would demand. The average result for a large number of observers will indeed indicate a fairly high degree of constancy, but individual reactions vary all the way from complete, or more than complete, constancy to hardly any at all. Also, when a person is asked to change his attitude toward what he sees he tends to produce quite different results. There appear to be three attitudes. One kind of observer perceives the contribution of the context as an attribute of the object itself. He sees, more or less, what a photographic camera records, either because he stares restrictively and unintelligently at a particular target or because he makes a deliberate effort to ignore the context and to concentrate on the local effect. An example is the training needed for realistic painting. It requires that the student learn to practice "reduction," that is, to see a given color value as it would look through a narrow peephole, or the size and shape of an object as though it were flattened out on a two-dimensional plane. The difficulties met in such training show how unnatural it is to see out of context. However, if such a reductive attitude is attained, it shows a given object as changing its character when the context changes. The Impressionists tried to replace local with context-born color, so that one and the same object, e.g., the Cathedral of Reims, looked quite different depending on the direction, strength, and color of the sunlight. Under certain conditions, such reduction to appearance can make identification difficult. If I may use an example from a very different field of cognition: an observer watching an individual in various social situations may be unable to grasp the character of the person as such because of his constantly changing behavior.

He cannot abstract the "local color" of the person from the influences exercised upon that person.

This incapacity or unwillingness to view the character of the particular object as the product of two separate contributions must be distinguished from two other attitudes, both of which do acknowledge the separation. One of them, already mentioned, seeks to peel off the influence of the context in order to obtain the local object in its pure, unimpaired state. The resultant object is constant, except for whatever changes it initiates by itself. The observer perceives the spatial location, illumination and so on, of the object and uses this information to subtract the effect of the context from the character of the object as such. This is the "practical" attitude of everyday life. The only reason for the housewife's interest in the green light that enlivens a display of vegetables is because she needs to know that the lettuces and cabbages "as such" look rather discolored. The scientist also seeks to establish the nature of any phenomenon in itself in order to distinguish it in each practical case from the conditions surrounding it.

Notice, by the way, that in these instances the abstraction of the object "as such" cannot be represented by any one practical realization. No object can show its local color without being illuminated by some light source, which has a color of its own. Physically, the weight of an object as such never exists without the presence of some gravitational condition. Only within a man-made world of fiction, conceived in such a way as to eliminate interaction—for example, in a textbook illustration, formula, or descriptive text—can the scientist show the forces emanating from the setting as separated from those inherent in the object. And in a child's drawing the trees can be a splendid green, quite independent of any influence by the yellow sun shining forth somewhere else in the picture. A view of consummated constancy created by the absence of interaction is characteristic for certain styles of art, some early, some late, whose interest is in the invariable object as such. It is characteristic also for the absolutistic approach to science. Interaction is represented as a meeting of separate, unimpaired entities.

But there is another way of acknowledging the distinction between context and object, which does not aim at eliminating the effect of the setting upon the object. On the contrary, this third approach fully appreciates and enjoys the infinite and often profound

and puzzling changes the object undergoes as it moves from situation to situation. In perception, the best example is found in the aesthetic attitude. The changing appearance of a landscape or building in the morning, the evening, under electric light, with different weather and in different seasons offers two advantages. It presents an extraordinary richness of sight, and it tests the nature of the object by exposing it to varying conditions. A person perceived as the dominant figure in his home, surrounded by subordinate furniture, offers an aspect of the human kind quite different from the small creatures crawling at the bottom of a city street. In a film, one may see a car or a group of persons running a gauntlet of changing lights, illuminated brightly in one moment and plunged into darkness a second later. The enlightenment one gains from such varying exposure goes beyond aesthetics. Just as the mountains of the moon can be seen only when the sunlight falls from the side and casts shadows, so the scientist is constantly on the lookout for novel situations, not because there is virtue in the collection of instances as such, but because they may reveal fresh information.

What distinguishes this third attitude from the one described first? The first view has the effects of the environment hide the identity of the object in a merry chase of transformations; the third sees the object unfold its identity in a multitude of appearances. The permanence of the object, its inviolate identity, is realized by the observer of the third type with no less certainty than by the one of the second, but his approach creates concepts quite different from those envisaged in traditional logic. A concept from which everything is subtracted but its invariants leaves us with an untouched figment of high generality. Such a concept is most useful because it facilitates definition, classification, learning, and the use of learning. The object looks the same, every time it is met. Ironically, however, this eminently practical attitude leaves the person without the support of any one tangible experience since the "true" size, shape, color he perceives are never strictly supported by what his eyes show him. Also the rigidity of such constancy may make the observer blind to revelations offered by a particular context and prevent him from reacting in a manner appropriate to the particular occasion. A most common form of unintelligent behavior consists precisely in the misuse of constancy, that is, in the assumption that what was true before must be true this time.

Keeping the context

The kind of concept created by the third attitude is best suited to productive thinking. Such a concept does not suppress the differences between the various species over which it presides as a genus but keeps them present in all-embracing comprehension. Quite apart from the enjoyable richness such a conception gives to life, it also assures the artist as well as the scientist of a continuing contact with the concrete manifestations of the phenomena in which they are interested. A perceiver and thinker whose concepts are limited to the kind foreseen by traditional logic is in danger of performing in a world of paralyzed constructs.

To be sure, it would be impossible to keep a great variety of manifestations under one heading unless they were held together by some sort of order. Here it should be remembered that in perception, as I said earlier, the various appearances of an object do not constitute a "bewildering variety," but come in continuous sequences. They come as gradual transformations rather than as a wildly scattered multitude of different instances.

We have here a good model of the kind of order that organizes the variety of possible manifestations in concepts typical of any field of productive thinking. To use an illustration from literature: Shakespeare's Antony exhibits the contradictory behavior of a disciplined warrior and a surrendered lover. However, the contradiction exists only at the surface, as long as context and "object" are not separated. Shakespeare offers the continuous presence of a figure whose identity is not impaired but unfolded by an orderly sequence of circumstances. As Antony is observed moving among the powers that are embodied in Caesar and Cleopatra he discloses himself gradually through his reactions, so that the moment of his death is also the moment of his completed revelation. Yet, at no time do we see Antony "as such."

In painting, Impressionism offers, as I said before, an extreme example of abandoned constancy. It shows local color and local brightness modulated by the influences of the color and brightness factors dominant in the situation. However, this does not mean that the painter adopts the attitude, mentioned first, of ignoring the context and forcing the mind to nail down each spot in its isolated color value. A painter could not possibly produce a meaningful image by adopting the mechanical procedure of color photography. True,

the Impressionists had to free themselves from the constancy effect of "practical" vision, but not in order to reproduce the color of each spot with mechanical faithfulness. Instead, this freedom enabled a painter like Cézanne to present the identity of a mountain or tree as a lawful, even though rich modulation of color values resulting from the interaction between the object and its world. Such a presentation is as remote from overlooking the effect of the context as it is from eliminating it in favor of a uniform and perhaps stereotyped image.

The difference I have in mind is illustrated by the art historian, Kurt Badt, who confronts the naturalism of the Impressionists with the realism of Symbolists, such as Gauguin or Maurice Denis:

The Symbolists derived their representation of the world from individual objects; they built it around single figures, composed it of objects, in Latin: *res*. Their intention was that of realists, regardless of the meaning they attributed to the objects. The Impressionists proceeded from impressions of the whole, from a connexion of things, into which these things had grown and which they had created by their natural growth. . . . In their conception of the world and in the intention of their art, which had the task of showing that conception, the Impressionists were naturalists (using the word *nature* in its original sense of *nasci:* being born, wanting to become, growing). This means that there was in fact a profound difference between the two artistic tendencies. But there is no difference of rank or value between the two conceptions of reality. They are two equally good aspects of the same thing. For this reality of the world exists, in man's conception, as connexion but also as segregation because the two can be thought of and represented only in mutual relation.

The abstraction of shape

In more than one way, perceptual abstraction can differ from the kind described in traditional logic. Typically, it is not a matter of extracting common properties from a number of particular instances. Neither the "true" size nor the "true" brightness or color of a perceived object is found in any one of its actual appearances. Perception points to a different notion of abstraction, a much more sophisticated cognitive operation. The perception of shape in three-dimensional space illustrates this even more strikingly.

As long as nothing but the distance of an object from an observer is altered, the change affects only the size of the object: it shrinks or grows but remains the same otherwise. Not so when the angle changes at which the object is perceived. In that case, shape is affected by transformations, which are generally more complex

than those provided by Euclidean geometry, that is, mere transla-
tion, rotation, or reflection in space. Change of angle gets us into
projective geometry. It affects the size of the angles of the object
and the ratios of length; it alters all proportions. The resulting distor-
tion is ruthless enough when the object is two-dimensional, like a
flat picture on the wall. It is much worse when the changing pro-
jections of a three-dimensional object, say, a regular cube, display
a varying number of side faces. The flat picture on the wall preserves
at least its quadrilaterality as an invariant throughout the projective
transformations. In the case of the cube, a three-dimensional object
of eight corners is represented on the retina as a two-dimensional
one of four or six corners. In spite of this transformation, a solid of
constant shape is perceived in many of its individual projections
and also when the cube turns in space or the observer moves
about it. Here then is an even more radical example of an abstrac-
tion in which the abstracted components are not contained in the
particular objects from which they are drawn. No one projection
of the cube *is* the cube or contains it as a part of its properties. (The
projections of the cube preserve at least the straightness of its
edges as an invariant element; in less simple solids even the shape
of the edges changes.)

How abstraction is possible under such conditions is, at first,
hard to imagine. But the difficulty is lessened when one remembers
that here again the various projections of the solid are not dispersed
randomly in space and time but appear as lawful sequences of
gradual change. Gurwitsch has maintained that the "harmony and
concordance" of the various aspects within the sequence suffice to
account for the perceived constancy of shape. He enlists the gestalt
principle of "good continuation," by which elements are fused in a
unified whole. He goes further and makes the important observation
that a particular aspect of an object contains *renvois*, that is, ref-
erences, which point beyond the given aspect to adjoining, subse-
quent ones. This amounts to saying that incompleteness is an
inherent characteristic of any particular aspect or appearance of
an object — an assertion that holds true, in fact, for some aspects but
not for others. A three-quarters profile does point to the continua-
tion of shape beyond its visible borders, but a straight profile or
front-face does it much less. Certain styles of sculpture rely heavily
on *renvois* to emphasize continuous roundness; see, e.g., Michel-
angelo's remark that a figure should always be serpentlike, that is,

spirally twisted. But other styles, especially archaic ones, insist on composing the figure of independent views, each complete in itself. A similar difference exists in painting, say, between an Egyptian mural, limited to straight profile and frontal views, and the gyrations of a Tintoretto.

However, such perspective references are limited to making the appearance of an object more dynamic by pressing for continuation beyond the given view. They promote a coherent sequence of views, but they are not sufficient to extract from this sequence the invariant three-dimensional shape of the physical object. The views that follow each other in the sequence are fused in such a way as to appear as states of one and the same persisting thing, but the percept does not necessarily maintain its invariant shape, nor need it correspond to the shape of the physical object. This can be seen in experiments by Wallach and O'Connell on the so-called kinetic depth-effect. The shadow of a rotating object projected upon a screen is perceived in some cases "correctly" as the image of a rigid object in motion. But when, for example, a rectangular block is rotated about an axis parallel to a set of its edges, subjects see on the screen a dark, flat, rectangular figure which expands and contracts periodically. Here the lawful sequence of aspects preserves the identity of the percept, which, however, undergoes protean transformations. There is no constancy, because the shape of the projected physical object is not preserved.

Constancy of shape does result when the various aspects of an object can be seen as deviations from, or distortions of a simpler shape. The various two-dimensional projections of a cube are seen as a cube because that three-dimensional solid is the simplest, symmetrical, rectangular shape to which they can all be referred. The effect is made more compelling by the time sequence, which displays a gradual variation of the underlying invariant form. To speak of the variation of the invariant involves no paradox here. The form subjected to the distortion remains invariably perceivable even though the distortion may vary.

How then is it possible to perform an abstraction without extracting common elements, identically contained in all the particular instances? It can be done when certain aspects of the particulars are perceived as deviations from, or deformations of, an underlying structure that is visible within them. In space perception, not every projection by itself fulfills this condition. The square one sees when

looking head-on at a cube is not perceived as a deformation of the cube; it contains no *renvois*. However, when such a view is embedded within a sequence of other views, it will acquire the character of a deformation by the context and by its relations to its neighbors in the sequence. In the same way, the behavior of a person in a particular situation may not appear, in itself, as the deformation of a simpler, underlying structure; here again the context of other situations may be needed to bring out the character of the particular one.

Needless to say, this type of abstraction is a cognitive performance of high complexity. It requires a mind that, in perceiving a thing, is not limited to the view it receives at a given moment but is able to see the momentary as an integral part of a larger whole, which unfolds in a sequence. William Hogarth has observed that "in the common way of taking the view of an opaque object, that part of its surface which fronts the eye is apt to occupy the mind alone, and the opposite, nay even every other part of it whatever, is left unthought of at a time: and the least motion we make to reconnoitre any other side of the object, confounds our first idea, for want of the connection of the two ideas, which the complete knowledge of the whole would naturally have given us, if we had considered it in the other way before." Actually, this handicap is found not so much in the "common way" but in painters mistrained to restrict their attention to what their eyes see from one particular point of view. But although the feat of realizing that a thing has many sides to it and of perceiving each partial aspect as an appearance of the whole is quite common, one must not fail to notice how much true intelligence it involves — an intelligence often left unequalled at higher levels of mental functioning.

The persistence of shape, just as that of size, color, etc., may be perceived in either of the two ways described above. A table top is seen as a rectangle, but the average person is not aware of the perspective deviations from which he abstracts. This is so because the initial generality of a visual concept will be differentiated only to the extent to which the purposes of the observer demand it. In the practice of daily life it is useful to see the table as an independent entity and to use the perspective aspects of the image only as indicators of the object's location relative to the observer. This practice is reflected in early stages of art, which reproduce the objective, permanent shape of objects as closely as the medium

permits; a cube may be drawn as a square or with the oblique but parallel edges of isometric perspective. A richer perception observes and enjoys the enchanting and enlightening variety of projectively changing shape. The visual concept of the cube embraces the multiplicity of its appearances, the foreshortenings, the slants, the symmetries and asymmetries, the partial concealments and the deployments, the head-on flatness and the pronounced volumes. This more complex experience is reflected also in art, be it in rather faithful renderings of perspective effects or in the freer interpretations of the shape of tables, chairs, or buildings in Cubist painting. Here the portrayal of the object serves to depict such aspects of human experience as the variations of character revealed by context, the charms of the fugitive moment, the distortions under pressure.

Distortion calls for abstraction

Two further observations may help to illustrate some characteristics of abstraction in more general ways. First, the projective distortions not only *permit* the discovery of the prototype inherent within them; they *call* for it actively. Projection produces not a static deviation but a dynamic distortion, which is perceived as animated by a tension directed towards the simpler form from which it deviates. The projection looks "pulled out of shape." More generally this means that an abstraction is not simply drawn from a perhaps recalcitrant object but "found" in the object, which calls for the abstraction. A diamond-shaped parallelogram is seen as a leaning rectangle. To abstract the rectangle from it means to comply with the request of the object, which wishes to be straightened out; to leave the rectangle under its precarious pressure may satisfy, however, a need of tension, distortion, drama.

Second, the distorting features are perceived not only negatively as an impurity, which interferes with the true form of the invariant object; they are also seen positively as the effect of a condition that overlays the true shape of the object. The effect is understood as the logical consequence of the object's position in space relative to the observer. The perspective distortion of the cube is seen as a geometrically simple slanting or convergence of its invariant shape, and the lawfulness of this imposed modification makes it possible for the mind to distinguish between what belongs to the object's

shape per se and what is due to the projective distortion. Similarly, distortions inherent in a physical object itself are sometimes perceived as meaningful. The deviation from symmetry in the shape of a tree may not be seen simply as a random imperfection but as an understandable effect of the tree's environment. The stunting of the symmetry is read visually as the work of a foreign, invading force, and the evident lawfulness of the imposition facilitates its separation from the equally lawful symmetry, which is perceived as the potential, "intended" shape of the tree. Similarly, a depraved person may appear to be inhuman. To understand such a person requires, first of all, the ability to see him not as an alien monster but as a distortion of human nature. The abstraction involved in detecting human nature in this disguise is facilitated, and understanding is enhanced, when the distortion is seen positively as the effect of definable interferences, such as social forces of deprivation and humiliation. In such cases also, to abstract does not mean simply to detect and isolate, in the depraved specimen, the invariable entity, "human nature." All aspects of that nature — love, pity, hope, devotion — may have been perverted. They cannot simply be extricated. Instead, the person's behavior must become perceivable as a distortion of the standard called "normal human behavior." And here again the perception of the distortion is not static. The call for rectification, that is, the demand to do something about the situation, is an intrinsic component of the distortion's very appearance.

Permanence and change

I hope I have succeeded in showing that to distinguish an object from the afflictions of its appearances is an awe-inspiring cognitive accomplishment. And yet, the examples I gave are only of the very simplest kind. The more complex the shape of the object, the harder the perceptual task of extricating it, and the same is true when the influences of the environmental factors are less simple than those to which I have referred. One most powerful complication needs at least to be mentioned. The objects of perception are not necessarily rigid; they move, bend, twist, turn, swell, shrink, light up, or change their color. Here the task of perception is broadened in more than one way. It is often necessary, first of all, to see the physical changes of the object as deviations from a norm shape,

e.g., when the various motions of the human hand and its mobile fingers are understood perceptually as variations of that star-shaped organ known to the eyes as the hand. It may be equally necessary to see an object as a coherent happening or process, for example, when the growth of a plant is watched in an accelerated-motion film or when a bubble grows and explodes.

Naturally, these objective, inherent changes of size, shape, and so on, enormously complicate the task of visually distinguishing them from the changes due to the location of the observer and other effects of context. Although performed with such ease in everyday practice, the perceptual abstractions needed for these tasks reveal a bewildering intricacy when their components are analyzed.

The labors of vision create the view of a world in which persistence and change act as eternal antagonists. Changes are perceived as mere accidentals of underlying persistent identity; but perception also reveals constancy as the shortsighted look of change. Windelband, in his introduction to a discussion of Greek thought, says: "The observation that the things of experience change into each other spurred the earliest philosophical considerations." Visual perception supplied philosophers looking for permanence with evidence of the *arche,* the world substance beneath the variability of material things, "which suffers these changes and is the origin from which all particular things spring and into which they retransform themselves." Perception likewise offered visible proof that all things are in a flux of constant modification. Neither of these views could have arisen if sense were not intelligent enough to extricate the lasting from the changing and to perceive the immobile as a phase of mobility.

4. *Two and Two Together*

To see an object in space means to see it in context. The preceding chapter pointed to the complexity of the task accomplished every time the sense of vision establishes the size, shape, location, color, brightness, and movement of an object. To see the object means to tell its own properties from those imposed upon it by its setting and by the observer.

Relations depend on structure

More generally, to see means to see in relation; and the relations actually encountered in percepts are not simple. This may come as a surprise, because the mechanisms of relation described in psychological theory are often quite elementary. Remember the old laws of association: items will become connected when they have frequently appeared together; or when they resemble each other. These laws assume that relations connect piece by piece, and that these pieces remain unchanged by being tied together.

Nothing so conveniently simple occurs in the kind of example I have given. The appearance of any item in the visual field was shown to depend on its place and function in the total structure and to be modified fundamentally by that influence. If a visual item is extricated from its context it becomes a different object. Similarly complex situations arise in other areas of perception whenever "two and two" are put together, that is, when several items are seen as a unitary pattern.

How is a visual object composed of the elements supplied by the retinal projection? How is an image composed of its parts? The simplest among the rules that govern these relations is the rule of similarity, which does indeed confirm one of the oldest assertions of the theory of association: things that resemble each other are tied together in vision. Many objects look homogeneously colored because point-sized stimulations adjoining each other will fuse into a whole when their brightness and color are sufficiently alike. We see, for example, an evenly blue sky. Homogeneity is the simplest product of perceptual relation. It is also true that when a sprinkling of items is seen on a sufficiently different background and sufficiently distant from the next sprinkling it will be seen as a unit. Similarity of location provides the bond. But these most primitive connections work only when they are protected by isolation or distance from more powerful structural factors. Among the constellations of the night sky some are little more than an assortment of dots, a bit of sparkling texture, accidental in character and hard to identify. They owe their unity only to the empty space around them. Others hold together much better and display a definite shape of their own because their items fit into an order. The seven brightest stars of the Ursa Major are seen as a quadrilateral with a stem attached to one of its corners. Here the perceptual relations go much beyond connection by similarity. What is seen is indeed a constellation, in which each item has a definite and unique role. Because of its graspable shape, the constellation can also be compared to familiar objects of similar visual structure, such as a dipper, a wagon, or a plough, or an animal with a tail. Its relation to neighboring constellations is established by further structural connections, since two of its stars point to Polaris and its "tail" leads to Arcturus, the bear-watcher.

In most examples intended to show that similarity makes for perceptual grouping, the effect is not created by similarity alone. Arrange a number of chips, some white, some black, in a random order, and you will see them loosely related by color without any definite grouping; but let the white chips form a straight line or a circle, and their segregation from the black ones will be immediate and stable. That is, similarity will exert its unifying power only if the structure of the total pattern suggests the necessary relation. For the purpose of our investigation this means that the cognitive operations inherent in the perception of visual patterns are typically

Figure 2. Henri Matisse, Tabac Royal (1943). The Albert D. Lasker Collection.

of a much higher order than mere connection by resemblance. They require more perceptual intelligence.

One need only look at the role that resemblances among elements play in a work of art. They are frequent and are used by artists for what Picasso once called assonances. "Painting is poetry and is always written in verse with plastic rhymes, never in prose," he said to Françoise Gilot. "Plastic rhymes are forms that rhyme with one another or supply assonances either with other forms or with the space that surrounds them . . ." A viewer discovering such assonances in a painting will thereby trace connections that may be essential to its structure. There is, for example, a painting by Matisse, *Tabac Royal*, showing on its left side a woman sitting in a rather angular position on an angular chair and on the right a pear-shaped mandolin sitting on a curved chair (Figure 2). This witty parallel is as essential to the formal composition as it is to the expression and meaning of the painting. The beholder is led to

connect the two items because they dominate the picture and are placed in symmetrically corresponding locations. But there are many other resemblances in such a work which, if given a similar prominence by the beholder, would break up the structure of the whole by suggesting false connections. Students are often mislead into analyzing patterns by hunting indiscriminately for similarities of shape, color or spatial orientation, without proper attention to the weight of the relation within the whole. Given the infinity of possible relations within a fairly complex visual pattern, the cognitive task of assigning to any particular instance its proper place in the hierarchy of the whole structure is most delicate. For example, a student of art history once insisted in a class of mine that for the proper perception of the façade of Palladio's church *Il Redentore* the triangle completed in Figure 3 by dotted lines should be considered. It will be seen that while the relation exists it must remain subordinate if the overall symmetry of the two overlapping pediments is not to be destroyed.

Figure 3

The hierarchy of compositional order determines which items of the total pattern are to be seen together and which are incommensurate. A Romanesque façade, such as that of the Cathedral of

Figure 4. Cathedral of San Rufino in Assisi. (Photo: F. Alinari)

San Rufino in Assisi, may subdivide at the top level of the hierarchy into three horizontal layers, namely, the ground floor, the second floor, and the triangular pediment of the roof (Figure 4). Each of these principal units contains a further, secondary subdivision: a group of three doors at the ground level, three windows at the second floor. Each door or window, in turn, is subdivided into further patterns, which can be pursued down to the smallest details. This layering of structural levels suggests certain relations and bars others. The unity of the whole is not established by short cuts of resemblance between, say, a large and dominant feature and a small and insignificant one; only a stepwise descent from level to level leads from the one to the other, and only by way of this indirect, bureaucratic gamut can the resemblance among hierarchically distant elements make its contribution to the unity of the whole.

Problem solving, in direct perception or elsewhere, makes it often necessary to search out the identity of elements whose shape is destroyed by the overriding structure of the whole. This is illustrated in well known experiments requiring a person or animal to find a given figure in a larger context. The overall pattern may be

organized in such a way that it breaks up vital connections in the figure it contains, and unites some of the elements of the figure with others belonging to the outside. Such perceptual relations are often strengthened by functional connections established in the past. These, too, are part of the visual image that faces the problem-solver. For example, Köhler has shown that a chimpanzee may not succeed in seeing a branch on a tree as the stick he needs for retrieving his food. Here the perceptual connection between branch and tree, inherent in the physical object, is probably strengthened by the animal's past experience, which makes him see branches as parts of tree-climbing operations whereas sticks used as implements are separate objects. Those experiences, however, are not additions to the visual image but operate as parts of it. To see the branch on the tree as an implement is perceptually different from seeing it as a part of the tree.

How is such a change of relation accomplished? It is not enough for the animal to *look* at the problem situation because the mere scanning of what is before him will not bring into play the factors that produce the solution. Nor is the problem solved by thought operations taking place apart from the perceptual scrutiny. Rather there must be an interplay between an image of the intended goal ("I need something sticklike") and that of the situation directly given. Under the pressure of the goal image the problem situation restructures itself perceptually into: branch minus tree equals stick.

Later on I shall have occasion to show how greatly such a bit of visual thinking resembles the kind of problem solving that leads to scientific discoveries. Here the following example might suffice. We experience objects on earth as striving actively downward because of a power inherent in them which we sense as what we call their weight. It is difficult to perceive them as being attracted by the earth, because no sensory experience suggests this interpretation. (Michotte in his experiments on the perception of causality did not succeed in producing an arrangement of moving objects that looked as though one object was attracted by another!) And yet it is possible to change the perceptual experience of an actively downward-pushing and moving weight into the equally perceptual one of the object being pulled down passively. In order to accomplish this restructuring it is necessary to let a goal image of attraction make contact with the situation presently perceived. This perceptual

transformation of a common experience is at the root of Newton's contention that weight is an effect of gravitation; and without going through this transformation in his own senses no student can truly be said to have absorbed the theory.

Pairing affects the partners

Relations among items of the perceptual field turn out to be rarely, if ever, as simple as the models of association in traditional theory suggested. Mere resemblance is a strong bond only if supported by the structure of the environment; and the relation does not leave the items untouched, but often modifies them strongly. What holds for similarity is true also for contrast. Here the relations among colors may serve as an example. Neighboring colors strive to relate. When they are similar they tend to assimilate, that is, to minimize or eliminate the difference. One may see one homogeneous color instead of two almost identical ones. When assimilation is not possible, colors will change in the direction of the simplest relation their difference offers. The striving toward complementarity is generally described as the phenomenon of "color contrast." Complementary colors complete each other to "whole" white light and, at the same time, exclude each other and thereby differ as much as hues can. Here again, as in assimilation, the partners may change their own appearance for the relation's sake, and it is instructive to note that they may relinquish their own simplicity in order to increase the simplicity of the relation among them. Under the pressure towards contrast a pure red adjoining pure yellow may turn purplish while the yellow becomes greenish. The purity, which prevents the two colors from relating to each other, is sacrificed in order to make the relation of opposition and completion possible.

Confrontation may single out, highlight, and purify a particular quality. Two famous haiku by the Japanese poet Bashō describe how silence is sharpened by the opposition of a noise. One of them can be translated as follows:

> Old pond:
> frog jump-in
> water-sound.

The poem suggests that the character of the pond is truly revealed to

the senses only through the momentary interruption of its timeless tranquillity. The other haiku says:

Stillness:
into the rocks pierce
locust voices.

The extent to which the perception of a complex visual pattern may be modified by the presence of a second pattern has been suggested by unpublished experiments of a student of mine, Miss Anne Gaelen Brooke. Observers were asked to describe their impressions of two paintings of quite different style shown next to each other. Then, one of the pair was replaced by another picture, and the changes resulting from the new combination in the remaining picture were noted. These changes can be remarkably strong, and they often lead to distortions since the two works were not made for each other. In one instance, Rembrandt's painting of the Polish rider on a white horse in front of a backdrop of brown rocks was paired with Jean Dubuffet's *Landscape with Partridge*. In the Dubuffet, a similarly brown and textured mass fills much of the canvas, except for the top area, in which a bird is perched. The similarity of the two large, brown areas gave the background of Rembrandt's painting a new and unsuitable importance. At the same time, this very relation increased the depth between the foreground figure of the horseback rider and the backdrop, which looked too far away in contrast with its counterpart in the Dubuffet, where the textured mass filled the frontal plane flatly. When the Dubuffet was replaced with a large running chicken by Chagall, there was a sudden emphasis on the movement of the trotting horse in the Rembrandt and a corresponding fading out of the backdrop. Similarly, a strongly stylized painting by Karel Appel made a Modigliani figure look realistic, whereas the same Modigliani looked suddenly flat when confronted with a Cézanne portrait. These latter examples show that the experiments also demonstrated the distorting effect of historical perspective in the arts, by which a work of the past is seen from the point of view of a style of the present, or vice versa.

In these examples, an arbitrary confrontation deformed the two components of the pair. Inversely, one can demonstrate how a portion of a painting may be disfigured by being isolated from the

rest of the work and how it acquires its true form when the context is restored.

Actually, Miss Brooke's experiments were designed to illustrate the psychological mechanism on which metaphors are based in literature. There, the pairing of two images throws into relief a common quality and thereby accomplishes a perceptual abstraction without relinquishing the contexts from which the singled-out quality draws its life. For example, the poet Denise Levertov says to her reader:

> and as you read
> the sea is turning its dark pages,
> turning
> its dark pages.

The motion of waves and the turning of pages cannot be fitted in a unitary perceptual situation. Confrontation, however, presses for relation, and under this pressure the common element, the rhythmic turning, comes to the fore in its purity, conveying a sense of elementary nature to the pages of the book and of readability to the waves of the ocean.

Relation, then, far from leaving the related items untouched, works as a condition of the total context of which the items are parts and produces changes that are in keeping with the structure of that context. Colors, in particular, are never seen in isolation; they are so puzzlingly variable as to justify a curious observation written by Goethe while he was concerned with the theory of color:

The chromatic has a strange duplicity and, if I may be permitted such language among ourselves: a kind of double hermaphroditism, a strange claiming, connecting, mingling, neutralizing, nullifying, etc., and furthermore a demand on physiological, pathological, and aesthetical effects, which remains frightening in spite of longstanding acquaintance. And yet, it is always so substantial, so material that one does not know what to think of it.

This elusiveness is not so much a particularity of perception as it is characteristic of cognition in general. The privilege of observing everything in relation raises understanding to higher levels of complexity and validity, but it exposes the observer at the same time to the infinity of possible connections. It charges him with the task of distinguishing the pertinent relations from the impertinent ones and of warily watching the effects things have upon each other.

Experience indicates that it is easier to describe items in comparison with others than by themselves. This is so because the confrontation underscores the dimensions by which the items can be compared and thereby sharpens the perception of these particular qualities. However, the procedure has its dangers. It is easier to describe the United States by comparing it with China than by itself without such reference; but the comparison highlights characteristics quite different from the ones to be gotten from a comparison with, say, France, and is therefore arbitrary.

Some of the modifying effects of relation may take place at a very elementary physiological level. This may be true, for example, for color contrast. But, as I pointed out at the beginning of this book, it does not matter for my argument at what level of the perceptual process an operation takes place. At any level, perception involves operations of a structural complexity similar to that of cognitive behavior more in general.

Let me give now a few examples from the relations among shapes, especially symmetrical shapes. The strong connection uniting the corresponding parts of a symmetrical pattern comes about because these parts are identical in shape but opposite in spatial orientation. Through their opposition they add up to a highly unified whole. The coherence of such a whole is particularly strong when it is obtained by the mirroring of units which are irregular and unstable in themselves—just as two complementary color mixtures add up to a strong union. Two leaning lines (Figure 5a) support each other in a

a *b*

Figure 5

stable whole when they are placed symmetrically. Also, similar to what I pointed out for color, a shape may abandon its own stability in order to adapt itself to a stable whole: in Figure 5b, the line on the right tends to give up its verticality in favor of a position sym-

metrical to that of the left line. A similar willingness to relinquish simple shape for the benefit of a larger configuration is evident in the experiments in which shapes adapt to each other when perceived in succession ("figural after-effect") or simultaneously. For instance, in Figure 6, taken from Köhler and Wallach, the left half of the

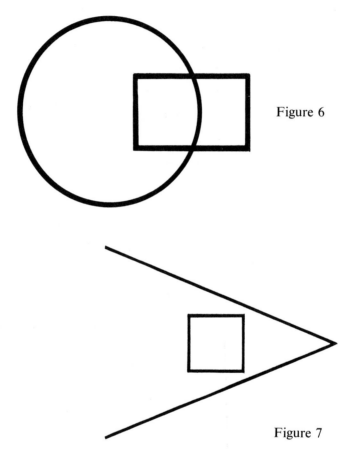

Figure 6

Figure 7

rectangle shrinks and compensates thereby for its asymmetrical relation to the circle. This results in a better balance of the two masses. Similarly, in Figure 7, the square abandons its own regular shape and shrinks on the left, thereby counterbalancing the oblique-ness of the two legs of the angle; this distortion approaches sym-metry of the whole as closely as the rather firm stimulus permits. Effects of this nature can be observed in many other so-called optical illusions.

In a broader sense, symmetry is but a special case of fittingness,

the mutual completion obtained by the matching of things that add up to a well-organized whole. Convexity fits concavity, the key fits the keyhole, and in the fable told by Aristophanes the male and the female yearn to restore the spherical wholeness of the original human body. Often a problem presents itself perceptually in the form of something "looking incomplete," and the solution may be found when the situation points to a completion. For example, in Köhler's experiments, a chimpanzee sees that two hollow bamboo sticks of different diameter fit each other, as soon as their position suggests a direct visual relation (Figure 8).

Figure 8

Basically, then, things relate by assimilation or by contrast and often by a combination of the two. Assimilation is probably the primary condition. Homogeneity prevails unless a sufficiently strong stimulus breaks up the field into separate units, as when a red object is seen on a green ground or when parts of the field are separated by a spatial distance or when an object moves through an immobile environment. Separation by difference imposes itself also when the observer is called upon to make a choice among given items. Psychologists have studied this condition in the so-called discrimination experiments.

Perception discriminates

In these experiments, an animal or person is made to learn which of two simple stimuli, e.g., two geometrical patterns, is tied to a reward. Since there is no sensible connection between the visual sign and the reward the task is intellectually unattractive, though practically gainful. The best the rat or monkey or human subject can do is to find out by repeated trials which figure is the winner. The experiments show how much perceptual intelligence is displayed even under unfavorable conditions.

What animals see can be inferred only from what they do or by analogy with human experience. When first confronted with the two stimuli of a discrimination experiment, an observer is likely to see a fairly unitary pattern, more or less clearly subdivided into a somewhat symmetrical pair. This lack of emphasis on the difference between the two is especially probable when the two shapes have not been endowed with any particular meaning by past experience and therefore are united by being both new. The test patterns may be set off against the ground more or less clearly. The distinction between figure and ground is known to be basic; it is more elementary than the perception of shape. How closely related the two patterns appear to be will depend on how near they are to each other, how much they resemble each other objectively, and how much of that resemblance is perceived.

Whether or not the observer pays attention to the whole rather than to parts of the pattern depends on circumstances on which one can hardly generalize. Also, how many aspects of form and color are grasped and what weight any one aspect carries in the whole will be influenced by individual differences. Different kinds of animals are known to have preferences in this respect, and the studies on children indicate that they respond more strongly to color at one age and to shape at another. Infants are known to distinguish shapes rather well even in the first months of life and are more interested in certain kinds of figure than in others; for example, they will look longer at patterned than at unpatterned ones. What matters for my present purpose is that neither in the first confrontation at the beginning of the experiments nor in later phases is vision likely to consist in the mechanical recording of the shapes and colors presented to the observer's eyes.

Perception compares

The overall uniformity of the pair pattern is likely to be dominant until the situation calls for distinction. This happens when the observer realizes that one of the two figures is "right," the other "wrong," for instance, when the choice of one of them is rewarded. Under the pressure towards the reward, the view of the pattern as a unified whole gives way to one of a pair of alternatives. Perception shifts from similarity to distinction. Differentiation takes place because the situation calls for it.

During learning, the distinguishing features of test patterns

come to the fore. The difference may be one of kind or of degree. If it is one of degree, such as size or intensity, learning is typically concerned with the relation between the stimuli rather than with their absolute magnitudes. The observer, whether animal or human, learns to select the larger of two sizes or the darker of two grays. Within certain limits, he is unaffected by a transposition of the pair of values to a higher or lower location on the scale; and the interval between the two values can be narrowed or stretched. Similarly, when the difference is one of kind,—red versus green or triangle versus circle—learning will not refer narrowly and mechanically to the specific shade of green or the particular shape of the triangle. What is learned is the difference between redness and greenness, between triangularity and circularity. Cognitively, this means that the distinction demanded by the task is kept at a level as generic as the task permits. This is the very opposite of a mechanical recording of stimulus values.

Evidence of this intelligent economy in perceptual learning comes from experiments on "stimulus equivalence" or "stimulus generalization." Here learning must be transferred to different sets of shapes or colors resembling the original one in some way. If, for example, a person or animal being tested has learned to choose a circle rather than another figure, will the subject transfer this training to an ellipse? If he does, he shows himself capable of abstracting the features which rounded shapes have in common from those in which they differ. This requires the twofold ability to discover the crucial common qualities and to disallow the ir- relevant ones. Not to see the resemblance between two things or not admit it because the two things are not completely identical can be a symptom of limited intelligence.

Different creatures vary as to what they are able and willing to accept as resemblance. If a rat is trained with a triangle of solid black and is confronted with the mere outline of an identically shaped triangle, it will hesitate at first, indicating that it does perceive the difference between what it has learned and what it sees now. But the resemblance of shape will tend to favor the transfer.

After all, the outline of the triangle is identically present in both instances. This example, however, must not be taken to mean that transfer is necessarily easiest when the two patterns in question contain the critical feature in exactly the same form. What matters more is how easy or hard it is to spot the critical feature in its

context. I referred earlier to experiments which prove what any artist knows from practical experience, namely, that a given shape may be absorbed or dismembered by the structure of the surrounding pattern in such a way that it can be discerned only with great difficulty, whereas it may detach itself easily from its surroundings when its structure is relatively independent of that of its setting. Also, when the crucial common feature has a very different place and function in the two contexts that are to be compared — when it dominates the one but is subordinate in the other — it may be hard to discover even though it is of exactly the same shape and detaches itself fairly well from its surroundings. The animal's hesitation reminds us that the same item in two different contexts cannot be said to be psychologically identical.

In many experiments, the elements on which abstraction is based differ considerably from each other. When a rat is trained to distinguish horizontal stripes from vertical ones he will respond to the difference between horizontality and verticality even if the spatial directions are represented only by rows of two or three dots each. In the words of Karl Lashley: "The differentiating characters are always abstractions of general relationships subsisting between figures and cannot be described in terms of any concrete objective elements of the stimulating situations." This raises the question of what the animal does in fact perceive if it does not see "any objective elements of the stimulating situations." How does one perceive an abstract relation? The question is indeed puzzling unless it is assumed, as I did in discussing the perception of shape, that to see an object is always to perform an abstraction because seeing consists in the grasping of structural features rather than in the indiscriminate recording of detail. Which features are grasped will depend on the observer, but also on the total stimulus situation. A figure perceived in comparison with another, for example, may look different from the way it would appear by itself.

What happens to the attributes of the training pattern which are not usable, or not used, for the abstraction? In its responses, the animal may behave as though they had not been present at all. Take the following two examples from Lashley's experiments. A rat learns always to choose the larger of two circles. When tested with pairs of other shapes, with two triangles for instance, it will again choose the larger shape consistently. This suggests that the rat learned intelligently. If he had learned mechanically by treating

all the attributes of the two patterns as though they were equally necessary for the solution of the training task, transfer would have been impossible. Instead he concentrated on the feature of size, which determined the discrimination. If the training period is followed by a test in which the rat must discriminate between a circle and another shape of equal area he shows no initial preference for the circle. He behaves as though he had had nothing to do with circles before.

In another experiment, one group of rats is trained to choose a white circle of 5 cm. diameter on a black card and distinguish it from a plain black card. Another group receives the same training with an 8 cm. circle. If, after the training, the animals are asked to choose an 8 cm. circle and reject a 5 cm. one, those of the second group would have an easier time if they had profited from the experience of always picking a circle of that absolute size. No such difference between the groups is found.

Perhaps the animals actually noticed only the features needed for the discrimination or they forgot all the others. But this is not the only possible explanation. A human subject, reacting similarly, might nevertheless be able to remember the roundness of the training figures in the first experiment and the approximate size of the training circle in the second. The training task may establish a perceptual hierarchy of features, distinguishing between what is predominant and what is irrelevant. Some features are being endowed with the quality of irrelevance and therefore are not eligible for use in the test tasks.

When more than one feature is usable for the solution of the task, the animal may proceed according to the preferences of its species. "If a monkey is trained to choose a large red circle and avoid a small green one, he will usually choose any red object and avoid any green but will make chance scores when like-colored large and small circles are presented" although he is perfectly capable of learning to discriminate circles by size.

What looks alike?

There are limits beyond which the range of an abstraction refuses to be stretched. A chimpanzee, trained to choose a white triangle on a black ground, will not react positively to a triangular arrangement of six white dots on a black ground even though the size of

the two figures is kept equal (Figure 9). A two-year-old child, however, will make the transfer. It is easy to see why the chimpanzee has trouble with this task. The triangle is not spelled out explicitly by contour but indicated only through the arrangement of the white spots. The distances between the spots must be bridged. In principle, this is not beyond the capacities of an animal. I mentioned that even a rat will respond to the horizontality or verticality of a pair of dots. But apparently, when the six dots are evenly dis-

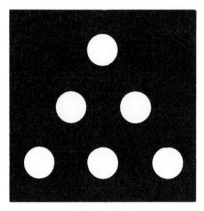

Figure 9

tributed so that the intervals along the contours are equal to the internal ones, the triangularity of the whole cannot impose itself sufficiently for the chimpanzee. The self-contained circular shape of each disk stresses the character of the pattern as a loose arrangement of separate, closed units. A grown-up human subject might find himself in a similar situation when, trained to look for triangles, he were faced with a painting showing a triangular grouping of figures in the style of the Renaissance. Unless he is versed in the refinements of art appreciation, the accumulation of the Renaissance figures may not add up for him to a triangular whole. It certainly would not for a two-year-old child.

The feat of extricating a particular element from a pattern shows intelligence at work within perception itself. Quite in general, intelligence is often the ability to wrest a hidden feature or disguised relation from an adverse context. It is an ability that can lead to important discoveries. At the same time, the resistance of the context to such an operation raises a peculiar problem. After all, there is good sense in the warning that "one must never take things out

of context." They may be falsified, distorted, and even destroyed by the isolation. At the very least, they may be changed. The curious question arises: how desirable is it to be able to perform such extrications?

Consider the difficulties that develop for the subjects in the experiments on stimulus equivalence when the test pattern varies from the training pattern by its orientation in space. A triangle standing on one of its corners is accepted as the equivalent of a triangle resting on its base by a chimpanzee and a two-year-old child, but not by a rat or a chicken. Even an adult person, capable of making such a transfer, will notice nevertheless a definite change of character and structure when a figure alters its position in space. On the other hand, it is well known that children under five years of age do not turn pictures around which they happen to hold upside down, and they recognize objects in an abnormal position more easily than do adults. Köhler comments: "In this sense they are for once capable of higher achievements than we are." But a few pages later he objects to the view that one of the necessary components of form perception is the ability to recognize a figure independently of its orientation in space: "Obviously from this point of view the form perception of adults would be strikingly inferior to that of children."

Probably the young child is not really abstracting from the context of spatial orientation. This context, be it psychological or physiological in nature, may be not yet accessible to him in pictures. In this sense he is inferior to the mature rat or pigeon, who has acquired that context but cannot abstract from it. Spatial orientation is a matter of basic biological importance. Living in a strong gravitational field as we do, we acknowledge the relation of an object to the up-and-down dimension as a vital aspect of its nature. A man who stands on his head is a very different creature from one in the more orthodox position; and if he could not tell the difference he would be severely handicapped. Weightlessness is perceived as a threat to the security of habitual orientation; and perhaps there is a broader significance to the experiment which has shown that the octopus—an animal adapted to water, that is, to an environment of reduced gravitational stress—accepts triangles as equivalent even though they have been rotated in space.

To lift something out of its context means to neglect an important aspect of its nature. In this sense, the inability (or shall we say:

the refusal?) of the pigeon or rat to ignore a change of spatial orientation has its cognitive merits. On the other hand, progress and profit may come from the ability to spot similarities in spite of the differences of context.

Mind versus computer

Analogy problems are often used in intelligence tests because the cognitive operations displayed in visual perception when a person discovers analogies among patterns are surely intelligent behavior. This becomes particularly clear if one compares the procedure of the average person in such a test with the way a machine goes about the same task. Analogy problems take the following form: Given two patterns, A and B, can you select from a group of patterns, D_1, D_2, D_3, the one relating to C as B relates to A? Since computers can be made to solve such problems they have been widely credited with "artificial intelligence." But not every problem that can be solved by intelligence can be solved only by intelligence. Intelligence is a quality of mental process, and when we call a discovery intelligent we are justified in doing so if we have reasons to believe that it was made by a particular kind of procedure, namely by an understanding of the relevant structural features in the problem situation. The computer's procedure cannot be called intelligent unless one is willing, with carefree operationalism, to define mental processes by their external output or unless one's notion of how intelligence functions is so mechanistic that the behavior of the computer does in fact meet the description.

It is embarrassing to realize that the problem solving procedure called intelligent in computers today is essentially the same which the psychologist Edward L. Thorndike attributed to animals in the 1890's in order to prove that they cannot reason. All that animals do, contended Thorndike, is to run blindly through a number of possible reactions until they stumble upon a successful one. The more often the successful reaction occurs, the more smoothly will it become connected, in the animal's brain, with the problem situation. This association is no more intelligent than the behavior of rainwater that runs more and more readily through a deepening gully. There is no understanding, said Thorndike. The computer differs from the behavior of Thorndike's hypothetical animals by running mechanically through the entire set of instances to which

it is exposed whereas the animals limit themselves to random trials and operate more slowly. But the verdict is the same.

There is no need to stress here the immense practical usefulness of computers. But to credit the machine with intelligence is to defeat it in a competition it need not pretend to enter. What, then, is the basic difference between today's computer and an intelligent being? It is that the computer can be made to see but not to perceive. What matters here is not that the computer is without consciousness but that thus far it is incapable of the spontaneous grasp of pattern — a capacity essential to perception and intelligence.

A geometrical figure of the kind used for analogy tests can be submitted to a computer, for example, by means of a tablet on which a stylus produces the appropriate drawing. In order to make the drawing suitable for processing it is dismembered into a mosaic of point-sized bits. This is very much like what the retina of the eye does with stimulus material. But the analogy stops right there because the decisive phase of visual processing takes place at a level of the nervous system which, whatever its precise physiological nature, must function as a "field," that is, it must allow free interaction among the forces generated and mobilized by the situation. Under such conditions, the stimulus material will be organized spontaneously according to the simplest overall pattern adaptable to it, and this grasp of structural features is the basic prerequisite of perception and any other intelligent behavior. Gestalt psychology calls this procedure the approach "from above," that is, from the whole to its constituents.

Today's computer, instead, proceeds "from below." It starts with the elements and, for all the combinations it can produce, never gets beyond them. Moveover, all it can give us about each element is information of a binary nature. It can say yes or no, present or absent, black or white, or whatever other meaning we choose to attribute to its alternations. How easily this limitation can be overlooked may be illustrated by an example given by Marvin L. Minsky, who wishes to show that the computer is enabled by "reasoning power" to "recognize a global aspect of the situation." The computer is able to describe Figure 10a as a combination of a square and a triangle. This looks indeed as though the machine were capable of perceptual organization. Purely mechanical recording might describe the figure as a group of ten straight lines, and equally mechanical processing will produce any com-

bination of these elements which it is called upon to deliver. Figure 10*b* is one such possible combination; Figure 10*c* is another. However, the machine has no preference for any one of these versions of the material, unless such a preference is imposed upon it by the operator. The machine can be instructed, for example, to dissolve the pattern into a minimum number of closed shapes, in which case it will produce Figure 10. If it is asked to dismantle the design into closed figures composed of a minimum number of straight lines, it will again come forward with Figure 10. And the same will happen when it is given the much more primitive task, as it is in Minsky's example, of looking in *a* for the shapes contained in *c*.

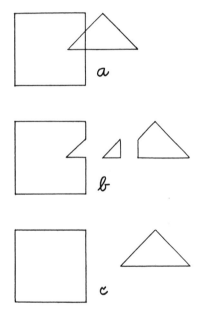

Figure 10

The qualitative difference between the geometrically simplest arrangement and any other, more irregular one, exists in the brain of the programmer, not in his machine. The computer will pick out "global aspects" of the situation if it is told to do so and if these global aspects are redefined for it in piecemeal terms as particular combinations of elements. Thus instructed, it will faultlessly solve every task in which the structural principle to be applied can be reduced to a mechanistic criterion.

The difference between intelligent perception and the behavior of the computer turns out to be still more fundamental if we realize that even such form properties as straightness and closedness

cannot be grasped directly by the machine but must be reduced to combinations of point-shaped units. To illustrate this, I will refer once more to pattern recognition by machine. A computer can be made to respond to basic structural features of letters or numerals and to neglect other, irrelevant properties of individual shapes. But it does so not by proceeding "from above," that is, by comparing the structural skeleton of a given letter with that of its norm shape and finding them sufficiently similar. It proceeds "from below" by counting the number of elementary places occupied in the picture-plane by both figures. It proceeds similarly when the matching process becomes more flexible by allowing for the tilting, stretching, or twisting of shapes.

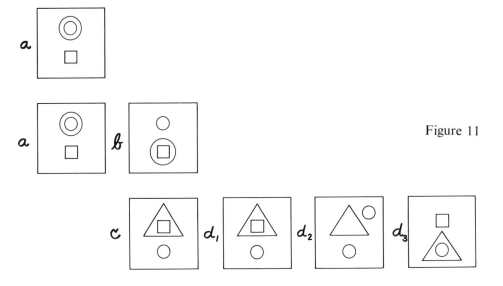

Figure 11

We are now ready to compare the ways in which the human brain and the machine go about solving analogy problems. What happens when a person is confronted with a figure such as Figure 11*a*? The reaction will vary somewhat from individual to individual as long as no particular context calls for concentration on specific structural features. By and large, however, the observer is likely to notice a vertical arrangement, made up of two units, of which the upper is larger and more complex than the lower; he may also notice a difference in shape. In other words, he will notice qualitative characteristics of placement, relative size, shape, whereas he is unlikely to notice much of the metric properties from which

the computer's reading of the pattern must set out, namely, absolute size and the various lengths and distances by which this individual figure is constructed. If one asks observers to copy such a figure, their drawings will show concentration on the topological characteristics and neglect of specific measurements.

Confronted now with a pairing of a and b, the human observer may have a rather rich and dazzling experience. He may see, at first, fleeting, elusive resemblance among basically different patterns. The over-all figure, made up of the pairing of the two, may look unstable, ungraspable, irrational. There are two vertical arrangements, combining in sort of symmetry; but those two columns are crossed and interfered with by diagonal relations between the two "filled" large circles and the two smaller, unfilled shapes. The various structural features do not add up to a unified, stable, understandable whole. Suddenly, however, the observer may be struck by the simple rectangular arrangement of the four smaller figures: two equal circles on top, two equal squares at the bottom. As soon as this group becomes the dominant theme or structural skeleton of the whole, the remainder—the two large circles—joins the basic pattern as a secondary, diagonal embellishment. A structural hierarchy has been established. Now the double figure is stable, surveyable, understandable, and therefore ready for comparison with other figures. A first act of problem solving has taken place.

If the observer turns to Figure c, his view of this new pattern is determined from the outset by his preceding concern with a and b. Perceived from the view point of a, c reveals a similar vertical structure, distinguished from a mainly by a secondary contrast of shapes. The family resemblance is great, the relation comes easily. But if c is now paired with d_1, the resemblance looks excessive, the symmetry too complete. On the contrary, a comparison with d_2 offers too little resemblance. The correct partner, d_3, is recognized at once as the missing fourth element of the analogy, if the relation between a and b had been properly grasped before.

This episode of perceptual problem solving has all the aspects of genuine thinking: the challenge, the productive confusion, the promising leads, the partial solutions, the disturbing contradictions, the flash appearance of a stable solution whose adequacy is self-evident, the structural changes brought about by the pressure

of changing total situations, the resemblance discovered among different patterns. It is, in a small way, an exhilarating experience, worthy of a creature endowed with reason; and when the solution has been found there is a sense of dis-tension, of pleasure, of rest.

None of this is true for the computer—not because it is without consciousness but because it proceeds in a fundamentally different fashion. We are shocked to learn that in order to make the machine solve the analogy problem the experimenter "had to develop what is certainly one of the most complex programs ever written." For us the problem is not hard; it is accessible even to the brain of a young pupil. The reason for the difference is that the task calls for the handling of topological relations, which require the neglect of purely metric ones. The brain is geared precisely to such topological features. They inform the organism of the typical character of things rather than of their particular measurements. The machine, by telling the experimenter which quantitative factors are germane to the solution and which are not, may lead him to hit upon the idea that topological criteria provide the answer; but the kind of machine we have today cannot itself behave topologically. Topology was discovered by, and relies on, the perceptual powers of the brain, not on counting and measuring. Inversely, the machine can also furnish the quantitative data indicating the presence or absence of a topological condition, if man supplies it with the necessary criteria. It can tell the experimenter that all the dots forming a particular loop are among the dots located in an area that is bounded by another loop of dots. From this information the experimenter can infer that the first loop lies inside the second, and the clumsiness of the quantitative information needed to supply the data for the simple topological conclusion explains why the programming for this task is so arduous.

The programmer must supply the topological dimensions of inside and outside, above and below, right and left, etc., and it is he who must work out the quantitative, non-topological criteria for their presence or absence. It is he who had to decide in the first place that topological criteria were needed for the solution, and in order to know this he had to learn how to solve such tasks before he ever submitted them to the machine. Without being tipped off beforehand by his own human disposition he would have no way of excluding the possibility that the analogy was based

on purely quantitative criteria. The analogy could be based, for example, on the number of identically located dots in the pairs of patterns. In that case, no human eye could hope to solve the problem whereas the computer would do it with relish.

By deciding that the task was topological the experimenter had made the decisive intellectual step toward the solution before the computer was approached. He thereby made it unnecessary for the machine to run through an infinite number of irrelevant relations as it would have to do if it were on its own—and on its own it would have to be if its contest with the brain were to be carried out in earnest. Left with the secondary task of finding out which of a given set of relations apply to the patterns under investigation it does its work in a purely mechanical fashion. It runs through all the criteria for all the given pairings of patterns, and comes up with the correct answer more reliably and perhaps faster than the human brain but without the use of a trace of intelligence. The practical efficiency of computations performed at electronic speed tends to make the observer overlook the intellectual inferiority of the procedure employed.

The brain would be in the same precarious position if it could not rely on perception. Only perception can solve organizational problems through sufficiently free interaction among all the field forces that constitute the patterns to be manipulated. In principle, of course, the handling of organizational problems by means of field processes is not inaccessible to machines. Few scientists still believe that organic mechanisms possess physical qualities that cannot be replicated eventually by man-made contraptions. If some day the replication is made, the machine can be expected to display the kind of intelligence found in the perceptual behavior of man and animal. This would support rather than refute my argument.

Someone may be willing to agree that the difference exists which I have tried to describe, but may not be convinced that it matters: "After all, the problems can be solved by either procedure, and you admit that the machine may work more reliably and faster!" He may also point out that perception, after all, is also based on the processing of elements and furthermore that attempts have been made to reduce the principle of simplicity, on which perceptual organization is based, to a quantitative method. Julian E. Hochberg, for instance, has suggested that the structurally

simplest version of a perceptual pattern is the one that can be described or constructed with a minimum of information. He has given examples to show that the smaller the number of angles, line segments, points of intersection, etc. constituting the figure, the simpler is its perceptual organization. Let us assume that, with some refinement of the scoring categories, the method would indeed work. In that case, a computer would be able to grade the qualitative structure of a pattern by quantitative criteria. However, Hochberg was careful to describe the result of his procedure as a mere "quantitative index," a set of "parallels" to the principles of visual organization. He did not pretend that he had discovered how shape is perceived. In fact, it is one thing to construct and predict a particular organization of a stimulus pattern and quite another to obtain it by means of the principle on which perceptual grasp is based. If Hochberg's method is valid, it may serve most usefully as a quantitative indicator of structural simplicity, just as the extension or contraction of a mercury column makes it possible to measure an amount of heat. But the mercury column says nothing about the nature of heat, and the counting of lines and angles nothing about the visual structure they make up. The analytical formula of a geometrical figure, for example, of a circle, gives the location of all the points of which the circle consists. It does not describe its particular character, its centric symmetry, its rigid curvature, etc.

However, it is precisely this grasping of the character of a given phenomenon that makes productive thinking possible. Let us remember why analogies are used for intelligence tests in the first place. Analogies are traced best by a person who can take hold of a basic similarity of character in the items he compares. He is capable of relevant abstraction when he deals with visual patterns, and intelligence testers go on the assumption that this ability is characteristic of his thinking more in general. His intelligence is revealed in the way he perceives.

5. *The Past in the Present*

So far, visual thinking has been discussed only for direct perception. Even within this limited realm the cognitive operations turned out to be remarkably rich. However, perception cannot be confined to what the eyes record of the outer world. A perceptual act is never isolated; it is only the most recent phase of a stream of innumerable similar acts, performed in the past and surviving in memory. Similarly, the experiences of the present, stored and amalgamated with the yield of the past, precondition the percepts of the future. Therefore, perception in the broader sense must include mental imagery and its relation to direct sensory observation.

The effect of past experience on perception has received much attention by psychologists. In fact, everybody unwilling to credit direct perception itself with the shaping of sensory material has tended to attribute this important function to the past. A viewer is said to simply apply to the present what he has learned about things in the past; or, as the contention has been worded sometimes, we see things as we do because of what we expect them to look like. I have mentioned before that this one-sided approach leads to an infinite regression and never comes to grips with the question of how percepts were organized originally.

The influence of memory on the perception of the present is indeed powerful. But no shape acquired in the past can be applied to what is seen in the present unless the percept has a shape in itself. One cannot identify a percept unless it possesses an identity

of its own. How necessary it is to insist on this point can be seen, for instance, in a paper by Jerome S. Bruner, who comes close to the position taken in this book when he asserts that "all perceptual experience is necessarily the end product of a categorization process." However, looking at the paper more closely, one finds that according to Bruner this categorization is limited to putting the percepts of the present into cubbyholes constructed in the past. Although he admits that "certain primitive unities or identities within perception must be innate or autochthonous and not learned," he does not see these unlearned categories at work within direct perception itself. But how can the perceptual input of the present be sorted into the categories of the past, unless it possesses categorical shape in the first place? Bruner presents the sort of approach Wolfgang Metzger has in mind when he says that psychologists often face the problem of perceptual organization "first at the level of the next-higher storey," that is, too late. Any secondary manipulation of perceptual material presupposes the primary shaping of that material in direct perception itself.

Forces acting on memory

If a percept is a categorical shape rather than a mechanically faithful recording of a particular stimulus, then its trace in memory must be equally generic. This shape is unlikely to remain unaltered. Forces inherent in the shape itself or pressing on it from the surrounding field of traces will strive to modify it in two opposite directions. There will be, on the one hand, a tendency toward simplest structure or tension reduction. The trace pattern will shed details and refinements and increase in symmetry and regularity. This whittling down of the trace to a simpler figure will be checked by a countertendency to preserve and indeed sharpen the distinctive features of the pattern. Experiments have indicated that when observers are shown a figure with the instruction to commit it to memory as faithfully as possible "because your memory will be tested," they make an effort to preserve the characteristics of the figure. Under such circumstances they will recollect, for example, that a circle had a small gap, which otherwise might have dropped out in memory or not been actively perceived in the first place.

Distinguishing characteristics will also be preserved and exaggerated when they arouse reactions of awe, wonder, contempt,

Figure 12

amusement, admiration, and so forth. Things are remembered as larger, faster, uglier, more painful than they actually were.

Both tendencies will be at work in the elaboration of each memory trace, paring it down to greater simplicity and at the same time preserving it and sharpening its distinguishing traits to the extent to which there are reasons to do so. The two can operate in any ratio of strength. At times, one of them will clearly prevail, but there is no reason to expect that in every case a trace will show a clearcut modification in only one of these directions, as has often been assumed in the psychological literature. Figure 12 reproduces a random sample of drawings made by college students who were asked to do a picture of the American continent from memory. A strong tendency to align the two land masses more symmetrically and simply to a common vertical axis is checked more or less noticeably by faithful observation and retention and by an active response to the rather violent deflection toward the east which distinguishes the geographic position of South America on the map.

A parallel to the two antagonistic tendencies in perception and memory, and surely to some extent a manifestation of them, can be found in the visual arts. A striving toward "beauty" in the classical sense of the term makes for simplified shape and for tension reduction in compositional relations. Expressionist leanings, on the other hand, lead to distortion and high tension created by discord, mutual interference, avoidance of simple order, and so on. These stylistic forms are determined partly by the subject matter, partly by the purpose of the pictorial representation, but also by the general outlook and attitude of the artist or period. And here again, the range between the more extreme manifestations of classicist and expressionist tendencies is filled with works displaying all the shades of the variable ratio between the two.

Antagonistic though the tendencies of leveling and sharpening are, they work together. They clarify and intensify the visual concept. They streamline and characterize the memory image. This process is further enhanced but also hampered by the fact that no trace is left to its own devices. Every one of them is susceptible to continuous influence by other traces. Thus, repeated experiences with the same physical object produce new traces, which do not simply re-enforce the existing ones but subject them to unending modification, as an artist may keep changing a work for years while

he has it in his studio. Our image of a particular person is the quint-essence of many aspects and situations, sharpening, amplifying, altering it. Traces resembling each other will make contact and strengthen or weaken or replace each other. To put it in the terms of Kurt Lewin: memory is a much more fluid medium than per-ception because it is farther removed from the checks of reality.

The result is a storehouse of visual concepts, some clear-cut and simple, some elusive and intangible, covering the whole of the object or recalling only fragments. The images of some things are rigidly stereotyped, others are rich in variation, and of some we may possess several images unwilling to fuse into one unitary con-ception, e.g. the front-face and profile views of certain individuals. All sorts of connection tie these images together. Although the total content of a person's memory can hardly be called an inte-grated whole, it contains organized clusters of small or large range, families of concepts bound together by similarity, associations of all kinds, geographical and historical contexts creating spatial set-tings and time sequences. Innumerable thought operations have formed these patterns of shapes and continue to form them.

Percepts supplemented

Memory images serve to identify, interpret, and supplement per-ception. No neat borderline separates a purely perceptual image — if such there is — from one completed by memory or one not directly perceived at all but supplied entirely from memory residues. It may be useful, therefore, to give here first a few examples in which an incomplete stimulus is completed perceptually without any neces-sary recourse to memory, that is, to past experience. A pencil placed in such a way that its retinal projection crosses the blind spot of the eye will look uninterrupted. Similarly, when brain damage blinds a person in certain areas of the visual field (hemianopsia), a circle, half hidden by the blind area, will look complete. So will an incom-plete circle exposed to observers for a split second or at reduced light. These are examples of what Michotte has called "modal com-plements" because gaps have been filled in the actual percept. Com-pletions of this kind are likely to be caused by the tendency toward simple structure, inherent in the perceptual process itself.

Equally perceptual in nature are many instances in which ob-servers report that the complement is "actually there" although it

is seen as "hidden." Michotte has investigated the so-called tunnel effect. The course of a train is experienced as perceptually uninterrupted when the train passes through a short tunnel. One can produce the effect experimentally even on a flat surface, for example, by making a dot or bar move toward an obstacle, behind which it seems to disappear, only to "emerge" on the other side a moment later. Under favorable conditions, observers "see" the moving object continue its course "behind" the obstacle although objectively no such behind exists. The percept is experienced as complete, so much so that observers are often unwilling to believe that in actual physical fact there was no such continuity of the movement. The completeness of the percept remains unimpaired even when the observer has been apprised of the physical situation. The psychologist is compelled to assume that the coherence in space and time of the two movements—the one before and the one behind the obstacle—is such as to actually complete the imprint of the movement at some physiological level. The stimulus sequence is interrupted, but the brain process it produces is not.

This must be so also in the many cases of perceptual induction in which the limitations of the stimulus are clearly seen and yet the percept completes itself under the control of this limited stimulation. Looking at the skeleton of a cube, one is perfectly aware that physically the cube has no walls, and yet one perceives these walls equally clearly as glassy, immaterial surfaces bounding the cube. (Michotte notes that when a wire cube rotates its empty content is seen as rotating with it.) The incorporeal quality of the walls is the result of a compromise resolving a paradox: they are seen as physically absent and yet perceptually present. All outline drawing is successful because the completion effect fills the contoured shapes with substance.

We may hesitate to admit that the unity of the two pieces of visible movement in a tunnel experiment can be a genuinely perceptual accomplishment. Has not Piaget shown that when an infant sees a person disappear behind a screen he keeps watching the place of that disappearance and is distinctly surprised when the person emerges on the other side? Does this not suggest that perception supplies only the visible pieces and that the intelligent integration of the two is a secondary elaboration performed at "higher" levels on the basis of prolonged experience? Quite possibly the tunnel effect takes time to develop, although Piaget's particular setup does

not necessarily satisfy the conditions on which the phenomenon depends even in adults. But such a gradual development does not prevent the final result from being a genuine percept. The tunnel effect, as so many other perceptual phenomena, presupposes that the stimulus situation be surveyed as a whole, and it is this comprehensive way of looking which, in many instances, develops through the gradual extension of an originally limited view. Units of the perceptual field that are sufficiently self-contained are seen at first by themselves, and only when the range of the survey has been sufficiently enlarged will the whole be integrated spontaneously in perception. This happens in the dimension of space, but also in that of time. The self-contained movement before the obstacle is gradually integrated with the later movement after the obstacle until the two form an unbroken perceptual event.

What is attained here by mental growth is not the capacity to connect percepts by some secondary operation but the condition that allows perception gradually to exercise more of its natural intelligence. The difference will be evident to anybody experienced in the arts. A beginner may see his own work or that of others in pieces, grasping certain sections but not the whole. After overcoming this limitation he sees the work as a genuine perceptual unity, which is more than a combination of the pieces originally perceived.

The result of the tunnel situation is quite different when the complement is due merely to the observer's knowledge of what the physical state of affairs is or can be presumed to be. I see an old lady, who is walking her dog, disappear behind a house that hides a part of her path. Although I can assume that she continues to walk steadily I "lose" her while she is behind the house. A new percept begins when she reappears even while my knowledge tells me: There she is now! Similarly, in the tunnel experience, the moving object fades out and is re-activated after an interval when the tunnel or the time interval is too long. In other words, the completion of the incomplete, one of the fundamental accomplishments of intelligent behavior, is purely perceptual when the structure of the context is sufficiently strong to determine the nature of the missing portion.

The effect is less compelling when we "see" the hidden back side of an object completed in accordance with the shape of the visible part. The continuation beyond the limits of the visible is

genuinely perceptual, but the actual nature of the continued part remains vague. For example, the shape of a ball, because of its visible incompleteness, makes us see the volume as continued whereas its color presses for no such completion but merely lends itself to it. When a disk or rectangle is partly hidden from sight, the structure of the visible portion is often not strong enough to actually spell out the rest of the figure. The continuation as such is indeed compelling, and it is also true that we would be surprised to see anything but the remainder of the disk or rectangle emerge from behind the obstacle. But the actual visualization is fairly weak and becomes increasingly weaker the less the hidden portion is determined by the character of what can be seen. The head and chest of a person looking over a wall are seen as incomplete and continued behind the wall; but the hidden torso and legs are not directly perceptual completions of the visible parts. They are supplied only by visual experiences of the past and therefore much less compelling.

Michotte calls complements "amodal" when they are not strong enough to replace the missing portions in such a way as to make the figure look as though nothing were hidden or absent. Our few examples have shown that amodal complements come in all grades of strength, from the tunnel effect, which under optimal conditions defines the hidden portion most compellingly, to instances of completion relying strongly on what has been perceived in the past. Perceptually weak though these latter effects may be, they are nevertheless a most valuable enrichment of visual experience. They interest us here because they show the intertwining of data of the present with data of the past, which is so typical of all genuine thinking.

To see the inside

Much of what is known about the hidden inside of things presents itself as a bona fide aspect of their outside appearance. I see the typewriter cover as containing my typewriter; I see the Peruvian clay pot on the shelf as empty. This knowledge is entirely visual. Visual acquisitions of the past are lodged in the appropriate places of my present perceptual field, completing it most usefully. The typewriter is not only known to be under the cover but seen as being there—seen, in fact, in the appropriate position defined by

the spatial orientation of the cover. (At times, external appearance seduces us to see hidden objects in a position we may know to be wrong; for example, behind the turned-down lids the eyes seem downcast although actually they face straight ahead.) The intelligence of these perceptual complements becomes particularly evident when one remembers that not everything an observer knows automatically becomes a part of his visual field. Completion is selective. A man may see a certain young lady as a female body covered with clothing whereas her mother's figure may be determined for him entirely by her external dressed shape. No male nude is seen hiding in the uniform of the train conductor, and only under special conditions will the head of the young lady appear as the surface cover of a skull, which in turn encloses the kind of brain known from the butcher shop or anatomy book. The Venus from Melos has no intestines; and the telephone may not contain visually the bell and wires I know are in it. In fact, many objects of practical use are designed so as not to suggest any internal technology. They are more attractive when their appearance points to no physical mechanism. Under such conditions, the perceptual inside is not called for by the outside, as the back side of the ball is called for by its front; it is merely available. It will partake in the visual work only if it is relevant to the observer.

Given the visual nature of such knowledge, there is no break between what is known and what is seen. The inside fits snugly into the outside. This continuity extends perception beyond what is depicted on the retinae. The mind is not held back by the surfaces of things. They are seen either as containers, or their inside appears simply as a homogeneous continuation of the outside. Only under special conditions is the outside experienced as an obstacle, which checks the freedom of penetration, for instance, when an enclosure prevents us from knowing what we want to know or when it appears as an impediment to something that wants to get out from inside. In a case of schizophrenia published by Marguerite Sechehaye, the patient had her first inkling of abnormal estrangement at the age of five when she heard the voices of school children practicing a song while she was walking past the building. "It seemed to me that I no longer recognized the school, it had become as large as a barracks; the singing children were prisoners, compelled to sing. It was as though the school and the children's song were set apart from the rest of the world."

Visible gaps

Visual knowledge is also responsible for the many examples in which the absence of something functions as an active component of a percept. James Lord reports a reaction of the artist Alberto Giacometti:

He began to paint once more, but after a few minutes he turned round to where the bust had been, as though to re-examine it, and exclaimed, "Oh, it's gone! I thought it was still there, but it's gone!" Although I reminded him that Diego had taken it away, he said, "Yes, but I thought it was there. I looked and suddenly I saw emptiness. I *saw* the emptiness. It's the first time in my life that that's happened to me."

To see emptiness means to place into a percept something that belongs there but is absent and to notice its absence as a property of the present. A setting in which lively action took place or is expected to take place looks strangely motionless; the emptiness may appear pregnant with events to burst forth. Sechehaye's patient reports: "In the endless silence and the strained immobility, I had the impression that some dreadful thing about to occur would break the quiet, something horrible, overwhelming."

Rarely do the contributions of the past to the present attempt or succeed in actually altering the given stimulus material. Rather, they use openings offered by that material. An empty spot is such an opening. In the language of the psychology of perception one may say that the stimulus material can be perceived as the ground for an absent figure. This effect may be brought about experimentally. Siegfried Kracauer quotes the film director, Carl Dreyer, illustrating the mood he wanted to obtain in his *Vampyr:* "Imagine that we are sitting in an ordinary room. Suddenly we are told that there is a corpse behind the door. In an instant the room we are sitting in is completely altered: everything in it has taken on another look; the light, the atmosphere have changed, though they are physically the same . . . This is the effect I want to get in my film."

Relevant here are the many instances in which an object is visually endowed with what it is to be used for. The psychiatrist Van den Berg describes the look of a bottle of wine he had set on the floor near the fireplace to warm it in preparation for a friend's visit. When the friend calls his visit off, the room seems quieter, the bottle looks forlorn. In a much broader sense, all implements tend to include in

their appearance the invisible presence of what is needed to fulfill their function. A bridge is perceived as something to be walked over, a hammer as something to be gripped and swung. This extension is much more tangible than would be a mere association between an object and its use, or the mere understanding of what the object can serve to do. It is the direct perceptual completion of an object that looks incomplete as long as it is unemployed. This becomes evident when we look at such objects displayed in an art museum or exhibition. In the company of works of art they are now regarded as pure shape, and the absence of their visible function can change their appearance quite strangely. A pair of eye glasses deprived of its connotation by such a display becomes a spidery, blind-eyed ghost. Some modern artists have succeeded in alienating the familiar simply by presenting utensils of our daily lives as objects of contemplation.

Recognition

The most useful and common interaction between perception and memory takes place in the recognition of things seen. Visual knowledge acquired in the past helps not only in detecting the nature of an object or action appearing in the visual field; it also assigns the present object a place in the system of things constituting our total view of the world. Thus almost every act of perception involves subsuming a given particular phenomenon under some visual concept—an operation most typical of thinking.

As I pointed out earlier, this subsumption can take place only if perception involves also first and foremost the formation of a concept of the object to be classified. The object of classification is not simply "the sensory stuff from which percepts are made," as Bruner calls it in the paper to which I referred earlier. The mind cannot give shape to the shapeless. This has been evident, for example, in the development of the so-called projective techniques in psychology. Amorphous material might be expected to give the mind the utmost freedom to impose its own conception on the sensory stuff. Instead, the responses to totally unstructured stimulation are poor and gratuitous. It takes a rich assortment of clearly articulate but ambiguous patterns, such as those of the Rorschach inkblots, to make the mind respond with acts of recognition. Recognition presupposes the presence of something to be recognized.

It is true that perception and recognition are inseparably inter-

twined. And yet, if one considers the primary organization of the stimulus to be too elementary to deserve much attention one will miss the important and interesting spectacle of interaction between the structure suggested by the shaping of the stimulus configuration and the components brought into play by the knowledge, expectation, wishes and fears of the observer. In some cases, this effect of the observer's attitude on the percept is minimal. The sight of red and green traffic signals is determined almost totally by the nature of the color stimuli, although the response to them has been acquired by learning. The effect is maximal in hallucinations since a powerful need can impose an image of the observer's making on the scantiest objective condition. When the starving prospector in Chaplin's film, *The Gold Rush,* sees his companion as a huge, appetizing chicken he has nothing objective to go by but the shaggy appearance and stalking gait of the other man in his heavy fur coat.

A percept will be classified instantaneously only if two conditions are met. The percept must define the object clearly and must resemble sufficiently the memory image of the appropriate category. When these conditions are fulfilled, seeing a car is tantamount to seeing it *as* a car. Often, however, there is enough ambiguity in the stimulus to let the observer find different shape patterns in it as he searches for the best fitting model among the ones emerging from memory storage. Memory concepts aid this search by being no less flexible than percepts. Under the pressure of the need to discover the suitable equation ("This is a car!") various aspects of such a concept may be called upon until an appropriate one presents itself. Difficult cases make the mind resort to ingenious acrobatics in order to adapt the two structures to each other. However, percepts are stubborn enough to admit modifications only within the range of the ambiguities they contain. Insufficient attention has been given to this fact by psychologists studying the mechanisms of "projection." They have explored what is seen and for what personal reasons it is seen, but they say little of the stimulus conditions exploited to this end. Strongly subjective though the impulses are in such perceptual acts, they are still bound by a profound respect for what is given to the eyes, save for extreme abnormal behavior.

Scientific exploits consist often in discovering good fits hidden by the primary appearance of the evidence, yet applicable through ingenious re-structuring. Copernicus succeeded in seeing the intricate gyrations of the stars as simple movements of these heavenly

bodies overlaid by the effects of an equally simple movement performed by the observer's base. Figure 13 shows in a schematic diagram how the erratic back-and-forth motion of an observed planet can be seen as circular and steady when the observer's base is assumed to be rotating also. In order to re-structure the problem situation in this way, Copernicus had to free himself of the suggestions imposed upon him by the directly given astronomical image. He also needed a remarkable visual imagination, which let

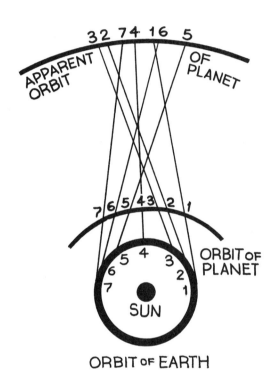

Figure 13

him light upon the idea that a model of very different appearance could be applied to the situation he saw. Playful examples of visual paradoxes ingeniously exploited may be found in the "droodles" of the cartoonist Roger Price. They are good study material for any explorer of visual perception. Figure 14 shows a droodle produced, I hope originally, by one of my students and accompanied with the caption: "Olive dropping into martini glass or Close-up of girl in scanty bathing suit."

William James uses the term *preperception* for such instances, in which stored visual concepts help to recognize insufficiently explicit perceptual patterns. However, James shows the traditional mistrust of unaided perception when he asserts that "the only things which we commonly see are those which we preperceive, and the only things which we preperceive are those which have been labeled for us, and the labels stamped into our mind. If we lost our stock of labels we should be intellectually lost in the midst of the world."

It is true that visual knowledge and correct expectation will facilitate perception whereas inappropriate visual concepts will delay or impede it. James refers to early experiments by Wundt in which reaction time is shown to be shortened or lengthened depending on whether the appearance of a particular stimulus is expected

Figure 14

or not at a particular moment of the sequence in which it appears. Bruner cites recent work to the same effect as well as a study of his own in which one and the same figure was read as a numeral or a letter, depending on it setting. A Japanese reads without difficulty ideographs printed so small that a Westerner needs a magnifying glass to discern them, not because the Japanese have more acute eyesight but because they hold the *kanji* characters in visual storage. For similar reasons, bird watchers, hunters, mariners, physicians, or microbiologists often seem endowed with superhuman powers

of vision. And the average layman of today has no trouble perceiving human figures or animals in Impressionist paintings that looked like assortments of meaningless color patches eighty years ago.

The effect of the past upon the present shows up even more dramatically when one meets an old acquaintance for the first time after several decades and sees his face suddenly sharpen or shrivel like the portrait of Dorian Gray. The remembered face transforms itself in front of one's eyes into the presently perceived one. Or take the experience of seeing, at some distance, a person you recognize as someone you know. The familiar figure looks uncannily deformed: a curious dragging of the gait or a disturbing stoop—until you discover that the person is not your friend at all but a stranger, at which point the drag and stoop disappear because the memory basis of reference from which they deviated no longer exists. What looked abnormal in the friend has become the normal speed and stance of a stranger.

It should be noticed that the effect of such "preperceived" images depends not simply on how often their prototypes have been met in the past but also quite importantly on what the nature of the given context seems to call for. What one expects to see depends considerably on what "belongs" in that particular place.

The perception of familiar kinds of object, then, is inseparably related to norm images the observer harbors in his mind. For example, there is a norm image of the human figure, symmetrical, upright, frontal, as reflected in the drawings of children and other early stages of pictorial conception. Whether or not a particular figure, encountered in daily life or in a picture, is recognized and accepted as human depends on whether the beholder can see it as a derivate of his norm figure. He may recognize the human frame in a painting under various aspects, just as in the perception of three-dimensional objects the perspective variations are seen as deviations from a norm shape. A figure can also be bent and twisted in many of the postures to which the joints of the body lend themselves and yet be recognized as a declension of the familiar form. To what extremes a particular observer will follow such deviation depends on the range of his visual experience, the attention he pays to it, and his flexibility in the handling of standards.

For the purposes of the visual arts, the psychology of recognition must stress two points. First, what is recognized in daily life is not necessarily accepted in pictorial representation also. Pictorial

Figure 15. Georges Seurat. Sunday on the Island of La Grande Jatte ('1884–86). Detail. Courtesy of The Art Institute of Chicago.

recognition takes its clues from the more limited set of declensions admissible in a particular style of representation rather than from the richer store of experiences available in the same observer for his coping with the physical world. Secondly, one must distinguish between a percept that can merely be *understood* as a version of a particular norm image and one that can be *seen* as such. Thus, when the cartoonist Roger Price calls a straight black line a "side view of a naughty French postcard" he exploits the lack of visual continuity between the pattern seen and the pattern intended. The straight line by itself cannot be seen as a deviation from a rectangular picture; it can only be associated with it from earlier visual experience of what belongs together. The picture makes a good joke just because it is so inefficient. In general, artists rely on versions of objects that can be related back to their norms in immediate perception. However, different styles vary in their tolerance for paradoxical representations and some relish as a positive value the discrepancy between what is seen and what is meant. For example, the famous sitting nursemaid in Seurat's *Grande Jatte* offers an

estranged sight of a person because this particular back view is linked by no immediate continuity to the more characteristic front view (Figure 15). Also, the view chosen by Seurat has a strongly structured character of its own and therefore contradicts its referent almost as violently as does Price's straight line. Or when Andrea Mantegna limits his presentation of the dead Holofernes to the sole of a naked foot peeping through the dark opening of the general's tent he uses a small part to represent a whole that can be completed only by experience.

Every break of the visual continuity between percept and memory norm also interrupts the dynamics connecting the two. A bent figure receives much of its characteristic expression through its visible pull toward or away from the norm, of which it is perceived to be a deviation. Therefore, the particular specimen is not seen merely, dispassionately and undynamically, as belonging under the heading of a familiar species. It looks rather like a particular manifestation of a matrix that has generated variations under the stress of given conditions. The forces of this generative process animate perception visibly, every time a perceived thing evokes its prototype.

6. *The Images of Thought*

One can say a great deal about the relation of memory to perception without facing the disturbing question of what memory is actually like. We say that a visitor to the zoo, approaching the cage of the elephants, compares the appearance of the animals with his own visual concept of elephant and thereby identifies what he sees. I have dealt at some length with the nature of the percept derived from the physical object, emphasizing in particular that it is not a mechanical recording but the active grasping of structural features. How, then, is its counterpart in memory constituted? Is it an internal picture of some kind, which enables a person to contemplate with closed eyes the imprint of a particular elephant or of something elephantlike?

As long as one studies the relations between memory residues and direct perception one can concentrate on the effect exerted upon the percept and delay asking what exerts it. The situation may be illustrated by the example of an artist who makes a drawing of something he knows from memory. He sits in his studio and draws an elephant. If you ask him from what model he is drawing he may deny convincingly that he has anything like an explicit picture of the animal in his mind. And yet, as he works, he constantly judges the correctness of what he is producing on paper and steers and modifies his shapes accordingly. With what does he compare them? What is this "inner design," the *disegno interno,* as Federico Zuccari called it in 1607 in order to distinguish it from the *disegno esterno* on the canvas? What was the *certa idea* Raphael had in

mind when he wrote in a famous letter to Count Baldassare Casti-
glione: "In order to paint a beautiful woman I should need to see
several fair ones, and you would have to help me with the selec-
tion; but since fair women and competent judges are rare, I make
use of a certain idea that comes to my mind."

The question is easily avoided because the operation seems to
take place in the perceived outside world, on the drawing board:
as the lines and colors appear, they look right or wrong to the drafts-
man, and they themselves seem to determine what he must do about
them. Some aspects of his judgment may indeed give the impression
as though they depended on the percept alone, for example, the
formal factors of balance and good proportion. Actually, however,
even they are inseparable from the question: "Is this my notion of
the elephant?" and this question can only be answered by reference
to some standard in the mind of the draftsman.

What are mental images like?

When the inner counterpart of the percept is not applied to any
external image but stands on its own, the question of what it is
like becomes even more urgent. Thinking, in particular, can deal
with objects and events only if they are available to the mind in
some fashion. In direct perception, they can be seen, sometimes
even handled. Otherwise they are represented indirectly by what
is remembered and known about them. Aristotle, explaining why
we need memory, pointed out that "without a presentation intel-
lectual activity is impossible." But he also ran immediately into the
difficulty that has plagued philosophers and psychologists ever
since. Thinking is necessarily concerned with generalities. How,
then, can it be based on individual memory images?

John Locke used the word "ideas" to describe perceptual
as well as memory material and individual as well as generic phe-
nomena. He defined ideas as "whatsoever is the object of the under-
standing when a man thinks" and as the equivalent of "whatever
is meant by phantasm, notion, species, or whatever it is which the
mind can be employed about in thinking . . ." This definition ignores
the distinction, customary today, between percept and concept.
Locke applied his term to sensations (simple ideas) but also to the
percepts of objects (complex ideas) and finally to concepts (abstract
ideas). Did he intend to describe these various mental phenomena

as one and the same thing, or did he rather leave the issue in abeyance? Probably the latter; for Locke also felt uneasy about the nature and status of concepts as phenomena of the mind. He said:

The ideas first in the mind, it is evident, are those of particular things, from whence, by slow degrees, the understanding proceeds to some few general ones; which being taken from the ordinary and familiar objects of sense, are settled in the mind, with general names to them. Thus particular ideas are first received and distinguished, and so knowledge got about them; and next to them, the less general or specific, which are next to particular. For abstract ideas are not so obvious or easy to children, or the yet unexercised mind, as particular ones. If they seem so to grown men, it is only because by constant and familiar use they are made so. For, when we nicely reflect upon them, we shall find that general ideas are fictions and contrivances of the mind that carry difficulty with them, and do not so easily offer themselves as we are apt to imagine. For example, does it not require some pains and skill to form the general idea of a triangle, (which is yet none of the most abstract, comprehensive, and difficult,) for it must be neither oblique nor rectangle, neither equilateral, equicrural, nor scalenon; but all and none of these at once. In effect, it is something imperfect, that cannot exist; an idea wherein some parts of several different and inconsistent ideas are put together.

Locke thought of generalities as makeshift devices, needed by a mind too imperfect to hold the total range of a concept in simultaneous view and therefore restricted, for practical purposes, to summaries. But he failed to see what concrete shape these conglomerations of mutually exclusive properties could take in the mind. To say that general ideas "cannot exist" obviously did not solve the problem. If thinking was based on them they had to exist in some form. Berkeley saw this clearly, and his objections to Locke, which will be discussed later, are surely well taken.

The dilemma was very real. Visual presence seemed to be an obstacle to generality and therefore apparently had to be abandoned by the very thinking that required it. If visual presence was given up, was there a non-perceptual realm of existence in which thinking could dwell? The problem is still with us. A recent paper by Robert H. Holt, symptomatically entitled *Imagery: The Return of the Ostracized*, describes various kinds of imagery. "Thought image" is defined as

A faint subjective representation of a sensation or perception without an adequate sensory input, present in waking consciousness as part of an act of thought. Includes memory images and imagination images; may be visual, auditory, or of any other sensory modality, and also purely verbal.

The Lockean flavor of disapproval is still there: the thought image is faint because it does not have enough of what it ought to have. It is second-best to perception. Elsewhere in Holt's paper, there is some recognition of the positive role imagery might play just because of its particular nature. But what is this nature?

Can one think without images?

Around the turn of our century psychologists looked for an answer by experiment. They asked their subjects questions that made them think, e.g., "Should a man be allowed to marry his widow's sister?" Afterwards they enquired: What took place within you? From his results Karl Bühler concluded in 1908 that "in principle any subject can be thought and meant completely and distinctly without any help of imagery [Anschauungshilfen]." At about the same time Robert S. Woodworth was led to assert that "there is non-sensuous content" and that "according to my experience, the more effective the thinking process is at any moment, the more likely is imageless thought to be detected."

The doctrine of "imageless thought" did not hold that nothing observable goes on when a person thinks. The experiments did not indicate that the fruit of thought drops out of nowhere. On the contrary, the consensus was that thinking often takes place consciously; but this conscious happening was said not to be imagery. Even skilled observers were at a loss to describe what went on in their minds while they were thinking. In order to define such imageless presence positively, Ach called it "Bewusstheit (awareness)." Marbe called it "Bewusstseinslagen" (dispositions of consciousness)." But mere names were of little help.

Not much is heard about this puzzling situation these days. In a recent investigation on the mental image, Jean Piaget deals with memory extensively but indirectly, by what it enables children to do. But Holt, in the paper I quoted above, pleads for a new and more direct consideration of mental imagery with psychologists who maintain that the nature of thinking should be determined by what it accomplishes. His point is well taken. Experiments on problem solving have told us much about the kinds of tasks a child or animal can perform and the conditions that help or hinder such a performance. But the experiments have also shown that if one wishes to understand why subjects succeed in one situation and fail in another,

one has to make inferences about the kind of process that goes on in their nervous systems or minds. For example, the nature of problem solving by "insight" can only be described if one knows what mechanisms it involves. The term "insight" refers to "sight" and raises the question of how much the perceptual awareness of the problem situation contributes. Without any idea of what sort of process is at work, how is one to comprehend why certain conditions enhance understanding whereas others hamper it? And how is one to discover the best methods of training the mind for its profession?

Looking back at the controversy about the role of imagery in thinking, one can see now that its conclusions remained unsatisfactory, first of all, because both contending parties seem to have tacitly agreed that imagery could be involved in thinking only if it showed up in consciousness. If introspection did not reveal at least minimal traces of imagery in every thought process there was no way of asserting that such imagery was indispensable. The so-called sensationalists tried to cope with the negative results of many experiments by suggesting that "automatism or mechanization" could reduce the visual component of thought to "a feeble spark of conscious life," and that under such conditions experimental observers could not be expected to identify the "unanalyzable degenerate" (Titchener) as what it actually was.

Nowadays psychologists would agree that to demonstrate the presence of a phenomenon in consciousness would greatly help in convincing them that it exists in the mind. But if a mental fact is not found in awareness one can no longer conclude that it does not exist. Quite apart from the rather special mechanisms of repression described by the psychoanalysts, many processes—perhaps most of them—are now known to occur below the threshold of awareness. This includes much of the routine input of our senses. A good deal of what we notice and react to with our eyes and ears, with our sense of touch, and the muscle sense involves no consciousness, or so little that we often cannot remember whether or not we saw our face when we brushed our hair in the morning, whether we felt the pressure of the chair when we sat down for breakfast, or whether we "saw" the elderly lady we avoided running into when we walked to work. Sensory experience, then, is not necessarily conscious. Most certainly it is not always consciously remembered.

In thinking, there are many responses given automatically, or

almost so, because they are readily available or because the needed operations are so simple as to be almost instantaneous. They will disclose little about the nature of thought. Probably for this reason, the experimenters I just mentioned had their subjects wrestle with tasks that mobilized their power of reasoning.

If even under these circumstances thoughts were reported to be "imageless," there are essentially three ways of coping with the findings. Since thinking must take place in some medium, one can propose that human beings think in words. This theory is not tenable, as I shall try to show in a later chapter. Or one can argue, as I have done so far, that imagery may do its work below the level of consciousness. This is quite likely to be true in many cases but tells us nothing about what the images are like and how they function. There is a third approach. Perhaps thought images are and were accessible to consciousness, but in the early days of experimentation, observers were not geared to acknowledging them. Perhaps they did not report the presence of images because what they experienced did not correspond to their notion of what an image is.

Particular and generic images

What are mental images like? According to the most elementary view, mental images are faithful replicas of the physical objects they replace. In Greek philosophy, the School of Leucippus and Democritus "attributed sight to certain images, of the same shape as the object, which were continually streaming off from the objects of sight and impinging upon the eye." These *eidola* or replicas, just as physical as the objects from which they had detached themselves, remained in the soul as memory images. They had all the completeness of the original objects. The closest approximation to these faithful replications which the modern psychologist has been able to discover are the so-called eidetic images — a kind of photographic memory that, according to the Marburg psychologist Erich Jaensch, was to be found in 40 per cent of all children and also in some adults. A person endowed with eidetic recall, for example, was able to commit a geographic map to memory in such a way that he could read off from the image the names of towns or rivers he did not know or had forgotten. In an experiment on eidetic imagery made around 1920 by August Riekel, a ten-year-old boy was asked to examine the picture reproduced in Figure 16 for nine seconds. Later, looking at

an empty white screen, he was able to glean details of the picture as though it were still present. He could count the number of the windows on the house in the back and the number of cans on the milk cart. When asked about the sign on top of the door he deciphered it with difficulty: "That's hard to read . . . it says 'Number,' then an 8 or 9 . . ." He also could make out the name of the shop owner and the drawing of a cow beneath the word *Milchhandlung*.

Figure 16

Not much has been heard of eidetics since the 1920's. The most striking recent reports on vivid imagery have come from the laboratory of Wilder Penfield, who obtained them by stimulating certain areas in the temporal lobes of the brain electrically. The experiential responses, as Penfield calls them, are described by the patients as flash-backs to scenes they knew in the past. One of them heard "the singing of a Christmas song in her church at home in Holland. She seemed to be there in the church and was moved again by the beauty of the occasion, just as she had been on that Christmas Eve some years before." All patients agreed that the experience is more vivid than anything they could recollect voluntarily; it is not remembering but reliving. The experienced episode proceeds at its natural speed as long as the electrode is held in place; it can neither be stopped nor turned back by the patient's will. At the same time it is not like a

dream or hallucination. The person knows that he is lying on the operation table and is not tempted to talk to people he sees in his vision. Such images seem to approach the completeness of scenes directly perceived in the physical environment; like that outer visual world, they seem to have the character of something objectively given, which can be explored by active perception the way one scrutinizes a painted or real landscape. In this respect, they can also be compared with afterimages. The ghostly white square that appears after a person has stared at a black one turns up without any initiative of the observer. He can neither control nor modify it, but he can use it as a target for active perception. Eidetic images seem to be of this kind. They behave like the projections of stimuli rather than like products of the discerning mind. Therefore, they can serve as material *for* thought but are unlikely to be a suitable instrument *of* thought.

The kind of "mental image" needed for thought is unlikely to be a complete, colorful, and faithful replica of some visible scene. But memory can take things out of their contexts and show them in isolation. Berkeley, who insisted that generic mental images were inconceivable, admitted nevertheless that he was "able to abstract in one sense, as when I consider some particular parts or qualities separated from others, with which, though they are united in some object, yet it is possible they may really exist without them." He could, for example, imagine "the trunk of a human body without the limbs." This sort of quantitative difference between the memory image and the complete array of stimulus material is the easiest to conceive theoretically. It leaves untouched the notion that perception is a mechanical copy of what the outer world contains and that memory simply preserves such a copy faithfully. The mind, we are told, can cut pieces from the cloth of memory, leaving the cloth itself unchanged. It can also make collages from memory material, by imagining centaurs or griffins. This is the crudest concept of imagination or fantasy—a concept that concedes to the human mind nothing more creative than the capacity to combine mechanically reproduced "pieces of reality."

Incompleteness is indeed frequently reported in memory experiments. Kurt Koffka tells in an experimental study of 1912 that one of his observers, asked to respond to the stimulus word *jurist*, stated: "All I saw was a briefcase held by an arm!" Even more frequently, an object, or group of objects, appears in memory on

empty ground, completely deprived of its natural setting. I shall
show soon that one cannot account for the refined abstractions
commonly found in mental imagery by simply asserting that memory
images often fail to reproduce some of the parts of the complete
object. But even this unsophisticated procedure of abstraction by
selection is not satisfactorily described by the theory implied in
Berkeley's example.

There is a fundamental difference between Berkeley's "human
body without limbs" and the jurist's arm holding the briefcase.
Berkeley refers to a physically incomplete object—a mutilated
trunk or a sculptured torso—completely perceived. In Koffka's
example a complete object is incompletely perceived. The jurist is
no anatomical fragment; but only a significant detail of him is seen.
The difference is somewhat like that between a marble torso seen
in broad daylight and a complete body partially revealed by a flash-
light. This sort of incompleteness is typical of mental imagery. It
is the product of a selectively discerning mind, which can do better
than consider faithful recordings of fragments.

The paradox of seeing a thing as complete, but incompletely,
is familiar from daily life. Even in direct perception, an observer
glancing at a lawyer or judge might catch little but the salient feature
of an arm carrying a briefcase. However, since direct perception
always takes place against the foil of the complete visual world,
its selective character is not evident. The memory image, on the
other hand, does not possess this stimulus background. Therefore
it is more evidently limited to a few salient features, which corre-
spond perhaps to everything the original visual experience amounted
to in the first place or which are the partial components the observer
drew from a more complete trace when he was asked to visualize
a jurist. It is as though, for the purpose of imagery, a person can call
on memory traces the way he calls on stimulus material in direct
perception. But since mental images can be restricted to what the
mind summons actively and selectively, their complements are often
"amodal," that is, perceived as present but not visible.

The capacity of the mind to raise parts of a memory trace above
the threshold of visibility helps to respond to the question: How can
conceptual thinking rely on imagery if the individuality of images
interferes with the generality of thought? The first answer is that
mental images admit of selectivity. The thinker can focus on what is
relevant and dismiss from visibility what is not. However, this

answer takes care only of the crudest definition of abstraction, namely, generalization through the picking out of elements. A closer look at the experimental data makes us suspect that mental imagery is actually a much subtler instrument, capable of serving a less primitive kind of abstraction.

Berkeley had no difficulty in admitting the existence of fragmentary mental images. But he saw that fragmentation was not sufficient to produce the visual equivalent of a concept. In order to visualize the concept of a horse, more was needed than the ability to imagine a horse without a head or without legs. The image had to leave out all references to attributes in which horses differ; and this, Berkeley contended, was inconceivable.

When, early in our century, the experiment was actually made, several reliable investigators, working independently, found that generality was precisely what observers attributed to the images they saw. Alfred Binet subjected his two young daughters, Armande and Marguerite, to prolonged and exacting enquiries. At one occasion, he had Armande observe what happened when he uttered the word *hat*. He then asked her whether she had thought of a hat in general or of a particular hat. The child's answer is a classic of introspective reporting: "C'est mal dit: en général—je cherche à me représenter un de tous ces objets que le mot rassemble, mais je ne m'en représente aucun." ('In general' expresses it badly: I try to represent to myself one of all the objects that the word brings together, but I do not represent to myself any one of them). Asked to respond to the word *snow*, Marguerite first visualizes a photograph, then "I saw the snow falling . . . in general . . . not very clearly." Binet notes that Berkeley is being refuted when one of the girls reports "a lady, who is dressed, but one cannot tell whether her dress is white or black, light or dark."

Koffka, using a similar procedure, obtained many *Allgemeinvorstellungen* (generic images), which were often quite "indistinct" —a waving tricolor flag, rather dark, no certainty as to whether the colors run vertically or horizontally; a train which one cannot distinguish as being a freight or passenger train; a coin of no particular denomination; a "schematic" figure, which might be male or female. (In a more recent study, *What People Dream About,* Calvin S. Hall found that in 10,000 dreams he collected from men and women 21 percent of the characters were not identified as to sex.)

In reading these experimental reports, one notices, in the formulations of the investigators as well as in those of their observers, a

tendency to get around the paradox of images that are particular and at the same time generic by describing these experiences as indistinct or unclear: You cannot tell whether the object is blue or red because the image is not sharp enough! Such a description tends to dismiss the phenomenon as a purely negative one, the implication being that if the observer could only discern the object a little better, he would be able to tell whether it is red or blue. But there is no such thing as a negative phenomenon. Either the incomplete image is experienced or it is not, and if it is, the challenge to Berkeley's contention is fully with us.

Visual hints and flashes

Among psychologists, Edward B. Titchener had the gift and the courage to say exactly what he saw, no matter how offensive his observations were to common sense theory. He reports in his *Lectures on the Experimental Psychology of the Thought-Processes* of 1909:

My mind, in its ordinary operations, is a fairly complete picture gallery,—not of finished paintings, but of impressionist notes. Whenever I read or hear that somebody has done something modestly, or gravely, or proudly, or humbly, or courteously, I see a visual hint of the modesty or gravity or pride or humility or courtesy. The stately heroine gives me a flash of a tall figure, the only clear part of which is a hand holding up a steely grey skirt; the humble suitor gives me a flash of a bent figure, the only clear part of which is the bowed back, though at times there are hands held deprecatingly before the absent face . . . All these descriptions must be either self-evident or as unreal as a fairy-tale.

This was the voice of a new era. As clearly as words permit, Titchener pointed out that the incompleteness of the mental image is not simply a matter of fragmentation or insufficient apprehension but a positive quality, which distinguishes the mental grasp of an object from the physical nature of that object itself. He thus avoids the stimulus-error or—as he rightly suggests it would better be called—the *thing-error* or *object-error*, that is, the assumption that the mind's account of a thing is identical with all or some of the thing's objective properties.

The reference to painting and to Impressionism is significant. Titchener's descriptions of visual experience differ as fundamentally from those of other psychologists as did the paintings of the Im-

pressionists from those of their predecessors. In spite of the considerable liberties which artists before the generation of Edouard Manet took in fact with the objects they portrayed, the accepted convention held that a picture had to be intended as a faithful likeness. Only with the Impressionists did aesthetic theory begin to accept the view that the pictorial image is a product of the mind rather than a deposit of the physical object. The realization that the image differs in principle from the physical object lays the groundwork for the doctrine of modern art. A similar fundamental break with tradition occurs in the psychology of visual experience a few decades later.

The comparison with Impressionist painting can also help us to understand the nature of Titchener's "visual hints" and "flashes." Instead of spelling out the detailed shape of a human figure or a tree the Impressionist offered an approximation, a few strokes, which were not intended to create the illusion of the fully duplicated figure or tree. Rather, in order to serve as the stimulus for the intended effect, the reduced pattern of strokes was to be perceived as such. However, one would again commit the stimulus-error if one identified the resulting experience with the strokes that provoked it. The intended results were in fact hints and flashes, indicators of direction and color rather than defined outlines or patches. The assembly of colored strokes on the canvas was responded to by the beholder with what can only be described as a pattern of visual forces.

The elusive quality of such experiences is hard to capture with our language, which commonly describes objects by their tangible, material dimensions. But it is a quality invaluable for abstract thought in that it offers the possibility of reducing a theme visually to a skeleton of essential dynamic features, none of which is a tangible part of the actual object. The humble suitor is abstracted to the flash of a bent figure. And this perceptual abstraction takes place without removal from the concrete experience, since the humble bend is not only understood to be that of the humble suitor but seen as the suitor himself.

Note that these images, although vague in their outlines, surfaces, and colors, can embody with the greatest precision the patterns of forces called up by them. A popular prejudice has it that what is not sharply outlined, complete, and detailed is necessarily imprecise. But in painting, for example, a sharply outlined portrait by Holbein or Dürer is no more precise in its perceptual form than the tissue of

strokes by which a Frans Hals or Oskar Kokoschka defines the human countenance. In mathematics, a topological statement or drawing identifies a spatial relation such as *being contained in* or *overlapping* with the utmost precision although it leaves the actual shapes entirely undetermined. In logic, nobody contends that the generality of a concept makes for vagueness because it is devoid of particularized detail; on the contrary, the concentration on a few essentials is recognized as a means of sharpening the concept. Why are we reluctant to admit that the same can be true for the mental image? In the arts, the reduction of a human figure to the simple geometry of an expressive gesture or posture can sharpen the image in precisely this way. Why should it not do the same in mental imagery? Here again an observation of Titchener's can be of help. He invited his students to compare an actual nod of the head with the mental nod that signifies assent to an argument, or the actual frown and wrinkling of the forehead with the mental frown that signifies perplexity. "The sensed nod and frown are coarse and rough in outline; the imaged nod and frown are cleanly and delicately traced."

To be sure, a sketchy image, painted on canvas or seen by the mind's eye, can be imprecise and confused, but so can the most meticulously detailed picture. This is a matter of shapelessness rather than of lack of detail or precision. It depends on whether or not the structural skeleton of the image is organized and orderly. The composite pictures of healthiness, illness, criminality, or family character which Francis Galton obtained by superimposing the portrait photographs of many individuals are fuzzy and unenlightening because they are shapeless, not because they are blurred.

How abstract can an image be?

So far I have referred to mental images of physical objects, such as human figures or landscapes. Some of these images, however, had been evoked by abstract concepts such as modesty or gravity or pride. Also, the visual content of some of these images had been reduced to mere flashes of shape or direction, so that what was actually seen could hardly be described as a likeness of the object. The question arises: How abstract can a mental image be?

Synesthesias come to mind because they commonly involve non-mimetic images. In cases of *audition colorée* or color hearing, a

83 Inquiries into Human Faculty

I give woodcuts of representative specimens of these Forms, and very brief descriptions of them extracted from the letters of my correspondents. Sixty-three other diagrams on a smaller scale will be found in Plates I., II. and III., and two more which are coloured are given in Plate IV.

D. A. " From the very first I have seen numerals up to nearly 200, range themselves always in a particular manner, and

in thinking of a number it always takes its place in the figure. The more attention I give to the properties of numbers and their interpretations, the less I am troubled with this clumsy framework for them, but it is indelible in my mind's eye even when for a long time less consciously so. The higher numbers are to me quite abstract and unconnected with a shape. This rough and untidy[1] production is the best I can do towards representing what I see."

[1] The engraver took much pains to interpret the meaning of the rather faint but carefully made drawing, by strengthening some of the shades. The result was very very satisfactory, judging from the author's own view of it, which is as follows:—" Certainly if the engraver has been as successful with all the other representations as with that of my shape and its accompaniments, your article must be entirely correct."

Number-Forms 84

senting what I see. There was a little difficulty in the performance, because it is only by catching oneself at unawares, so to speak, that one is quite sure that what one sees is not affected by temporary imagination. But it does not seem much like, chiefly because the mental picture never seems *on* the flat but *in* a thick, dark gray atmosphere deepening in certain parts, especially where 1 emerges, and about 20. How I get from 100 to 120 I hardly know, though if I could require these figures a few times without thinking of them on purpose, I should soon notice. About 200 I lose all framework. I do not see the actual figures very distinctly, but what there is of them is distinguished from the dark by a thin whitish tracing. It is the place they take and the shape they make collectively which is invariable. Nothing more definitely takes its place than a person's age. The person is usually there so long as his age is in mind."

T. M. " The representation I carry in my mind of the numerical series is quite distinct to me, so much so that I cannot think of any number but I at once see it (as it were) in its peculiar place in the diagram. My remembrance of dates is also nearly entirely dependent on a clear mental vision of their *loci* in the diagram. This, as nearly as I can draw it, is the following :—

Figure 17. From Galton: *Inquiries into Human Faculty and Its Development.*

person will see colors when he listens to sounds, especially music. In general, these visual sensations fail to make music more enjoyable or more understandable even when tones evoke the same colors somewhat consistently. On the other hand, the attempts to accompany music with moving colored shape (Oskar Fischinger, Walter Ruttmann, Norman McLaren) have been strikingly successful when the common expressive characteristics of motion, rhythm, color, shape, musical pitch, strengthened each other across sensory boundaries. Whether or not such combinations of sensory modes are helpful or disturbing depends largely on whether structural correspondences can be experienced among them.

The same holds true when theoretical concepts, such as the number series or the sequence of the twelve months are accompanied with color associations or spatial arrangements. These accompaniments, too, appear quite spontaneously in some persons, as Francis Galton established in his famous inquiries into imagery, of which a sample page is given in Figure 17. They also can be quite stable. But although they are sometimes used as mnemonic aids, there is no indication that they are of help in the active handling of the concepts. This is so because the structural relations among the visual counterparts do not seem to illustrate those among the concepts. One of the Fellows of the Royal Society whom Galton interviewed saw the number series from zero to a hundred habitually arranged in "the shape of a horseshoe, lying on a slightly inclined plane, with the open end towards me," and with the numeral 50 located on the apex. No benefit to the professor's arithmetic is likely to have come from this image.

Theoretical concepts are not handled in empty space. They may be associated with a visual setting. The images resulting from these associations may appear more accidental than they actually are. Titchener, after sitting on the platform behind "a somewhat emphatic lecturer, who made great use of the monosyllable 'but'" had his "feeling of but" associated ever afterward with "a flashing picture of a bald crown, with a fringe of hair below, and a massive black shoulder, the whole passing swiftly down the visual field, from northwest to southeast." Although Titchener himself cites this example as an instance of association by circumstance, the image may have taken so firmly to the concept because there was an intrinsic resemblance of the barrier character of "but" and that of the turned-away speaker and his massive black shoulder. And

although the image is not likely to have helped Titchener's reasoning, it will have sharpened his sensitivity to the dynamic quality of "but"-clauses, i.e., to the kind of brake these clauses impose on affirmative statements.

Some visualizations of theoretical concepts can be described as routine metaphors. Herbert Silberer has reported on the "hypnagogic states" which he frequently experienced when he made an effort to think but was hampered by drowsiness. Once, after a futile effort to confront Kant's and Schopenhauer's philosophy of time, his frustration expressed itself spontaneously in the image of a "morose secretary" unwilling to give information. At another occasion, when he was about to review an idea in order not to forget it, he saw, while falling asleep, a lackey in livery, standing before him as though waiting for his orders. Or, after pondering how he might improve a halting passage in his writing, he saw himself planing a piece of wood. Here the images reflect an almost automatic parallelism among attitudes of the mind and events in the physical world. Rather similar examples are cited in Darwin's studies on the expression of emotion. While a person is struggling with an irritating problem of thought he may scratch his head, as though trying to assuage a physical irritation. The organism functions as a whole, and the body produces a physical equivalent of what the mind is doing. In Silberer's hypnagogic states, the physical counterpart is conjured up by spontaneous imagery.

This sort of simple-minded illustration may be more of a distraction than a help to the thinker. When Galton discovered, to his astonishment, that "the great majority of the men of science to whom I first applied protested that mental imagery was unknown to them" he finally concluded that "an overready perception of sharp mental images is antagonistic to the acquirement of habits of highly-generalized and abstract thought, especially when the steps of reasoning are carried on by words as symbols, and that if the faculty of seeing the pictures was ever possessed by men who think hard, it is very apt to be lost by disuse."

But there is only a fine line between the pedestrian explicitness of the illustrative image and the power of a well chosen example to test the nature and consequences of an idea in a kind of thought experiment. Thinking, I said earlier, can deal with directly perceived objects, which often are handled physically. When no objects are

present, they are replaced by some sort of imagery. These images need not be lifelike replicas of the physical world. Consider the following instance from Silberer's half-dreams. In the twilight state of drowsiness he reflects on "transsubjectively valid judgments:" Can judgments be valid for everybody? Are there some that are? Under what conditions? Obviously there is no other way of searching for the answers than to explore pertinent test situations. In the drowsy thinker's mind there arises suddenly the image of a big circle or transparent sphere in the air with people surrounding it, whose heads reach into the circle. This is a fairly schematic visualization of the idea under investigation, but it also makes its basic structural theme metaphorically tangible: the dwelling of all heads in a common realm, the exclusion of the bodies from this community, etc. It is something of a working model. The image presents natural objects—human figures, a sphere—but in a thoroughly unnatural constellation, not realizable on our gravity-ridden earth. The visual constellation is dictated by the dominating idea in the mind of the dreamy thinker. The centric symmetry of the converging figures is a simple, clear, most economical representation of "shared judgments," brought about without any concern for what is feasible in practical space. Also the transparency of the sphere, this paradoxical solid into which heads can reach, indicates that the image is physically tangible only to the extent that suits the thought and is compatible with it. While thoroughly fantastic as a physical event, the image is strictly functional with regard to the idea it embodies.

Galton, although critical of "overready perception of sharp mental images," realized that there was no reason to starve the visualizing faculty. He suggested that if this faculty is free in its action and not tied to reproducing hard and persistent forms "it might then produce generalized pictures out of its past experience quite automatically."

If objects can be reduced to a few essential flashes of direction or shape, it seems plausible that there can be even more abstract patterns, namely, configurations or happenings which do not portray any of the inventory of the physical world at all. In the arts, our century has produced nonrepresentational painting and sculpture. I pointed to Impressionism when I referred to Titchener's descriptions of imagery; and indeed one can date with some precision the phase of modern painting corresponding to some of his examples:

"Horse is, to me, a double curve and a rampant posture with a touch of mane about it; cow is a longish rectangle with a certain facial expression, a sort of exaggerated pout." But Titchener can sound even more modern. He describes the "patterns" aroused in him by a particular writer or book: "I get a suggestion of dull red . . . of angles rather than curves; I get, pretty clearly, the picture of movement along lines, and of neatness or confusion where the moving lines come together. But that is all, — all, at least, that ordinary introspection reveals." While Titchener was recording his introspections, artists such as Wassily Kandinsky were exploring the mysterious zone between the representational and the abstract. Titchener visualizes the concept of "meaning": "I see meaning as the blue-grey tip of a kind of scoop, which has a bit of yellow above it (probably a part of the handle), and which is just digging into a dark mass of what appears to be plastic material" — an image that would have qualified for exhibition at Kandinsky's *Blue Rider*.

How much modern art had Titchener seen and absorbed? I do not know, but in the instances I have cited he was surely able to look at the outer and the inner worlds of the mind in the spirit of the modern painters. This was not true for the average person, including the average psychologist. Up to our day it is not uncommon for psychologists, especially in dealing with perception, to speak about artists as though they were engaged in producing illusions of physical reality. For the psychologists who conducted the experiments on "imageless thought" as well as for their observers, an image was probably the sort of thing known from realistic illustrations or posters. If they looked at the famous paintings of the past — a Raphael, a Rembrandt, or even a Courbet — with the usual prejudice and without much care, they saw explicitly complete replicas of nature, landscapes and interiors, still lifes and human figures. Were they likely to acknowledge the presence of highly abstract patterns in their minds if by images they meant something completely different? Théodule Ribot, who collected nine hundred replies, gives only an occasional example of non-mimetic patterns; one of his observers saw the infinite represented by a black hole. Not surprisingly, one looks in vain for evidence in the more recent work on the psychology of thinking, which shares with behaviorism a preference for external, observable manifestations.

In the experiments that led to the doctrine of imageless thought, imagery is unlikely to have been absent. But it may well have in-

volved many patterns more abstract than those described by Koffka or Binet. The latter studies hardly called for thinking. Images evoked by words such as *hat* or *flag* can be reasonably concrete, whereas the solution of theoretical problems more often than not requires highly abstract configurations, represented by topological and often geometrical figures in mental space. These non-mimetic images, often faint to the extent of being barely observable, are likely to have been the "nonsensuous content," those "nonsensorial feelings of relations" that gave so much trouble because of their paradoxical status. They may be quite common and indeed indispensable to any mind that thinks generic thoughts and needs the generality of pure shapes to think them. "I am inclined to believe," admitted Ribot, "that the logic of images is the prime mover of constructive imagination."

7. *Concepts Take Shape*

If thinking takes place in the realm of images, many of these images must be highly abstract since the mind operates often at high levels of abstraction. But to get at these images is not easy. I mentioned that a good deal of imagery may occur below the level of consciousness and that even if conscious, such imagery may not be noticed readily by persons unaccustomed to the awkward business of self-observation. At best, mental images are hard to describe and easily disturbed. Therefore, drawings that can be expected to relate to such images are welcome material.

Drawings have been used frequently in memory experiments. They cannot be faithful replicas of mental images but are likely to share some of their properties. Therefore, the few examples I shall offer in this chapter are not intended to prove what the images generating them are like, but to suggest what structural characteristics they may have. I will show that such pictorial representations are suitable instruments of abstract reasoning and point to some of the dimensions of thought they can represent.

The prototype of the drawings I have in mind are those diagrammatic scribbles drawn on the blackboard by teachers and lecturers in order to describe constellations of one kind or another—physical or social, psychological or purely logical. Since such drawings are often non-mimetic, that is, do not contain likenesses of objects or events, what exactly do they represent? How are they related to the subject matter for which they stand? What are the means of representation at their disposal? How do they aid thinking? What factors determine how well such a drawing serves its purpose?

Abstract gestures

The difference between mimetic and non-mimetic shapes, so plausible at first glance, is only one of degree. This is evident, for example, in descriptive gestures, those forerunners of line drawing. There, too, one is tempted to distinguish between gestures that are pictographic and others that are not. Actually, the portrayal of an object by gesture rarely involves more than some one isolated quality or dimension, the large or small size of the thing, the hourglass shape of a woman, the sharpness or indefiniteness of an outline. By the very nature of the medium of gesture, the representation is highly abstract. What matters for our purpose is how common, how satisfying and useful this sort of visual description is nevertheless. In fact, it is useful not in spite of its spareness but because of it. Often a gesture is so striking because it singles out one feature relevant to the discourse. It leaves to the context the task of identifying the referent: the bigness portrayed by the gesture can be that of a huge Christmas parcel received from a wealthy uncle or that of a fish caught last Sunday. The gesture limits itself intelligently to emphasizing what matters.

The abstractness of gestures is even more evident when they portray action. One describes a head-on crash of cars by presenting the disembodied crash as such, without any representation of what is crashing. One shows the straight or devious path of a movement, its smooth rapidity or heavy trudging. Gestures enact pushing and pulling, penetration and obstacle, stickiness and hardness, but do not indicate the objects thus treated and described.

The properties of physical objects and actions are applied without hesitation to non-physical ones by people all over the earth, although not always in exactly the same fashion. The bigness of a surprise is described with the same gesture as the bigness of the fish, and a clash of opinions is depicted in the same way as a crash of cars. David Efron, investigating the gestures of two minority groups in New York City, has shown how the character of the movement patterns varies with the style of reasoning of the persons. The gestures of ghetto Jews, whose minds are formed by the traditional sophistry of Talmudic thinking, "appear to exhibit an angular change in direction, resulting in a series of zig-zag motions, which, when reproduced on paper, present the appearance of an intricate embroidery." On the contrary, the gestures of Italian immigrants, deriving typically from an agricultural background of low literacy,

reflect a much simpler style of thinking by maintaining "the same direction until the gestural pattern has been completed."

Gestures will act out the pursuit of an argument as though it were a prize fight, showing the weighing of alternatives, the tug of war, the subtle attack, the crushing impact of the victorious retort. This spontaneous use of metaphor demonstrates not only that human beings are naturally aware of the structural resemblance uniting physical and non-physical objects and events; one must go further and assert that the perceptual qualities of shape and motion are present in the very acts of thinking depicted by the gestures and are in fact the medium in which the thinking itself takes place. These perceptual qualities are not necessarily visual or only visual. In gestures, the kinesthetic experiences of pushing, pulling, advancing, obstructing, are likely to play an important part.

A pictorial example

Pictures that are not written in the air but leave a durable trace show more explicitly than gestures what the imagery of thought might be like. Again the resemblance can hardly be literal. For one thing, even in pictorial representation the particular shape of a given thought pattern will depend on whether it is produced on a flat surface or in three dimensions, by line or in broad masses of color, etc., whereas mental imagery is not determined by any of these material conditions. I will begin with an example somewhere in between the average person's ability to give visual shape to concepts and the control, precision, and striking expression characteristic of the work of artists. Figure 18 is the work of an undergraduate student, Miss Rhona Watkins, done shortly before she graduated from college. It represents a promising future temporarily obstructed by present obstacles. The picture is entirely nonmimetic, and yet there is the unmistakable resonance of experiences gathered in the visual world. Just as physical objects or events are often depicted by abstract properties of shape, so can abstract representations of ideas refer more or less openly to things of nature. Here again there is no dichotomy of mimetic versus non-mimetic representation, but only a continuous scale reaching from the most realistic images to the purest elements of shape and color.

The landscape-like distinction between a ground with objects resting on it and a kind of empty sky on top creates the basic dif-

Figure 18. Rhona Watkins. Woodcut (1966).

ference between the solid present and the vista of a distant future, the present filled with tangible matter, the ultimate future still vacant. Time is translated into the spatial depth dimension. Nearest in time and space are the dark, clearly articulated obstacles; farther away lies the promise of tomorrow, as yet undifferentiated and dominated by an over-all mood of affective color. The evenness of the distant mass is broken by a laterally penetrating wedge, which opens and menaces the compactness of the prospect, sharing its basic color but creating at the same time a jarring conflict between its own yellowish version of redness and the bluishness of the large mass. Similarly, the shape of the wedge, while breaking the contour of the mass, also acknowledges its limits.

These anticipations of the future are not directly connected with the present. No bridge leads from the front to the back. The immediate presence of the dark obstacles is self-contained and independent, something to be taken care of by itself, not affecting the future and yet blocking the way toward it. While this distinction is made clear, there is also the frightening suggestion that these obstacles do indeed touch the future because the horizontal bar on the left concides with the horizon, and the bar on the right with the top of the distant mass. Though recognized as an illusion caused by a purely subjective perspective, this threatening interference is, for the moment, visibly real, and the dark bars, metallic and hard, cover the prospect like the bars of a prison window.

At the same time, the impediment is not overpowering. The obstacles, although inorganically hard, are straight only in part. They bend at the bases and on top, indicating some flexibility and weakness, and they are thinnest where they would need their main strength. Neither the parallelism nor the symmetry of the two dark units is rigidly perfect, and this makes the structure of the obstacle somewhat accidental, hence vulnerable and changeable.

The abstractness of this visual statement is evident when compared with the subject matter it represents. Neither the present nor the future are given mimetic portrayal, and yet the essentials of the theme are depicted by thoroughly visual aspects of shape, color, and spatial relations. Although simpler and more obvious than the work of a more accomplished artist is likely to be, all crucial factors are rendered with more precision than we shall find in most of the quick amateur sketches to be presented next. Miss Watkins' print was the final result of considerable searching

and trying, and the search for the "correct" pattern was at the same time a means of working through the situation which she was trying to depict and to cope with. As observations in art therapy have shown, one of the main incentives for such work is the need to think through something important. The completion of the picture is also the solution of a thought problem, although there may be no words to tell about the finding.

Experiments with drawings

Drawings intended to represent specific concepts were obtained in preliminary experiments by my students. They are spontaneous scribbles, with little or no claim to aesthetic value. Miss Abigail Angell asked her subjects, mostly fellow students, to depict the notions of *Past, Present, and Future, Democracy,* and *Good and Bad Marriage* in abstract drawings; Miss Brina Caplan worked under similar conditions with the concept *Youth.* Verbal explanations, spontaneous or solicited, were obtained during or after the drawing.

The nature of the task created little hesitation in this particular population of subjects. Naturally, drawing ability ranged widely from few schematic, timid lines to more elaborate designs, and great differences in imagination were equally evident. Occasionally, conventional signs were used as shortcuts: a plus and a minus sign to depict good and bad marriage; an arrangement of stars and stripes for democracy; or a growing tree indicating youth. But seldom did a subject protest that such concepts simply were not visual things and therefore could not be shown in drawings. Persons of a different educational level and less familiar with the arts might respond less well; this, however, would tell us nothing about the nature or richness of the imagery in their thinking.

One basic decision the subjects had to make for each task was whether to present the given concept as one entity or as a combination of several. The instruction to draw *Past, Present, and Future* suggested a triad verbally, and in fact several persons drew three separate items, unrelated in space or perhaps arranged in a loose sequence. This, however, was not true for all. Although nobody drew the whole of life as one undifferentiated unit, a continuous line was not uncommon. Figure 19 indicates a straight and perhaps empty past, large and articulate shapes for the present,

Figure 19

Figure 20. "The *past* has been nothing—it is forgotten, and when thought of once again it is an illusion; the past is covered with dust.—The *present* is everything—movement, joy, despair, hope, doubt—it is now; one lives in the present.—The *future* is unknown."

and some smaller and vaguer ones for the future. Here, then, the whole of life is represented as an unbroken flow of time — a conception basically different from that of another type of subject, who exists in the present and thinks of it as a state of being rather than a phase of continuing growth (Figure 20).

The mere connection of the three units, of course, does not exhibit by itself much thought about the particular nature of their relation. Figure 21 gives more than a sequence of different entities. It shows gradual expansion, starting with the moment of birth. The break between past and present is maintained, but the largeness of the present is understood in part as a result of the preceding growth. The undirected roundness of the present interrupts the channeling of time, and yet this static situation in the middle of the drawing is "amodally" traversed by a current of movement initiated in the past and carried further into the open future, as a river flows through a lake.

The structural complexity of the present, experienced as a timeless state of affairs and yet perceived by the more thoughtful as a mere phase in the passage of a lifetime, can be represented as the

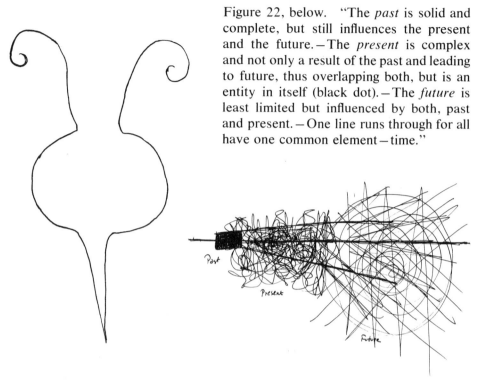

Figure 22, below. "The *past* is solid and complete, but still influences the present and the future. — The *present* is complex and not only a result of the past and leading to future, thus overlapping both, but is an entity in itself (black dot). — The *future* is least limited but influenced by both, past and present. — One line runs through for all have one common element — time."

Figure 21

superposition of two structures. In Figure 22, life is seen as generated by the "solid and complete" past, which projects strong, formative beams. But the present is not entirely determined by the past. It has a core and shape of its own. The resulting complication is presented generically as an agitated texture. The specific effect of the interaction is not worked out. The interacting powers of the past and the present meet in spatial over-lay but do not modify each other. The problem is seen but not resolved. The level to which the young draftsman carried her thought — or, at least, the representation of it — can be clearly diagnosed from her drawing.

Language represents the concept of *marriage* by one word; it does not suggest a pictorial twosome. But the concept itself refers directly to two physical persons. Many subjects, therefore, described marriage in their drawings as a relation between two units. Since both good and bad marriage had to be presented, the two kinds of marriage were shown as merely different from each other, or more intelligently, as different with regard to some common dimension and therefore comparable. Sometimes the relation alone was presented, without any attempt to derive it from the nature of the

Figure 23

Figure 24. "Here is a picture of my mother (top) and father (bottom). Although neither shape is particularly revolting in itself, the combination makes for an exaggeration of both forms, so that the top becomes more overpowering when placed next to the bottom form. And the bottom form diminishes in relation to the upper. Ugh!"

partners thus related. Two separate circles might depict the one relation, two overlapping ones the other, and the overlap was intended to suggest either desirable closeness or undesirable interference. Or, inversely, the two kinds of marriage were distinguished by the character of the partners, but not by their relation: two smooth circles versus two prickly circles, confronting each other in the same fashion. There is a significant difference between seeing the character of a marriage as derived from the relation as such or from the personality of the partners; and to consider either condition without the other produces necessarily a limited interpretation.

In Figure 23, the bad relation is shown as springing from the difference of the partners. An aggressive saw-tooth outline constitutes one of them, whereas smooth circles describe the other. In addition, the aggressive partner has the more tension-loaded shape of a spiral, the other is represented by more harmonious, concentric curves. The aggressive partner, of course, is not necessarily the male. The drawings, with few exceptions, depict mental, not physical forces. In Figure 24, the crushing boulder on top describes the personality of the subject's mother, the small, dripping dot that of her father, and

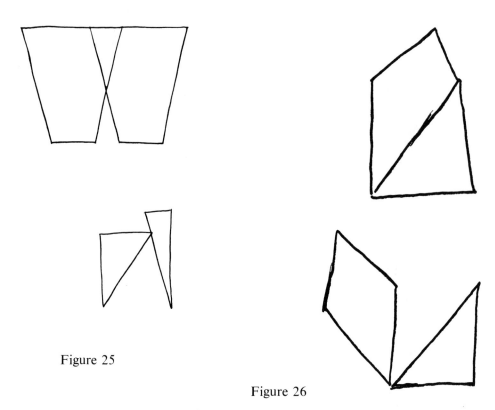

Figure 25

Figure 26

the inappropriateness of the relation is intended to reflect back upon the character of the marriage partners, "not particularly revolting" in themselves.

The coherence of the marriage can be indicated simply by the amount of contact among the partners: in the good relation, they share an interface, in the bad one they barely touch each other. Subtler are the attempts to show that the combination of the two partners does or does not add up to a whole, either because their characters do not fit or because they are not related in a fitting manner. Figure 25 presents the good marriage as a symmetrical pattern, in which the two partners, alike or undifferentiated in their personalities, fulfill the same function. The drawing indicates that the overall pattern of the marriage should be unified and well structured but that the partners retain integrity by fusing only partially. In the bad marriage, the shapes of the two components do not add up to a unified whole; their contact is accidental and precarious, and they remain essentially independent of each other. In Figure 26, the intended overall shape is less simple although closed and unified. Here, differences in personality are no obstacle to the union, but

Figure 28, above. "Good marriage: Smoothness and harmony; an easy and pleasant life. Bad marriage: Ups and downs, uneasy path in life. A rough life."

Figure 29, below. Left, good marriage; right, bad marriage.

Figure 27

probably an asset; the roles of the partners are not identical, and the somewhat accidental shape of the whole suggests that differently shaped wholes can work out equally well. In the bad marriage, the two jig-saw pieces cannot be fitted together. A much richer whole is presented by the good marriage in Figure 27, which evokes the image of a plant but uses it freely to show the combination of two units, growing out of each other in an interplay of support and dominance, and fitting into a common, upward-directed striving.

In the last examples there was no clear indication that the conception started with two separate units trying to establish a connubial relation. The parts and the whole were rather in balance, neither claiming priority. This leads to examples in which the primary vision was clearly that of a whole, subdivided more or less happily into its two components. In extreme cases, nothing but the overall effect is indicated (Figure 28): the smooth harmony of the one, the roughness of the other. The need for interaction is stated simply in Figure 29, more dynamically in the yin-yang design of Figure 30.

The task of drawing *Past, Present, and Future* suggested a hap-

Figure 30. Left, good marriage; right, bad marriage.

Figure 31

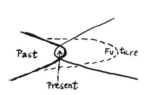

Figure 32. "The *past* has happened and is definite, therefore the darker line. *Present* exists where past and future overlap. *Future* develops from past and is indefinite, therefore the lighter line. The past constantly affects the future: dotted line."

pening in time, whereas *Marriage* is more nearly a thing or state. However, the drawings did not necessarily conform to this distinction. While some subjects presented the three stages of life as separate entities, Figure 31 shows life as a static object, in which the present moment as a vertical line separates a dark past from a larger and brighter future. Compare this undynamic apportionment with Figure 32, made up entirely of disembodied movement. The parabola of the past drives forward and is continued into the future. At the moment of the present, however, the convergence of the past is counterbalanced by the beginning of a new expansion— if we read the third parabola as open toward the right; or otherwise the future, mirroring the past, also converges upon the focus of the present, but in the opposite direction, thereby pointing to an experience that ignores the irreversible progress of time.

While life and its stages can appear as objects, marriage can be depicted as a story. In the good marriage of Figure 33, the partners move along parallel paths like two musical instruments playing the same tune at a constant interval, and when their paths cross they make contact rather than interfere with each other. In the bad marriage, one of the two partners is constantly in the other's way. The caption to Figure 28 indicates that the characteristic outlines of the marriages conceived as things are perceived at the same time as the smooth or rocky road of the travelling pairs.

Figure 33. "A good marriage (top) is two peo-
ple together but as individuals. They both rec-
ognize each other as separate from each other
but also involved with each other. — A bad mar-
riage (bottom) is one where two people support
each other and are absorbed into each other.
When a conflict occurs, they cannot help each
other."

Figure 34. "Equality among individuals."

Fig. 35. "All types can fit into system (outer
circle) in harmony and without losing their iden-
tities as individual entities, both persons and
concepts. All contribute to the whole."

In the representation of *Democracy,* some subjects envisage
distinct individuals entering a relation, whereas for others the to-
tality of the community is primary. In Figure 34, society is a loose
agglomeration of different characters, lined up without interrelation,
except for the common base on which they stand. At the other ex-
treme are examples in which the state is seen as a simply shaped
object, without any explicit reference to the human elements of
which it consists. Figure 35 makes only a perfunctory concession to
the overall shape of the community, which is seen as a bagful of in-
dividuals, different from, but unrelated to, each other or the whole.
This amorphous state of affairs in the drawing corresponds to think-

Figure 36. "Individuals who think more freely but are restricted when they come in contact with spheres of others."

Figure 37

ing about social coexistence at a very elementary level. Figure 36 is more elaborate in that it describes dynamically the deformations of individuals resulting from the uninhibited push and pull of human intercourse. The individual differences of shape are seen here as the result of free interaction, and the State is nothing but the sum of what neighbors do to each other. There is little organization and no government. The drawing is done from the outside in: the center is what remains after the individual pushes have exerted themselves.

On the contrary, pyramids of various shapes describe a hierarchic structure of democratic society (Figure 37). They stand on their base or tip, depending on whether the masses or the head of the state are envisaged as the ruler. However, they are statically limited to shape because they define the hierarchy only by diminishing quantity: the many are governed by the few. Vectors are often added in mandala or sunburst patterns, which show the centric organization of democracy. In Figure 38, the arrows run from the peripherally placed citizens, who are described by the variety of their differences, toward the center, thus indicating the contribution of the citizens to the government. That center, however, is empty. The government is nobody, and no arrows of control lead from the center to the governed. Individuals are given the right to authority but are not subjected to it.

Informal though these experiments are they show that educated young adults approach without much difficulty the task of representing abstract concepts by means of non-mimetic drawings. Quite clearly also, these abstractions go to the core of the themes. Of course, in thinking about the nature of the concepts to be drawn,

the subject will often have considered specific examples: their own experiences in the past or present, the character of a particular democracy, the happenings in this or that marriage. In fact, they had to do so, because the abstract forms reflected in the drawings do not offer the evidence needed to define the concepts; they represent only the purest structural shapes emerging from that evidence. The conditions of the experiment prevented the subjects from including any narrative elements. While most helpful in clarifying the theoretical concepts, the non-mimetic patterns must continuously derive their meaning from the live substance of the issues to which they refer.

Figure 38. "Everyone free to take part in government. Great difference in background."

The principal reason why these disembodied shapes can be so helpful is that thinking is not concerned with the sheer matter or substratum of things but only with their structure. The elementary qualities of a particular red color or a particular sound are supplied by the senses but are neither represented in thinking nor conveyable by it—they can only be pointed to through verbal signs by persons who are not blind or deaf. The perceptual features accessible to thought are purely structural, e.g., the expansiveness of that red, the aggressiveness of that sound, or the centric and compact nature of something round. Thinking treats space and time, which are containers for being, as the structural categories of coexistence and sequence. Both of these categories can be represented in the spatial medium of visual patterns.

Thought in visible action

I mentioned earlier that drawings, paintings, and other similar devices serve not simply to translate finished thoughts into visible models but are also an aid in the process of working out solutions of problems. Of this, one receives little evidence from studies that yield only one drawing for each task. Therefore, in the experiments

Figure 39 Figure 40

of Miss Caplan, subjects were encouraged to "use as many pieces of paper as you need: a new piece for each new idea; a new piece each time you want to correct an old idea. Continue until you are satisfied with your drawing! Think aloud as you draw and explain what you are doing as you do it!" Eleven subjects produced an average of nine drawings each; one drew as many as thirteen, and nobody settled for fewer than six.

A subject's style of drawing tended to become clearer, more definite, and more individualized as the experiment proceeded. This was evident when the first and the last drawing of a series were compared. As a rule, complexity increased. Sometimes, the experimenter reported, types or shapes of form became more intricate, or contiguity and overlapping were introduced, or a new element such as shading appeared, or some sort of gradient was utilized. Such increase in complexity does not necessarily imply that the first step and the final outcome were recognizable as successive phases of a clearly similar conception. A continuity of one underlying idea was evident in some instances, but not in others, and in no case was the whole series of drawings devoted to the gradual elaboration of only one specific pictorial theme. However, gradual

Figure 41

Figure 42

refinement was frequently observable in the progressive changes occurring from one drawing to the next, here and there in a series.

The task consisted in doing a non-mimetic drawing of *Youth.* One subject started by representing "a kind of upward growth" while thinking of youth at the same time as "turned in on itself, in a process of self-discovery." The first sheet (Figure 39) is covered with spirals, decreasing in size toward the sides and the top and arranged in a vague symmetry. In the second drawing (Figure 40), these elements are combined in a tree-like pattern, which integrates and clarifies the conception. Figures 41 and 42 show the seventh and eighth drawings of a subject who thought of youth as a round or amoebic blob transforming itself gradually into the firm rectangle of adulthood. The seventh drawing (Figure 41) presents three phases: Youth reaching out for age, learning from it by adapting to it, and finally overshadowing it. In the eighth drawing (Figure 42), the three phases have been refined into six. The first of them is essentially unchanged, except that the "reaching out" is explicitly shown by the more dynamic shape of the blob, the beginning of its amoebic response to "age," half advancing, half withholding. Monolithic adulthood also is treated now more subtly: it is open, accessible, and

perhaps actively engaged. During conjugation, "age" is already declining, and the final inversion of power is now carried further to involve not only size but also the change from blob to block, thus completing the new adult.

The gradual enrichment of the concept can be traced in the work of the student who needed thirteen drawings to arrive at a satisfactory statement. A verbal description will suffice to give an idea of the increasing complexity. At first, there is the upward movement of a single shape, which spirals in the first drawing and fills the second sheet as a large pointed wedge. This simple wedge now suffers breaks halfway up—the delays caused by the instability and complexity of adolescence. In the fourth drawing, the wedge is inverted to a cone expanding from its point: mere progression has been re-defined as growth. The cone becomes dark and three-dimensionally solid, the point of origin at the bottom now serving to describe the lack of a stable base. Drawing 7 returns to the original spiral, but now the whole sheet is filled with rising, wildly overlapping spirals. The individual is now multiplied to present the social scene, and this extension of view seems to have thrown the conception back to its initial shape. In Drawing 8, the interaction between growing individuals is more explicitly defined, for which purpose the spiral shapes have been simplified to straight lines, crossing or paralleling each other more clearly. Drawing 9 presents a move back towards individuality: the number of verticals is reduced to three, then to two, showing the "true communication" and "harmony" of two wavy parallels. In Drawing 11, the social context returns with a vengeance in the shape of two sinister solids gripping the two in a vise and causing them to wave rather violently. In the last two drawings, however, they grow beyond the pressure of the environment and rise in ultimate harmony.

The subject has used her sequence of drawings to tell her story of youth chronologically. However, at the same time she assembles the relevant factors step by step and ends up with a picture that contains them all in what she sees as their appropriate character, role, and relation. I will refer briefly to three more examples to illustrate aspects of this search for clarification. The use of the spiral and the wedge in one and the same set of drawings indicated already how a complete change of pictorial pattern may leave the basic theme nevertheless untouched. The same is true for another example in which a subject describes how the young person grows

Figure 43 Figure 44

from the carefree pleasures of the early years into the "complex, intricate web" of adolescence. The subject illustrates this change by overlaying the simple waves of childhood with a thicket of whirligigs and criss-cross shapes. In the next drawing, the same state of affairs is depicted as a geometrical maze — apparently a complete break of the pictorial continuity but actually just a more insightful interpretation of complexity, defined a moment earlier as nothing but a confused texture.

Other examples confirm the observation that pictorial breaks occur when the draftsman introduces a new cognitive factor. One subject used an assortment of circles to show completeness and lack of harshness in childhood. In the next drawing, she presented two groups of long lines as the pressures impinging on youth, only to combine the two disparate patterns in her next and final drawing, in which the circles, tightly packed and somewhat deformed, are confined, separated, and crossed by the straight lines depicting responsibility and duty.

Finally, an instance in which two different views of the same concept are first presented separately and later integrated. The subject starts with the notion of youth as jutting sharpness, something sticking out from a base discordantly. Suddenly, in her fifth drawing, youth appears instead as a shapeless blob — a blob, however, which, three drawings later, is plagued by ingrown "pains,"

and these pains, pointing inward along the contour of the blob, assume in the last drawing the same spiky sharpness that represented the concept as a whole in the beginning. Figures 43 and 44 show the first and the last drawings of the series.

Similar features can be found in the work of artists, for example, in the sketches Picasso did for his painting, *Guernica*. In a book on this subject I have shown the continuity and logic underlying the development from the first sketch to the completed work. However, these drawings and paintings, too, may appear, at first sight, as a sequence of erratic leaps from comprehensive views to details and back, a restless play of combining the basic constituents in ever new ways, and many changes of style and subject matter. Yet the final painting is a synthesis of tested acquisitions, a statement whose completeness and necessity defied further modifications.

There are, of course, profound differences between the work of an artist and our amateur scribbles. This would be even more evident if, instead of selecting suitable samples from the experiments, I reproduced a random selection of the drawings or all of them. There were many wildly prolific exercises, showing no disciplined concentration on the task or, at least, no ability to produce drawings that clearly reflected such an attitude. Nevertheless, the intention and the means of realization are basically similar to those of the artist. The amateur drawings contain a pidgin version of the rich and precise vocabulary characteristic of good art.

The drawings were intended to give an accurate visual account of a concept. As such they were purely cognitive, not different in principle from what scientists show in their schematic designs. However, they were apt to go beyond the visual enumeration of the forces constituting the patterns. The draftsmen tried to evoke, more or less successfully, a vivid resonance of these forces and thereby resorted to devices of artistic expression.

The aesthetic element is present in all visual accounts attempted by human beings. In scientific diagrams it makes for such necessary qualities as order, clarity, correspondence of meaning and form, dynamic expression of forces, etc. The value of visual presentation is no longer contested by anybody. What we need to acknowledge is that perceptual and pictorial shapes are not only translations of thought products but the very flesh and blood of thinking itself and that an unbroken range of visual interpretation leads from the humble gestures of daily communication to the statements of great art.

8.

Pictures, Symbols, and Signs

Simple line drawings can give visible shape to patterns of forces or other structural qualities. The drawings in the preceding chapter described the nature of a good or bad marriage or of democracy or of youth as conceived by the person who drew them. Highly abstract social or psychological configurations appeared in visible shape. However, images can also depict the things of our environment themselves, for example, a husband and a wife or a town meeting in a democracy. They commonly do so in a style that is more abstract than the way these persons, objects, or happenings would register on a photographic plate. Images, then, regard the world in two opposite directions. They hover somewhere above the realm of "practical" things and below the disembodied forces animating these things. They can be said to mediate between the two.

Three functions of images

In order to clarify and compare various relations of images to their referents I shall distinguish between three functions performed by images. Images can serve as pictures or as symbols; they can also be used as mere signs. This sort of distinction has been made by many writers on the subject. Some have used the same terms or similar ones, but the meanings they have given them overlap complexly with the distinctions I need for our purpose. Instead of analyzing these similarities and differences, I shall try to define the

three terms so tangibly that the reader will know what I mean by them.

The three terms — picture, symbol, sign — do not stand for kinds of images. They rather describe three functions fulfilled by images. A particular image may be used for each of these functions and will often serve more than one at the same time. As a rule, the image itself does not tell which function is intended. A triangle may be a sign of danger or a picture of a mountain or a symbol of hierarchy. We need to know how well or badly various kinds of images fulfill these functions.

An image serves merely as a *sign* to the extent to which it stands for a particular content without reflecting its characteristics visually. In the strictest sense it is perhaps impossible for a visual thing to be nothing but a sign. Portrayal tends to slip in. The letters of the alphabet used in algebra come close to being pure signs. But even they stand for discrete entities by *being* discrete entities: a and b portray twoness. Otherwise, however, they do not resemble the things they represent in any way, because further specification would distract from the generality of the proposition. On the other hand, signs possess visual characteristics derived from requirements other than those of portrayal, that is to say, they appear as they do for good reasons. The 1926 international convention on road signs decided that all traffic signs warning of danger should be given a triangular shape. Perhaps the sharpness of a triangle makes it look a bit more like danger than would, say, a circle, but its shape was chosen mainly because it is easily identified in itself and distinguished from other signs. In written language, the variety of letter groups used to designate words serves similar purposes of identification and distinction, and therefore letters and words are, to this extent, signs. Many words fail to fulfill their function well because languages are not created rationally but grow informally and produce accidental, arbitrary, adulterated shapes. Words can be ambiguous; for example, *pupil* refers to schoolchildren and to holes in the eyes, since the original connotation of smallness has been split up into different meanings. Apart from such imperfections, however, the characteristics of signs tend to be selected in such a way as to serve their function. In this sense, they are not arbitrary. The previously mentioned "innate releasing mechanisms" in biology are signs. Konrad Lorenz says of these visual releasers that their simplicity of shape and color makes them distinct in appearance and "improba-

ble" in occurrence, that is, unlikely to be confused with other things visible in the environment.

To the extent to which images are signs they can serve only as indirect media, for they operate as mere references to the things for which they stand. They are not analogues, and therefore they cannot be used as media for thought in their own right. This will become evident in the discussion of numerals and verbal languages, which are the sign media *par excellence*.

Images are *pictures* to the extent to which they portray things located at a lower level of abstractness than they are themselves. They do their work by grasping and rendering some relevant qualities — shape, color, movement — of the objects or activities they depict. Pictures cannot be mere replicas, by which I mean faithful copies that differ from the model only by random imperfections.

A picture can dwell at the most varied levels of abstractness. A photograph or a Dutch landscape of the seventeenth century may be quite lifelike and yet select, arrange, and almost unnoticeably stylize its subject in such a way that it focuses on some of the subject's essence. On the other hand, a totally non-mimetic geometrical pattern by Mondrian may be intended as a picture of the turmoil of New York's Broadway. A child may capture the character of a human figure or a tree by a few highly abstract circles, ovals, or straight lines.

Abstractness is a means by which the picture interprets what it portrays. This precious accomplishment is ignored if one pretends that an abbreviated representation invites the beholder to fill in the missing realistic detail. If this were true, a simply drawn cartoon or caricature would produce a particularly active response of this kind. The assertion is based on no evidence; it is simply inferred from the traditional notion that perception consists in a complete recording of the visual field and that therefore a percept of "incomplete" material will be completed by the mind from the stores of past experience. If this were so, all pictures would be transformed subjectively by the beholder into mechanically faithful replicas. The "incompleteness" would be remedied. But abstractness is not incompleteness. A picture is a statement about visual qualities, and such a statement can be complete at any level of abstractness. Only when the picture is incomplete, imprecise, or ambiguous with regard to these abstract qualities, is the observer called upon to make his own decisions about the nature of what he sees. (This

is true, for instance, for the inkblots of the Rorschach Test or the pictures of the Thematic Apperception Test, used by psychologists to induce subjective interpretations.)

Fortunately, "completion" by "imagination" is all but impossible and the desire to attempt it quite rare. A cartoon is seen at exactly the level at which it is drawn. Its forceful liveliness does not derive from supplements contributed by the observer but is made possible, on the contrary, by the intense visual dynamics of simplified line and color. It is true that the abstract style of such pictures removes their subject matter from physical reality. Human traits and impulses appear, unencumbered by physical matter and free from the tyranny of gravitation and bodily frailty. A blow on the head is an abstract assault responded to by an equally abstract expression of distress. In other words, the pictorial interpretation emphasizes the generic qualities with which all thinking is concerned—a kind of unreality quite different from that of miraculous, superhuman tales, which are generally represented with realistic faithfulness. The latter endow nonexistent forces with material bodies whereas the former extract constituent forces from physical substance.

An image acts as a *symbol* to the extent to which it portrays things which are at a higher level of abstractness than is the symbol itself. A symbol gives particular shape to types of things or constellations of forces. Any image is, of course, a particular thing, and by standing for a kind of thing it serves as a symbol, e.g., if it presents a dog in order to show what the concept *dog* is. In principle, any specimen or replica of a specimen can serve as a symbol, if somebody chooses to use it that way. But in such cases, the image leaves the effort of abstracting entirely to the user. It does not help him by focusing on relevant features. Works of art do better. For example, Ambrogio Lorenzetti's murals in the town hall of Siena symbolize the ideas of good and bad government by showing scenes of struggle and of prosperous harmony; and being works of art, they do so by inventing, selecting and shaping these scenes in ways that display the relevant qualities more purely than random views of town and country life would. Or, to use another example, Holbein's portrait of Henry VIII is a picture of the king, but it also serves as a symbol of kingship and of qualities such as brutality, strength, exuberance, which are located at a higher level of abstraction than is the painting. The painting, in turn, is more abstract than the visual appearance of the king in flesh and blood because it sharpens the formal features

of shape and color which are analogues of the symbolized qualities.

Symbolic functions can also be fulfilled by highly abstract images. The amateur drawings I discussed in the preceding chapter gave visible geometrical shape to the dynamic patterns characterizing ideas or institutions. The arrows by which physicists depict vectors show relevant qualities of forces, namely, their strength, direction, sense, and point of application. Musical notation operates partly by means of symbols; that is, it represents the pitch level of sounds by the structurally analogous location of the notes on the staff. In a similar way, drawings can symbolize a state of mind by translating some of its dynamic properties into visible patterns. Figure 45 shows a page from Sterne's *Tristram Shandy*, depicting the hero's straight-forward intention modulated by a more or less erratic spirit.

Figure 45.

78 THE LIFE AND OPINIONS

CHAP. XL.

I AM now beginning to get fairly into my work; and by the help of a vegetable diet, with a few of the cold feeds, I make no doubt but I shall be able to go on with my uncle Toby's story, and my own, in a tolerable ftraight line. Now,

Inv. T.S *Scul TS*

Thefe were the four lines I moved in thro' my firft, fecond, third, and fourth volumes*. —In the fifth volume I have been very good, —the precife line I have defcribed in it being this :—

A B c c c c c D

* Alluding to the firft edition.

By

OF TRISTRAM SHANDY. 79

By which it appears, that except at the curve, marked A, where I took a trip to Navarre;— and the indented curve B, which is the fhort airing when I was there with the Lady Bauffiere and her page,—I have not taken the leaft frifk of a digreffion, till John de la Caffe's Devils led me the round you fee marked D;—for as for *e c c c c*, they are nothing but parenthefes, and the common *ins* and *outs* incident to the lives of the greateft minifters of ftate; and when com-pared with what men have done,—or with my own tranfgreffions at the letters A B D,—they vanifh into nothing.

In this laft volume I have done better ftill, —for from the end of Le Fever's epifode, to the beginning of my uncle Toby's campaigns,—I have fcarce ftepped a yard out of my way.

If I mend at this rate, it is not impoffible,— by the good leave of his Grace of Benevento's Devils,—but I may arrive hereafter at the ex-cellency of going on even thus :—

which is a line drawn as ftraight as I could draw it by a writing-mafter's ruler (borrowed for that purpofe) turning neither to the right hand nor to the left.

This *right line*,—the path-way for Chriftians to walk in ! fay Divines,——

——The emblem of moral rectitude ! fays Cicero, ——

——The *beft line !* fay cabbage-planters,—— is the fhorteft line, fays Archimedes, which can be drawn from one given point to another.

I wifh

Images to suit their functions

Since images can be made at any level of abstraction, it is worth asking how well different degrees of abstractness suit the three functions here under discussion. I will limit myself to a few examples taken from the two extremities of the scale of abstraction. How about highly realistic images? As mentioned before, mere replicas may be useful as raw material for cognition but are produced by cognitive acts of the lowest order and do not, by themselves, guide understanding. Paradoxically, they may even make identification difficult, because to identify an object means to recognize some of its salient structural features. A mechanically produced replica may hide or distort these features. One of the reasons why persons brought up in cultures that are unacquainted with photography have trouble with our snapshots is that the realistic and accidental detail and partial shapelessness of such images do not help perception. It is a problem we shall meet again when we look at the so-called visual aids in education. Faithfulness and realism are terms to be used with caution because a bona fide likeness may fail to present the beholder with the essential features of the objects represented.

The human mind can be forced to produce replicas of things, but it is not naturally geared to it. Since perception is concerned with the grasping of significant form, the mind finds it hard to produce images devoid of that formal virtue. In fact, it is by the structural properties of lines and colors that even some "material" desires are best satisfied. For example, the mechanical faithfulness of artless color photography or painting is not the surest way of arousing sexual stimulation through the sense of sight. Sensuous pleasure is aroused more effectively by the smoothness of swelling curves, the tension animating the shapes of breasts and thighs. Without the dominance of these expressive forces the picture is reduced to the presentation of pure matter. To offer matter devoid of form, which is the perceptual carrier of meaning, is pornography in the only valid sense of the word, namely, a breach of man's duty to perceive the world intelligently. A harlot (Greek, *porné*) is a person who offers body without spirit.

As symbols, fairly realistic images have the advantage of giving flesh and blood to the structural skeletons of ideas. They convey a sense of lifelike presence, which is often desirable. But they may be inefficient otherwise because the objects they represent are, after all, only part-time symbols. A newspaper reported that one day,

some time ago, the Reverend January of the Zion Hill Baptist Church in Detroit took his four-year-old son, Stanley, to view a large mural, which had just been painted in the auditorium of a local school. "I see a train," said Stanley. "That track," said the Reverend January, "is the future coming toward us. The train is this country's unity, far off but bearing down on us." "No," said Stanley, "it's a train."

This disagreement between father and son arose because a train is not a full-time symbol. It is a piece of railway equipment, first of all, and acts as a symbol only by moonlighting—as an avocation, not advertised and therefore not necessarily recognized by the four-year-olds of our time nor by quite a few of their elders. The more lifelike a piece of sculpture or painting, the more difficult may the artist find it to make his point symbolically. Courbet's painting, *L'Atélier,* of 1855, presented groups of realistically painted persons surrounding the artist himself at work in his studio. The painting was subtitled *une allégorie réelle* and intended to show on one side the people of the practical life and on the other those concerned with feeling and thought, both equally arrested in a state of dream-like suspension, while the painter alone, vigorously at work on a canvas, held the center as the only person actively dealing with reality. Werner Hofmann, in an extensive analysis of this painting, mentions that "the realists felt the allegorical implications to be superfluous, the symbolists thought them out of keeping with the very robustness of the style." Only by a careful and unprejudiced examination of the whole painting will the viewer come to realize that, for example, the nude woman watching the artist at work in his studio is not only his model, at the realistic level of the representation, but also the muse, the traditional allegory of truth, the fullness of life, all at the same time.

The dilemma becomes particularly poignant when an artist aspires to fantasy and deeper meaning but lacks the pictorial imagination to make such qualities visible. Examples can be found among the more pedestrian Surrealists. There is a painting by René Magritte showing a tediously painted tobacco pipe on empty ground and the inscription: *Ceci n'est pas une pipe.* Unfortunately a pipe is all it is. A similar problem arises from the unskillful use of *objets trouvés* in collages or sculpture. The beholder is confronted with the un-transfigured presence of refuse. What he sees may inspire him to think, but the thought is not in the work. Yet, Picasso can evoke the very nature of a bull's head by simply combining the handlebar and the saddle of an old bicycle.

The more particular a concept, the greater the competition among its traits for the attention of the user. This becomes evident when traffic signs, posters, and similar pictorial indicators try to symbolize a limited point by means of a complex image. Martin Krampen has pointed to the example of a snail used in an older pictographic traffic sign to call for a reduction of speed. The fairly lifelike picture of the snail may indeed engage the driver's mind more vividly than the message "Reduce Speed," but Krampen notes that a snail is not only slow but also slimy, easily frightened, etc. Of course, the highway setting helps in picking out the relevant aspect, but the image itself offers no guidance for the selection.

The specificity of an image also calls for correspondingly specific knowledge in the person who is to understand it. Rudolf Modley notes that a traffic sign showing a pedestrian in Western clothing may be puzzling or unwelcome to drivers in a non-Western country and that the picture of an old-fashioned locomotive may let a driver of the young generation expect a museum of historical railroad engines rather than a crossing. Specific characterization can make it easier to identify the particular kind of thing if it is known to the observer but harder to draw forth a more abstract meaning.

At the other extremity of the scale of abstraction are highly stylized, often purely geometrical shapes. They have the advantage of singling out particular properties with precision. A simple arrow concentrates more efficiently on pointing than does a realistically drawn Victorian hand with fingernails, sleeve, cuff, and buttons. The arrow is also more nearly a full-time symbol and therefore invites the beholder to treat it as a statement rather than a piece of the practical world. However, highly abstract concepts, although narrow in intension, are broad in extension, that is, they can refer to many things. A drawing of two overlapping circles may be a picture of some physical object, such as a new type of pretzel or eyeglasses. It may be the ground-plan for a two-ring circus. It may also be a symbol of a good marriage or the brotherhood of nations. Still more generically, it may be meant to show the logical relation of any two overlapping concepts. Which of these meanings is aimed at, only the context can reveal.

This creates a problem in a civilization which constantly throws things together that do not belong together or puts them in places contradictory to their function. All the mobility, transportation, transmission, and communication in our century removes things

from their natural location and thereby interferes with their identification and efficiency. An apple makes its point more easily when seen in an orchard or fruit store. Placed in the company of hundreds of other household items, or advertised in the midst of heterogeneous matter, or talked about in places that have no relevance to fruit, the apple must make a much greater effort to be recognized and responded to. A palace or church crowning a hilltop town or introduced by an imposing vista, a triumphal arch placed at the crossing of a star of avenues are defined and helped by their location; whereas a traditional church building buried among New York skyscrapers not only receives no help but is refuted and derided by its setting. We pay for lack of redundancy in the environment by spending a greater effort on identifying the particular item or on making it identifiable.

A highly abstract design that bears little or no obvious resemblance to its referent must be restricted to a unique application or rely heavily on explanatory context. It is the context that will decide whether a cross is to be read as a religious or an arithmetical sign or symbol or whether no semantic function at all is intended, as in the crossbars of a window. It may take a powerful and prolonged effort to endow a simple design with a particular meaning, and even the most determined indoctrination may not exclude unwelcome associations. I remember that when Hitler visited Mussolini's Rome and the whole city was suddenly covered with Nazi flags an Italian girl exclaimed in horror: "Rome is crawling with black spiders."

The simple design of the swastika was sufficiently free of other associations to make it acceptable as a carrier of a new meaning. The imposition was so effective that in time the emblem came visually to contain and exude a highly emotional connotation it did not possess before. To be sure, the design was extremely well chosen. It met the ethological requirements of distinctness and striking simplicity. It conveyed the dynamics of the "Movement" by its tilted orientation in space. As black figure in a white and red setting it helped revive the old flag of the German empire and thereby appealed to nationalism. In the Nazi flag, red became the color of revolution, and the black was frightening like the storm-troopers' shirts. The swastika had the straight-edged angularity of Prussian efficiency, and its clean geometry was, ironically, in keeping with the modern taste for functional design. For the educated, there was also the reference to the Aryan race evoked by the symbol from

India. The pressures of the social context did the rest. No wonder a recent writer, Jay Doblin, has credited Hitler, "the frustrated artist," with having become "the trademark designer of the century."

What trademarks can tell

Commercial trademark designers cannot rely on the powerful social forces that were at Hitler's command. What makes their task all the more difficult is that in most cases they cannot make their designs self-explanatory. The taste and style of our time associates successful business with clean-cut, starkly reduced shape, and the disorder and rapidity of modern living calls for stimuli of split-second efficiency. The problem is that a pattern of high abstractness fails to specify its referent, whereas the identification of a particular company, brand, institution, idea, is the purpose of advertising. Doblin cites experiments to show that the "logotype," that is, the verbal name or slogan presented in commercial design, is identified by consumers more readily than the brandmark. In fact, the presence of the brandmark may decrease the number of correct responses to the logotype. Doblin concludes that "from a communications viewpoint a brandmark, for most companies, is not only a waste of time but can actually become a detriment." Whatever the validity of this argument, it illustrates the peculiar character of highly abstract patterns.

The inability of such patterns to specify a particular application brings to mind similar findings in experiments on the meaning of music. For example, in order to determine whether the "intentions of composers" can be gathered from their works, Melvin G. Rigg played a number of recordings, taken mostly from classical opera, and asked listeners to match them with descriptions listed on a questionnaire as to their generic mood (sorrowful, joyful), their overall subject category (death, religion, love, etc.), and their specific program (farewell, prayer, Good Friday music, spinning song, moonlight, etc.). The listeners did well at the highest level of abstraction but poorly at the lowest. To conclude from that, as Rigg did, "that the intentions of composers usually do not 'get over' in any specific way to the cultural strata of our population" is to misinterpret the nature of music and its relation to specific program content. The cognitive virtue of music derives precisely from the high level of abstractness at which it depicts patterns of forces. These patterns in themselves do not point to any particular "applica-

tion" but can be made to interpret such instances. Program music, the portrayal of narrative subject matter by sounds, has never been more than an awkward curiosity, exactly because it attempts to depict a particular content through a generic medium. Inversely, in an opera or as accompaniment to a theater play or film, music serves to give shape to the generic inherent in the particular. In the words of Schopenhauer, "music demonstrates here its power and higher aptitude by offering the deepest, ultimate, and most secret revelations about the feelings expressed in the words or the action which the opera represents, and discloses their proper and true essence. Music acquaints us with the intimate soul of the happenings and events of which the stage gives us no more than the husk and body."

Visual images have similar virtues and weaknesses. Just as Saint-Saëns' music cannot hope to identify *Omphale's Spinning Wheel,* trademarks and other such emblems cannot identify a particular product or producer. Identification can only be obtained by what the men in the trade call "strong penetration," that is, insistent re-enforcement of the association of signifier and referent, as exemplified by religious emblems (Cross, Star of David), flag designs (Canada's maple leaf, Japan's rising sun), or the Red Cross. Therefore, to test the value of trademarks independently of the context that ties them to their owners is like evaluating a diagram on the classroom blackboard without reference to the professor's explanatory speech.

The color blue a lady is wearing may be experienced by an observer as an essential feature of her personality; but that color by itself may in no way invoke the image of the lady. Thus, a good trademark can strengthen the individual character of its wearer by a striking sensory supplement without evoking that reference by itself. When I meet the trademark designed by Francesco Saroglia for the International Wool Secretariat (Figure 46) I may not identify it, because its supple, flexible, smooth shapes portray a very generic quality. It has an elegance deliberately chosen to counteract the connotation of stodgy tweeds, but it is not specific to wool. In the proper context, the simple design focuses on these essential and desirable properties in a tangible, concentrated fashion, helpful to the intended message.

A good modern trademark interprets the character of its wearer by associating it with sharply defined patterns of visual forces. The

well-known emblem of the Chase Manhattan Bank designed by Chermayeff and Geismar may serve as an example (Figure 47). The inner square and the outer octagon produce a centrically symmetrical figure, conveying the sense of repose, compactness, solidity. Closed like a fortress against interference and untouched by the changes and vicissitudes of time, the little monument is built of sturdy blocks defined by parallel straight edges and simple angles. At the same time, it has the necessary vitality and goal-directedness. The pointed units contribute dynamic forces which, however, do not displace the figure as a whole but are confined within the stable, directionless framework. The antagonistic movements compensate

Figure 46

Figure 47

each other to an overall enlivened stillness or add up to the steady, contained rotation of a motor. Furthermore, the four components are tightly fitted into the whole but at the same time preserve an integrity of their own, thus showing multiplicity of initiative, executed by elements, whose individuality is limited, however, to a difference of position in the whole. In addition, the figure is usefully ambiguous in the connection of the four elements. Seen as right-angular blocks with a corner clipped off, the four fit each other like bricks in a wall. Seen as four symmetrical prisms they overlap each other and thereby interlock. The delicate balance between adjoining each other and interacting with each other by cooperative clasp further illustrates the nature of the internal organization.

To some extent, so highly abstract an image will always have the chill of remoteness. It cannot give the sensuous fluffiness of wool conveyed by a good color photograph or realistic painting. It cannot show the bustle of the bank, its people, its splendid halls.

On the other hand, it need not limit itself to the mere identification of relevant structural properties. Any design has dynamic qualities, which contribute to characterizing the object. Simple shapes can evoke the expressive qualities of suppleness or vitality or harmony. This sort of evocation is indispensable in art. The emblems here discussed dwell curiously between art and the cognitive functions of mere identification and distinction. An emblem may be a perfectly acceptable analogue of the referent for which it stands, and yet it may not intend to evoke its dynamic impact or not succeed in doing it.

This is particularly evident when the referent has strong emotional connotations. Figures 48 and 49 give two examples, the one

Figure 48

Figure 49

Ernst Roch's proposal of a trademark for the Canadian World's Fair of 1967, the other designed by Saul Bass for the Committee for a Sane Nuclear Policy. Both are most distinctive and display attractive intelligence in reducing the objects they depict to simply defined visual patterns. Roch's design, in which Leonardo's famous drawing of the Vitruvian man reverberates, was intended to illustrate the theme of the exhibition: Man and His World. Bass shows protective hands trying to contain an atomic explosion. While both designs focus on essential elements of their subject matter with great precision, Roch's terrestrial globe does not attempt to convey a sense of vastness, and there is no real reaching, embracing, or upholding in the arms, no power in the straddled legs. Similarly in the Bass emblem, the exploding fragments have little destructive power, and the hands may not look actively protective to some observers.

This reduction of expressive dynamics to a mere hint may be exactly appropriate. The principal function of an emblem is not

that of a work of art. A painting or piece of sculpture is intended to evoke the impact of a configuration of forces, and the references to the subject matter of a work are only a means to that end. Inversely, a design, meant to serve identification and distinction, uses dynamic expression mainly for this principal purpose; just as the three strokes of the Chinese character for "mountain" hint not only at peaks but also at their rising and thereby make the reference a bit more lively. Of course, even the most sober and neutral design can unleash violent passion through the meaning associated with it. But the dynamics inherent in a visual object — in a Baroque painting, for instance — is one thing; the emotions released by it — such as by hammer and sickle — are quite another.

Experience interacting with ideas

Pictorial analogues, I said earlier, fulfill a mediating position between the world of sensory experience and the disembodied forces underlying the objects and events of that experience. A portrait by Rembrandt is a picture, interpreting a particular inhabitant of Amsterdam as a kind of person, characterized by a particular pattern of physical and psychical forces — a man, let us say, battered but upright, vigilant but thoughtful. At the same time, the unknown man from a past century is of lasting interest as a symbol because his image gives animated appearance to those more abstract qualities of oppression and resistance, outward-directedness and inner containment. The same is true for a good "abstract," i.e., nonmimetic work of art. Since it does not portray the external shape of physical objects, it is closer to the pure forces it presents symbolically; but it portrays at the same time the inherent nature of the things and events of the world and thereby maintains its relevance to human life on earth. In sum, every pictorial analogue performs the task of reasoning by fusing sensory appearance and generic concepts into one unified cognitive statement.

How essential it is that these two aspects of the image should complement each other constantly, not only in the arts but everywhere in human thinking, has been pointed out by Goethe in an eloquent passage of his *Theory of Color:*

With regard to figurative speech and indirect expression, poetry has great advantage over all the other ways of language. It can use any image, any relation to suit its own character and convenience. It compares the spiritual with the physical

and vice versa: thought with lightning, lightning with thought, whereby the interdependence of the matters of our world [das Wechselleben der Weltgegenstände] is expressed in the best way. Philosophy, too, in its climactic moments, needs indirect expressions and figurative speech, as witnessed by its use of symbolism, which we have often mentioned, both censuring and defending it. Unfortunately, history tells us that the philosophical schools, depending on the manner and approach of their founders and principal teachers, suffer from employing one-sided symbols in order to express and master the whole. In particular, some of them insist on describing the physical by spiritual symbols while others want physical symbols for the spiritual. In this fashion, subjects are never worked through; instead, a disjunction comes about in what is to be represented and defined and therefore also a discrepancy among those concerned with it. In consequence, ill will is created on both sides and a partisan spirit establishes itself.

There are paintings and sculptures that portray figures, objects, actions in a more or less realistic style, but indicate that they are not to be taken at their face value. They make no sense as reports on what goes on in life on earth, but are intended primarily as symbolic vehicles of ideas. The beholder is overcome by the uncanny feeling of which Hegel speaks with regard to the symbolism of ancient oriental art: "Wir fühlen, dass wir unter Aufgaben wandeln" (We have the sensation of wandering among tasks.) Since the picture does not simply interpret life, the beholder faces the task of telling what it symbolizes. Picasso's early painting *La Vie* is called by Wilhelm Boeck a tribute to the secularized philosophical symbolism of art around the turn of the century. Boeck describes this representation of "Life" as follows:

A barefoot woman is standing at the right, her serious face in profile, with a sleeping infant in the folds of her draped garment. At the left stands the graceful nude of a young couple, seeking each other's protection as though suddenly frightened; the man is larger, with the high forehead of an intellectual, the tender woman is all devotion. They face the mother but their glance is turned inward; engrossed in their own destiny, they do not see her, although the index finger of the man's sensitive left hand points emphatically to the child. Behind the foreground figures we see two painted studies: the lower one shows a squatting nude lost in a reverie; the upper one, a seated couple whose attitude echoes that of the couple standing in the foreground.

Clearly, the painter has undertaken to represent an idea of the kind directly expressed as a theoretical schema, for example, in Keats' sonnet *The Human Seasons* or in the riddle of the Sphinx ("What creature goes on four feet in the morning, on two at noonday, on three in the evening?") Clearly also, the painter treads on dangerous

ground. Explicitly symbolical representations are common in all cultures. But since they take their principal cue from an idea, the style of the presentation must warn the beholder that he is not in the realm of earthly happenings. On the other hand, in this twilight area between diagram and art, there is always the risk of ideas coercing the life of the image. The so-called allegory travesties the task of the symbol by illustrating ideas through standardized clichés. Conceptual norm becomes poverty of imagination. Hence the chilling effect of overly cerebral novels, in which unconsummated theorems are draped over the characters as though they were the dummies of a dressmaker. Hence also the ludicrousness of schematic symbolism in some amateur art, cheap oratory, or dreams. Roger Fry has poked fun at the poor artistic quality of the dreams cited by the psychoanalyst Oskar Pfister, who wished to show that poetic inspiration derives from the same source as do dreams. Here is an example:

A youth is about to leap away from a female corpse onto a bridge lost in a sea of fog, in the midst of which Death is standing. Behind him the sun rises in bloodred splendor. On the right margin two pairs of hands are trying to recall or hold back the hurrying youth.

I suspect that the repulsiveness of amateur fantasy, which Freud noted in reactions to daydreams and cheap fiction, is aroused not so much because desires and fears are revealed in their nakedness, but because preconceived ideas and hackneyed imagery are permitted to interfere with the truthfulness of the statement. These products of the mind are cognitively unclean.

Two scales of abstraction

What I have tried to say about the functions of pictorial analogues is summed up in Figure 50. Pictures and symbols depict experience by means of images in two complementary ways. In a picture, the abstraction level of the image is higher than that of the experience it represents; in a symbol the opposite is the case.

While every image connects two specific levels of the two scales, it is most desirable for the particular purposes of art that the whole range of both scales reverberate in each instance of pictorial representation. This means for the Image Scale that although a painting

may be entirely "abstract" (non-mimetic), it needs to reflect some of the complexity of form by which realistic works depict the wealth of human experience. Inversely, a realistic portrayal, in order to be readable, generic, and expressive, must fit its presentation of objects to the pure forms, more directly embodied in non-mimetic art.

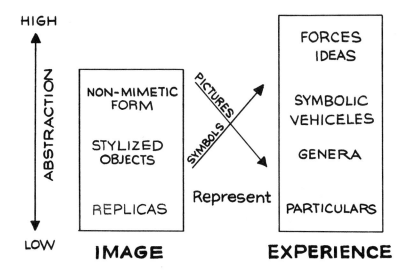

Figure 50

For the Experience Scale this condition demands that while focusing upon the ultimate forces inherent in existence, the mind view them as creating the richness of empirical manifestation; and vice versa, the teeming multiplicity of particular phenomena must be seen as organized by underlying general principles.

This doctrinaire demand will appear justified if one thinks of what happens when the two scales are not fully extended or not fully permeable. Under such pathological conditions, a scale is trimmed or cut through at some level, leaving the mind with a restricted range. Restriction to the bottom of the image scale may lead to the thoughtless imitation of natural objects. At the top end, isolation makes for a rigid geometry, orderly enough, but too impoverished to occupy the human brain, the most differentiated creation of nature. On the side of experience, limitation to the bottom of the scale makes for a materialistic, utilitarian outlook, unrelieved by guiding ideas. At

the top we get anaemic speculation, the purely formal handling of theoretical propositions or norms.

Any such restriction of thought and expression weakens the validity of artistic statements. In an ideal civilization, no object is perceived and no action performed without an open-ended vista of analogues, which point to the most abstract guiding principles; and, inversely, when pure, generic shapes are handled, there reverberates in human reasoning the experience of particular existence, which gives substance to thought.

9. *What Abstraction Is Not*

We need and want to rebuild the bridge between perception and thinking. I have tried to show that perception consists in the grasping of relevant generic features of the object. Inversely, thinking, in order to have something to think about, must be based on images of the world in which we live. The thought elements in perception and the perceptual elements in thought are complementary. They make human cognition a unitary process, which leads without break from the elementary acquisition of sensory information to the most generic theoretical ideas. The essential trait of this unitary cognitive process is that at every level it involves abstraction. Therefore the nature and meaning of abstraction must be examined with care.

Our thesis is simple enough. But there is little hope that its positive aspects will be understood and accepted unless a number of misleading conceptions of abstraction are described and refuted.

In its literal sense, the word *abstraction* is negative. It speaks of removal since the verb *abstrahere* means actively to draw something away from somewhere and passively to be drawn away from something. The Oxford Dictionary quotes seventeenth century usage: "The more abstract we are from the body . . . the more fit we shall be to behold divine light." An absent-minded man is "abstracted," and a person having "no idea of poverty, but in the abstract" is understood to be somebody who does not really know. Similarly, to abstract something means to take it away from somewhere, as in this example dating from 1387: ". . . the names of the authors of whom this present chronicle is abstract."

153

A harmful dichotomy

This sense of removal and detachment places an inauspicious burden on the name of this mental operation. In psychological theory, the term *abstraction* has frequently been taken to refer to a process that is based on sensory data but leaves them behind and abandons them totally. John Locke said that in order to abstract we take the particular ideas received from particular objects and separate them "from all other existences and the circumstances of real existence, as time, place, or any other concomitant ideas." And further:

Such precise, naked appearances in the mind, without considering how, whence, or with what others they came there, the understanding lays up (with names commonly annexed to them) as the standards to rank real existence into sorts, as they agree with these patterns, and to denominate them accordingly.

Even in our own time we still meet the belief that a conception, in order to be truly abstract, must be free from any perceptual collateral, which would be viewed as an impurity. For example, René Pellet, in a book intended to describe the development from the "perception of the concrete" to the "conception of the abstract," states: "We shall understand the word 'abstraction' in its most elevated sense when the mind is capable of conceiving outside of the concrete representations, that is, of creating without any support based on what is perceptually given or remembered." Abstraction, he says, is an organization of the mind that passes beyond the concrete and has freed itself from it.

Instead of relying on sensory experience, abstract thinking was supposed to take place in words. It was believed, for example, that a creature deprived of speech could not abstract. In the passage just quoted, Locke said of animals that "the power of abstracting is not at all in them, and that the having of general ideas is that which puts a perfect distinction betwixt man and brutes." And Pellet states: "Since the deaf and dumb are limited to their gesture language, which is descriptive and chronological and applies only to concrete facts or acts they never attain the process of abstraction or generalization."

The misleading dichotomy between perceiving and thinking is reflected in the practice of distinguishing "abstract" from "concrete" things as though they belonged to two mutually exclusive sets; that is, as though an abstract thing could not be concrete at the

same time, and vice versa. The state of affairs is nicely illustrated by the anecdote of a child who asks his father: "What is abstract?" The father answers after some hesitation: "Abstract is what cannot be touched." Whereupon the child: "Oh, I know: like God and poison ivy!" The crudest misuse of the two terms, then, is that of saying "concrete" when "perceivable" is intended, and "abstract" to describe what is not accessible to the senses.

It is equally misleading to call concrete that which is physical and abstract that which is mental. Compare the usual opening of the game Twenty Questions: "Is it concrete or abstract?" A table is concrete, but liberty is supposed to be abstract. My friend is concrete but friendship is not. This apparently simple distinction involves, first of all, an ontological muddle since *table* can either be a material object or an object perceived, remembered, or thought about. If the distinction intended is that of things in the physical world beyond the senses as against the contents of the mind, there is no excuse for replacing clear terms with misleading ones. If, however, the assumption is that a person knows only what is in his mind, the distinction is between extracerebral percepts, which are due to objects or events located outside of the brain (table, solar eclipse, stomach ache) and intracerebral percepts, caused by processes within the brain itself (memory images, thoughts, concepts, sentiments). In this case, it is necessary to realize that the latter are as concrete as the former. The experience of seeing a table or sensing a pain somewhere in one's body is no more or no less concrete than that of having an image or idea of something. Any of these experiences may be precise or imprecise, sharp or vague, but they are all invariably concrete.

All mental contents are particular, unique items, even if they are also "universals," that is, even if they are concepts standing for a kind of object or idea. This observation was made most clearly by Berkeley and was hailed by Hume as "one of the greatest and most valuable discoveries that has been made of late years in the republic of letters." Berkeley realized that "an idea, which considered in itself is particular, becomes general by being made to represent or stand for all other particular ideas of the same sort"; and further on:

. . . Universality, so far as I can comprehend, not consisting in the absolute, positive nature or conception of any thing, but in the relation it bears to the particulars

signified or represented by it: by virtue whereof it is that things, names, or notions, being in their own nature particular, are rendered universal.

In other words, the concept *table* is just as concrete and individual a mental content as the memory image of a table or the percept of a physical table standing in front of the observer. Friendship is as concrete as any particular friend. God and the notion of God are as concrete as the concept of poison ivy or any specimen of that plant. But any object, event, or idea becomes a universal when it is treated as standing for a population of instances. It becomes an abstraction when it is treated as a distillate drawn from some more complex entity or kind of entity.

In no way can the terms "concrete" and "abstract" serve to sort the items of experience in two containers. Neither are they antonyms nor do they refer to mutually exclusive populations. Concreteness is a property of all things, physical or mental, and many of these same things can also serve as abstractions.

How necessary it is to clear up the confusion becomes evident when, in a well-known and typical introduction to logic, one comes across the sentence: "Let us, therefore, admit, as we all can, that abstractions are not real if the real is defined as that which is concrete and not abstract." Here our two adjectives are treated as disjunctives, as though a thing could not be abstract and concrete at the same time; and concreteness is equated with material existence. A bit later, the same book admonishes us to realize "that the abstract objects of thought, such as numbers, *law,* or *perfectly straight lines,* are real parts of nature (even though they exist not as *particular* things but as the *relations* or *transformations* of such particulars) . . . " This statement confuses what a thing is with what is may stand for and asserts that an entity can exist without being a particular.

Any phenomenon experienced by the mind can acquire abstractness if it is seen as a distillate of something more complex. Such a phenomenon can be a highly rarified pattern of forces or it can be an event or object in which the relevant properties of a kind of event or object are strikingly embodied. Using a term introduced in the preceding chapter, we may say that a phenomenon is an abstraction when it serves as a picture. It may fulfill this function for one person but not for another, for the adherents of one culture but not for those of another; and it may suddenly acquire this property of pointing beyond itself for a person who had not looked on it that way before.

Abstraction based on generalization?

An abstraction is defined traditionally as the sum of the properties which a number of particular instances have in common. Locke tells us that "the senses at first let in particular ideas and furnish the yet empty cabinet." He explains that the natural tendency of the mind is towards knowledge; but the mind finds that, if it should proceed by, and dwell upon, only particular things its progress would be very slow and the work endless. Therefore, to shorten its way to knowledge and make each perception more comprehensive, the first thing it does is "to bind them into bundles and rank them into sorts so that what knowledge it gets of any of them it may thereby with assurance extend to all of that sort."

Traditionally, then, all abstraction is supposed to be based on generalization. So accustomed are we to this belief and so convincing does it sound that we no longer realize how much it is at variance with what actually happens and what difficulty it presents even in theory. To be sure, generalization exists, and I shall suggest later in what way it serves abstraction. But it is hard to see how it could be the first step to knowledge, as had been claimed ever since Locke. In his *Principles of Psychology* William James proposed what he called "the law of dissociation by varying concomitants." This law stated: "What is associated now with one thing and now with another tends to become dissociated from either, and to grow into an object of abstract contemplation by the mind." He was quick to add: "Why the repetition of the character in combination with different wholes will cause it thus to break up its adhesion with any one of them, and roll out, as it were, alone upon the table of consciousness, is a little of a mystery." It is a mystery indeed, but the problem is not so much in the why as in the how. Why it is convenient for the mind to generalize has been shown quite lucidly by Locke. But how that mind could proceed to generalities if faced by nothing but particulars is hard to imagine.

Presumably there are no two things in this world that have nothing in common, and most things have a great deal in common. Suppose now that every community of traits would induce us to group the corresponding things under a concept. Obviously, the result would be an incalculable number of groupings. Each individual thing would be explicitly assigned to as many groups as there are possible combinations of its attributes. A cat would be made to hold membership

in the associations of material things, organic things, animals, mammals, felines, and so forth, all the way up to that exclusive club for which only this one cat would qualify. Not only this, but our cat would also belong among the black things, the furry things, the pets, the subjects of art and poetry, the Egyptian divinities, the customers of the meat and canning industries, the dream symbols, the consumers of oxygen, and so on forever. In the universe of theoretical logic all these memberships are in fact constantly present when the concept *cat* comes up; but the actual consummation of all of this infinity of groupings based on different traits, different groups of traits, and differing in the number of their members would not contribute to sensible orientation. It would rather produce a catastrophic onslaught of information.

This being the dismal prospect, one would need, first of all, some criterion of selection. If abstraction were in fact a device of economizing by reducing the many to the few, the logical procedure might be to start with properties or groups of properties found in the largest number of individual cases and work one's way gradually to those representing fewer and fewer. Is this what we actually do? A glance at a child's concepts shows that it cannot be so. There may be only one dog in the child's world but from the beginning that dog will constitute a distinct category although the category contains only one member, whereas trees or houses or clouds, numerous though they are, may have much less priority in the child's world order. Grouping seems to be quite unrelated to how many members each group comprises.

Perhaps we do not go by size of population but by number of traits, grouping those individual instances which have the most traits in common. This indeed reminds us of something we do. We match man with man, bird with bird, matchbox with matchbox. Whether we do so by counting traits is a question to be kept in abeyance. In the meantime, we notice that such a procedure would suffer from diminishing returns. The larger the number of common traits, the smaller the number of individuals comprised in the group tends to be, even in an age of mass production, and therefore the more limited is its use for practical classification. In the extreme, we are left with as many classes as there are individuals. We are back to where we started and have no classification at all. Add to this the fact that quite frequently we make groupings on the basis of one distinguishing trait alone. Flammable or non-flammable—nothing else may matter.

The conclusion seems to be that while at times we classify according to the number of specimens covered by a concept or the number of traits it contains, counting does not give the criterion needed here. It seems more promising to say that people group things according to their particular interests. For example, cases can be cited in which human beings are classified by size, weight, income, skin color, number of gold teeth, or their ideas about the supernatural—no criterion of selection seems ineligible, each may be justified by the proper occasion, and what serves one purpose or direction of interest may be absurd for another. Anthropologists and psychologists have shown that even with regard to very basic conceptions the criteria of classification vary widely, but that they derive sensibly from the purpose in each case.

However, interest, although providing a criterion for selection, does not solve the basic cognitive problem. Let us consider an example. According to Freud, the human mind groups, at the level at which dreams are made, sticks, umbrellas, knives, steeples, watering cans, serpents, fishes, nail files, hammers, zeppelins and the number three. Another group of dream items comprises pits, hollows, caves, bottles, boxes, chests, pockets, ships, gates, and mouths. This grouping is made because of a vital concern with the organs of reproduction. More specifically, the grouping is not based on just any attribute objects happen to have in common with the genitals but on those crucial to the sexual interest, namely, pointedness and the capacity to rise and pour versus concavity, receptivity, etc.

If this is so, are we not implying that in order for the grouping to occur an abstraction had to take place beforehand? The crucial attributes just mentioned had to be distilled from the particular shape and functioning of the sexual organs. Without this prior abstraction there could be no selection of the objects serving as dream images. This means that an abstract concept, supposed to be the fruit of generalization, turns out to be its necessary prerequisite. We find ourselves entangled in what Piaget and Inhelder have described as "a vicious circle which can only be resolved by a genetic analysis." On the one hand, they explain, we cannot determine what properties are common to a set of elements, i.e., the "intension" of the class, by studying individual members in succession because we could not be sure of abstracting correctly until we had examined all members of the group, which is most often impractical or impos-

sible. On the other hand, we cannot pick the particulars to be examined in the first place without establishing some common property by which to choose them. "In other words, extension presupposes intension, and *vice versa*."

Henri Bergson clearly diagnosed the "circle" in 1896: "In order to generalize one must first abstract, but in order to abstract usefully one must already know how to generalize." He also suggested that the trouble was due to the assumption that perception is limited to the recording of individual cases. This was a most helpful observation. Bergson took another decisive step forward by pointing to what he called the utilitarian origin of sense perception. Perception, one might say in elaboration of his thought, is an instrument of the organism, developed during phylogenetic evolution as a means of discovering the presence of what is needed for survival and for being alerted to danger. These needs, argues Bergson, refer to kinds of thing, to qualities rather than to particular individuals. What attracts the herbivorous animal is herbage in general, "the color and the odor of herbage, sensed and submitted to as forces . . . " The precise distinction of individual objects, he says, is *"un luxe de la perception"* — a luxury of perception.

This observation is most relevant. However, we cannot follow Bergson when he denies that such perceptual selectivity in animals is an early form of abstraction. He bases his contention on comparisons with other processes in nature that are not abstractions. If hydrochloric acid discovers carbonate of lime in its various embodiments and acts on them always in the same way, whether they be marble or chalk, or if a plant draws invariably the same substances from the soil, are we going to say they perform abstractions? Probably not, for the reason that they do not select some properties from a given context. By their very nature they can respond only in these particular ways. The rest of the environment does not impinge upon them, and therefore there is no need of abstraction, or opportunity for it. Similarly, a blind man cannot be said to abstract the sounds he hears from their natural context of sights, since those sights were not given to him from the outset. Nor does the sense of sight "abstract," from the range of electromagnetic waves, that narrow band of wave lengths between sixteen and thirty-two millionths of an inch to which it is responsive. A filter does not abstract, nor does a coin-sorting machine.

However, the mind of a human being or animal is, for the most,

not in this situation when it gathers the primary generalities from the world of visual experience. Bergson holds that no abstraction takes place in perception. As percepts, he maintains, all the particular instances met in experience are different from each other; but some of them are reacted to in the same way and yield the same useful results; e.g., they all indicate things good to eat. In consequence, "something they have in common will detach itself from them." To argue in this way is to turn the facts upside down. Percepts are reacted to in a similar way because similarities have been discovered in them. The mechanism of this discovery of similarity needs to be explained.

The absurdity of Bergson's suggestion should be evident, but the idea is nevertheless attractive to theorists reluctant to admit abstraction in perception. For instance, Jean Laporte has asserted that abstractions are drawn from perceptual material by means of imitative gestures, which have already been elaborated on other similar objects and are now applied again. A circular tracing movement, for example, will be the response to something round, and in this way the object is fitted to "*quelque schème préexistant*," such as circularity or right-angularity. Laporte uses the abstractness of descriptive gestures, which I discussed earlier, without acknowledging that it presupposes the prior perception of abstract shape.

There is no way of getting around the fact that an abstractive grasp of structural features is the very basis of perception and the beginning of all cognition. The grouping of instances, allegedly the necessary preparation for abstraction, must be preceded by abstraction, because from where else would the criteria for selection come? Before one can generalize one must single out characteristics that will serve to determine which things are to belong under one heading. This is to say: generalization presupposes abstraction.

Susanne K. Langer describes primary abstraction as "the principle of automatically abstractive seeing and hearing." She writes:

The abstraction of form here achieved is probably not made by comparison of several examples, as the classical British empiricists assumed, nor by repeated impressions reinforcing the engram, as a more modern psychology proposes, but is derived from some single instance under proper conditions of imaginative readiness; whereupon the visual form, once abstracted, is imposed on other actualities, that is, used interpretively wherever it will serve and as long as it will serve. Gradually, under the influence of other interpretive possibilities, it may be merged and modified, or suddenly discarded, succeeded by a more convincing or more promising gestalt.

The value of this beautiful statement is largely undone, however, when Mrs. Langer asserts that such "presentational abstraction" is specific to the arts and to be distinguished from "generalizing abstraction," which she considers the method of science: "In scientific thinking, concepts are abstracted from concretely described facts by a sequence of widening generalization; progressive generalization systematically pursued can yield all the powerful and rarefied abstractions of physics, mathematics, and logic." This is an unfortunate, misleading limitation. In the sciences and elsewhere, there are instances in which a set of items is searched for common properties, but they are not typical of the way in which abstraction takes place. On the basis of some common characteristic a scientist may indeed search a group of cases for other properties they may share—such as a particular virus in the blood of individuals suffering from cancer— but he will resort to such mechanical scanning only because for the time being he is without the data needed for a better procedure. Also, here again, before he began his search, the group of cases to be examined was selected by an abstraction. Nobody analyses random samples of cases without determining by some criterion the population from which the samples are to be drawn. The mind is always steered by purpose.

The relation between abstraction and generalization is reflected in the age-old discussion concerning the nature and value of *induction*. Induction, commonly defined as "the process of discovering principles by the observation and combination of particular instances," consists in drawing general conclusions from what has been observed in a number of cases. By now, most theorists would agree that, in the words of Morris R. Cohen, "science never draws any inference from any sense-data except when the latter are viewed as already embodying or illustrating certain universals." That is, science makes full use of the "presentational abstraction" which Mrs. Langer considers a privilege of the arts. In an illuminating radio talk, entitled "Is the Scientific Paper A Fraud?" the British scientist P. B. Medawar complained, however, that even now the usual presentation of scientific findings tends to sustain the fiction that the facts were gathered without any previous assumption as to what they might tell. "You have to pretend that your mind is, so to speak, a virgin receptacle, an empty vessel, for information which floods into it from the external world for no reason which you yourself have revealed." The accepted style of writing, he explains, derives from a clinging to the traditional notion of induction as the only

purely factual scientific procedure, not contaminated by precon-
ceived opinion:

The conception underlying this style of scientific writing is that scientific discov-
ery is an inductive process. What induction implies in its cruder form is roughly
speaking this: scientific discovery, or the formulation of scientific theory, starts
with the unvarnished and unembroidered evidence of the senses. It starts with
simple observation — simple, unbiased, unprejudiced, naive, or innocent observa-
tion — and out of this sensory evidence, embodied in the form of simple proposi-
tions or declarations of fact, generalizations will grow up and take shape, almost
as if some process of crystallization or condensation were taking place. Out of a
disorderly array of facts, an orderly theory, an orderly general statement, will
somehow emerge. This conception of scientific discovery in which the initiative
comes from the unembroidered evidence of the senses was mainly the work of a
great and wise, but in this context, I think, very mistaken man — John Stuart Mill.

Before induction can be practiced, the population to which it is to
be applied must be selected. Since the very notion of induction
implies that the cases to be investigated are not all identical, this
selection requires a criterion, that is, the prior abstraction of certain
properties which must be present in the individuals to be chosen.
For example, all these individuals may have to have a high school
diploma or high blood pressure. Also any sensible enquiry limits
beforehand the sort of property to look for. The cancer specialist
may not spend time on finding out with which letter of the alphabet
the names of his subjects start but he may conceivably be interested
in where they were born. Thus induction presupposes abstraction.
Generalization presupposes generality.

Generality comes first

A superficial look at the origins of knowledge may seem to contra-
dict this contention. Take the behavior of Pavlov's dogs in his
experiments on conditioning. When Pavlov started his work, he
found to his displeasure that the animals responded not only to the
particular stimuli on which the training was based but to any change
whatsoever in the laboratory. The slightest movement of the experi-
menter — a blinking of the eyelids or movement of the eyes, posture,
respiration — provoked the conditioned reaction. Nor was it suffi-
cient to banish the experimenter from the room.

Footfalls of a passer-by, chance conversations in neighboring rooms, slamming
of a door or vibration from a passing van, street-cries, even shadows cast through

the windows into the room, any of these casual uncontrolled stimuli falling upon the receptors of the dog set up a disturbance in the cerebral hemispheres and vitiate the experiments.

Does not this behavior suggest that the dogs were totally unable to abstract, to pick the relevant features from the environment? Pavlov suggested this much when he explained that the cerebral cortex of the brain is "a signalizing apparatus of tremendous complexity and of most exquisite sensitivity, through which the animal is influenced by countless stimuli from the outside world. Every one of these stimuli produces a certain effect upon the animal, and all of them taken together may clash and interfere with, or else reinforce, one another." We get the picture of a passive victim, helplessly exposed to whatever impinges upon it and reacting automatically to all of it. Pavlov saw only two ways of remedying this situation. He could make abstraction unnecessary by eliminating all happenings in the environment, except the particular metronome sound or electric shock for which the animal was to be trained. In fact, he found a "keen and public-spirited Moscow businessman," willing to pay for the construction of a soundproof and lightproof laboratory, in which the experiments could be performed by remote control.

Pavlov thought of another method. An animal could be prevented by inhibition from reacting to the stimuli to which it had responded initially and automatically. This could be done by leaving all reactions to the undesirable stimuli unrewarded or by punishing the animal for these reactions. Thereby a gradual differentiation could be obtained between events to react to and others not to react to. This was a useful principle, which pointed to an important psychological mechanism. But the principle should not be taken to prove that every stimulus is reacted to automatically until the reaction is stopped by some secondary influence.

Note, first of all, that in experimental conditioning the initial response to any change in the environment is found not only in animals but also in human adults. Lashley has reported that with human subjects, conditioned to the sound of a bell, he obtained "the conditioned reaction without further training from the sound of a buzzer, of breaking glass, of clapping hands, from a flash of light, from pressure or prick on arm or face. The only 'dimension' common to such stimuli is that all produce a sudden change in the environment. Such tests show that the conditioned reaction is initially

undifferentiated . . . " If one looks around for instances in which animals or humans seem to respond indiscriminately, one discovers that this happens only when the various stimuli responded to are in fact equivalent for the reacting organism and its particular purpose. Think of a cat's, and indeed your own, immediate reaction to every sudden change. This change may be inconsequential; but it may also be vitally important. Whether an event matters or not can be found out only by paying attention to it. The quick shifting of the glance towards any spot at which a change occurs serves as a screening process for which all changes whatsoever are important and must be attended to. In other words, what we have here is not the automatic and indiscriminate response by a creature helplessly at the mercy of every individual stimulus, but on the contrary a highly appropriate reaction, whose great generality is required by the large variety of stimuli relevant to the purpose. They are all pertinent because they are all changes. They are all reacted to, not because the creature is incapable of abstraction but because the criterion for the abstraction appropriate to the situation is so generic and comprehensive that every happening at all belongs in its purview. The broad reaction is not a failure to discriminate but an asset.

A response may be inappropriate objectively and yet sensible in terms of the situation as the person or animal experiences it. In a newborn infant, sucking may occur in response to light, sounds, or smells. Piaget cites a study by Rubinow and Frankl according to which any solid object approaching the face makes the infant respond with sucking although one month later only pointed objects produce this result. These reactions take place in a world dominated by a few strong needs and penetrated by external stimuli that may or may not be relevant to those needs but about which the infant knows nothing or little. The pressure of any need tends to broaden the range of stimuli to which the individual responds, but the lack of knowledge about these events justifies the extension. Here again the response is at the appropriate level of abstractness. The situation of the dog in the Moscow laboratory is very similar. A strapped-down, anxious, hungry animal, which is learning that some strange and senseless signal is always the herald of food, will naturally and rightly put all the other senseless events in the category of food-announcers until he comes to know better.

We cannot tell what the newborn child or the experimental dog perceives; we have to rely on their observable responses. But adult

human beings can cite countless examples to show that in an un-familiar realm of experience the common properties of its constitu-ents will predominate to such an extent as to make the differences invisible. The members of a strange race of human beings look all alike until one learns to tell them apart. A farmer, a shepherd, a zoo keeper perceives each animal as a distinct individual. To the out-sider, sheep are sheep, and monkeys are monkeys. Soldiers in their uniforms or nuns in their garb may seem to show no individuality. The waiter, the salesgirl, the barber may be differentiated by the customer only to the level of their profession, but within that pro-fession there is no observed *differentia*. The extent of differentia-tion will depend on how interested the particular person or cultural group is in the refinement of the initial abstraction. To the casual museum-goer all Italian art of the Quattrocento or all Egyptian sculpture may look alike. The naturalist Edwin Way Teale tells of his wife's trouble with automobile models:

It was in this section of the trip that Nellie began concentrating on the 'fieldmarks' of automobiles. It was a mystery to me, I had pointed out, how anyone able to note slight plumage differences in sparrows and warblers and shore birds had difficulty telling a Ford from a Rambler or a Chrysler from a Buick. Her explana-tion, not without logic, had been: 'The trouble is, automobiles keep changing their plumages.'

Change or not, the average ten-year-old boy, interested in cars, has no such trouble. The varying degree of perceptual differentiation is reflected to some extent in the principles of classification found in languages. The anthropologist Franz Boas has shown that any lan-guage, from the point of view of another, may seem arbitrary in its classifications. "What appears as a single simple idea in one language may be characterized by a series of distinct phonetic groups in another."

The first mental operations in new situations are not acts of gener-alization, for generalization must always be preceded by the distinc-tion of individually perceived cases. Instead, high generality is a quality of perception from the very start. It is a generality brought about by primary abstraction, in the sense that the differences which it hides are well above the threshold of the sense of sight. Details accessible to the eyes are not yet differentiated by the mind.

Let me return for a moment to the early, undifferentiated state of infant experience. William James' brash remark about the baby

viewing the sensory world as "one great blooming, buzzing confusion" has been quoted to death by those who delight in believing that the senses provide an amorphous chaos, which has to be waited upon by the order-producing "higher" faculties of the mind. But confusion is not a normal reaction of the organism at any level of development. Confusion results from special conditions, such as pathology, fatigue, passivity, or an onrush of excessive stimuli attacking a receptive sensorium. It occurs when the input is too strong or the processing power too weak. James himself describes confusion as the lapse into the indiscriminating state, the opposite of focused attention, "a sort of solemn sense of surrender to the empty passing of time." Actually, James' remark about the baby occurs in a discussion of discrimination and comparison, in which he makes the important point that any number of impressions, from any number of sensory sources, falling simultaneously on a mind which has not yet experienced them separately, will fuse, for that mind, into a single undivided object: "The law is that all things fuse that can fuse, and nothing separates except what must."

Now fusion is not confusion. The texture of a homogeneous field is a state of low-level order, well suited to serve as a background for prominent stimuli. Most likely this, and not confusion, is the primary experience provided by the undeveloped senses of the baby. The meticulous observer of children, Arnold Gesell, objecting to James' famous aperçu, suggests that "much more probably the young baby senses the visible world at first in fugitive and fluctuating blotches against a neutral background." Gesell could no more look into the infant's mind than could James, but observations of external behavior bear him out.

The eyes of a newborn baby are apt to rove around both in the presence and absence of a stimulus. After several days or even hours, the baby is able to immobilize the eyeballs for brief periods. Later, he stares at surroundings for long periods. When he is four weeks old we may dangle a ring . . . in the line of his near vision: he regards it. We move the ring slowly across his field of vision: he "follows" it with his eyes through an arc of about 90°.

The organized response of fixation can be assumed to correspond to an equally orderly organization of the perceived field of vision, a simple distinction of a neutral ground and prominent "figure." It is a highly abstract primary experience. The field is reduced to "noise," i.e., the undifferentiated foil from which the positive mes-

sage is set off. The message, a light, a sound, a moving shape, is likely to be also quite generic. It is a positive "something" in an as yet ungraspable world.

A person who wishes to insist that perception is only the recording of individual items can argue that elementary generalities are not due to abstraction at all but rather to imprecise observation. He can point out that if observers catch nothing but a few crude overall qualities of any one thing, they will fail to notice the differences distinguishing similar things from one another. Evidently, for example, the blur of nearsighted vision is not a product of abstraction. No choice is involved. The badly focused eye merely catches all it can grasp. This seems to be the model for what Jean Piaget has in mind when he adopts the term "syncretistic perception." The following quotation tells the story:

Children therefore not only perceive by means of general schemas, but these actually supplant the perception of detail. Thus they correspond to a sort of confused perception, different from and prior to that which in us is the perception of complexity or of form. To this childish form of perception M. Claparède has given the name of *syncretistic perceptions,* using the name chosen by Renan to denote that first "wide and comprehensive but obscure and inaccurate" activity of the spirit where "no distinction is made and things are heaped one upon the other" (Renan). Syncretistic perception therefore excludes analysis, but differs from our general schemas in that it is richer and more confused than they are.

To be sure, obscure and inaccurate percepts do exist. They can come about when one looks at something under unfavorable conditions, for example, when one is inattentive or hasty or slow to catch on, or when the stimulus pattern is disorganized or excessively complex. In general, however, even when the stimulus is blurred, the mind tends to articulate it into some simple, regular and precise shape. And there is certainly no reason to assume a condition of blurred stimulation when the observer's eyes are physiologically capable of correct focusing and when his mind is reasonably alert and attentive. Perceptual abstraction cannot be dismissed as an inability. It is a positive accomplishment, typically of great precision because of the relative simplicity of the form patterns drawn from the stimulus material.

Medieval philosophers knew that the perception of particular specimens is, in the strictest sense, impossible. *Mens nostra singulare directe cognoscere non potest,* asserts Thomas Aquinas, i.e.,

our mind cannot cognize singularly and directly. All form is universal. Only by acknowledging abstraction in perception is it possible to overcome the theoretical dilemma which René Bouissou describes eloquently: "Nous sommes contraints de choisir entre l'abstrait vide et le singulier impensable." (We are being forced to choose between empty abstraction and particulars inaccessible to thought.) More explicitly, Bouissou says:

In fact, if it is true that a concept is brought about by emptying a state of consciousness of any element of, or relation to, the concrete, the bridges between the perceivable and the intelligible are definitively destroyed and the unity and continuity of knowledge become illusory.

Sampling versus abstraction

Samuel Johnson defined the outcome of an abstraction as "a smaller quantity containing the virtue or power of a greater." The definition seems to hint at a richer, more adequate view of abstraction than the one offered us by traditional logicians, without, however, contradicting the latter explicitly.

If abstraction takes a smaller quantity from a larger one, what is the nature of that quantity? Perhaps, since an abstract concept often covers a number of instances, one specimen of that population could serve as a concept to represent the whole. George Berkeley suggested that a particular triangle can be used to stand for all possible triangles; and so it can. However, a triangle is just a specimen of its population, and although an abstraction can be performed upon it, not every specimen is suited to serve by itself as an abstraction of its population or entity. A specimen is first of all a mere sample. A sample of fabric is not an abstraction of it. Nor is a sample performance an abstraction of a person's capacities. If all men were strictly equal, no man could serve as an abstraction of mankind. He would be only a sample. However, given the wide variety of human beings, mankind can be abstracted through the presentation of particular persons, who embody the nature of many or all people in important respects. Although they are individuals of flesh and blood, such persons can serve, like the players in *Hamlet*, as the abstracts and brief chronicles of the time. Similarly, the members of the Congress of the United States are not meant to be a sample of the American people but an abstraction of it. They are considered, and must consider themselves, as possessing the capacities which

enable the American people to make their own laws; and those capacities alone are referred to when the members of the Congress act as representatives — as an abstraction of the people.

Abstraction, then, is not simply a sample of a population. It is not just a sample of traits either. For example, an attribute, or group of attributes, may distinguish a kind of object from others and yet not be a suitable abstraction of the object. If the colors blue and yellow distinguish the airplanes of one company from those of any other, the two colors serve as a sign or signal for that airline but do not necessarily depict its character or nature in any sense. Similarly, a mere sign or cue is not an abstraction. A few hairs, picked up by a detective, are not an abstraction of the criminal. However, Joseph's stained coat of many colors is more than circumstantial evidence and proof of disaster. For the reader of the Bible as well as for Joseph's father and brothers, the precious coat, the gift of the father, stands for Jacob's partiality, and the blood stains depict the assault upon the favorite. The choice of the telltale sign is not accidental. It is a powerful visual abstraction of the family drama.

A lost wrist watch is not an abstraction of its owner, who left it behind. But the display of old-fashioned, mangled clocks and watches in the small museum at Nagasaki, on the hill over which the atomic bomb exploded, serves as an abstraction that arrests the heartbeat of the visitor. All the clocks stopped at 11:02, and this sudden concerted end of time, the death of innocent daily action, conveys an immediacy of experience, which is almost more powerful than that of the photographed horrors shown in the same museum. An essential aspect of the event evokes the event itself.

It would be pleasantly simple to understand the nature of abstraction if it involved only the removal of one or several elements from some entity. This approach, however, runs into at least three difficulties. First, strictly speaking the same element cannot be found in more than one specimen. Second, an arbitrary selection of traits does not lead to a meaningful abstraction. Third, even when such a selection picks essential traits, a mere adding-up of traits does not create an integrated concept. I will briefly illustrate these points.

One can conceivably extirpate elements from one particular specimen — the outlines of a face, the color of the eyes, the shape of the nose, to produce a rudimentary portrait. Such a procedure, although difficult, would be quite mechanical. But a whole family

of specimens, let us say, twenty faces, will hardly contain exactly the same color or shape, unless they are machine-made. Therefore, in order to pick an element common to them all one must possess, in most cases, the more sophisticated ability to discover sufficiently similar shapes of a particular quality. This task, although not mechanical, is quite easy. The uniqueness of every particular, actual specimen presents the mechanistic theory of abstraction with a puzzle, which one of the early nominalist philosophers, Boethius, has put in the following way. He teaches that nothing shared by a multiplicity of things can be an entity in itself because every thing exists only by virtue of being one thing. When one thing is shared by many proprietors, each of them owns only a piece of it; or they use it in succession, as happens, for example, with a well or a horse. Otherwise, they share it without really possessing it, as, for example, when a number of spectators share a performance. It is useful to look at the matter so palpably because we see at once that in order to extract a common element one must clean it of the individual differences adherent to it in the various specimens, and of the different connotations it assumes under the influence of different contexts. The yellow of Van Gogh is not for all purposes the yellow of Vermeer.

The second difficulty I mentioned is that an arbitrary selection of common traits is not often useful. A sorting machine can be instructed to gather the common properties of any assortment of items. It could tell us that the number of a dog's teeth equals the number of counties in a certain state of the country. While this finding would qualify as an abstraction logically, it would not necessarily serve the purposes of productive thinking.

Third, a mere enumeration of traits, relevant though they may be, does not create an integrated concept. For example, when a psychologist wishes to describe an individual's "personality" he may resort to the traditional technique of establishing a personality profile by assessing the standing of the individual with regard to a number of traits, of which one such test uses the following list: intelligence, verbal fluency, dominance, self-insight, tolerance, emotional expressiveness, conventionality, social extroversion. The degree to which the person possesses each of these traits might or might not constitute a relevant abstraction of the person himself, but the sum of all scores certainly does not. The psychologist creates the semblance of a profile by connecting the eight points of the diagram, but

this profile consists only of lines on paper. In order to obtain a portrait of the person's mind he would have to combine the eight data in an organized whole. Another example may make this point more explicitly. Some years ago an essayist, John A. Kouwenhoven, wrote a book on "what is American about America" by asking himself what such symptoms as the following had in common: the Manhattan skyline, the gridiron town plan, the skyscraper, the model-T Ford, jazz, the Constitution, Mark Twain's writing, Whitman's *Leaves of Grass*, comic strips, soap operas, assembly-line production, chewing gum. In this personality profile of our country, each symptom may be a legitimate abstraction ("the land of Mark Twain," "the land of skyscrapers"), but together they are a jumble of information until they are welded into unity. In the present case, this was accomplished by a further abstraction, which brought forth a trait common to all twelve symptoms, namely "a concern with process rather than product." If this diagnosis is valid, the abstraction has yielded an enlightening concept by revealing something essential of the thing abstracted.

10. *What Abstraction Is*

The art of drawing essentials from a given kind of entity can apply only to organized wholes, in which some features hold key positions while others are secondary or accidental. Little knowledge would be obtained about such organized wholes if abstraction consisted in the extraction of random traits. Gestalt psychologists have pointed out that traditional logic fails in this respect because what it offers are, in the words of Max Wertheimer, "concepts which, when strictly regarded, are sums of attributes; classes which, when strictly regarded in the light of what traditional logic concretely achieved are bags containing those concepts; syllogisms consisting of any two propositions thrown together at random so long as they contain that property . . . "

It is comforting to notice, however, that in practice the operations of logic are not generally applied in a mechanical fashion. The traditional procedure of defining a concept by genus and differentia may serve as an example. A genus is the set of attributes that distinguishes a particular kind of thing from its neighbors; and the differentia is the attribute that distinguishes a particular species of the genus from the others. In principle, any trait or group of traits establishing such distinctions would suit the purpose of definition, regardless of whether these traits pointed to essentials or not. Actually, however, the human mind endeavors to define things by what is important about them. If, for example, man is defined as a reasoning animal or, according to Hans Jonas, as the image-making

creature, the distinguishing characteristics are clearly intended to describe the center of human nature. To define a man as a featherless biped may separate him equally well or better from other animals, but this description impresses us as a letdown or a joke, just because it ignores what matters most. Spinoza has said that "if a definition is to be called perfect, it must express the innermost essence of a thing and must prevent us from taking particular propties for the thing itself."

One can express this also by saying that in order to produce a sensible abstraction, a concept should be generative. It should be possible to develop from the concept a more complete image than that offered by the concept itself. S. E. Asch has shown in his experiments that when subjects are given a short list of well-chosen traits they are able to derive from it a more complete description of the individual. He also found that certain adjectives, such as "warm" and "cold," refer to key attributes, which will influence the other traits of the individual whereas, for example, "polite" or "blunt" have little determining power. If somebody is described as a cold person, a rather complete image of a kind of behavior can derive from this one attribute, and, within limits, we can tell how this sort of individual would act under particular circumstances. This generative power of abstractions brings to mind Aristotle's notion of entelechy, the principle by which universals generate particulars.

Types and containers

The distinction between generative or central attributes and accidental or peripheral ones helps to clarify the nature of productive abstraction. But it is necessary to go further, beyond the traditional approach, and to remember that we are not concerned with the extraction of particular traits but with the description of structural properties. The coldness of a person is not a self-contained property like the coldness of a stove or the moon. It is an overall quality, affecting many aspects of the person's behavior. In order to focus on this characteristic of abstraction we may distinguish between container concepts and types.

A container concept is the set of attributes by which a kind of entity can be identified. A type is the structural essence of such a kind of entity. The abstractions characteristic of productive thinking

are types rather than containers—in science as well as in art. The psychiatrist Ernst Kretschmer's investigation of body types may serve as an illustration. I am not concerned here with the validity of these types, which Kretschmer related to corresponding mental dispositions, but with the cognitive status of typology and with Kretschmer's procedure.

In order to fend off the possible suggestion that his types are arbitrarily conceived and imposed upon the bodies of his patients, Kretschmer claims to use a method analogous to that of Francis Galton's composite photographs. "We proceed as though we printed the pictures of a hundred persons of the same type simultaneously on the same piece of paper, whereby similar features would reinforce each other while the nonfitting ones would blur each other." Actually, Galton's photos have shown that the results of such superposition are singularly unenlightening because the variations from specimen to specimen blur not only the atypical traits but the typical ones as well. This is so because most specimens do not literally embody the type, and their various approximations to the type cancel each other out rather than eliminating the accidental deviations.

In fact, Kretschmer asserts almost in the same breath that his description of types is not based on what is seen in the largest number of cases but is illustrated by the "most beautiful" specimens. These represent most clearly the common features, of which the bulk of the cases affords only a blurred view. The "classical cases" are "happy finds," not often met in the run of the mill.

For accuracy's sake, Kretschmer insists on photographs and measurements, but he considers them as supplementary data, which cannot replace direct visual impression. The reasons are obvious: measurements are limited to single lengths or shapes and their numerical relations and therefore miss the interplay of features within the whole pattern; photographs prejudge observation by singling out accidentals as readily as essentials. "The tape measure sees nothing," says Kretschmer. "Everything depends on the perfectly artistic, sure training of our eyes," and he recommends that immediately after the examination of each patient the observer record his fresh impression by summarizing the essential features in writing.

The struggle to reconcile two divergent demands, which is apparent here, comes about because contemplative thought—in the

scientist, the artist, or anybody else — aims at the nature or principle of things, at the forces underlying their appearance and behavior. In practical action, on the other hand, one is primarily concerned with the handling of particular specimens. The classification of such specimens poses no problem of principle if it is based on container concepts. Any specimen possessing, in reasonable approximation, the attributes constituting the concept qualifies for membership. The criteria must be readily isolated. For example, we can decide with precision that somebody is or is not a citizen of our country. If membership cannot be based on the presence or absence of a given trait or set of traits, one can list the kinds of object that come under the heading of the container concept in question. For example, one can define antiques as copper teakettles, cut glass, Hitchcock chairs, candelabra, etc. In other cases, one can use a scale to define an antique as an object made before a certain date.

Kretschmer, as a scientist, was not primarily concerned with the sorting of individuals. He was interested in an abstract bodily configuration, quite precisely defined in itself by a set of structural features but realized in actual persons only more or less impurely; and he sought to relate this physical type to an equally abstract type of human personality. However, for the practical purposes of testing his hypothesis quantitatively and for applying his theory to diagnosis, he had to classify his patients as to whether or not they belonged to one type or another. There is no ideal way of combining the two standards. A type is not a set of traits, either present or absent in any particular individual. In practice, gradients lead from relatively pure embodiments to weaker and weaker manifestations, or to what in motion picture language is called lap-dissolves between one type and another. To draw a borderline across a gradient is always arbitrary, and to put up with container concepts got in this fashion is an unhappy prospect for anybody whose work dedicates him to the identification and clarification of types.

And yet, one of the most stubborn and awkward ways in which the practical mind interferes with the seeking of the truth consists precisely in replacing types with container concepts based on the staking out of territory. In art history, for example, one can gain genuine understanding by defining styles, such as Expressionism or Cubism, as pure types of attitude and manifestation and by showing how in a given artist such ingredients combine in a particular blend. In that way, one begins to understand the history of art as a

fluctuating interplay of underlying types of approach, by which a particular pattern comes to the fore at some time or place or in some person, only to dissolve into another. But to try to stake out historical territory by determining when the Renaissance began or ended or whether Cézanne belongs among the Impressionists or the Cubists is an absurd and hopeless undertaking. It is not justified by any practical necessity for compromise between types and container concepts. In the history of art, just as in other areas of science, one can find the occasional *Glücksfall,* that is, an approximation of the pure type in the flesh, but owing to the one-sidedness of generic types, such purity is found in the arts more often among the limited talents than among the richly endowed. The most typical Cubist was not the greatest.

By the standards of container concepts, types may be misinterpreted as being less firm, more flexible. For example, August Seiffert, in his book on the subject, expresses himself ambiguously. He warns, on the one hand, against the misunderstanding that the nature of the type exhausts itself in the mere approximation to a more sharply outlined form. On the other hand, he calls types flexible, adaptable, elastic, diffusely delimited, as against the rigid definitions applied elsewhere. However, types aspire as much to precision as do traditional container concepts. Kretschmer's descriptions of the asthenic, athletic, and pyknic body types are as precisely drawn as, say, those of Don Quixote or Sir John Falstaff, but the admission to such a type is not based on the either-or policy characteristic of container concepts. Rather, scales of gradual difference lead from the purest embodiments of a type to the weakest. It is quite misleading to maintain, as Seiffert does, that "basically nothing is less welcome to a science of types than the discovery of intermediary forms" because they "disturb the conception." Empirical material may reveal that a type concept needs correction, but intermediary forms as such have no bearing on the concept, only on its application. The assignment of a given specimen to one of two neighboring types may be quite debatable ("Is he an introvert?") when it is located between the two, but this sort of difficulty does not affect the types in themselves. It does embarrass concepts that aim at rigidity of application because it reveals how arbitrarily their walls are placed.

Container concepts also can be defined in such a way as to accommodate ranges of application, but this does not change their basic

character. This seems to me to have been overlooked in the investigation of Hempel and Oppenheim, who suggest that types are obtained when rigid "either-or" attribution is replaced with gradation. The psychological concept of intelligence, for example, does become more usable if instead of dividing mankind into two kinds of persons, the intelligent and the unintelligent, one introduces a scale that assigns degrees of intelligence. Such a procedure, however, concerns only the application of the concept, not the nature of the concept itself. In no way does it replace the container concept of intelligence as the set of persons capable of tackling certain test questions with the type concept of intelligence as a structural pattern of mental behavior.

Static and dynamic concepts

Concepts tend to crystallize into simple, well-shaped forms. They are tempted by Platonic rigidity. This creates trouble when the range they are intended to cover includes relevant qualitative differences. The concept of movement, for example, may neglect differences of speed. However, for certain purposes slow motion is different in nature from fast motion. Perceptually and aesthetically, the leisurely, heavy, smooth quality of slow motion differs from the racy power of high speed. Such qualitative differences are hidden when the concept of movement refers simply to locomotion as such, the way a human figure or animal in a child's drawing simply "moves," without reference to the quality of a particular speed.

The same problem can arise when the various phases of a movement differ qualitatively. For certain purposes it is important to distinguish between the high degree of tension characterizing the maximum deviation of a pendulum from the plumb line, and other phases of the same movement. Near its extreme positions, the pendulum hesitates, stops for a moment, and inverts its direction; and it passes smoothly through the vertical symmetry axis, which stands for zero tension. If the concept of pendulum movement is limited to that of mere back-and-forth swing, it hides these differences. I will call such a concept static.

There is a fascinating interplay in the human mind between the desire, and indeed the need, to comprehend the total range of a phenomenon and the attractive simplicity of static concepts, which pick out some one characteristic state of an object or movement

and let it stand for the whole. At early cognitive levels, the mind is not yet able to handle much complexity and therefore uses simple shapes and uniform movement in its concepts. Such static concepts facilitate a first approach to the phenomenon by congealing its structure, but they will also oversimplify, freeze, and isolate the phenomenon, and this is not conducive to more comprehensive knowledge.

This inadequacy of static concepts has been noticed with discomfort in the past. Locke surprises us with his observation on our motives for collecting instances under a genus, which we do

not out of necessity, but only to save the labor of enumerating the several simple ideas which the next general word or genus stands for; or, perhaps, sometimes the shame of not being able to do it. But . . . though defining by the genus be the shortest way, yet it may be doubted whether it be the best. This I am sure, it is not the only, and so not absolutely necessary. For, definition being nothing but making another understand by words what idea the term defined stands for, a definition is best made by enumerating those simple ideas that are combined in the signification of the term defined

In a different context, Francis Galton, writing on "normal variability," exclaims:

It is difficult to understand why statisticians commonly limit their inquiries to Averages, and do not revel in more comprehensive views. Their souls seem as dull to the charm of variety as that of the native of one of our flat English counties, whose retrospect of Switzerland was that, if its mountains could be thrown into its lakes, two nuisances would be got rid of at once.

This observation should give pause to those who use the same Galton's method of composite photographs as a model for concept formation by the superposition of particulars.

Earlier, I mentioned Berkeley's suggestion that a generic proposition could be represented by a particular specimen. He argued that if we gather from a particular instance an observation that employs some of its attributes while leaving others unused we can be sure that the observation will hold true for all individual cases which possess those critical attributes, regardless of whether or not they also have the rest of them. For instance, if the sum of the angles in one particular triangle is found to be equal to two right ones, the discovery can be confidently taken to apply to all other triangles because our proof need not make any reference to the size

of the angles. What we have here is an expedient already anticipated in Aristotle's treatise on memory and reminiscence. In geometrical demonstrations, says Aristotle, "though we do not for the purpose of the proof make any use of the fact that the quantity in the triangle (for example, which we have drawn) is determinate, we nevertheless draw it determinate in quantity." Similarly, if the intellect deals with something that is not quantitative "one envisages it as quantitative, though one thinks it in abstraction from quantity."

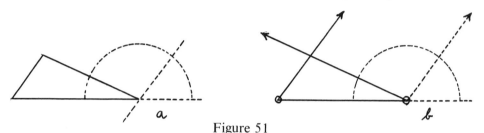

Figure 51

We may replace this container concept of the triangle by a structural type and yet be dissatisfied with its static character. Something better is needed for the sake of true understanding. If I demonstrate Euclid's thirty-second proposition by drawing a parallel to one of the edges of a triangle (Figure 51a) and by showing that the equivalent of the three angles adds up to half a circle, I can point out, with Berkeley, that the size of the angles need not be referred to, and I thereby prove that the proposition holds for any triangle. To prove the correctness of a proposition is valuable practically; but what counts for thinking is that the range of the proposition be made evident. The figure I used shows, in fact, that the three angles add up to 180° in this case. But in order to truly understand that this is so in all triangles and for what reason, I must go beyond the particular figure to a full range of triangles. If I think of two of the edges as hands of indefinite length, hinged in such a way that they can sweep independently across the entire half circle (Figure 51b) I see that, whatever their positions, they will form three sectors adding up to the same semicircular whole. When one angle grows, its neighbor declines automatically by the same amount. In this way, the size of the angles is not ignored—as Berkeley bids us to do, at the price of losing our visual grip on the situation—but perceived in the sweep of its total range. A static concept has been replaced with a dynamic one. Generality intended is now represented by generality perceived.

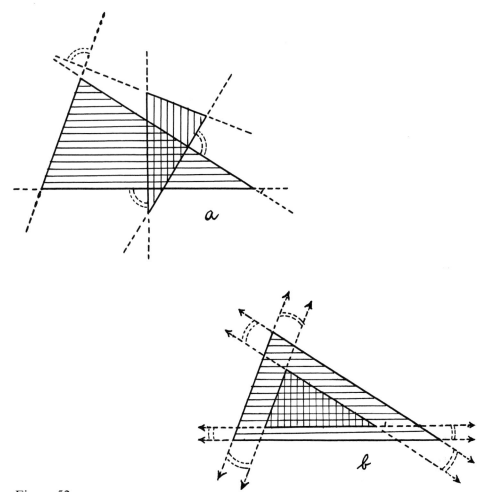

Figure 52

Another example is given by Jean Victor Poncelet in his treatise on the projective properties of figures. Someone proves that two triangles are geometrically similar when each of the three pairs of corresponding sides meet at a right angle (Figure 52*a*). This proof can be generalized to indicate that the angles at the crossings need not be 90°; they can be of any size. As long as they are equal the proposition will hold. We can envisage this, says Poncelet, by making one of the triangles rotate. The angle at all three crossings will change at the same rate. In fact, we realize now that if we turn the proposition around and start with two similar triangles in parallel orientation (Figure 52*b*) we shall easily visualize the three pairs of edges continuing to cross each other at equal angles as the triangles change their orientation towards each other.

The usual illustrations in textbooks and on the blackboard help to make a problem visible, but they also freeze it at one phase of the range to which the proposition refers. Therefore, they tempt the student to mistake accidental circumstances for essential ones. The solution is not to leave out illustrations but either to produce mobile models, for instance, by means of film animation, or, at least, to use immobile illustrations in such a way that the student realizes which of their dimensions are variables.

For the purposes of definition or classification it may be sufficient to reduce a concept to the minimum of traits needed to determine to what genus it belongs and by what property it can be distinguished from its fellow members in the group. But when it comes to using concepts for productive thinking, the fullest range of their content should be presented. In education, this latter approach deserves precedence since students need training in productive thinking more urgently than the ability to perform logical operations.

Concepts as highspots

A concept, statically defined, represents what a number of separate entities have in common. Quite often, however, a concept is instead a kind of highspot within a sweep of continuous transformations. In the Japanese kabuki theatre, an actor's play suddenly petrifies into an immobile, monumental pose, the *mi-e,* which marks the climax of an important scene and epitomizes its character. Less obviously, dance and musical sequences quite in general are often organized around such simply shaped highspots, which summarize the state of the action at certain moments and serve as markers to orient the beholder or listener on his way through the performed work.

In painting or sculpture, the artist often endeavors to abstract a movement or action in a timeless image. Such a static image crystallizes the nature of a more complex event in one arresting pattern; but it also suppresses the action and reduces the variety of phases and appearances to a single representative of them all. I showed earlier how in perception the perspective projections of an object appear as deformations of the "object as such." To see this epitome not as isolated from its particular manifestations but in their company as their center, produces a dynamic concept.

One can express this view of abstraction in the language of gestalt psychology by saying that many phenomena of experience are variations organized around *Prägnanzstufen,* phases of clear-cut structure. Wertheimer has pointed out that an angle of 93° is not seen as an entity in its own right but as a "bad" right angle. When the open strings of a violin are out of tune, they produce an impure or incorrect fifth, which is perceived as "sharp" or "flat" but not as "a different interval." The clear-cut phases of the sequence serve spontaneously as bases of reference, from which the in-between values deviate or toward which they lead, like the "leading tones" in the diatonic scale. Edwin Rausch, in a systematic discussion of the phenomenon, analyzes the qualitative changes occurring when an

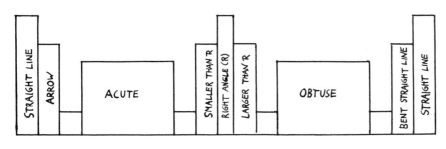

Figure 53

angle grows from 0° to 180° (Figure 53). First, the straight line splits up into an "arrowhead," whose narrowness is separated from more typical obliqueness by one of the four "low" indifferent, characterless, or ambiguous zones. Another such zone lies between typical obliqueness and the halo around the right angle. A similar organization is found in the second quadrant, which is dominated by the area of the clearly obtuse angle. Close to 180° we no longer see "a real angle" but rather a bent straight line. Needless to say, the abrupt division between the zones in Rausch's drawing correspond to gradual transitions, and the values within each area are not constant but vary along gradients.

At times, the variations deviate so much from the *Prägnanzstufen* that they are no longer readily acknowledged as dependents of that particular concept. Perceptually, a rectangle is not simply the set of all four-cornered figures with right angles but refers to the typical structure of that shape. Therefore, a person who knows very well what a rectangle is, may be surprised to discover that an object

one yard long and half an inch wide has the right to be called a rectangle. Visually it belongs among the sticks. For certain purposes, perceptual, artistic, or scientific, it is necessary to be able to stretch concepts beyond what the primary evidence suggests. In an earlier chapter I referred to the norm image of the human figure and to difficulties of identification occurring in visual perception and art.

Dynamic concepts do not require an actual physical continuity of the phenomena for which they stand. The human mind is capable of organizing such a continuum from separate, widespread entities if they resemble each other sufficiently. The Museum of Natural History in Washington has a display of stuffed dogs, wolves, foxes, etc., which unites the various adumbrations of the concept *canine* in a coherent image. Another illustration may be taken from Schopenhauer:

> For example, to grasp completely the Ideas expressing themselves in water, it is not sufficient to see it in the quiet pond or in the evenly-flowing stream, but those Ideas completely unfold themselves only when the water appears under all circumstances and obstacles. The effect of these on it causes it to manifest completely all its properties. We therefore find it beautiful when it rushes down, roars, and foams, or leaps into the air, or falls in a cataract of spray, or finally, when artificially forced, it springs up as a fountain. Thus exhibiting itself differently in different circumstances, it always asserts its character faithfully; it is just as natural for it to spurt upwards as to lie in glassy stillness; it is as ready for the one as for the other, as soon as the circumstances appear.

Similarly, in the arts a group of figures or objects often represents various aspects of one and the same theme. Auguste Rodin's *Burghers of Calais* are six variations of the response to the arduous duty of surrender.

In some instances, the variations of a conceptual theme are organized around a single highspot, dominant enough to unite secondary concepts under the common abstraction. In other cases, however, there are several such highspots of similar strength. They can be so different from each other that to see them as belonging to one family of phenomena requires mature understanding. To the young mind, they look as different from each other as did the morning star from the evening star to the ancients. In geometry, the history of the conic sections offers a telling example. The various shapes which we can now treat as members of one geometrical family displayed no such connection originally. Because of their compelling simplicity and self-contained structure, the circle, ellipse,

parabola, etc. were considered as independent entities, subject to totally different principles of construction. William M. Ivins, in a spirited, if opinionated book, has taken the ancient Greeks severely to task for doing so. Assuming that the Greeks were tactile rather than visually minded, he treats their approach to geometry as a deficiency, instead of realizing that the exploration of basic shapes is a positive and necessary first step, without which further progress is impossible. The early perception of clear-cut, simple shapes is just as thoroughly visual as the later view, which makes them dissolve into each other as phases of a unitary sequence.

If, on the other hand, we slice up a cone, keeping the sections parallel or changing their orientation as we go, the highspots of circle, ellipse, etc., may be hardly noticed when we pass through them. The smooth transitions gloss over qualitative changes. Assume that the sectioning plane approaches the cone parallel to the cone's axis: the section presents itself as a hyperbolic curve, which grows and becomes more pointed gradually until it transforms itself into two straight lines meeting at an angle. The hyperbola and the angle, although parts of a continuous sequence, differ qualitatively. Similarly, if the sectioning plane is lowered upon the cone perpendicularly, the sections will start with a point, which expands into a circle, growing without changing shape. The situation is different if the plane changes angle and performs a tilt. Now the circular section begins to stretch, it becomes an ellipse, getting longer and longer, until it opens at one of its sides when the plane has come to lie parallel to one of the cone's contours, and emerges as a parabola. Again, circle, ellipse, parabola, although phases of a continuous sequence, are separate, qualitatively different figures.

Since these geometrical figures were treated first as separate, static concepts, they had to be restructured in order to emerge as aspects of one unitary dynamic concept. This perceptual restructuring, performed against the grain of the primary evidence, revealed the ellipse as a distorted circle, the straight line as a limiting case of the parabola. The discovery served, in the words of Poncelet "to broaden the ideas, to link by a continuous chain truths that seem remote from each other, and to make it possible to embrace in a single theorem a throng of particular truths."

The story of the conic sections shows how closely concept formation is related to the perception of structural simplicity. Poncelet, a mathematician of the nineteenth century, saw the difference be-

tween shapes that were structurally clear-cut and others that were not. In his treatise on the projective properties of figures, he calls the distinctive shapes "particular states" as against "general or indetermined states," and he says that the only difficulty is evidently that of clearly understanding what one means by these terms. "In each case, the distinction is easy: for example, a straight line meeting another in a plane is in a general state, as compared with the case in which it comes to be perpendicular or parallel to that other line." In our own language and for our own purpose we can conclude that static concepts come about when the mind culls structurally simple patterns from the continuity of transformations, and that dynamic concepts, in order to encompass the range of a continuum, often have to overcome the conservative power of simple shapes.

On generalization

The discovery of the theory of conic sections is a beautiful example of generalization in productive thinking. So far, generalization has fared poorly in what I have said about concept formation. I showed that primary abstraction cannot be said to presuppose an act of generalization. Instead, percepts are generalities from the outset, and it is by the gradual differentiation of those early perceptual concepts that thinking proceeds toward refinement. However, the mind is just as much in need of the reverse operation. In active thinking, notably in that of the artist or the scientist, wisdom progresses constantly by moving from the more particular to the more general.

Such a generalization took place in the thinking of Kepler, Desargues, and Poncelet, as they developed the theory of the conic sections. They came to realize that a group of separate geometrical shapes could be fitted under a common heading. But how did they go about it? Did they practice induction? Did they look for common traits in the circle, the ellipse, the hyperbola; and did the new, more general concept consist of these common traits?

Something fundamentally different took place. Those basic geometrical figures had been satisfactory, self-contained entities since antiquity. Now a new perceptual entity, the sectioned cone, offered itself as a new whole, into which the formerly isolated figures could be fitted as parts. A new understanding of their structural nature was brought about by their relations to what turned out to be their neigh-

bors in a continous sequence of shapes and by their locations in the total perceptual system of the cone. Generalization, then, was an act of restructuring through the discovery of a more comprehensive whole.

Often these structural developments are less spectacular, more gradual. In human thinking, every concept is tentative, subject to modification by growth. This may be illustrated by the manner in which someone's view of another individual, or a psychologist's theory of a type of personality, changes through new evidence. Peter has acquired an idea of what kind of a person Paul is. This idea is not automatically confirmed or altered by the mere number of times Peter has occasion to observe Paul. Certain particular situations, however, will provide a test, which either confirms the concept in its present shape or calls for a modification. The picture may become richer, or some of its features may be revealed as artifacts. The new evidence may affect the overall structure of the concept by displacing accents, revealing accidentals as essentials, changing power ratios. In some cases, an initially unitary concept splits up into two or three.

Generalization is not a matter of collecting an infinite or large or complete or random number of instances. Instead, the thinker— the scientist, the artist, the man in the street—approaches the task with a preliminary notion of what the concept might be like. One looks for examples, but the choice is not arbitrary. One is guided by a sense of where characteristic aspects of the phenomenon might reveal themselves. One discards weak, unclear instances and neglects unnecessary repetitions. One matches each example with the tentative concept, thereby completing, rectifying, trimming it. It is this gradual shaping of an abstraction, of which the theory of "generalization by induction" is such a barren parody. True generalization is the way by which the scientist perfects his concepts and the artist his images. It is an eminently unmechanical procedure, requiring not so much the zeal of the census-taker, the bookkeeper, or the sorting machine as the alertness and intelligence of a functioning mind.

11. *With Feet on the Ground*

Two antagonistic ways of describing abstraction have emerged from the discussion. Traditionally, abstraction is a withdrawal from direct experience. This view assumes a dichotomy between perceiving and thinking. One perceives only particulars, but one thinks in generalities, and therefore, in order to think one must sweep the mind clean of perceptual material. Abstraction is supposed to perform this function.

Abstraction as withdrawal

The purely cognitive difficulties opposing this approach have been discussed. I have pointed out that perception and thinking cannot get along without each other. Abstraction is the indispensable link and indeed the most essential common trait of perceiving and thinking. To rephrase Kant's pronouncement: vision without abstraction is blind; abstraction without vision is empty. This is a grave warning. But the danger is not limited to cognitive functioning in itself. The notion that abstraction entails a withdrawal from direct experience also threatens to misrepresent the attitude of productive thinking towards reality. It suggests that in order to show that a person is capable of truly abstract thinking he must ignore, defy, contradict the life situation in which he finds himself.

 To describe abstraction as withdrawal means to give a false account not only of the practices of philosophers and scientists but also of that of artists. In aesthetics, the doctrine can be illustrated by

Wilhelm Worringer's attempt to describe highly formalized ("abstract") styles of art as the expression of a flight from external reality. I have shown in a separate study how Worringer's book, *Abstraction and Empathy: A Contribution to the Psychology of Style,* written in 1906, tried to formulate the rationale of modern art by distinguishing in principle between naturalistic and geometrically stylized art. Worringer's valuable contribution consisted in the refusal to think of early styles of art, of Egyptian, archaic Greek, African, or of Oriental and indeed modern European art as imperfect attempts to portray nature. Instead he ascribed to them a positive aesthetic goal of their own. This most helpful accreditation, however, was based on the distinction of two attitudes, one a trustful approach to nature resulting in naturalistic art, the other an escape from the frightening irrationality of nature resulting in the simplified shapes of stylized art. That is, Worringer linked the abstract quality of artistic form to an attitude of withdrawal. Abstraction became a refuge from the complexity offered by the senses and cherished by naturalistic art. This approach made for a harmful theoretical split between art that did and art that did not involve abstraction. Although Worringer established abstraction as a legitimate device of art, he failed to see that it is indispensable to any form of art, whatever its relation to nature.

To be sure, there is an important connection between withdrawal and abstraction. When the mind removes itself from the complexities of life, it tends to replace them with simplified, highly formalized patterns. This shows up in the "unrealistic" speculations of secluded thinkers or the ornamentalism of artists out of touch with the direct challenges of reality. Extreme examples can be found in the speech and drawings of schizophrenics. But although withdrawal often leads to abstraction, the opposite is by no means true. If one asserts that abstraction requires withdrawal, one risks subjecting the mind to conditions under which thinking cannot function; one will also fail to acknowledge genuine thinking when it is concerned with problems posed by direct experience.

A gold-mine of examples is contained in Kurt Goldstein's and Martin Scheerer's monograph on abstract and concrete behavior in psychiatric patients. Published in 1941, it has deeply influenced the psychology of cognition. Goldstein and Scheerer maintained that certain mental patients, most of whom had cerebral lesions, were distinguished from normal persons by their inability to ab-

stract. They considered the power of abstraction as different in principle from what they called concrete behavior. Abstraction was not "a gradual ascent from more simple to more complex mental sets"; it was "a new emergent quality, generically different from the concrete."

Goldstein's and Scheerer's interpretations have run into criticism. They deserve to be examined here at some length because they show what can happen when abstraction is thought of as withdrawal. Also, abstractness and concreteness are used in the monograph not simply as diagnostic symptoms, but the former is described as more valuable than the latter. The particular deficiencies of the patients are used by implication to discredit a much more general mental attitude, "confined to the immediate apprehension of the given thing or situation in its particular uniqueness." Therefore, the study can serve as a telling illustration of the prejudice against perceptual cognition.

I have pointed out earlier that the very opposition of "concrete" and "abstract" implies a misleading dichotomy. Norman Cameron puts the matter most sharply:

There is good reason for doubting the usefulness, to say nothing of the validity, of these determined efforts to maintain separate categories of "abstract" and "concrete" behavior. The notion is based upon an equally hypothetical differentiation between "perceptual" and "conceptual" thinking; and upon inspection this will be found to reduce to little more than the ancient narcissistic flattery that granted rationality to adult human thought but denied it to children and animals — some stoutly denied it to women also. The current form of the dichotomy is grounded in certain nineteenth-century evolutionary doctrines of ontogeny and phylogeny which, paradoxically enough, were originally designed to establish not such breaks or chasms between species but an essential *continuity* between the structure-functions of human beings and other animals.

Goldstein's and Scheerer's descriptions contain clear indications that their patients were in fact capable of perceptual abstraction. For example, if by abstraction one means simply the drawing forth of common elements or qualities, one finds that "all the subjects were able to group together a variety of given objects of similar color or similar use." If abstraction means to isolate the components of a pattern, we are told that a patient can discern geometrical figures in a design in which they overlap. Or if abstraction means grasping the structural features of a complex type of thing and recognizing them in a simplified representation, we learn that the patient under-

stands the picture of a house made of ten or twelve sticks and can reproduce it. This certainly involves abstraction; for, as Anatol Pikas has pointed out, to see a triangle as a roof means to disregard all the particular features contained in the patient's memory of real roofs.

Goldstein and Scheerer fail to see abstraction in these perceptual accomplishments because what the patients are doing here is to grasp features inherent in the situation to which they are exposed, and this, in the terms of the authors, constitutes mere "concrete behavior." Concrete behavior, found to be prevalent even in the normal person but considered the only one of which the patients are capable, is called "passive" because it responds to "the immediate claims of a particular outer world situation," thrust upon the person as "palpable configurations or palpable contexts in the experiential phenomenal realm." What, then, is missing? What is missing, we are told, are the abilities to name in words the principle inherent in a given practical behavior, to detach oneself from the demands of the present situation, and to perform operations that go against the grain of that situation.

The extraction of principle

There is ample evidence that the patients find it hard to cope with demands of this sort. For example, one of them may be able to throw balls into three boxes located at different distances from him. He never misses; but "asked which box is farther and which is nearer, he is unable to give any account or to make a statement concerning his procedure in aiming." An average normal person would have little trouble with these questions but might get stymied by similar demands at his own, higher level. It is hard and often impossible for human beings quite in general to account "in the abstract" for a principle they apply in practice without difficulty. Teachers and parents know the problem well because they are often called upon to spell out the rationale of a particular technique or conduct. They know things should be done in a certain way but cannot quite tell why. Scientific scrutiny also faces this task constantly. In daily life, we expertly balance our bodies standing up, walking, riding a bicycle, but we are at a loss to say how we do it. We see that the structure of a sentence is illogical or that a pictorial or musical composition is out of balance; but we may struggle in vain to formu-

late for the student the principle he is violating. The American pilot flies his airplane "by the seat of his pants," the German photographer develops his negatives *"nach Schnauze,"* the Italian chef cooks *"a lume di naso."* Such expertness is learned, perfected by practice, and often transferred from one kind of task to others. However, in order to extract the principle explicitly, a person must be able to identify the relevant factors by isolating them from the context of the total phenomenon or performance; he must further discover what these factors contribute and why their contributions produce the effect.

Of course, the extraction of principle demands a higher level of intellectual ability than its mere application. However, the importance attributed to this ability depends on one's values and goals. If one evaluates persons mainly by their capacity for theoretical formulation, one may consider the brain-injured more harmfully impaired than if one cares mostly about the success and intelligence of their performance. This is not a matter of pragmatism but of the kind of mental functioning considered most productive. In particular, we must ask whether the average person, such as the average psychiatric patient, should be judged by his ability to isolate generic principle from the context of its application or rather by the intelligence he displays in using it implicitly when he solves actual tasks.

A person made aware of the principle underlying his action may find himself hampered in his performance. This happens in the learning of almost any skill and can become an invincible disturbance. In the arts, for example, to learn a generic formula for which one is not ready intuitively can be harmful. It is a problem which knowledge raises quite in general. Psychological theories may suspend a person's sensitivity for what is going on in others or indeed in himself. Or, as Paul Valéry has said in his *Introduction to Poetics:* "Achilles cannot defeat the tortoise if he thinks of space and time."

However, it is also true that superior performance may be attained if the principles inherent in it have been identified and then absorbed again in intuitive application. Professional skills, expecially in physical activities, require this sort of preparation. Furthermore, man exploits his mental endowment more fully if he not only acts intelligently but also understands intellectually why he acts as he does and why his procedures work.

The scientist is the prime expert at distilling principle from particular instances. However, for the purpose of our investigation it

is relevant to see that he is able to perform such feats not primarily because he can detach theoretical concepts from the events to which they refer but because he can trace them within these events. To understand an event or state of affairs scientifically means to find in it a pattern of forces that accounts for the relevant features of the system under investigation. Just as the compositional pattern of a work of painting or architecture makes sense only in application to that work and not in isolation from it, so nearly all productive thinking about theoretical statements is done with constant reference to the phenomena they describe. Reference to one familiar example may suffice to illustrate this point. Newton's discovery of gravity as a general phenomenon of nature is impressive as an intellectual feat because he was capable of relating the movements of the planets to that apple tree at Woolsthorpe; but the similarity he spotted was of enduring value only because the power of attraction plays the same part in the context of the solar system as in that of the falling piece of fruit. When this condition is fulfilled, the abstraction does not abandon the context from which it was drawn. On the contrary, it preserves the flesh and blood of perceivable validity by being referable at any moment to the kinds of actual event from which it derived and to which it applies. We are likely to conclude that the most productive feats of abstraction are performed not by those who most brilliantly overcome, and indeed ignore, contexts but by those whose boldness in extracting the similar from the dissimilar is matched by their respect for the contexts in which the similarities are found.

The psychiatric patient who is unable to answer questions dealing with theoretical concepts such as "distance" does not fail because he is incapable of withdrawal and detachment—which he may well be—but primarily because he cannot find the generic notion of distance *in* that situation. He can abstract to the extent of handling the relation between the distance of the boxes and the ball-throwing effort within the context of his performance, but he cannot make this abstraction explicit by isolating it in the context. The normal and intellectually trained person "sees" that greater distance demands greater effort; the patient, who in addition to his brain deficiency, may be handicapped by a lack of intellectual schooling, can obey the same principle but cannot pick it out. Therefore, when confronted with verbal concepts such as "near" or "far" he cannot relate them to his experience. But there can be no denying that the

patient knows what he is doing. Hence, harmful misinterpretations must result if one believes, with Wittgenstein, that " 'knowing' it means only: being able to describe it."

Against the grain

A patient is also said to be unable to abstract when he cannot repeat sentences such as: "The snow is black," or say "The sun is shining," on a rainy day. He cannot be made to demonstrate how to drink out of an empty glass although he can drink from a full glass. He can write his name on paper, but not in the air. Does this sort of failure really indicate that the patient cannot abstract? Black snow is not an abstraction of white snow, and the drinking task is rejected precisely because the empty glass is recognized as a state of affairs in which the essential element is missing. What indeed is meant by saying that the patient "cannot" perform? Clearly, he is either unwilling to comply or he does not know under special circumstances how to do something he can normally do quite well. What causes the obstacle? Is the incapacity a cognitive one? An incapacity to think? Or does the patient fail because he cannot or will not do something the situation does not require or contradicts? Is it not because he will not go against the grain of what he is facing?

In spite of what I said about the attitude of the thinker toward the objects of his inquiry, it may seem that not to be able to free oneself from a given situation is a fatal handicap. After all, in order to solve a problem one must be able to alter the structure which the situation spontaneously presents to the mind. To perceive is to grasp the salient features of a given state of affairs; but to solve a problem is to find, in that state of affairs, ways of altering relations, accents, groupings, selections, etc., in such a way that the new pattern yields the desired solution. It is quite likely that this freedom of mind is impaired in certain mental patients. However, one can hardly judge the extent and nature of this damage unless one takes into account that even the normal person makes use of this independence only when the restructuring is demanded by the requirements of the task. Far from being arbitrary or nonsensical, the new, more appropriate structure is discovered in the situation itself. A problem solver does not reorganize what he sees without reason. He is driven by the need to obtain from the given situation something it seems unprepared to give. In the words of Karl Duncker: "If a situation is introduced in a certain perceptual structuration, and if this structure is

still 'real' or 'alive,' thinking achieves a contrary structuration only against the resistance of the former structure." In the problem solver, the image of the goal situation exerts pressure on the image of what is presently given and tries to force a transformation in the direction of what is required by the task. The demands of the goal image justify the reorganization of the present structure.

The primary obligation, then, is to what is presently given. In one of Hank Ketcham's newspaper cartoons the ingenious but formidable boy, Dennis the Menace, pulls out the drawers of a chest stepwise in order to construct a staircase, which will allow him to climb to the cookie jar on top of the chest. The usual image of the drawers resists being seen as a set of steps, but the goal image of "getting up there" draws the ingenious discovery of the steps from the potentialities of the given resource.

Restructuring can be playful, a kind of game, such as when Picasso smilingly changes, for the amusement of a film audience, the drawing of a fish into one of a chicken. It occurs in jokes and puns. But in order to play one must feel safe, and the things one plays with must offer no serious objection. Finally, restructuring may occur when a person's contact with reality has been so severely weakened that only an external shell is left of its structure and meaning—a surface pattern that can be transformed at will. This sort of irresponsible freedom is often found in the drawings of schizophrenics.

The brain-injured patients seem to have the opposite problem. They cannot detach themselves from the demands of the present. But are there not very "normal" reasons for some of this "abnormal" behavior? The patient is asked by the psychiatrist to do something absurd: to call the snow black, to drink water that is not there, to write on air. The doctor's office in the hospital is a place that neither admits nor calls for playfulness; nor is the patient likely to be in the mood for games. Owing to his terrifying impairment, he is in a state of what Goldstein and Scheerer themselves call "a justified catastrophic reaction." If, as a medical test of what is wrong with him, he is asked to do absurd things he may well assume that to do them would prove that he is indeed crazy. Is this a suitable situation for the testing of his cognitive flexibility? It would be interesting to know what would happen, for instance, if the patient were told: "Suppose you were in a foreign country where people do not speak your language. How would you make

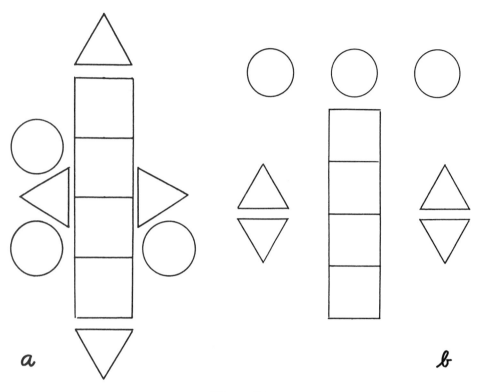

Figure 54

them understand that you are thirsty? How would you ask for a pair of scissors?" Or a theatre performance without props could be improvised among the patients. Seated around a table, they might be asked to pretend to drink and eat, without glasses or silverware.

I am discussing these clinical interpretations because they offer a tragicomic example of what is all too frequently considered the characteristic aspects of good intellectual functioning. The notion that thinking requires detachment from direct experience has become so dominant that the ability to ignore the given circumstances is made a prime indicator and virtue of intact reasoning. Ironically, it is the patient who is put in the position of defending sensible behavior against tasks of unjustified absurdity. And only because detachment has been designated the prime requirement of thinking, can the term "abstract" be applied to behavior that has nothing to do with abstraction as a cognitive operation.

This approach also explains why the experimenters do not recognize impressive feats of restructuring performed spontaneously by their patients. Here is one. The patient is given forty-eight figures: sixteen triangles, sixteen squares, sixteen disks. In

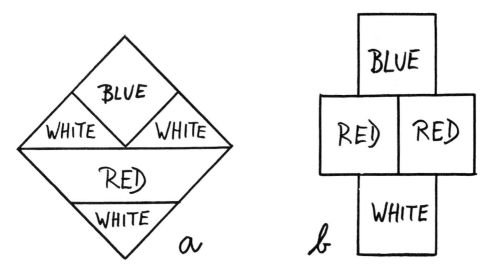

Figure 55

each group four figures are colored red, four green, four yellow, four blue. He is told: "Sort those figures which belong together!" or "Put those together which you think can be grouped together!" In one instance, the patient picked out all red figures and arranged them as Figure 54a shows. Accidentally the fourth red disk was missing; it had fallen under the table. Observing this, the patient changed her design spontaneously to Figure 54b. This is a typical case of intelligent restructuring. The patient grasps the principle of the figures presented to her in a random heap: There are four groups distinguished by color! In the red group, there are four of each shape. On the basis of this abstraction she is able to notice: There ought to be one more! In this predicament she invents a totally new arrangement, involving new patterns and new relations, in order to satisfy her wish for symmetry. This indeed is productive freedom from the given structure.

The patient broke a given whole into parts in order to reorganize it—precisely what, according to Goldstein and Scheerer, the brain-injured are unable to do. But the patients do have trouble in copying model figures such as Figure 55a. They may use the right colors but change the shapes and the arrangement (Figure 55b). Quite often, the faulty solution, as it does in this case, amounts to rendering a relatively complex model by a structurally simpler organized pattern—an adaptation to the level of visual comprehension accessible to the person. This sort of simplification, so well known from the drawings of children, does not necessarily prove that the person

was unable to grasp the pattern of the model. It rather represents a perceptual abstraction, indicating an elementary level of conception, but no cognitive defect.

One of the reasons for "incorrect" reproduction is that unless a person has received specific instruction in mechanically correct copying he tends to look for the overall structure of the model rather than imitating it painstakingly, piece by piece. Gustave Jahoda describes this approach in his experiments with Nigerian teen-age boys, who were given some of the Goldstein-Scheerer tests. Instead of matching one block after the other systematically, the boys would look at the model figure for a while, then concentrate on reproducing it, without more than cursory further glances at the model.

An artist will work in the same way unless he aims for a faithful copy in the naturalistic manner. To look for the overall structure of a given situation rather than examine or reproduce it mechanically piece by piece is most desirable and indeed indispensable for the intelligent solution of many tasks. Art teachers discourage students from piecemeal copying or from neglecting the overall structure of a composition. A grasp of overall structure is equally essential for the intelligent assessment of social situations or the solution of scientific problems. To be sure, mechanical copying may be a desirable skill, but if someone is incapable of it or unwilling to do it, we must not lightly charge him with failure. What prevents him may be not so much a deficiency as a most positive human trait, spontaneous abstraction. Natural, uncoerced perception does not involve systematic scanning of detail; vision is not a cathode ray steered by a machine.

People disagree on what constitutes a satisfactory copy. In the Goldstein-Scheerer test, many subjects "failed" because they ignored the spatial orientation or the size of the model. Here again, the liberty taken with the model is more often an asset than a liability. To be able to identify types of objects in spite of different orientation and modified shape is an accomplishment tested in experiments on perceptual equivalence with young children and animals. The neglect of size difference is essential also to the perception of objects at varying distance and indispensable for the understanding of pictures. Some special tasks do require a meticulous observation of orientation or size; but basically the neglect of these factors makes for more intelligent and useful behavior than their pedantic

observation. Certainly, an instruction such as "I want you to copy this design with these blocks," does not specify which approach is desired.

On the other hand, when a patient, asked to put together shades of color, refuses to group a given shade with any but an exactly identical one he stands convicted of inability to abstract. Should he have acted differently? Suppose for a moment we were confronted with such a task and our life depended on the correct answer. How would we behave? The examiner shows us a certain shade of green and asks: "Which of these others can be grouped with this one?" or "belongs to this one?" or "can go with this one?" You see that they are all green, but since it is a matter of life and death, would you not play it safe and refuse to associate any two shades unless they were practically identical? Perhaps the patient's ability to group similar things was indeed impaired; but a test such as this one does not prove it.

An illuminating difficulty arises when the patient is given skeins of wool dyed in various shades of green and asked "whether these don't all belong or fit together." In a case reported by Goldstein and Scheerer, the patient resists this leading question; he points to one particular shade in the bunch and says "Green!" but insists that none of the other skeins can be grouped with this one. Here the traditional technique of concept formation clashes with the intuitive procedure of abstracting by "type", which I have discussed earlier. The experimenter uses the criterion of traditional logic: every specimen containing greenness belongs in the category "green." The patient, just as any other person who uses his eyes, does not see simply a set of colors united by a common trait, but a pure, "real" green with many approximations surrounding it. Compared with that one true green, which is Kretschmer's *Glücksfall*, i.e., the pure type luckily met in the flesh, those pale, yellowish or bluish colors are not legitimate green at all. Clearly, the patient "fails" not because he cannot abstract but because his procedure of abstraction differs from the one taken for granted by the experimenter. By no means can one conclude that he did not see the relation among all the hues presented to him.

In love with classification

Unsuitably narrow notions of what constitutes abstract behavior

also derive from a devotion to the so-called categorical attitude, that is, the ability to perform logical classifications and to account for them in theoretical terminology. This hobbyhorse of our particular intellectual culture should not be permitted to discriminate against other, equally productive ways of reasoning, which fortunately flourish in our midst. Good examples can be found in the scoring criteria for the similarities test, a subsection of the Wechsler-Bellevue adult intelligence test. Here a person, asked to tell in what ways oranges and bananas are alike, may fail to reply that both are fruit, although in the pursuit of his daily life he can be expected to know and make use of this similarity. He is not trained to cast his knowledge into generic sentences such as "fruit is different from vegetables" because he has no need for them and because they may require generic words with which he is not familiar. Here again the person is not unable to perform the desired abstractions but to handle them in isolation from the contexts to which they are relevant.

In other instances, the desired abstractions are indeed alien to the thinking of certain persons. How are we to evaluate such failures? Here is another example from the similarities test. A person, asked in what way wood and alcohol are alike, is given a zero score if he answers: "Both knock you out." No doubt, this answer testifies to a bright intellect. It comes from a person capable of finding at the spur of the moment a striking common feature in two things not obviously alike. In life, we would reward him with an appreciative smile. If nevertheless his cleverness makes him fail the test, it is because the examiner prefers logical categories of scientific classification. He is justified in doing so if he wishes to find out whether the testee's mind is geared to the kind of logical operation practiced in academic settings. But if the purpose is to reveal productive intelligence, the zero score is misleading. In order to do well, the testee was supposed to answer: "Wood and alcohol are both organic substances" or "they are both hydro-carbons." These answers dig more deeply; but it is also true that only in the mind of a considerably educated person will they be in contact with the facts that make them relevant. Classification by logical subsumption, on which so much school training of the intellect focuses, is not the main concern of the scientist but only an external outcome of his work. The classification of animals into mammals, birds, amphibia, etc. is only the precipitate of discoveries that revealed marvelous functional similarities in creatures of great variety. These discoveries are alive in the mind of

the biologist when he uses the Linnean categories, which are little more than labels for the average person. Whether or not a person uses such labels tells us little about the quality of his thinking.

When somebody draws his abstractions spontaneously from a context that has substantial meaning to him, he should be given credit for good thinking. One of Goldstein's and Scheerer's patients, asked to give the names of animals, listed them in the order in which the cages come in the zoo of her home town. To be sure, the patient clung to a "concrete" instance; but to point this out is to characterize her behavior insufficiently. One must add that she derived her abstraction intelligently from the only true knowledge about the order of animals she is likely to have possessed. Similarly, when somebody is asked which among a group of colors "belong together," his upbringing may not have prepared him for relating this question to categories of perceptual order. Instead of putting all the greens or all the reds together, one patient, after careful choosing, matches a bright green sample with a dark blue and white skein and a bright yellow sample with a dark brown and dark yellow skein. Her explanation: "This is a jumper and a skirt, this is a shirt front." Whether her criterion of what belongs together is less relevant than classification by common traits is surely debatable, unless one automatically prefers the juggling with logical relations to the kind of thinking that reaches for a solid grounding in order to function.

Much of the foregoing discussion was based on particular clinical research. It highlights, however, a theoretical prejudice all too widespread even nowadays among psychologists and educators quite in general. They know that the human mind develops its capacity for thought by handling situations presented through the senses and that "abstract" concepts of the academic variety are late products of special cultural conditions. Yet when the latter are absent, there is a tendency to assume that abstract thinking in the broader and more relevant sense of the term is absent also. Hence the notion that abstract thinking is not found in the "primitives," as we call them, or the "naturals," as John Locke called them more graciously and more correctly. It is worth quoting here a passage from Locke, in which he contends that "abstract maxims" cannot be expected from children or the wild inhabitants of the woods.

Such kind of general propositions are seldom mentioned in the huts of Indians: much less are they to be found in the thoughts of children, or any impressions of

them on the minds of naturals. They are the language and business of the schools and academies of learned nations, accustomed to that sort of conversation or learning, where disputes are frequent; these maxims being suited to artificial argumentation and useful for conviction, but not much conducing to the discovery of truth or advancement of knowledge.

Whatever his views on the thinking of the naturals, Locke knew well how restricted was the value of the thought operations in which he found them lacking. He thereby helped to anticipate a re-evaluation that has been slow in coming in our own day. Ways of cognitive behavior that are different from our own but not necessarily inferior to it are easily condemned as the results of cultural underdevelopment or deprivation. They may even be attributed to a lack of natural endowment. Actually, studies of the early stages of intellectual development reveal attitudes that we tend to neglect in ourselves to our detriment.

In touch with experience

In our own midst, persons of little schooling often think in a way that Frank Riessman, speaking of the "style" of the so-called deprived child, has summarized as follows. The child is:

1. Physical and visual rather than aural.
2. Content-centered rather than form-centered.
3. Externally oriented rather than introspective.
4. Problem-centered rather than abstract-centered.
5. Inductive rather than deductive.
6. Spatial rather than temporal.
7. Slow, careful, patient, persevering (in areas of importance), rather than quick, clever, facile, flexible.

Clearly, the kind of deprived child to whom these traits apply is not the typical maimed child of urban slums or the victim of suburban stultification, so often deficient in the very qualities here described — children neither curious nor observant, unable to concentrate and stymied in the spontaneous expression of thought and feeling. Before speaking of them, it is necessary to refer to the handicaps of persons whose cognitive and motivational equipment is reasonably intact but who are deprived in the sense of lacking the training needed to succeed in school, in intelligence tests, or in specialized urban skills.

Partly the problem is linguistic. The words and sentence structure of the language practiced by the educated middle class and therefore in the schools often refer to objects, customs, facilities, thought operations alien to the "lower" classes. Allison Davis has pointed out that in an intelligence test a person may be unable to deal with verbal analogies because he does not understand the meaning of such phrases as "is to" in the statement: "Loud is to sound as bright is to what?" He is defeated before he ever faces the task. And yet, she declares:

In nearly all general intelligence tests, the authors have depended chiefly upon two types of verbal questions to furnish the most difficult problems in their tests, and to screen the 'mediocre' and 'average' pupils from the 'superior' pupils. These two types of questions are based upon (1) verbal relationship and complex academic phrasing (such as verbal 'analogies' and 'opposites,' and 'syllogisms'); and (2) rare words (used in vocabulary tests and 'definitions').

Verbal difficulties, although often decisive in practice, concern us here only to the extent to which they reflect differences in cognitive mode. The core of the problem is reached when we hear an expert say: "What all intelligence tests measure is the ability to deal with *symbols*. The more intelligent a person is, the more complex and abstract these symbols can be." The term *symbol* can mean many things. I spoke in an earlier chapter of symbols in which percepts and concepts unite. Here, however, symbols are intended as the very opposite, namely, as thought objects detached from direct experience. Another quotation will illustrate this. "The middle class handles chiefly symbols for living, the working class handles chiefly things." Put the two together, and you are told that intelligence is a privilege of the middle class.

In common usage, the word *symbol* covers the whole range of images and signs indiscriminately. It endows the most mechanical and remote relations between the signifier and the signified with an undeserved halo borrowed from the most productive kind of signification. What is actually referred to in the statement above is that roughly half of our population, businessmen and office workers, teachers, lawyers, civil servants, and salesmen, spend their working days handling references to things, products, and services rather than producing or employing these things themselves. The indirectness of relation leads easily enough to a partial or complete detachment from the objects of these activities. The salesgirl, with the

merchandise right in her hands, may think of it only as a means of making sales; a lawyer may be absorbed by the purely formal play of fitting a given case to its legal precedents; the teacher is tempted to lose, in the transmission of textbook data, the sense of what these data are about. This harmful alienation occurs in people largely concerned with things that stand for other things. It is a pathological detachment. But it is equated with the highest form of human intelligence if abstraction is considered a withdrawal from direct experience.

Therefore, when the naturals, the children, the uneducated are said to have trouble with "symbols", it is necessary to inquire what is meant. Are they unable to think abstractly? Or are they incapable or unwilling to engage in mental operations unrelated to tangible tasks at hand? The former deficiency would be fatal to their functioning as intelligent beings; the latter must be weighed carefully against the great fundamental value of a mental attitude that refuses to operate out of context.

The pertinent literature indicates that there are two "styles of expression," namely, the motoric and the conceptual; or that the lower-class child is "thing-oriented" whereas the middle-class child is "idea-oriented." This distinction may have some merit as a description of typical behavior; but one must keep in mind that the two attitudes do not exclude each other. When a person of the motoric type makes "such heavy use of the voluntary, and particularly the large muscles of the body," he is not necessarily using his body instead of his mind. Far from being a brainless athlete, he may be the kind of person who thinks best by doing things, either robustly like a manual laborer or delicately like a watchmaker. What matters is not that he prefers physical activity to the "manipulation of ideas" but what sort of activity he uses his body for. A motoric person must also be a perceptually oriented person, since in order to act upon the world he must be aware of the situation to react to. The range and depth of his perception will determine the intelligence level of his behavior. There is obviously no ceiling on the intelligence at which such "motoric" people as surgeons, mechanics, or sculptors can do their work; on the other hand, a person strictly limited to the "manipulation of ideas" is not immune against operating with distressing dullness.

Let us remember here also the importance of manipulation for all problem solving, whether or not it involves bodily performance.

To try out how a thing works or whether a solution is feasible is a method of choice in all productive thinking. The physical version of such experimental handling shows up as motor behavior. E. Paul Torrance, writing on "The Role of Manipulation in Creative Thinking," refers to studies on inventors showing that manipulative tendencies are important for inventiveness. In his own experiments with children, Torrance noticed that there appeared to be "a meaningful relationship between the child's manipulation of the objects provided to evoke creative thinking, or inventiveness, and the quantity and quality of his responses." By behaving motorically, the child can handle ideas.

It follows that to educate persons who function best in tangible situations is not a matter of replacing motor activity with ideas. Riessman asserts that the "deprived" children he has in mind do not dislike abstract thinking; rather they go about it differently. "They need to have the abstract constantly and intimately pinned to the immediate, the sensory, the topical." After they have acquired some feeling for broad generalizations from seeing them derived and applied in practice, they may, to some degree, appreciate abstract formulations per se. In this light, one may wonder about Riessman's suggestion that teaching machines should be particularly effective with deprived children because they tend to learn physically and admire machines. Gadgetry as a bribe may make learning more palatable, but if the programed instruction is based on the kind of formalistic thought operation that is alien to these children, the incentive to tinker is unlikely to translate itself into a desire to learn in the long run; nor will the learning procedure be more congenial to the child's cast of mind.

Recent educational practices acknowledge that what children need are objects of a wide variety of clearly expressed shape, size, and color. Any object of articulate appearance conveys perceptual principles to the observant mind, and every perceptual principle observed helps build the foundation of thought. In the same way, principles of action, such as the notion of causality, must be made evident by simple, impressive devices. We tend to think that children growing up in an essentially "practical" environment have ample opportunity for such learning even though they may own no suitable toys. This can be quite true for those who live on a farm or play in their father's workshop or store. It is not true, however, for the children in urban slums. As Martin Deutsch has observed,

"visually, the urban slum and its overcrowded apartments offer the child a minimal range of stimuli. There are usually few if any pictures on the wall, and the objects in the household, be they toys, furniture, or utensils, tend to be sparse, repetitious, and lacking in form and color variations." Compare this with the perceptual environment of the privileged middle-class child, who is offered stimulation indispensable for his mental growth from the very beginning of his life. He is more likely to profit early from the ingenious and beautiful but expensive toys that apply the practical functions of building, balancing, fitting, grouping, etc. to simple and colorful form and are made of solid materials, as compared with the shoddy and cluttered imitations of vehicles, implements, or human figures stamped out in cheap metal or plastic. The poverty and confusion of the sensory environment is reflected in the poverty and inarticulateness of the mind. At school, the slum children are initially inferior not only in their handling of language and generic concepts but also in manual facility and the grasp of perceptual relations. This is the more distressing impairment because it undermines the very base of thought.

Need I add that the object-bound way of thinking is found not only in educationally and socially impaired persons but appears as a characteristic mode of cognitive functioning also under the most favorable conditions? In an essay written years ago on the teaching of psychology, I described students who are "empiricists," in that their dealings with the world are based essentially on concrete, particular experiences; whereas others strive for knowledge mainly by manipulating abstract generalities.

At the one extreme, there are students who like to deal with children, observe animals, attend court trials, or canvass the neighborhood. They are absorbed by what can be watched and touched. They handle people with intuitive wisdom. But they become uneasy when called upon to draw general conclusions, to compare one theory with another, or to evaluate the soundness of a proof. Scientific terms, which they handle gingerly or quite unconcernedly, acquire a strange poetical flavor. When asked to define the conditioned reflex, they may say: "They had a dog on the table, and they made a harmless operation at the jaw, so that they could count the drops of his saliva, and then they rang a bell . . . "

At the other extreme, there are the clever jugglers. They are in love with terminology and quick in connecting ideas which stem from disparate contexts. But their brilliant short-circuits are often purely formal and therefore unproductive. Detached from the facts to which they refer, concepts drift and combine at ran-

dom. The careful presentation of evidence makes such students impatient: "Why does he have to go through all these cases since the main idea was clear on the first page?"

These are extreme types, both mentally onesided. However, apart from the personal preferences of the individual teacher, there is surely no suggestion here that prevalence of the former attitude is less promising than that of the latter. Many an educator, on reading Riessman's seven characteristics of the deprived child, is likely to confess that such a student, although a heavy challenge to the teacher in many ways, is precisely the kind he considers most worthy of his efforts. In fact, immediately after reporting his list of traits, Riessman mentions that according to another psychologist, Irving Taylor, the pattern is very similar to that found in one type of highly creative person.

This resemblance is not accidental. In a later chapter I shall have occasion to give examples of the intelligence great artists display in the handling of visual problems. Although quick reasoning can be an asset, the intelligence of such an artist feeds typically on the slow and intense absorption of what his eyes observe in his work and in the surrounding world. That this is equally true of the productive thinker and scientist may seem less obvious. And yet it is the relentless attachment to the world of the senses from which great ideas take flight.

Our educational system, including our intelligence tests, is known to discriminate not only against the underprivileged and the handicapped but equally against the most gifted. Among those capable of becoming most productive in the arts and sciences are many who will have particular trouble with the formalistic thought operations on which so much of our schooling is based, and will struggle against them most strenuously. To what extent do our schools and universities serve to weed out and retard the most imaginative minds? Intelligence test scores and creativity correlate poorly, and the mentally more lively children tend to be a nuisance to their teachers and peers and a liability in class work. These are ominous symptoms.

12. *Thinking with Pure Shapes*

A thinker must subtly control the relations of his concepts to the matter for which they stand. In order to acquire sufficient generality, these concepts must transcend the particular aspects of the experiences from which they are taken. But in spite of their abstractness, they must continue to reflect the relevant features of their referents. The risk of neglecting this obligation is particularly great in concepts that do not directly envisage their applications but replace or superimpose upon them other images at a more abstract level. This is true especially of numbers and of scientific and philosophical theories. Although they do not detach themselves from perceptual imagery, they often operate with images of a more generic nature; I will call these images "pure shapes." They have the advantage of being simple, but possess properties of their own, not necessarily applicable to the facts to which the concepts are applied. Mathematical concepts, for example, are handled independently of practical situations. This raises the question of what kind of perceptual model is best suited to sustain them at their more abstract level. It also means that they are liable to neglect aspects of quantitative or spatial relations considered vital under certain cultural conditions. To these I shall refer first.

Numbers reflect life

Thoughtless and inappropriate behavior can result when a situation is handled only in terms of the quantities it contains. For example, in order to decide how many persons can be accommodated

in a certain place, factors other than the purely numerical relation between customers and facilities have to be considered. Two half-time teachers may not add up to a full-time teacher. The working hours from eight to two o'clock cannot be equated with those from two to eight. The fourth spatial dimension does not relate to the third as the third does to the second. And so forth.

Max Wertheimer, in a study of numbers and number patterns, has illustrated the differences between quantities in practical experience and their correlates in pure arithmetic. A family, a team, a herd are not thought of as a sum in which each element can take the place of the other or which is changed only in quantity if some units are taken away or added. Each member has its particular function in the whole. This function changes when the number of the total group changes and depends on which member is lost or added. Each numerical change alters the structure of the group. Therefore, the statement $5 - 1 = 4$ does not refer to identical situations when in one family the father dies; in another, an infant.

A pair (of eyes or shoes or mates) is not simply a quantity of two, but a symmetrical structure that is violated when the number is diminished, and submerged when it is increased. A face with three eyes is not a face with more of the same. One horse $+ 1$ horse $= 2$ horses; 1 man $+ 1$ man $= 2$ men; but 1 horse $+ 1$ man $=$ a horseback rider. In some so-called primitive languages it is not possible to use the word "mother" in the plural. There can be only one mother; two mothers do not add up. Similarly, under certain conditions it is not possible to combine disparate objects or numbers of disparate persons: your two children and his three children may not add up to five.

Particularly at early stages of cognitive development, the mind deals with quantities in their natural dependence on the contexts from which they are taken. Is it psychologically sound to introduce young children in the primary grades to the mathematical notion of sets by telling them that any odd things at all can be grouped together in a set? For example, the Educational Research Council of Greater Cleveland, in its guide for the primary school teacher, stresses the point that "the Battle of Waterloo, the sun, and the number twenty-three" make a perfectly good set. Edwina Deans, in a booklet on elementary school mathematics, says:

A "set" is a well-defined collection of objects which are not necessarily alike in any way; for example, a triangle, a square, and a circle; and a balloon, a cart

and a jump rope. In each example there are three things. The objects of one set can be matched one-to-one with the objects of the other. The triangle can be matched with the balloon, the square with the cart, and the circle with the jump rope to show that these are equivalent sets. Both have the same cardinal set.

It may be true that pure quantity is most drastically illustrated by groupings of things that have nothing in common but quantity. In the examples just cited, however, the children are not presented with pure quantities, which, as I shall show in a moment, would give them no trouble. Instead, they are faced with groups in which practical daily-life relations are not absent but absurdly offended and which even to the mind of the adult have the surrealist flavor of Lautréamont's famous saying: "Beautiful like the accidental meeting of an umbrella and a sewing machine on a dissection table." Here again we run into the tendency to define abstraction as the ability to violate the natural order of things. Are the consequences harmless educationally? The child is told, on the authority of his teacher, that the natural bonds and meanings of life are not to be respected. Systematic training in alienation during the very first school years may prepare some of the children for the spirit of higher mathematics, to be met, perhaps, in the distant future; it will not necessarily help them to reconcile school with life outside.

The absurdity of relation by mere quantity can be stimulating poetically. Here is a passage from Jacques Prévert's poem, *Inventaire*:

> two Latin sisters three dimensions twelve apostles
> thousand-and-one nights thirty-two positions six
> parts of the world five cardinal points ten years
> of good and loyal service seven capital sins two
> fingers of the hand ten drops before each meal
> thirty days of prison of which fifteen in solitary
> confinement five minutes intermission

In practical situations, the number of persons and objects appropriate for certain purposes is actually a matter of constant attention. A time-honored social rule prescribes that the persons invited to a dinner party should be fewer than the Muses but more than the Graces. In artistic compositions, numbers are not arbitrary. A sonata consisting of three movements or a temple front with seven columns has a center piece, which an even number of components

does not provide. Two saints, one at each side of the Madonna, make for a formal pattern reflecting a hierarchic concept, whereas an uneven number of attendants produces a more lifelike crowd scene. The 5-7-5 syllable form of the Japanese haiku poems makes the second line the center of a vertical symmetry and also produces an open, more dynamic sound structure than lines with even numbers of syllables would. In the fairy tales in which the youngest son succeeds there are always three brothers, because the repeated behavior of the two older ones is the minimum number needed to present the average way of behaving, overcome by the exceptional young hero. Four brothers would be redundant. Two would make for a closed, symmetrical group, which would present the duality of good and evil, stupid and clever, and so on. King Lear must have three daughters, no more, no less; and the Trinity needs three elements in order to represent intertwining rather than contrast.

These stray examples are intended to show that an inability or unwillingness to deal with the quantitative aspects of situations as mere numbers is not simply a deplorable shortcoming of backward people. More often than not, such quantities are inseparable from their role and function in the whole of which they are a part.

Quantities perceived

Numbers are a relatively late acquisition of the mind. They are not necessarily the best instrument for describing, understanding, or dealing with objects or other situations that involve quantity. Counting is preceded by the perceptual grasp of groups, which remains the only suitable approach for certain purposes. A painter may never count the figures or shapes he puts in a particular work; he determines how many he needs by what the composition demands visually. A child will draw a hand or a foot with as many fingers and toes as will make the pattern look right. He may know how to count, but in his drawing the exact number does not matter or would even interfere with the visual order of the shape. Wertheimer notes that the number of ropes needed to steady a ship's mast or the number of posts to set up the skeleton of a house are not necessarily known by counting but, among primitive tribesmen, more typically by the visual image of the constellation and its functions. A shepherd or team leader may know when his group is complete without knowing the number of members or without counting them. The shape of

a geometric figure or pattern of dots may be known, recognized, and reproduced without any awareness of the number of elements it contains.

In many instances and for many purposes, the exact quantity of elements is irrelevant. Jean Piaget has shown that young children, when asked to copy a figure made with counters, do justice to the shape of the figure without using the correct number of counters. I mentioned in the last chapter that the criteria for what is acceptable as an exact copy vary greatly. A remark by Martin Heidegger may be relevant here, according to which it makes no sense to assert that modern science is more exact than that of antiquity or that its way of apprehending existence is more appropriate. The Greek word, he says, from which "mathematics" derives refers to what man knows beforehand of the entities he contemplates and the things he deals with. Only when number is among the foreknown properties of things is a numerical mathematics applied to them. This particular predisposition does not exist for some approaches to knowledge, which must reject numerical exactness in the interest of their own kind of rigor.

Four pistols are a meaningful number, but four grains of rice may not be "four" at all, but rather "almost nothing," "hardly any rice left." We smile when a pedant or a simple soul who values things by quantity uses precise numbers where they are out of place, as for example, Leporello in his boastful inventory of his master, Don Giovanni's, exploits:

> In Italia sei cento quaranta
> In Almagna due cento e trent'una
> Cento in Francia, in Turchia novant'una
> Ma, ma, in Ispagna sono già mille e tre.

However, when in the gospel of Matthew, Jesus asks Simon Peter: "Thinkest thou that I cannot now pray to my Father, and he shall presently give me more than twelve legions of angels?" the reference to a particular number adds perceptual color to the statement and is understood not to be taken literally.

There are, then, two quite different ways of ascertaining a quantity, — by counting or measuring, and by the grasp of perceptual structure. Of course, counting and measuring are also perceptual operations, but they break down the structure of the pattern to single units, so that the visual part of the operation is reduced to

recognizing these units one by one; or they fit the given quantity to some standard introduced from the outside. The other method consists in estimating and relating quantities by the perceptual inspection of an organized pattern. Sometimes this method ascertains exact numbers, such as when the constellations of pips on domino pieces are recognized as ones, twos, or fives; more often it produces mere estimates of sizes. Needless to say, both procedures have their place.

Numbers as visible shapes

Relations between numbers are particularly pure and clear-cut. There is great temptation in pure number. Ever since the Pythagoreans found simple numerical ratios for the musical intervals on the flute and on the string and applied them to the spatial distances of the planetary system, thinkers and scientists have been in danger of forcing the facts of nature into numerical schemes. Francesco Sizi, a Florentine astronomer of the seventeenth century, argues as follows against Galilei's discovery of the Jupiter moons:

> There are seven windows in the head, two nostrils, two eyes, two ears, and a mouth; so in the heavens there are two favourable stars, two unpropitious, two luminaries, and Mercury alone undecided and indifferent. From which and many other similar phenomena of nature, such as the seven metals, etc., which it were tedious to enumerate, we gather that the number of planets is necessarily seven.
> Besides, the Jews and other ancient nations as well as modern Europeans have adopted the division of the week into seven days, and have named them from the seven planets: now if we increase the number of the planets this whole system falls to the ground.

In these cases the mind is unable or unwilling to face the facts of the primary situation because a model of pure quantities imposes different demands. It is a model that attracts the mind by its elegant simplicity. Although perceptual, it presents an "ideal" realm.

Numbers are perceptual entities, visual and to some extent tactual and auditory. This fact is of decisive importance for the teaching and learning of arithmetic. Educators who do not realize that numbers have a perceptual realm of their own relate arithmetic to "life situations" in order to overcome the "abstractness," supposedly so difficult for the untrained mind. Thus, in the Special Training Unit of the army, designed for the educationally under-

privileged, "a fictional character, Private Pete, is followed through his military career and the entire course is designed along a functional level. It has been found that men will retain a great deal more if they are taught that one man had four apples and another man gave him four more apples so that the first man had eight apples, rather than 4 + 4 are 8."

Whether or not this method is preferable depends on what the alternative is. If otherwise the teaching of arithmetic would consist in the handling of mere speech sounds and written numerals, committed to memory by drill and subjected to mysterious, meaningless operations, then indeed the trainees, as any other sane person, would greet with relief any reference to comprehensible life situations. But the teaching of arithmetic by "practical examples" is a double-edged device. This point has been vividly made in some of the more recent work on the subject. Marguerite Lehr, in her introduction to Catherine Stern's book on structural arithmetic, refuses to accept the assumption that "the actual number notion 'two' is a more difficult abstraction than 'red' or 'chair'." And she continues:

When man worked so hard, through so many inadequate language forms, to get rid of the hampering bond: *two legs, two stones,* when he pondered over two lions, a pair of boots, first man, second man, and finally recognized *two* in all its richness and simplicity with its connotations of order, size, and pattern, and its complete indifference to two *what?*—why should we deliberately start our children as if they were contemporaries of those first savage tribes?

The traditional approach of teaching arithmetic by dressing up numerical problems as life situations beclouds the facts on which the student is supposed to concentrate. But at least it does not confound the realm of nature with the realm of pure quantities. It limits itself to the life situation and charges the student with the task of discovering the numbers hidden in it and ignoring everything but the numbers. More serious trouble is invited when the realm of nature and the equally perceptual realm of quantities are thrown together. This results in images consisting of incompatible elements, which undo each other. For example, the Arithmetic Project of the University of Illinois has the children learn mathematics through "number line games." The number line is a horizontal decimal scale, drawn on paper and marked with numerals starting with 0 on the left and leading to 25 on the right. The child is told that there are "plus

crickets," which jump along the line from the left to the right, and "minus crickets," which jump toward the left. A "+4 cricket" makes jumps of four units each toward the right; a "—3 cricket" makes jumps of three units each toward the left. In a typical problem, "a +4 cricket begins jumping at 2 and makes five jumps; where does he end up?" This is $(4 \times 5) + 2 = 22$, translated into the new approach.

The child may not have too much difficulty with imagining a nonexistent cricket on a visible mensural scale. He may even manage to distinguish between three-jump crickets and four-jump crickets. He reaches the real hurdle when he is asked to understand the very feature for which the system was thought up, namely, the relation between plus and minus. He is expected to understand plus and minus by analogy to right and left; but this analogy is false. Visual space in the world of crickets and humans is isotropic, as far as the horizontal directions go, i.e., moving in one direction is the mirror image of moving in the other. This symmetry exists in arithmetic only if one overlooks the meaning of the terms "addition" and "subtraction." In the realm of purely formal manipulation the transposition can indeed be spatially symmetrical:

$$3 + 4 = 7 \qquad\qquad 7 - 4 = 3$$

However, this is so only as long as one neglects the essential fact the child needs to understand, namely, that *plus* is neither a name for crickets nor a road sign but means adding something, and that minus means taking something away. No such difference exists when somebody makes jumps in opposite directions; and to eliminate the difference means to reduce a meaningful handling of quantities to a mere juggling of numerals. The task has been referred to an inappropriate perceptual universe.

Figure 56

One more example, simpler and more drastic, may further illustrate this point. In the Stanford Project for the teaching of mathematics in the first and second grades of elementary school, actual pictures of objects — balls, drums, cubes — are placed between brackets in the formulae of set theory (Figure 56). Now an adult

can interpret the drawing of a ball or a drum as an ideograph and may be able therefore to fit it with letters, numerals, and other signs into a unitary discourse. For a child, however, such a drawing shows a piece of reality and therefore should be contained not in brackets but in a picture of the shelf in the playroom. It is one thing to illustrate the concept of set by groupings of actual objects; it is quite another to put the objects in the formulae.

It seems most urgent for educators to overcome the notion that quantitative relations can be put in touch with direct perceptual experience only if they are represented by practical objects of the environment. Quantitative relations refer to a perceptual universe of their own, which can be neither ignored nor contradicted with impunity. They are best represented by a system of "pure shapes," e.g., in the form of the well-known Cuisenaire sticks and the mental images the sticks leave behind.

Naturally, these sticks and images are highly abstract when compared with the practical situations to which arithmetic can apply. But children have no trouble envisaging and depicting abstract qualities. For instance, in their drawings they present the straightness of legs by straight, parallel lines, which do not exist physically in the human bodies they are portraying. Just as those lines depict the abstract nature of straightness directly, spontaneously, and naively, so a set of wooden blocks can portray the abstractness of quantities perceptually. Man, in perceiving the complex shapes of nature, creates for himself simple shapes, easy on the senses and comprehensible to the mind. One function of these shapes is that of producing physical equivalents of non-mimetic images harbored by the mind—"abstract" paintings, scientific diagrams, arithmetical concepts. These objects and images, although abstract with regard to more complex situations represented by them, are perceivable, particular entities, perfectly accessible to the mind of a child. The *Cuisenaire Reporter* may not be too far off the mark with the observation: "The power of making abstractions is at its peak in 6-to-9-year olds."

Adults whose lives have been concerned entirely with practical situations may feel helpless when faced with pure shapes, because in spite of their perceptual immediacy these things are "nothing" to them. They often have trouble with non-mimetic "modern" art. Children do not. They take with ease to pure shapes, in art or elsewhere.

Quantities are a particular variety of perceptual shapes. They are simpler than circles and squares because they consist in extension only, but at the same time are capable of an infinity of changes and combinations within that one dimension. It is to the magic and challenge of these transformations that children respond with delight.

Meaningless shapes make trouble

Why then have so many children trouble with numbers? Why is there, in college students, so often a fear of mathematics and aversion to it, which persists through life? Catherine Stern answers with a devastating chapter, called *A Barbarian Method of Teaching Arithmetic,* in which she reminds adults of how they would feel if they were confronted with a set of what psychologists call nonsense syllables and an equally meaningless set of visual signs, and if they were invited to perform additions and subtractions with them. More precisely, the words "addition" and "subtraction" and the operations for which they stand would be equally unknown, and therefore the task would consist in learning that if those mysterious signs are combined in certain ways, other signs are supposed to result. Since there is no way of knowing why this is so, one would have to memorize by mere mechanical drill which sign is supposed to follow when which signs are connected. The combinations are many, and the job of memorization is such as to make the learning of Chinese characters look less forbidding.

And yet, this is the discipline to which the conventional teaching of early arithmetic subjects the learner. It is possible to teach a captive clientele how to give lip service to numbers by memorizing combinations of their meaningless equivalents. Since numerals are visual and audible shapes, one can learn to recite sequences of them. Just as one can recite a hymn or a poem in a foreign language without understanding a word, so one can learn that three and four is seven. But the work is painful and slow; it contributes neither to the enjoyment of life nor to the training of intelligence, and it easily causes mistakes.

A child who in a computation writes 71 instead of 17 commits what Mrs. Stern rightly calls "a bad error," that is, one due to lack of intelligent participation. The fault may be the child's own or that of the system by which he is taught. The reason for the error is clear.

As visual signs, 71 and 17 look exchangeable, like an object and its mirror image. There is little difference between them, especially not for a child who has still to overcome the perceptual symmetry of right and left.

Children make such mistakes when they have been trained to operate at the wrong perceptual level. A good comparison can be

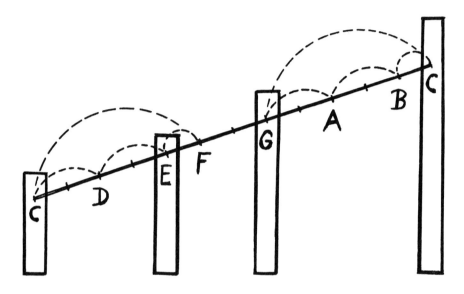

Figure 57

made here with the tones of the musical scale, which are called by various letters or speech sounds, *c, d, e, f, g, a, b*. A person without any experience of music could easily learn this sequence of letters. He might also learn that *c, e, g* is called a triad and sounds good and steady whereas a combination of *a* and *b* sounds squeezed and harsh. He may take the teacher's word for it and may even retain in memory what he has learned. But the sequence of letters from *c* to *b* is entirely without structure, except for being made up of separate entities. There is no discoverable logic to it: one item is no different from the next, and therefore the order is arbitrary. This is not true for the musical sounds to which the letters refer (Figure 57). The audible scale has a rising slope of pitch, which assigns a different height to each tone. These height differences are not equal. The scale is subdivided into two tetrachords of two full tones and one half tone each, the first reaching, in the key of *c*, from *c* to *f*, the

second — after an interval — from *g* to *c*. This subdivision is overlaid by a different structure, namely, the triad, *c, e, g*, which supports the scale as a skeleton. Within this very complex pattern of perceptual forces, each tone has a personality of its own, and the relation between any two or three tones is unique in character. Only because of this structural complexity of the diatonic scale, can Western music be derived from it.

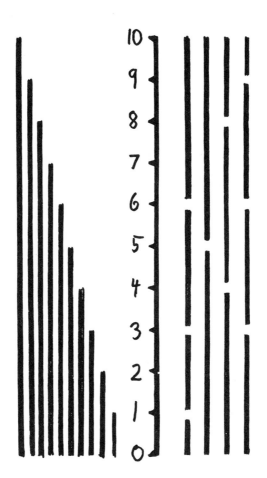

Figure 58

The situation in arithmetic is quite similar (Figure 58). Here, too, the eyes and ears are presented with a set of signs totally unrelated to the structure of the pure quantities which they name. The scale of those quantities consists of ten units, and they, too, rise stepwise. The whole can be divided into two equal parts of five each. Two kinds of quantity, even and odd ones, alternate. Some of the numbers are indivisible, others are divisible in more than one way. None

of this shows in the set of numerals, which are not portraits of quantities, let alone symbols, but merely signs. Some primitive languages do have ways of counting that reflect the relations for which they stand. For example, the Andamanese, who use a scale of five, count: One, the other, the middle one, the last but one, the last.

The method first suggested by Maria Montessori and considerably modified and developed since her time, introduces the children to the perceptual properties of the pure quantities themselves. The numbers are columns of different length. The horizontal dimension of space is used for the comparison and sequence of the columns. Addition and subtraction are complementary operations of putting together and taking away. The anatomy of each number, instead of being hidden by a name, is first elucidated to the eyes and the hands of the child. Ten is $1 + 2 + 3 + 4$ — the beautiful order of the tetractys, which enchanted the Pythagoreans; but ten is also $5 + 5$, and the two structures cross each other as the tetrachords and the triad do in the diatonic scale of music. Even numbers can break in half, odd ones have centerpieces or left-overs. Differences between right and wrong show up; mistakes visibly disturb the simple pattern of the whole system. Counting, when needed, is only a means to a perceivable end, and names are secondary labels for the quantities and operations to which they refer.

The intelligence of the average child is easily caught by the challenges, surprises, and satisfactions offered by the game of quantities. His behavior leaves no doubt that he is in direct perceptual contact with absorbing tasks. Any attempt at "vitalization" would only detract him from this experience. If the child were presented with a story about rabbits and cabbages, the thought of those captivating animals and vegetables would make it hard for him to extract the quantities. But once he has acquired arithmetical skills, he will proudly apply them to whatever practical occasion comes along. In the words of Catherine Stern: "We do not fill situations with numbers. We fill numbers with life."

Numbers filled with life are ready to be applied to any situation in which the relations among quantities need to be clarified. Often the numbers are an impeccable model of these relations. If a farmer needs to find out how many cabbages four rabbits will eat if each of them eats two, he can safely reduce the practical state of affairs to one of pure quantities and solve the problem at their perceptual

level. The structure of the more abstract image resembles that of the less abstract one sufficiently.

However, I have also mentioned examples in which pure numbers neglect vital aspects of situations to which they apply. Such difficulties can arise when arithmetic or algebra serve as models for geometry. Numerical relations may suggest incorrect analogies. In Plato's *Meno*, Socrates asks the boy: If a square with the area of four square feet has sides of two feet length each, how long would the side of a square have to be if its area were to be twice as large? The boy answers that the side would have to be twice as long because "a double square comes from a double line." Here the model of quantity, which has only one dimension, namely, that of the more and less, blocks the view of a two-dimensional situation. The boy fails, not because he is thinking "in the abstract" but because he abstracts from a different perceptual situation.

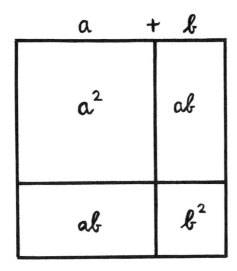

Figure 59

Algebra, just as arithmetic, has a thoroughly perceptual basis. In fact, C. Gattegno's suggestion that algebra should be studied before arithmetic is psychologically sound. Perception relies largely on relations rather than absolute values, and generalities precede particulars in sensory experience. The colored Cuisenaire sticks represent relations among quantities; their absolute length is irrelevant and readily transposable.

However, when applied as a mere formula, algebra, just as arith-

metic, can block the understanding of geometry. Who would not sympathize with the following remark of Jean-Jacques Rousseau in his *Confessions:*

I never got far enough to truly grasp the application of algebra to geometry. I did not like the way of operating without seeing what one is doing, and it seemed to me that to solve a geometrical problem by equations was like playing a tune by turning a crank. The first time I found by calculation that the square of a binomial consisted of the squares of its two parts plus twice the product of the two, I refused to believe it until I had drawn the figure. I had a great liking for algebra considered as a mere abstract quantity; but when applied to extension I wanted to see it operate on lines; otherwise I no longer understood anything.

A glance at Figure 59 shows immediately *why* the square of $(a + b)$ is equal to the square of a plus the square of b plus twice the rectangle ab. But whole generations of students were taught the formula without the figure, because the lesson called for algebra, not for geometry.

Self-evident geometry

Under debate here is not the difference between numerals and line figures. What matters is whether or not a mathematical operation refers explicitly to a perceptual pattern that tells why the facts involved are the way they are. Geometry can fall short of this requirement just as much as can arithmetic or algebra. Schopenhauer violently denounced what he called the conjurer tricks of the Euclidean type of geometrical proof, in which, he said, the truth enters almost always by the back door and results from an accidental, rather than essential circumstance. He objected to the auxiliary lines drawn for the proof of the Pythagorean theorem: one does not know why they are drawn but finds out afterwards that they are traps which snap tight unexpectedly; they capture the assent of the student, who is puzzled by having to agree to something that remains totally incomprehensible to him in its inner context.

This is an educational matter of fundamental importance. Historically, it is perhaps best illustrated by the difference between the Greek and the Indian approach to geometrical evidence. Hermann Hankel, in his history of mathematics, points out that as early as the fifth century B.C. Greek geometry refuses to rely on direct visual grasp. Instead, every proof is derived step by step from a few axioms

by a series of logically connected propositions. The geometricians of ancient India, on the other hand, rely explicitly only on one theorem, namely, that of the square of the hypotenuse. Otherwise, every proposition is presented as a self-contained fact, relying on its own intrinsic evidence. Instead of presenting a sequence of steps, the Indian mathematician shows the relevant figure, completed, if necessary, with auxiliary lines and offered with no comment other than the word "Behold!" The proof consists in the evidence visible within the given figure.

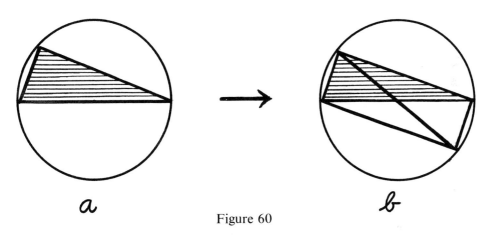

Figure 60

Quite in general, early geometry tends to rely on perceptual simplicity, e.g., on symmetry. The following example, taken from Hankel, may serve as an illustration. It seems that the Indians, in order to prove that the triangle based on the diameter of the circle is always right-angled (Figure 60a), drew a line from the vertex of the triangle through the center of the circle and arrived thereby at a rectangle (Figure 60b), located symmetrically within the circle. By its position in this rectangle, the vertex of the triangle was shown to be an angle of 90°. Behold!

In Greek geometry also, the reliance on the simplicity of symmetrical figures can be seen in the sequence in which some of its discoveries are likely to have been made. The Pythagorean theorem was shown first for the isosceles triangle, later for other right-angled triangles of less regular shape. The sum of the angles in the triangle was demonstrated to be 180° first for the equilateral, then for the isosceles, and last for the scalene triangle. The Euclidean axioms are based on intuition; and I mentioned before that the early view

of the conic sections as separate, independent entities corresponds to the perceptual tendency towards simple shape.

Perhaps it is worthwhile to point out here explicitly why mathematics can be based on sensory experiences. This has sometimes been considered impossible because mathematics deals with ideally perfect shapes. Perception, on the other hand, is unreliable, as shown by the many optical illusions, and can refer only to actual, physically given objects, which are always imperfect. However, physical objects must not be confused with the percepts derived from them. Their distortion or imperfection has no necessary bearing on the percepts. When a person reports that he sees a square, he is referring not to a physically deficient specimen but to the pure shape of the perfect square, with which geometry is concerned. He sees a figure with truly right angles and truly equal sides. Whether or not his percept is reporting faithfully on the particular physical object that gives rise to it—if indeed the person is looking at any object at all while visualizing the square—is irrelevant, just as the imperfections of a figure drawn on the blackboard by a mathematician are irrelevant to the pure shapes he is discussing. The mathematician deals with If-Then propositions: "If this is a right-angled triangle and if these are the squares on its sides, then . . ." If a person sees a line drawing as the Pythagorean figure, he can determine by visual analysis that the square of the hypotenuse equals the squares of the two other sides.

Schopenhauer mistook perceptual evidence for ontological truth because, following Kant, he considered space the *a priori* condition of all visual knowledge. But he was surely correct when he insisted that geometrical demonstration must start from the direct visual awareness of the fact to be proven. The restructuring involved in the proof must not dismember the pattern by relying on elements that are not genuine components of it. After all, it is that original pattern about which enlightenment is sought, not some independent other figure it happens to contain as a foreign body in its bowels. The Indian demonstration I cited earlier restructures the figure by transforming the diametrical hypotenuse into the diagonal of a rectangle; but in the end the original triangle is still visible in the circle.

This demand for a perceptual base can hardly be invalidated by the increasing removal of mathematics from practical experience. The pure shapes constituting the perceptual basis of the operations

may become more and more abstract, but the productive work in the field will continue to refer to that basis although the formal processing, needed to support the work, may not.

Since mathematics is so closely related to perceptual evidence it can arouse keen interest in unspoiled people. This is observed in the response of young children to structural algebra and arithmetic. It is equally true for the person of mature mind. If he is forced to perform at a level at which the task can only be solved by memorized routines, his reasoning will protest or dry up. If instead he can operate in such a way that perception invites comprehension, he will realize by his own experience why Bert Brecht makes his Galileo say: "Thinking is among the greatest pleasures of the human race."

13. *Words in Their Place*

Thoughts need shape, and shape must be derived from some medium. Just as the physicist or chemist cannot conceive of an action unless there is matter or energy capable of performing it, so the psychologist must find a realm of existence for thinking. This realm is not necessarily consciousness. Thinking could be a purely physiological occupation of the brain. In fact, if one assumes that everything in the mind must have its counterpart in the nervous system, one must expect the brain to contain the bodily equivalent of all the concepts available to thinking as well as of all the operations to which concepts can be subjected. In theory one could imagine the operations of problem solving or reasoning to be farmed out by consciousness to brain mechanisms not represented in consciousness, just as certain operations can be entrusted to an electronic computer, and the results would be delivered back to consciousness. Such a theory would have to be seriously considered if indeed no traces of thinking could be discovered in awareness. It would amount to saying that thinking is unconscious.

However, to call something unconscious is to make a purely negative statement. It tells only what and where something is not. If, for example, psychoanalysis could say no more about certain processes than that they are unconscious it would have achieved little. Actually, psychologists have speculated about such processes, either by treating them as analogies to possible conscious

happenings or by comparing them metaphorically with physical events. A physiological description might also be possible and will actually be indispensable some day.

This holds true also for the psychology of thinking. Physiological descriptions of thought processes do exist, but for the time being the devices they present are hardly more refined than, say, the switchings in a railroad yard. When more adequate explanations are found of how concepts are formed and related in the brain, there will remain the task of showing how the variety of the concepts themselves with all their individual characteristics can have their counterparts in brain mechanisms. It will not be sufficient to show by what physiological switching dog associates with cat; it will be necessary also to find the properties of the brain tissue representing the particular traits of cat and dog—tasks reserved for the neurology of the remote future.

With a physiological explanation in abeyance, psychologists interested in the nature of thought face a problem similar to that of electricity in physics. They know a good deal about what thinking does but little about what it is. Many of them have accepted this situation by asserting that thinking is what thinking does. Their experiments have been most valuable in indicating what kinds of task animals and humans can perform. But for anybody who believes that psychology must do more than predict and control, a principal question remains. What are the mental shapes of thought?

Can one think in words?

The answer I suggested in chapter 4 was that concepts are perceptual images and that thought operations are the handling of these images. I tried to make it clear that images come at any level of abstractness. However, even the most abstract among them must meet one condition. They must be structurally similar (isomorphic) to the pertinent features of the situations for which the thinking shall be valid. The question arises whether verbal language is such a set of perceptual shapes. Are the sensory properties of word sequences, visual or auditory, such as to be able to reproduce the structural features relevant to a range of thought problems? This question amounts to asking: Can one think in words, as one can think in circles or rectangles or other such shapes?

The answer commonly given is almost automatically positive.

In fact, language is widely assumed to be a much better vehicle of thought than other shapes or sounds. More radically, it is taken to be indispensable for thought and perhaps the only medium available. Thus Edward Sapir says in his influential book on language: "Thought may be a natural domain apart from the artificial one of speech, but speech would seem to be the only road we know of that leads to it."

Nobody denies that language helps thinking. What needs to be questioned is whether it performs this service substantially by means of properties inherent in the verbal medium itself or whether it functions indirectly, namely, by pointing to the referents of words and propositions, that is, to facts given in an entirely different medium. Also, we need to know whether language is indispensable to thought.

The answer to the latter question is "no." Animals, and particularly primates, give clear proof of productive thinking. Roger Brown has concluded that it is very clearly the character of the animal mind to abstract. Animals can respond to categories of things, and they display "an astonishing disregard of the unique object." By means of their perceptual concepts, animals solve problems that look elementary if judged by human standards but have the striking characteristics of genuine productive thinking. Animals can connect items of their environment by relations that lead to the solution of a given problem; they can suitably restructure a situation facing them; they can transfer a solution to different, but structurally similar instances. And they do all this without the help of words.

However, animal thinking may be inferior to that of humans in one important respect. It may be limited to coping with directly given situations. A chimpanzee uses his powers of abstract thought ingeniously for the practical purpose of escaping from an enclosure or fashioning a tool. But there is no evidence that he can think about how one could make a short stick longer if the problem does not face him then and there. Experiments do tell that a chimpanzee's reasoning is not strictly confined to what meets his eye. He can turn around and get from his den a blanket he wants to use to retrieve an object outside his cage. But it is quite possible that he cannot detach his thinking from his immediate practical needs. In the words of Wittgenstein: "We say, the dog is afraid his master will beat him; but not: he is afraid his master will beat him tomorrow. Why not?"

How man succeeded in overcoming this limitation need not concern us here. What matters is, first, that this independence of human

thought is by no means necessarily a gift of language and, second, that it is not in itself an aspect of reasoning. Detached, theoretical thinking can function without words; and the ability to think about a remote question while sitting at a desk or walking through the woods concerns the organism's use of its cognitive functions, not the nature of these functions themselves. In many ways it is surely easier to think about something when one has the facts in front of one's eyes, although the stubborn presence of these facts can also hamper the freedom of thought. It is easier to play a game of chess with one's eyes on the board than to play it blind, but it is equally true that one may have to remove one's attention from a given particular event in order to find the solution of a problem. The nature of the cognitive operations that constitute thinking does not depend on whether the target of thought is physically present or absent. The range, applications, and objectives of animal thinking may be severely restricted; but the feats that reasoning animals do perform, without the benefit of language, have the earmarks of genuine thought.

Words as images

Language, then, is not indispensable to thought, but it helps. The question is, in what way. Since language is a set of perceptual shapes—auditory, kinesthetic, visual—we can ask to what extent it lends itself to dealing with structural properties. The answer must ignore the so-called meaning of words, that is, their referents. They belong to a different realm of perceptual experience. It must limit itself to the shapes of language.

Suppose we asked what reasoning can be done with the shapes of music. I referred earlier to the intricate pattern of pitch relations in the diatonic mode of Western music. A pentatonic scale divided into five equal intervals suggests a simpler level of thought. But even so-called primitive music is made dazzlingly complex by the interaction of structural variables. There are the many ratios of duration, the variety of rhythms, the relations between melody and harmony, the ranges and sequences of intensity, the different timbres of instruments. To handle these intricate patterns calls for thinking that taxes the brain to its limits. Musical thinking takes place entirely within the formal resources of the medium itself, although the content of musical statements is derived from, and applicable to, life experience beyond the realm of the tones.

If one examines verbal language in this same way one finds its perceptual dimensions severely limited. To be sure, there is no dearth of sounds, noises, or rhythms; in fact, there are more of them in every known language than there are in most purely musical systems. But, variety does not guarantee structure. The structural aspects of speech patterns are quite limited. Words or word sequences can vary in length and rhythm; they are all composed of a limited number of elements, and they can produce assonances and other auditory and visual resemblances. However, these perceptual dimensions of language are structurally so amorphous that nothing at all complex can be built of them. Compared with even the simplest musical tune, the sound pattern of a poem is a largely irrational sequence of noises, sustained by some regular meter and by some phrasing of pitch and rhythm. This statement will sound offensively absurd if the reader fails to remember that I am talking here exclusively about language as perceptual shape; about what comes across from the sounds or written characters of a language to a listener who does not understand a word of it. The point is that the sounds of language achieve their subtle beauty, order, and meaning largely by reference to the intended meanings of the words.

The similarity of words based on common elements can be used for grouping. Rhyme ties similar words together; identical prefixes or suffixes create verbal categories. But the mere grouping of otherwise unrelatable sound patterns yields very little structurally. For example, the elementary grammatical difference between things and actions is not depicted by the sounds of language, although language sounds can, of course be either static or dynamic in character. One can tell nouns from verbs by their different sounds, but the distinction produces nothing but two bagfuls of sound patterns of no further common or different meaning whatsoever. Similarly, the linear sequence of words in sentences is a clear-cut structural feature, but language makes little use of it, if compared with the musical structure of a melody. In certain languages, one can distinguish nouns from verbs by their location in the sentence. But since nouns and verbs are nothing but two nondescript agglomerations of sounds, the purely sensory gain is negligible.

Given so largely amorphous a medium, it is not possible to think in words, unless one is satisfied with elementary statements such as: *a* sounds like *b*; or *a* comes always before *b*; or *a* takes longer

than *b*. The human mind needs better tools than that.

It is true that a certain type of cognitive operation can be carried out within the language medium itself, but although useful it is hardly productive thinking. It is possible to learn that words which stand for certain concepts are related to each other in certain ways. One learns, for example, that ten minus seven is three. The learning can be done by routine drill, and the meaning attached to the concepts can be neglected or indeed unknown. Every time the statement "ten minus seven" is fed into the system, "three" will turn up automatically. This sort of association requires no reference to anything beyond the verbal material. It leads to a system of storing and retrieval which makes information available. But the work can be done by machine and involves no productive thinking.

Language can supply information by what Kant calls analytical judgments. In such propositions, the predicate is nothing but a known property of the subject and therefore simply explicates an aspect of the subject. The statement "All physical bodies have extension" is analytical if extension is one of the properties by which physical bodies are defined. No foray into the world of experience is needed. Such analytical judgments can be produced in a purely verbal way if the word that stands for the subject has been associated by verbal learning with words standing for predicates. Suppose somebody tells me that Mrs. X, who lives in Kansas City, is looking for a psychiatrist. I know a Dr. Y, whose name is tied in my mind to the information that he lives in Kansas City. I can therefore accommodate Mrs. X without going appreciably beyond the realm of language. But the same help could be supplied by a suitably programmed sorting machine, which would retrieve the pattern of punched holes assigned to Kansas City psychiatrists. Assume now that I were asked whether Dr. Y is the kind of person likely to establish good rapport with Mrs. X. This question will probably require what Kant calls a synthetic judgment, in which the predicate adds to the subject something not contained in its verbal definition. I must go beyond words to my experience with both persons and come forward with a relation not previously established. For this problem, more nearly one of productive thinking, words as such are of little use.

Purely verbal thinking is the prototype of thoughtless thinking, the automatic recourse to connections retrieved from storage. It is useful but sterile. What makes language so valuable for thinking,

then, cannot be thinking in words. It must be the help that words lend to thinking while it operates in a more appropriate medium, such as visual imagery.

Words point to percepts

The visual medium is so enormously superior because it offers structural equivalents to all characteristics of objects, events, relations. The variety of available visual shapes is as great as that of possible speech sounds, but what matters is that they can be organized according to readily definable patterns, of which the geometrical shapes are the most tangible illustration. The principal virtue of the visual medium is that of representing shapes in two-dimensional and three-dimensional space, as compared with the one-dimensional sequence of verbal language. This polydimensional space not only yields good thought models of physical objects or events, it also represents isomorphically the dimensions needed for theoretical reasoning.

The histories of languages show that words which do not seem now to refer to direct perceptual experience did so originally. Many of them are still recognizably figurative. Profundity of mind, for example, is named in English by a word that contains the Latin *fundus*, i.e., bottom. The "depth" of a well and "depth" of thought are described by the same word even today, and S. E. Asch has shown in a study on the metaphor that this sort of "naive physics" is found in the figurative speech of the most divergent languages. The universal verbal habit reflects, of course, the psychological process by which the concepts describing "nonperceptual" facts derive from perceptual ones. The notion of the depth of thought is derived from physical depth; what is more, depth is not merely a convenient metaphor to describe the mental phenomenon but the only possible way of even conceiving of that notion. Mental depth is not thinkable without an awareness of physical depth. Hence the figurative quality of all theoretical speech, of which Whorf gives telling examples:

I "grasp" the "thread" of another's arguments, but if its "level" is "over my head" my attention may "wander" and "lose touch" with the "drift" of it, so that when he "comes" to his "point" we differ "widely," our "views" being indeed so "far apart" that the "things" he says "appear" "much" too arbitrary, or even "a lot" of nonsense!

Actually, Whorf is much too economical with his quotation marks, because the rest of his words, including the prepositions and conjunctions, derive their meanings from perceptual origins also. Of course, the non-visual senses contribute their share to making non-perceptual things thinkable. An argument may be sharp-edged or impenetrable; theories may harmonize or be in discord with each other; a political situation may be tense; and the stench of corruption may characterize an evil regime. Man can confidently rely on the senses to supply him with the perceptual equivalents of all theoretical notions because these notions derive from sensory experience in the first place. To put it more sharply: human thinking cannot go beyond the patterns suppliable by the human senses.

Language, then, argues loudly in favor of the contention that thinking takes place in the realm of the senses. If so, what have words themselves to contribute? The answer to this question requires a short excursus on a more general problem of cognition.

Intuitive and intellectual cognition

There are two kinds of perceptual thinking, which I will distinguish as intuitive and intellectual cognition. Intuitive cognition takes place in a perceptual field of freely interacting forces. Consider as an example the way a person apprehends a work of painting. By scanning the area enclosed in the frame, the observer perceives the various components of the picture, the shapes and colors and the relations between them. These components exert their perceptual effects upon each other in such a way that the observer receives the total image as the result of the interaction among the components. This interaction of perceptual forces is a highly complex field process, of which, as a rule, very little reaches consciousness. The final outcome does become conscious as the percept of the painting, organized in a certain way and consisting of shapes and colors whose particular character is determined by their place and function in the whole.

A great deal of thinking and problem solving goes on in, and by means of, intuitive cognition. The thought mechanisms in perception which, as I described at the beginning of this book, determine the size, shape, color, and so on, of visual objects, are interactions among field processes. The compositional order of a work of art is created and controlled in the same way. Productive problem

solving in the sciences also relies on the restructuring of perceptual situations, on "synoptic thinking," as a German art educator recently called it.

But there is another procedure, namely, intellectual cognition. Let us assume that an observer, instead of absorbing the total image of the painting intuitively, wishes to identify the various components and relations of which the work consists. He describes each shape, ascertains each color, and prepares a list of all of these elements. He then proceeds to examine the relations between the individual elements, for example, the effects of contrast or assimilation they have upon each other. Once he has collected all these data he seeks to combine them and thereby to reconstruct the whole.

What has this observer done? He has isolated items and relations among items from the perceptual field in order to establish the particular nature of each. In this fashion, stable and independent concepts develop from the more or less stable and more or less circumscribed entities constituting the perceptual field. By gradually solidifying the perceptual concepts gained from direct experience, the mind acquires the stable shapes, which are helpful for consistent thinking.

The components of intuitive thought processes interact within a continuous field. Those of intellectual processes follow each other in linear succession. The person who tries intellectually to trace the individual relations that establish a work of art must take up and connect them one after the other. Representative examples of intellectual thought processes are the stringing of concepts in verbal sequences, the counting or adding up of items, the chains of logical propositions in syllogisms or mathematical proofs.

I cannot resist inserting here a quotation which N. R. Hanson found in an eighteenth-century Latin treatise on the plants of Switzerland, written by the anatomist, physiologist, and poet, Albrecht von Haller. At the end of a section describing the various species of lilies, Haller explains that from there he could proceed in natural order to arrow-grass, rush, and sweetflag, using the anther as the basis of the relation; but that the natural order would lead him equally well from the lilies to the orchids, which have similar roots, leaves, flowers, and fruits but quite different stamens. And he adds:

Natura in reticulum sua genera connexit, non in catenam: homines non possunt nisi catenam sequi, cum non plura simul possint sermone exponere.
[Nature connects its genera in a network, not in a chain; whereas men can only follow chains, as they cannot present several things at once in their speech.]

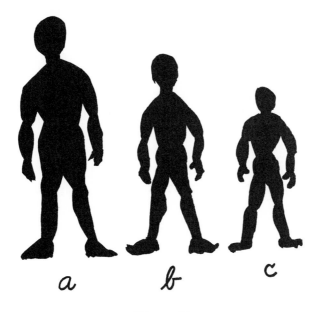

Figure 61

Intellectual operations are stepwise connections between fixed entities. Compare this with what happens when a person ascertains intuitively the size relations among the three men in Figure 61. He does so by inspecting the locations of the three within the total spatial pattern. If now, instead of looking at a picture, the person is presented with the propositions

> A is taller than B
> B is taller than C
> Therefore, A is taller than C

he has to deal with two self-contained images that must be combined somehow to produce the third.

Artists speak disapprovingly of an "intellectual" procedure when they notice that someone has introduced into his composition elements that owe their appearance to operations performed outside of the perceptual field of the work. Geometrical constructions, imitations, tricks and formulae may produce foreign bodies, not integrated intuitively in the whole. There is no necessary conflict, however, between intuitive and intellectual cognition. In fact, productive thinking is characterized, in the arts and in the sciences, by the interplay between the free interaction of forces within the field and the more or less solidified entities that persist as invariants in changing contexts.

Language assists the mind in stabilizing and preserving intellectual entities. It does this, for example, with the perceptual concepts that emerge from direct experience. The generalities acquired in perception are embedded in the continuum of the visual world. The concept of tree rests on an endless variety of trees of different color, shape, and size; it is found inherent in each tree but is not identical with any one specimen. Furthermore, the range to which such a type concept applies is not clearly confined but slides into that of its neighbors. Trees border on shrubs, vegetables blend with fruits, violas with violins, the Romanesque with the Gothic, Miss A with Miss B. Thought needs discrete types, and perception is geared to supply it, but the structure of the raw material of experience does not furnish neat dichotomies, simple either-or's; it consists of ranges, shades, gliding scales.

Here language is helpful. It supplies a clear-cut, distinct sign for each type and thereby encourages perceptual imagery to stabilize the inventory of visual concepts. The universe of sound is ideally suited to supply these verbal labels. It is much less of a continuum than the universe of sights. On a background texture of noise or silence it can present nicely segregated units. Significant sound patterns appear on their foil, as written or printed words appear clearly legible on empty paper.

The universe of hearing furnishes an endless supply of meaningless shapes, easily producible and reproducible in daily life. Being created by man rather than offered by nature, the sound shapes of words meet, at least approximately, the conditions favoring disciplined thinking. Each type receives its unique, discernible sign. Primitive though the perceptual variables of the verbal medium are, they are sufficient to help sustain the order inherent in the sensory world. Words are like pointers that single out significant peaks from the unbroken contour line of a mountain range on the horizon. The peaks are not created by the pointers. They are given objectively; but the pointers fortify the observer's urge to discriminate them.

The delicate influence of language on perceptual thinking has been caricatured by the one-sided approach of certain linguistic determinists. They describe sensory experience as shapeless raw material, confined to a disorderly variety of particular instances. No generalization is said to be possible within perception itself. In an absurd reversal of what actually takes place, verbal concepts are described as a set of given moulds to which the amorphous

raw material is fitted and which thereby impose order on the chaotic reality we would face otherwise. Words are said to segregate one thing from the next, discover similarities and differences, establish genera.

Early advocates of this extraordinary perversion are Johann Gottfried von Herder and Wilhelm von Humboldt in the eighteenth century. In our time, Ernst Cassirer and the linguists Edward Sapir and Benjamin Whorf have propounded the theory more or less radically. The experience of sight, says Herder in his essay on the origin of language "is so bright and over-resplendent, it supplies such a quantity of attributes, that the soul succumbs to the manifoldness." The visual world is "dispersed in infinite complexity." He calls the sense of vision "too subtle" because what it tells us is "confusing and empties our heads." Vision, according to Herder, "presents us with everything at once and frightens the novice by the infinite expanse of its simultaneity." Some hundred and fifty years later, Cassirer echoes this view by speaking of the "rhapsody of perception." Whorf, in turn, tells us that "the world is presented in a kaleidoscopic flux of impressions which has to be organized by our minds—and this means largely by the linguistic system in our minds." The world of sight appears as a colorful nightmare, truly the invention of men of words.

To Herder, human beings are distinguished from the instinct-driven animals by what he calls *Besonnenheit*, reflection.

Man gives proof of reflection when the power of his soul acts so freely that he can segregate, if I may say so, one wave in the entire ocean of sensations which rushes through all of his senses—segregate it, stop it, direct his attention to it, and be conscious of his attention. He gives proof of reflection when out of the whole drifting dream of images that passes by his senses he can collect himself in one moment of wakefulness, dwell voluntarily upon one image, observe it lucidly and more calmly and pick out for himself characteristics which show that this is the object and no other.

And reflection, he asserts, is made possible by speech.

Our own contemporaries put the matter more bluntly. "It is not only in the organization and articulation of the conceptual world," writes Cassirer, "but also in the phenomenal structure of perception itself—and here perhaps most strikingly—that the power of linguistic formation is revealed." And Whorf: "Segmentation of nature is an aspect of grammar. We cut up and organize the spread

and flow of events as we do, largely because, through our mother tongue, we are parties to an agreement to do so, not because nature is segmented in exactly that way for all to see."

As an illustration of the theory, Herder describes how primitive man, confronted with a lamb — "white, gentle, woolly" — exercises his capacity for reflection by seeking a characteristic of the animal. Suddenly the lamb bleats, and lo! man has found the distinguishing trait. "This bleating, which has made the liveliest impression on his mind and which freed itself from all other properties of sight and touch, stood forth and entered most deeply into his experience — 'Ah! You are the bleating one!' — and it remains with him." The notion that the visual characteristics of an object are incapable of being distinguished and remembered unless they are associated with sound and thus related to language, I have called the myth of the bleating lamb.

What words do for images

Although there is no reason to assume, with these thinkers, that language is needed to do the work of perception, words do supply stable tags that commit sensory experience to acknowledging certain types of phenomena. But language does more. Psychologists have pointed out that the words by which things are named are categories. Such naming, therefore, indicates to some extent the level of abstractness at which an object is perceived and ought to be perceived. One can refer to one and the same particular creature by speaking of an animal, a mammal, a feline, a domestic cat, the cat Yoshi. The level of abstractness is not chosen arbitrarily but depends — at least in the speech of adults who master the language — on the degree of generality appropriate to a given situation. If there are mice in the house, a cat is needed, no matter which one; but if Yoshi is wanted, no other cat may do. Now it is true that the level of abstraction at which an object or event is viewed shows up perceptually. There is a difference between seeing a suitcase as "something" obstructing passage and examining its features when one considers purchasing it. However, these distinctions of level in perception are rather subtle and tend to get blurred by the fact that they all refer to one and the same object. If the level of abstractness is labeled by words, the speaker's thinking maintains it more firmly.

Words come in especially handy when a statement applies several levels of abstractness to one entity. "Lions are cats"—this requires me to see one and the same kind of thing at two levels, a possible but awkward thought operation. The verbal statement helps by giving two different names to the two levels. It is true that, on the other hand, because of the arbitrariness of speech sounds, the two terms "lions" and "cats" do not reflect the intimate kinship of their referents, but are simply two different noises. Here the visual image comes to the rescue, and it is precisely by making up for each other's deficiencies that the two media, verbal language and imagery, co-operate so successfully.

Often language does better than merely assigning an arbitrary tag to a kind of object. It can give to an individual or species a name that indicates its belonging to a broader category. For example, by calling a group of animals "insects" one defines them as being *insecta*, namely segmented creatures. Many illustrations are given by Socrates in Plato's parody of reckless etymology, the *Cratylus*. Socrates maintains, for instance, that heroes are so called because they are born of love, *eros* being contained in *heros*. To use a more serious but equally fanciful example: if the moon had been thought of in antiquity as a torn-off piece of the earth, it might have been called *Perdita*, rather than *Luna*, and thereby classified linguistically among the lost things rather than the shiny ones.

By such categorical names, language can codify changes of classi-fication which an object undergoes in practice. The painter Georges Braque once observed: "A coffee spoon near a cup acquires at once a different function when I place it between my heel and my shoe. It becomes a shoehorn." Such a change of function is ac-companied by a definite perceptual restructuring; the stem of the spoon, for example, changes from a handle into a lever. But the identity of the object, which nevertheless remains, is counteracted by the verbal distinction of coffee spoon and shoehorn. More in general, language helps to offset a tendency in perception to see things as pure shapes. Having been coined by practical needs, language tends to suggest functional rather than formal categories and thereby to go beyond more appearance. Inversely, an art teacher, intent on making his students see shapes rather than uten-sils, may try to reduce the effect of conventional names on their ob-servations.

The sentence "lions are cats" showed how linguistic statements

can strengthen the perceptual reality of relations that are theoretical rather than empirical. The sentence poses two distinct entities and connects them by the spatial relation of inclusion: lions belong among the cats. It thereby helps to prepare the perceptual arena for a purely logical connection. This assistance is of great value since reasoning constantly relates things not thus related in the physical world of space and time. The statement "Alexander was a greater man than Napoleon" treats the two men as quantities, the one larger than the other. It reflects a psychological process that is exceedingly difficult to describe because it connects perceptual images at two levels of abstractness. There are the images of Alexander and Napoleon, which are discontinuous, whatever particular form they may take. In addition, the relation will be represented by an image, such as that of "larger than," which helps to translate greatness into a perceivable comparison of size—a highly abstract percept, distinct from the images of the men, and yet at one with them in the thought on which the sentence reports. The superordinate image of the purely formal relation of "size" difference is somewhat hard to maintain against the empirical conceptions of Alexander and Napoleon as organically solid and empirically self-contained, independent entities. The verbal statement solidifies the more precarious, more abstract image. Wittgenstein has said that "in a sentence a world is put together tentatively [probeweise zusammengestellt], as an automobile accident is represented with puppets, etc., in a Parisian court of law." This puppet show is encouraged when the theoretical relation is represented in the tangible medium of language.

The imagery of logical links

Language turns out to be a perceptual medium of sounds or signs which, by itself, can give shape to very few elements of thought. For the rest it has to refer to imagery in some other medium. Obviously, this must hold true for all the parts of verbal statements, not just for some; they all need a mental realm to exist in. What about concepts that do not refer to physically tangible things? It is easy to think of images representing "house" or "struggle" or even relations between physical objects, such as "larger than" or "included among." But what about "if, because, like, although, either-or"? These are conjunctions and prepositions mentioned

by Freud for a very similar purpose. Being concerned with the so-called dream work, which has to give sensory appearance to the underlying dream thoughts, Freud raises the question of how the important logical links of reasoning can be represented in images. An analogous problem, he says, exists for the visual arts. There are indeed parallels between dream images and those created in art on the one hand and the mental images serving as the vehicle of thought on the other; but by noting the resemblance one also becomes aware of the differences, and these can help to characterize thought imagery more precisely.

The principal difference is that thought imagery, in order to fulfill its function, must embody all the aspects of a piece of reasoning since this imagery is the medium in which the thought takes shape. A dream or a painting, on the other hand, is a product of thoughts, which an observer can try to extract from the image by interpretation. A dream can suggest, Freud tells us, that one fact is the cause of another by simply making the episodes follow each other in time. In doing so, however, the dream does not express the causal relation; it merely implies it, just as the English language often omits the logical links and simply suggests the relation by sequence, thus leaving the reader with the task of supplying the connections. This is not possible in thought imagery. What is not given shape is not there and cannot be supplied from elsewhere.

If a dream depicts resemblance, identification, or comparison by fusing the images of several things into one it creates a contradiction between what is shown and what is meant and thereby poses a puzzle. In thought imagery, such a contradiction would be self-defeating. Similarly, if Raphael, to use Freud's example, assembles on a mountain top or in a hall philosophers or poets who never met, he shows a geographical community and leaves it to the beholder to understand that these men belong together only in thought, not in space and time. Minotaur and centaur symbolize the meeting of beastly and human nature only for the interpreting spectator; as images they show two species of a fantastic zoology and nothing more.

Thought imagery achieves what dreams and paintings do not because it can combine different and separate levels of abstractness in one sensory situation. To repeat my example, it can leave the images of the empirical figures of Alexander and Napoleon unrelated in time and space as the historical facts demand it, and over-

lay this level of imagery with the more abstract one of "greater than," thereby connecting the two components of the thought without letting them blur each other.

It is not difficult to become aware of the kind of spatial action to which conjunctions and prepositions point. Since they are theoretical relations they are best represented by highly abstract, topological shapes. I referred in an earlier chapter to the barrier character of "but," quite different from "although," which does not stop the flow of action but merely burdens it with a complication. Causal relations, as Michotte's experiments have shown, are directly perceivable actions; therefore "because" introduces an effectuating agent, which pushes things along. How different is the victorious overcoming of a hurdle conjured up by "in spite of" from the oscillation of displacement in "either-or" or "instead"; and how different is the stable attachment of "with" or "of" from the belligerent "against."

Language overrated

Language interacts with the other perceptual media, which are the principal vehicles of thought; it is more than "the final label put upon the finished thought"—a view called naive by Sapir. By sanctioning and preserving concepts formed in perceptual experience, language influences the organization of thought. Of this influence, the more radical formulations of linguistic determinism have given a crudely one-sided account. They maintain that the vocabulary and grammatical makeup of a language creates the worldview of the people who use it. In the words of Humboldt:

Man lives with his objects chiefly—in fact, since his feeling and acting depends on his perceptions, one may say exclusively—as language presents them to him. By the same process whereby he spins language out of his own being, he ensnares himself in it; and each language draws a magic circle round the people to which it belongs, a circle from which there is no escape save by stepping out of it into another.

In such statements, the doctrine seems to derive its impetus from an introverted need to view the human mind as the creator of the outer world. It could not otherwise ignore the obvious question of how a language came to develop a particular vocabulary and grammar in the first place; nor would it transfer characteristics of

language so confidently to the mentality of the people who speak it, without a shred of independent evidence indicating that the non-linguistic behavior of the population does in fact parallel the idiosyncrasies of their forms of speech. It is quite possible that the Wintun Indians, who, as Dorothy Lee reports, make no distinction between singular and plural, "recognize or perceive first of all humanity, human-being-ness, and only secondarily the delimited person." There is increasing evidence, after all, that human cognition starts with generalities and differentiates them only in the course of its development; however, this is equally true for cultures whose languages distinguish singular and plural carefully. It is quite another matter to conclude (as does Dorothy Lee) from the one-dimensional character of a medium such as language that its users view the world one-dimensionally:

The people of the Trobriand Islands codify, and probably apprehend reality, nonlineally in contrast to our own lineal phrasing. Basic to my investigation of the codification of reality on these two societies, is the assumption that a member of a given society not only codifies experienced reality through the use of the specific language and other patterned behavior characteristics of his culture, but that he actually grasps reality only as it is presented to him in his code.

In such a view, perception and thinking fit preordained patterns of codification passively. Also all mental reactions of an individual or group are assumed to be identical in structure. Actually, the mind is not so homogeneous; the facts are less simple. To mention just one example, Marcel Mauss observes that in Polynesia and China a rigid division of the sexes regulates all aspects of social life, such as the assignment of kinds of labor or the possession of goods; yet the languages of these cultures have no distinction of gender. Having grown up myself with a language that distinguishes three genders, I have no indication that the world I saw was in any way pervaded by a corresponding triple sexuality. A table looked no more masculine than a clock did feminine; nor was a maiden a neuter because *Mädchen* was. And in moving to an English-speaking country I observed no change in this respect in either myself or in others.

In order to evaluate the important role of language more adequately it seems to me necessary to recognize that it serves as a mere auxiliary to the primary vehicles of thought, which are so immensely better equipped to represent relevant objects and rela-

tions by articulate shape. The function of language is essentially conservative and stabilizing, and therefore it also tends, negatively, to make cognition static and immobile. I mentioned in an earlier chapter that type concepts come in two forms. They either crystallize into one particular, simple and well-shaped pattern, or they cluster around this center a range of varieties covered by the concept. The first is more convenient for classification, identification, communication, whereas the second is needed for broad, flexible, truly productive thinking. The first, however, is the one favored and supported by language since the verbal name is a fixed label and therefore tends to strengthen an equally fixed concept. The word "triangle" suggests an equally definite image.

Fortunately, the stereotyped thinking that the names of things advocate does not always prevail. But words can help to freeze notions, with the harmful effect illustrated by Whorf's famous examples of faulty thinking, which cause dangerous accidents. His interpretations of the examples mislead when they suggest that the meaning residing in the verbal names is to blame for the faulty handling of the corresponding objects. If, for example, the word "empty" has two meanings, one referring to a container no longer filled with what it is intended to hold, the other to the absence of any content whatsoever, the difference in meaning clearly originates and persists in the perceptual image of the container. Which image dominates depends on the context in which it is used. A person concerned, for example, with "exhausted supplies" will view emptiness in the former sense, whereas somebody intent on cleanliness, i.e., the absence of undesirable substances, will view it in the latter sense. None of this requires the help of words, but if a given version of an image is consolidated by a word of fixed definition it may persist more stubbornly in an inappropriate situation.

A list of concepts for which the English language has no "familiar or generally understood" words has been assembled by James Deese. I cite a few:

> Sources of illumination
> Things that change size and shape
> Parts of the body (including organs, limbs, etc.)
> Corpses of plants
> All of the surfaces of a room
> Animate beings with legs
> Inanimate objects with legs
> Things to sit on.

If the reader will try these categories on himself, he will find that some of them have a firm perceptual basis even though no name is available. Take the last example: "Things to sit on." Years ago, E. G. Sarris made experiments on what is "chair" to a dog. A dog had been trained to jump on a common, everyday chair at the command of "Chair!" It turned out that he obeyed the command for any object, if he could jump on it, lie down on it, and look around, regardless of the object's significance for human beings. In cases such as this, the common perceptual basis of the category is strengthened by the functional kinship ("things to jump on") and facilitated by the absence of contradictory categories (a suitcase will be more acceptable as a "chair" to a dog than to a man). A category such as "parts of the body" is not easily formed because of the functional difference between limbs and internal organs. The same is true for the difference between walls, ceiling, and floor. If a categorical image is difficult to obtain, one cannot simply blame it on the absence of a verbal name; more probably the word is missing because the concept has not been formed in experience. It is true, however, that an individual is more likely to draw a concept from his experience if the language he has learned calls for it.

At best, the relation of words to their meanings is precarious. Being stable and permanent signs, words suggest that their meanings are equally permanent. This, however, is obviously not so, although Susanne K. Langer maintains that one of the salient characteristics of true language is that its elements are words with fixed meanings. Actually, words have different connotations in different contexts and for different individuals or groups. As a currency of thought they are hardly more reliable than coins would be if their value changed unpredictably from hour to hour, from person to person. Philosophers and scientists constantly struggle with the verbal shells which they must use to package their thoughts for preservation and communication. Should they keep a familiar term and try to invest it with a new meaning, at the risk of seeming to use a concept they have abandoned? Should they coin a new term? All this trouble arrives because words, as mere labels, try to keep up with the live action of thought taking place in another medium. "The birth of a new concept," says Sapir, "is invariably foreshadowed by a more or less strained or extended use of old linguistic material." This strain of birth exists primarily in the medium of thought itself. It comes about because the structure of the matter under scrutiny,

to which the mind clings, is put under stress by the new, more appropriate structure imposing itself. The struggle against the old words is only a reflection of the true drama going on in thought. To see things in a new light is a genuine cognitive challenge; to adjust the language to the new insight is nothing more than a bothersome technicality. Eric Lenneberg has stressed this point by asserting that "words tag the processes by which the species deals cognitively with its environment." Since these processes involve constant change, the referents of words cannot be said to be fixed.

The effect of linearity

Intellectual thinking, I said earlier, strings perceptual concepts in linear succession. Caught in a four-dimensional world of sequence and spatial simultaneity, the mind operates, on the one hand, intuitively by apprehending the products of freely interacting field forces; on the other hand, it cuts one-dimensional paths through the spatial landscape intellectually. Intellectual thinking dismantles the simultaneity of spatial structure. It also transforms all linear relations into one-directional successions—the sort of event we represent by an arrow. Equality, for example, which can be a state of symmetrical interaction between two entities to the eye—twins sitting on a bench—is transformed by intellectual thinking into the sequential event of one thing equating itself with another. An equation is first of all a statement about a one-dimensional operation of one thing upon another; only secondary contemplation can transform it into an image of symmetrical coexistence.

Verbal language is a one-dimensional string of words because it is used by intellectual thinking to label sequences of concepts. The verbal medium as such is not necessarily linear. Artistically, several strings of words can be used at the same time, for example, in duets or quartets of opera. In fact, verbal sequences can be made entirely unlinear when a group of speakers, performing simultaneously, shout isolated words at irregular intervals. Words can also be distributed freely over the area of a painting or a book page, as in "concrete poetry."

Language is used linearly because each word or cluster of words stands for an intellectual concept, and such concepts can be combined only in succession. Since words are not pictures but only signs, the spatial relation involved in the statement "Cherries on trees" cannot be depicted in the verbal phrase, which is a mere

enumeration of three concepts: cherries, on, and trees. Similarly, language can describe action only by nonaction. Susanne K. Langer has put it well:

The transformation which facts undergo when they are rendered as propositions is that the relations in them are turned into something like *objects*. Thus, "A killed B" tells of a *way* in which A and B were unfortunately combined; but our only means of expressing this way is to name it, and presto!—a new entity, "killing," seems to have added itself to the complex of A and B. The event which is "pictured" in the proposition undoubtedly involved a *succession* of acts by A and B, but not the succession which the proposition seems to exhibit—first A, then "killing," then B. Surely A and B were simultaneous with each other and with the killing. But words have a linear, discrete, successive order; they are strung one after another like beads on a rosary . . .

The examples show that the sequences of intellectual concepts which language presents are often statements about an intuitively perceived situation and can serve to reconstruct that situation. The phrase "Cherries on trees" was derived by the speaker or writer from the spatial image of an orchard and can be used to conjure up a similar scene in the listener or reader. "A killed B" can evoke a scene of murderous action. In such examples, language serves as a bridge between image and image. However, the linear nature of the connecting medium is not without effect on the images it suggests. Although the image can supply the action that cannot be directly depicted by words, that evoked action tends to remain linear. For example, simultaneous interaction cannot be described in speech directly, and the effect of such interaction is difficult to convey by words. The classical discussion of this problem can be found in Lessing's *Laokoön*, a treatise on the limitations of painting and poetry. Lessing argues that painting, concerned with shapes and colors in space, is equipped to deal with objects which coexist in space or whose parts do so; whereas actions, successions in time, are the proper concern of poetry. Painting can depict actions indirectly through bodies, and poetry can describe bodies indirectly through actions. If poetry — and this includes all language — undertakes instead to describe a visual situation by an enumeration of its parts, the mind is often unable to integrate these pieces in the intended image. Instead of citing Lessing's own examples, I will take one from the letters of Georg Christoph Lichtenberg, who, having gone to the theatre in London, attempted to describe to a German

friend how David Garrick performed Hamlet's reaction to the appearance of his father's ghost:

Garrick, upon these words, throws himself suddenly around and in the same moment falls two or three steps backward with collapsing knees. His hat drops to the floor; both arms, especially the left, are almost completely extended, the hand is at the level of the head, the right arm more bent than the left and the right hand lower; the fingers are spread out, and the mouth is open. Thus he stops, as though petrified, in a large but not excessive step, supported by his friends, who are better acquainted with the apparition and who fear he may fall. In his face horror is expressed in such a way that dread overcame me repeatedly even before he began to speak.

This transcript by enumeration is unlikely to reconstruct in many minds the image Lichtenberg saw. Therefore writers, relying intuitively on the principle which Lessing formulated in theory, tend to describe what is by what happens. They introduce the static inventory of a scene on the wings of action. This device performs the task of describing a situation by means congenial to language. It traces linear connections across the state of affairs and presents each of these partial relations as a one-dimensional sequence of events. More importantly, it presents these sequences in a meaningful order, starting perhaps with a particularly significant or evocative detail and making the facets of the situation follow each other as though they were the steps of an argument. The description of the scene becomes an interpretation. The writer uses the idiosyncrasies of his medium to guide the reader through a scene, just as a film can move the spectator from detail to detail and thereby reveal a situation by a controlled sequence. This technique is particularly evident and effective in the very first sentences of a piece of fiction, in which the narrator calls up the introductory scene from nothingness by a series of select strokes. The first sentences of Henry James' *The Turn of the Screw* are a masterly example. As a less familiar illustration I will insert here the beginning of Albert Camus' story, *The Adulterous Woman*.

A housefly had been circling for the last few minutes in the bus, though the windows were closed. An odd sight here, it had been silently flying back and forth on tired wings. Janine lost track of it, then saw it light on her husband's motionless hand. The weather was cold. The fly shuddered with each gust of sandy wind that scratched against the windows. In the meager light of the winter morning, with a great fracas of sheet metal and axles, the vehicle was rolling, pitching, and making hardly any progress. Janine looked at her husband. With wisps of graying hair growing low on a narrow forehead, a broad nose, a flabby

mouth, Marcel looked like a pouting faun. At each hollow in the pavement she felt him jostle against her. Then his heavy torso would slump back on his wide-spread legs and he would become inert again and absent, with vacant stare. Nothing about him seemed active but his thick hairless hands, made even shorter by the flannel underwear extending below his cuffs and covering his wrists. His hands were holding so tight to a little canvas suitcase set between his knees that they appeared not to feel the fly's halting progress.

In the empty cloud chamber of the reader's mind appears the one-dimensional track of the insect's flight, pacing the narrow dimensions of the bus and animating the static hollow space with action. The wind is introduced not as an item of the scene's inventory but by the effect it makes. Constant features of the situation, such as the cold air, enter the stage at an appropriate point of the sequence, like an actor obeying his cue. A continuous action, such as the exploits of the fly, can be given three separate appearances, for three different purposes: the pacing of the confined space, the discovery of the contrastingly motionless hand, the demonstration of the man's insensitivity to touch. By selecting a few significant features and by describing them with a purposeful stress on some of their qualities, the writer presents the abstract, dynamic components of his plot: the frantic struggle against confining walls, an observant woman, a man moved by nothing but his sense of possession, contact without communication, chill, a clumsy locomotion without progress, burdensome weight. Here then the perceptual evocation of a stationary situation is channeled into controlled scanning. This is obtained by imposing upon the potentially two-dimensional or three-dimensional medium of visual imagery the one-dimensional medium of language. Language forces the referents of the verbal statements into a sequence by acting as a kind of template.

Needless to say, such a sequence of statements can serve at the same time to build up the whole stationary situation gradually, as brush strokes build up a painting. But one needs only to compare the effect of a painting on a somewhat similar subject, perhaps Daumier's *Third Class Carriage*, with the visual experience produced by Camus' narration to grasp the fundamental difference.

A pictorial image presents itself whole, in simultaneity. A successful literary image grows through what one might call accretion by amendment. Each word, each statement, is amended by the next into something closer to the intended total meaning. This build-up through the stepwise change of the image animates the literary

medium. It is an effect beyond the mere selection and sequence of features, which I illustrated by the sample from Camus. Take the first stanza of Dylan Thomas' poem, *The Marriage of the Virgin:*

> Walking alone in a multitude of loves when morning's light
> Surprised in the opening of her nightlong eyes
> His golden yesterday asleep upon the iris
> And this day's sun leapt up the sky out of her thighs
> Was miraculous virginity old as loaves and fishes,
> Though the moment of a miracle is unending lightning
> And the shipyards of Galilee's footprints hide a navy of doves.

The statement starts with "walking," pure action without a body, and not before line five does the reader arrive at the subject "miraculous virginity," which tells who is — or, in fact *was* — walking. This openness of shape calling for closure produces the suspense of expectation, by which the dynamics inherent in the image makes up for the lack of coherence in the verbal signs. A directly perceptual medium, such as music, offers this suspense in what is heard rather than indirectly in the mental imagery evoked by the stimulus. "Walking," an action without a possessor, is modified in the meantime by "alone" and then by "in a multitude of loves" — each amending and enriching the image through gradual accretion. Inversely, in "morning's light" we have a thing without action, immediately amended by the next word to "light engaged in the action of surprising." This swift and sudden animation of a thing by the verb that follows it is the specifically linguistic effect on the image, which I am trying to illustrate. "Surprised," a transitive verb, opens another long syncopation by putting the reader on the scent of a needed object, which finally turns up in "his golden yesterday." These demands for overarching connections create tensions that knit the sprawling length of verbal discourse together. In the meantime, some of the perceptual relations inherent in the sound pattern of the words themselves become structurally meaningful by making contact with their referents: assonance connects "sky" with "thighs" and "old" with "loaves" and the parallel between the "multitude of loves" of the first line and its religious equivalent, "navy of doves," in the last, ties the stanza together by both meaning and sound. Needless to say, none of all this could take place if the sounds of language were not in constant fusion with the images they evoke.

Verbal versus pictorial concepts

Since all media accessible to the human mind must be perceptual, language is a perceptual medium. Therefore it is not useful to distinguish, among the media of representation, languages from non-languages and to do so by asserting that non-languages employ images whereas languages do not. A verbal language is a set of sounds or shapes, and as such it is not entirely without structural properties that can be used for isomorphic representation. For example, language attributes individual signs to individual concepts and describes thoughts and experiences as sequential events. These correspondences are exactly as pictorial in principle as is the fact that in a drawing two dogs can be shown as two separate line patterns or that the phases of an event are represented in their proper sequence in a motion picture or stage play. On the other hand, verbal language is too poorly structured to permit much representation by such correspondence. Therefore, it does most of its work by assigning labels to facts of experience. These labels are arbitrary, in the sense in which a red light is an arbitrary traffic sign for stopping.

All media of representation can rely on isomorphic and on non-isomorphic references. They are partly analogues, partly signs. In principle, there is no difference in this respect between verbal and non-verbal languages. The most important difference in practice is one of ratio. In the visual arts or in music, for example, strictly non-isomorphic references are exceedingly rare. In verbal language, they do most of the work. A continuous gamut of shapes leads from the least to the most isomorphic media; it includes such intermediate features as onomatopoetic speech sounds, ideographs, allegories and other conventional symbols. To put verbal language in a class of its own is misleading.

It is not true, as I pointed out earlier, that verbal language uses constant, standardized shapes whereas a pictorial language such as painting uses shapes of infinite individual variety. Of course, no two pictures of flowers are alike, whereas the word *flower* persists unchanged. However, verbal language is not composed simply of words but, first of all, of their meanings. As Sapir has said, the word "house" as a purely auditory, kinesthetic, or visual percept is not a linguistic fact; "it is only when these, and possibly still other, associated experiences are automatically associated with the image of a house that they begin to take on the nature of a symbol, a word, an element of language." Although the standardized sound is a

part of any verbal concept, it is by no means its hard core. It has no way of preventing the enormous variety of character and range, typical of concepts. Language offers no guarantee that concepts will have the stability desirable for thinking and communication.

Roger Brown has argued that the kind of mental image described by Titchener as the visual component of his verbal concepts would be ill-suited for respectable thought because they were capriciously individual, contained accidental components, and fluctuated unpredictably. Titchener's image of a cow — "a longish rectangle with a certain facial expression, a sort of exaggerated pout" — relies on traits never mentioned in the definition of a cow. This is true, but the capriciousness of such images will be found in all concepts under similar conditions. A concept a person thinks about does not have the relatively stable persistence of an object he sees in front of him. The bunch of yellow chrysanthemums I am looking at is subject to all the fluctuations of grasp, attention, relation; but the sturdy base supplied by the physical stimulus remains as long as I look. The mental image, not anchored to any such independent, objective base, draws from memory alone. It is open to the onrush of the experience of a lifetime. Therefore, any component of thought must rely on context for precise identification. If an experimenter asks a person, or himself, what goes on in his mind when he thinks of "cow," the concept is caught in a vacuum or purely accidental context, and the result will be correspondingly capricious. But ask about the difference between a domestic cow and an elephant cow or think about the likely effect of cows on automobile traffic in India, and the image begins to sharpen.

The protean nature of word meanings becomes painfully evident when an inept teacher asks pupils to look up certain terms in the dictionary and then write sentences containing them. James Deese reports on the results a teacher of seventh-grade English obtained with the word *chaste*. One student, finding that chaste meant "simple in design" wrote: "The amoeba is a chaste animal"; others, using the word as a synonym of *unstained* or *pure* wrote: "The milk was chaste" or "The plates were still chaste after much use." This attractive nonsense came about because the teacher forced his pupils to pick facets of a concept out of context. The words of the dictionary point to a random collection of such facets, and there is no way of using them correctly unless one knows the context in which they belong. As soon as a concept is placed in a meaningful

proposition, the context will focus upon its relevant aspects. Definitions are particularly useful in nailing down the meaning of a concept by fastening it to a trellis of relations. To be sure, even definitions do not fixate the meaning of the concept "as such" but only in reference to a particular conceptual framework. The zoological definition of cow has little bearing on the goddess Hathor or on Jean Dubuffet's painting, *The Cow with the Subtil Nose.*

Since any verbal concept is committed to one of its particular aspects by the proposition, definition, or other context in which it is used, its visual nature is not different in principle from pictorial representation in drawing and painting. True, the part of the concept which the eyes can see directly is limited in verbal representation to an almost totally arbitrary sign or complex of signs whereas the visible picture contains more elements of portrayal. But there is only a difference of degree between the verbal concept *reclining nude* and a particular piece of sculpture representing that subject. Both percepts, the words and the bronze, are hung with mental associations beyond what is directly perceived. The statue, being much more specific, restricts the range of pertinent connotations more severely. It is much less adaptable. One cannot take pictures or pieces of pictures and put them together to produce new statements as easily as one can combine words or ideographs. Pictorial montages show their seams, whereas the images produced by words fuse into unified wholes. The shapes and color patterns of visual art form the particular image that constitutes the statement. The shapes of verbal language are tooled for the mass evocation of images, whose individuality is induced indirectly by the combination of the standardized labels.

14. *Art and Thought*

Thinking calls for images, and images contain thought. Therefore, the visual arts are a homeground of visual thinking. This needs to be shown now by a few examples.

To treat art as a form of visual thinking may seem unduly one-sided. Art fulfills other functions, which are often considered primary. It creates beauty, perfection, harmony, order. It makes things visible that are invisible or inaccessible or born of fantasy. It gives vent to pleasure or discontent. None of this is denied here; but in order to fulfill such functions a great deal of visual thinking must be done. The creation of beauty poses problems of selection and organization. Similarly, to make an object visible means to grasp its essential traits; one can depict neither a state of peace nor a foreign landscape nor a god without working out its character in terms offered by the image. And when Paul Klee writes in his diary: "I create *pour ne pas pleurer;* that is the first and last reason," it is evident that Klee's drawings and paintings could serve so great an artist and so intelligent a human being as an alternate to weeping only by clarifying for him what there was to weep about and how one could live with, and in spite of, this state of affairs.

Inversely, some of the objectives attributed to art are means of making visual thinking possible. Beauty, perfection, harmony, order do serve to give a sense of well-being by presenting a world congenial to human needs; but they are also indispensable conditions for making a cognitive statement clear, coherent, comprehen-

254

sible. Aesthetic beauty is the isomorphic correspondence between what is said and how it is said.

Thinking in children's drawings

If one wishes to trace visual thinking in the images of art, one must look for well-structured shapes and relations, which characterize concepts and their applications. They are readily found in work done at early levels of mental development, for example, in the drawings of children. This is so because the young mind operates with elementary forms, which are easily distinguished from the complexity of the objects they depict. To be sure, children often give only rough approximations of the shapes and spatial relations they intend to depict. They may lack skill or have not actively explored the advantages of well-defined patterns. Also, children draw and paint and model not only for the reasons that interest us here particularly. They like to exert and exercise their muscles, rhythmically or wildly; they like to see something appear where nothing was before, especially if it stimulates the senses by strong color or a flurry of shapes; they also like to defile, to attack, to destroy. They imitate what they see elsewhere. All this leaves its traces and keeps a child's picture from being always a neat record of his thought.

Yet we need not look far for demonstrations of our contention. Figure 62 is the picture of a horseback rider drawn by a girl of three years and nine months. It shows the horse as a large oval and a horizontal line representing "what the man sits on." The drawing is surely primitive when it is compared with the complexity of the objects it depicts. What matters more, however, is that instead of showing a mechanical, though clumsy adherence to the model the drawing testifies to a mind freely discovering relevant structural features of the subject and finding adequate shapes for them in the medium of lines on flat paper. The horse is not characterized as such but is abstracted to the level of an unspecific mount, a base sustaining the rudimentary man. One thing serves as a foil for the other, which it encloses. But this relation is too loose: it lets the little man float in the oval. In order to give him a pedestal on which he can solidly perch, the child introduces the baseline—which is not a picture of the horse's back, but is support in the abstract, although completely visual.

The child's statement, then, consists of visual concepts, which

Figure 62

are demanded by direct experience but depict the subject abstractly by some relevant features of shape, relation, and function. The drawing derives its form more directly from the "pure shapes" of very generic visual concepts than from the particular appearance of horse and rider. It shows thereby what matters to the child about the theme of the mounted gentleman: he is enthroned, surrounded, supported. And although the picture is so highly conceptual, it springs entirely from intense observation of the sensory world and interprets the character of the model without straying in any way from the realm of the visible.

Occasionally, a visual concept jells into a precise, almost stereotyped shape, repeated with little variation in spite of diverse applications. Figure 63 reproduces drawings of a six-year-old girl in which the Valentine heart shape is used to portray noses, brooches, a party dress, arms, wings(?), decorations of the crown, etc. The device, although somewhat conventional, displays all the traits and functions of a concept. It is simply structured, easily grasped. It serves to make understandable a number of different objects which resemble it sufficiently to be subsumed under it. This subsumption creates a common category of noses, brooches, arms, etc. It establishes a bit of order in a world of complexity.

Figure 63

The selection and assignment of visual concepts involves the kind of problem solving of which I spoke earlier as the intelligence of perception. To perceive an object means to find sufficiently simple, graspable form in it. The same is true for the representational concepts needed for picture-making. They derive from the character of the medium (drawing, painting, modeling) and interact with the perceptual concepts. The solutions of the problem show much ingenuity. Even in young children, they greatly vary from person to person. One may have seen thousands of children's drawings, but one never ceases to be struck by the inexhaustible originality of ever new solutions to the problem of how to draw a human figure or an animal, with a few simple lines.

Thinking requires more than the formation and assignment of concepts. It calls for the unraveling of relations, for the disclosure of elusive structure. Image-making serves to make sense of the world. Figure 64 shows a balloon salesman drawn by a seven-to-eight-year-old. In his natural habitat a balloon man is a confusing spectacle. Pummeled from all sides by his unruly merchandise, he makes his way through crowds, moving his limbs as he bends down to a child, detaches a balloon, takes the money. The basic structure governing the man and his wares is by no means easy to see. A

Figure 64

great deal of active exploring, involving more than the sense of sight, is necessary before the principle of the matter is understood. Genuine thinking is also needed to find the best equivalent of this principle in the medium of two-dimensional drawing. In the child's picture all confusion has vanished. The spatial arrangement elucidates the functional order. The man is shown as the central agent by being placed in the center. What happens to the left and to the right of this middle axis is treated symmetrically because no functional difference is intended between what the left and what the right are doing. The strings issue from the controlling hands as a family of evenly distributed radii. The balloons are circularly arranged around the central figure, indicating that they are homotypic, i.e., that they have the same place in the functional whole. The background is empty, devoid of distracting accessories. The total composition of the picture is devoted to clarification. It is not a rendering of any particular view of the scene the child actually saw but instead the clearest possible visual representation of a hierarchic setup. It is the

final accomplishment of a long process of perceptual puzzling and wrestling by which the child's thinking found order in the observed disorder.

At higher levels of mental development the compositional patterns become more complex, and so do the configurations of forces discerned in the draftsman's world and interpreted in his pictures. The divers in Figure 65 (Frontispiece) were drawn by a somewhat older, Egyptian child. Again one must bear in mind what the child is likely to have seen of such scenes. Only then can one appreciate the freedom with which the data of experience are transformed into an independent visual interpretation, executed with the resources of the two-dimensional medium. In actual life one can watch the divers leave their boats and disappear in the water. An underwater film may show them descending, going about their business, rising again. But all these views are partial. The drawing does better. It presents a vertical continuum, the unbroken relation between what happens above in the boats and below in the depths, one coherent event showing all functions and connections of the total process. Although entirely unrealistic, this view offers simple and directly pertinent instruction. In the universe of the flat picture space its visual logic is immediately convincing and appropriate.

The boats surround and support their crews two-dimensionally without hiding them partly from sight as they do "in reality." The men holding the ropes are treated as rows of equals because they are homotypic, equal in function. The steersmen, who have a different job, are distinguished in shape and color. The ropes are clearly traceable connections; they do not interfere with each other, except in one case, where the crossing is demanded by overriding needs of spatial distribution. The even, blue foil of the water sets off the other colors, which serve clearly to distinguish the men and the boats. The irregular placement of the divers shows that they float in unlimited space, as against the more static arrangement of the men in the boats. The figures of the divers explain with the utmost clarity their holding on to the ropes, the attachment of weights and baskets, etc.

I am describing these drawings as though they were diagrams of instruction, like maps or other informational material, because my task demands just that. At the same time, of course, a beautiful drawing has qualities of art. It tells not only about diving; it also conveys the "sense," the live experience of the event. This effect

is obtained by the aesthetic qualities of balance, order, and expression, the dominant regiment in the boats above, the swarming of the red figures below, the freedom of their floating and the weightiness of their bodies. However, all this is by no means alien to the visual lesson worked out and conveyed by the child. Here, as everywhere else in art, "beauty" is not an added decoration, a mere bonus for the beholder, but an integral part of the statement. Every aspect of the picture, informational or evocative, is in perfect fit with what the child understood, felt, and tells.

The situations elucidated by visual thinking never concern the outer world alone. As the child grasps the characteristics of the diving situation, he also finds and clarifies in them elements of his own experience: being suspended, "dependent" (in the literal and figurative meaning of the word), immersed into forbidding darkness, but safely held from above, exposed to adventure and duty, in company and yet alone. After all, it must be this sort of affinity that makes a person take a cognitive interest in what goes on outside his own business and that makes him want to hold and clarify it.

Figure 66a

Personal problems worked out

This personal involvement can be much more explicit. Figure 66 shows two drawings done at an interval of eight weeks by a seven-year-old girl whose family had just moved to the United States. Having been at a very strict European school, she felt lost in the

more informal setting of the American public school; she came home crying: "Nobody tells me what I should do anymore!" During those early weeks of distress, she drew the first picture. She portrayed herself twice, as the center figure in the top row and the one on the right underneath. She is surrounded by three females with wildly outward-streaming "American" hair: her older sister, who liked the American school, a college student who gave her violin lessons and whose unladylike slacks shocked her, and Nancy, another American girl. In the midst of these cheerfully smiling figures, she presented herself, melancholy and weeping, with pathetically reduced hair, armless or locked in her protective jump rope.

The second drawing was done when she had begun to make friends with her schoolmates in particular and America more in general. The discrepancy among the figures has vanished. They are all alike and smiling. A compromise hair style displays good grooming but also a pert flourish, and in three out of four instances the rope is no longer permitted to confine the beaming head. The child could not make these drawings without pinpointing the causes of

Figure 66*b*

her trouble. She observed in her environment the manifestations of painful exclusion and shocking license and later the cheerful solution. For these various themes she discovered the striking pictorial formulae. By doing all this, she made the various aspects of her worries and pleasures tangible and comprehensible. She diagnosed and shaped her problem, aided by her sense of sight.

The working out of personal problems is evident in drawings and paintings done by patients in art therapy. Case studies, such as those published by Margaret Naumburg, offer examples of how the work in its early stages may depict the raw threat of "free-floating anxiety," often poorly defined, and how with increasing elaboration there emerge also indications of the causes to which the threat is due. Toward the end, the hostile power is sometimes seen as properly reduced, put in its place, explained by its context. As a rule, the art work is only a part of the patient's guided effort to rid himself of his troubles. There is psychotherapy, there is the mental wrestling going on day and night, and to some extent the drawings and paintings are only a reflection of these struggles and their results. Evidently, however, the fight is waged also within the art itself. The effort to visualize and thereby to define the powers which the patient vaguely faces and to discover the correct relations between them means more than rendering observations on paper. It means to work out the problem by making it portrayable.

Often the pictures and sculptures of adult patients do not fulfill their task as completely as do the children's drawings shown above. The children are amateurs like the adults. But with their unspoiled sense of form they can still put all aspects of shape and color totally to the service of the intended meaning. In this sense, their work is like that of the accomplished artist. In the average adult of our civilization, however, the sense of form fades, rather than keeping up with the increasing complexity of the mind. His art work may contain elements of authentic expression—a woman hugging a child, a monster glaring in the darkness—but otherwise he mainly tells a story as best he can, without conveying its intrinsic meaning through the arrangement of the shapes and colors themselves. To the eye, such drawings can be confusing, misleading, and weak although they convey their message ideographically, by picture language.

Is it permissible to infer from what is known about imagery that such art work will have its full impact only if the perceptual pattern reflects the constellation of forces that underlies the theme of the picture? I am tempted to suggest that this is so. The direct perceptual evidence, which is the mind's most persuasive source of knowledge, must display itself in the overall composition and in the organization of detail if the message of the picture is to act with full therapeutic strength. Otherwise the insight derived from the

art work might be expected to remain partial and indirect. This means that ideally art therapy should also be art education, geared to guiding the person not only to the clarification of subject matter but to that of its visual representation. Only when the picture speaks clearly to the eye, can it expect to do its best for the mind. In this sense one can say that Margaret Naumburg's "scribble" technique, which encourages patients to "create spontaneous free-swinging forms in curves and zigzag lines upon a large sheet of paper," liberates not only the flow of unconscious content but can also help to recuperate the spontaneous sense of form from perceptually inanimate, constrained picture-making.

Figure 67

Cognitive operations

Genuine art work requires organization which involves many, and perhaps all of the cognitive operations known from theoretical thinking. I will give a few examples. Commonly in philosophical, scientific, or practical situations, a problem is solved first in a narrow, local range, which calls for modifications when the situation is to be treated in a larger context. Here is an elementary illustration of such restricted thinking in drawing. Young children often place the chimney obliquely rather than vertically on the roof (Figure 67). The practice makes good sense if one views it not just negatively as wrong but positively as a local solution of a spatial problem. The chimney rests on a slanted roof, and in relation to this slant it is placed perpendicularly. This is indeed the only proper placement as long as the problem is limited to its narrowest range. Only in the broader framework of the total scene is the roof revealed as being slanted, that is, divergent from the basic framework of space. The roof is not the firm platform it appears to be in the narrow view. Therefore, in order to obtain the stable position which the child intended to give to the chimney by placing it at right angles to the

roof, the chimney must conform to the vertical of the larger space. This creates an awkward, wrong-looking relation between the two neighbors, chimney and roof—a relation justified only when seen in the broader context.

Another basic cognitive problem is that of interaction: At an early level of thought, things are considered as self-contained entities. There may not be any relation between them. Just as young children will play next to each other but not with each other, so the figures in their drawings float in space, unconcerned with each other. When relation is depicted, it does not indicate at first that the partners are modified by it. In the very primitive drawing of Figure 62 the oval-shaped horse does not acknowledge the presence of

Figure 68

the rider nor does the human figure seem to be modified by the function of riding. Only the spatial placement tells that the relation between the two is something more than independent coexistence. At a next step the partners sacrifice some of their integrity in the interest of the interaction. In Figures 68a and 68d, the legs are omitted in order to solidify the interface between figure and support visually. But the partners do not yet invade each other. Figures b and c show a different solution. The partners are left unimpaired but they interpenetrate. They form a closer visual unity but are unaffected by it. Each is shaped the way it would be by itself, without the presence of the other. This creates areas that belong to both partners and may be interpreted wrongly as showing transparency.

Instead they are unacknowledged coincidences. But the double oc-
cupancy creates visual rivalry, and this conflict spurs the need for
a more unified treatment of the problem.

The clown on the elephant (Figure 68c) has assumed the profile
position in deference to his mount. In addition, however, he has
given up one leg. To accept this sacrifice as legitimate requires
a much stronger modification of early thought than did the mere
omission of the legs in Figure 68a and 68d. In early drawings, chil-
dren easily ignore limbs; but to acknowledge their presence and
to agree to the amputation nevertheless calls for a more radical
departure from the primary image of the human figure. The child
faces here, in a perceptually tangible and relatively neutral situation,
the often painful problem of interaction: the part must be modified
in the interest of the whole; and the particular form and behavior
of the part is understandable only through its function in the whole.
As a cognitive problem, interaction poses difficulties at all levels
of theoretical thinking; as a problem of interpersonal relations, many
people never truly succeed in solving it.

In the two more advanced drawings of a seated figure (Figure
68f and 68g) interaction leads to internal modification of the body.
The rigid primary figure of the earlier drawings is now recognized
as mobile in its joints or bendable. A reference to language may
illustrate how universally characteristic of human thought this dif-
ference is. The so-called isolation method of language forms sen-
tences by the stringing together of words which remain unmodified
within themselves. The connections between the words are ex-
pressed either by the mere sequence, as in Chinese, or by auxiliary
words such as prepositions, e.g., the indication of the possessive
case by the English *of* or the Japanese *no*. The inflective method,
on the other hand, modifies nouns, verbs, and other elements to
make the interaction between the components of a statement ex-
plicitly visible. This method prevails in Latin and German. The
terms *inflection* and *declension* derive etymologically from *bending*.
Although Sapir warns against the temptation of considering in-
flective languages as "higher" than the isolating ones, a develop-
ment from rigid to flexible word shape can be observed, for example,
in children; and Schlauch mentions that the inflected Indo-European
language "may have developed out of an earlier stage in which root
words and particles were loosely strung together as independent
and semi-independent elements."

Characteristic of thought processes quite in general are also the confused or "ugly" transitional forms that come about when a person abandons a well-structured conception in order to proceed to a higher, more complex and more adequate one. It is a reaction to the sort of risk a mountain climber takes when he lets go of a safe position in order to get to a more advanced place. Figure 69 shows schematically three ways of representing a house, typically found in children's drawings. Figure 69a, clearly defined and unimpeachable in itself, fails to indicate three-dimensionality and there-

Figure 69

fore tends to look unsatisfactory when demands become more exacting. Figure 69c is a new clear-cut solution, as perfect as the first but with some differentiation of front and side views. Figure 69b illustrates one of the many intermediate forms of disorientation by which the draftsman gropes for the more complex solution of the problem, following vague hunches, applying structural features inconsequently, and making tentative stabs in this or that direction.

The resulting disorder, though perhaps unappealing in itself, gives evidence of the searching mind in action. The exploration is goal-directed and productive and therefore necessary and educationally welcome. It must be distinguished from the very different kind of confusion that results when the sense of form is interfered with by misguided teaching or other disturbances. This difference between productive and unproductive confusion can be observed in other areas of human learning as well.

The simple shapes and color schemes found in the early drawings of children become more complex in all their aspects. Originally

Figure 70

they reflect the perceptual order which the human mind establishes at an early age by straightening out the distortions of projection, accidental aspects, overlapping, etc. However, as the mind grows subtler, it becomes capable of incorporating the intricacies of perceptual appearance, thereby obtaining a richer image of reality, which suits the more differentiated thinking of the developed mind. This greater complexity shows up in the art work of older children.

In the early drawings, the geometrical elements—circle, straight line, oval, rectangle—are presented explicitly, although rarely in perfect execution. They combine to form human figures, animals, trees but retain their own shapes. A circle, an oval, four straight lines, properly connected, make a primitive figure. Soon, however, these independent units tend to fuse into more complex shapes. Figure 70, a "prehistoric animal" drawn by a not quite five-year-old boy, is an impressive example. In order to perceive such a pattern, the mind employs its usual procedure of organizing it in terms of simpler elements, which are suggested by the approximations

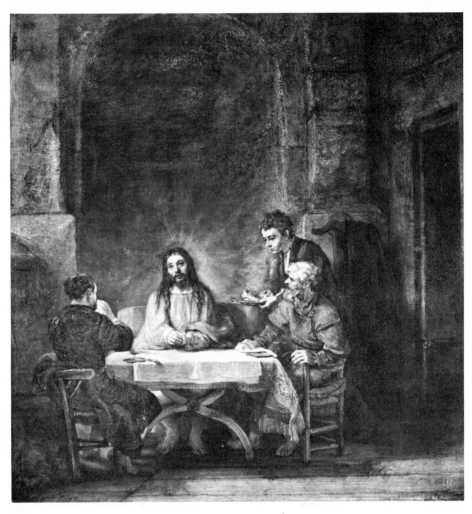

Figure 71. Rembrandt. Christ at Emmaus (1648).
Courtesy, Musée du Louvre. Below: Figure 71a.

actually given. They, as well as the skeleton that combines them structurally, are not spelled out by the drawing but potentially contained in it and discovered by the beholder. The effort of visual thinking needed to read such a pattern is correspondingly greater and subtler.

Abstract patterns in visual art

From these beginnings, an unbroken development leads to the accomplishments of great art. Perceptually, a mature work reflects a highly differentiated sense of form, capable of organizing the various components of the image in a comprehensive compositional order. But the intelligence of the artist is apparent not only in the structure of the formal pattern but equally in the depth of meaning conveyed by this pattern. In Rembrandt's *Christ at Emmaus* (Figure 71), the religious substance symbolized by the Bible story is presented through the interaction of two compositional groupings (Figure 71*a*). One of them is centered in the figure of Christ, which is placed symmetrically between the two disciples. This triangular arrangement is heightened by the equally symmetrical architecture of the background and by the light radiating from the center. It shows the traditional hierarchy of religious pictures, culminating in the divine figure. However, this pattern is not allowed to occupy the center of the canvas. The group of figures is shifted somewhat to the left, leaving room for a second apex, created by the head of the servant boy. The second triangle is steeper and more dramatic also by its lack of symmetry. The head of Christ is no longer dominant but fitted into the sloping edge. Rembrandt's thinking strikingly envisages, in the basic form of the painting, the Protestant version of the New Testament. The humility of the Son of God is expressed compositionally not only in the slight deviation of the head from the central axis of the otherwise symmetrical pyramid of the body; Christ appears also as subservient to another hierarchy, which has its high point in the humblest figure of the group, namely, the servant.

Needless to say, this analysis covers only the barest scaffold of Rembrandt's painting. If one wished to do fuller justice to the work of art, one would have to show how the theme is carried out in the detail. What matters here, however, is that the basic compositional scheme, often considered a purely formal device for pleasant

arrangement, is in fact the carrier of the central subject. It presents the underlying thought in a highly abstract geometry, without which the realistically told story might have remained a mere anecdote.

The nature of visual thinking in art becomes particularly evident when it is compared with elements of "intellectual" knowledge, which, although legitimate constituents of the work, are imported into the visual statement from the outside. Jan Vermeer's *Woman Weighing Gold* (Figure 72) is identified in the guide book as an allegory: "The young woman weighs her worldly goods standing before a painting of the Last Judgment wherein Christ weighs the souls of men." The parallel between the two actions is indispensable for the understanding of the picture. However, this is an intellectual connection, not displayed compositionally. If one knows of the Last Judgment, one can compare the subject matter of the background story with that of the foreground. All the painter does to suggest the relation is to frame the head of the lady in such a way as to place it directly below the figure of Christ. This relation, although close, is unspecific. The intellectual theme, however, is also expressed visually. The most conspicuous feature of the background picture is the dark, rigidly vertical ledge of the frame, which descends in the very center of Vermeer's composition. This powerful shape takes hold of the woman's hand and suspends the hand's movement. By this device the worldly scene of the foreground is arrested, while a light from above, stronger than the mundane glitter of the jewelry, causes the woman's eyes to close. Here again, the basic compositional pattern spells out the deepest and central thought of the work in great directness. The iconographic data add only a religious specification to the broader human theme.

The foregoing examples have shown what enables a work of art to be more than an illustration of a particular event or thing or a sample of a kind of event or thing. An abstract pattern of form, or more precisely, of forces is seen embedded in the image. Because of its abstractness, such a pattern is a generality. Through its particular appearance it represents the nature of a kind of thing. I have shown earlier that in principle this is true for all perception; but since the objects of nature and also many artifacts were not made for the purpose of fulfilling this perceptual function, they carry visual form only impurely and approximately. They leave much to the formative power of the observer. Works of visual art, on the other hand, are made exclusively for being perceived,

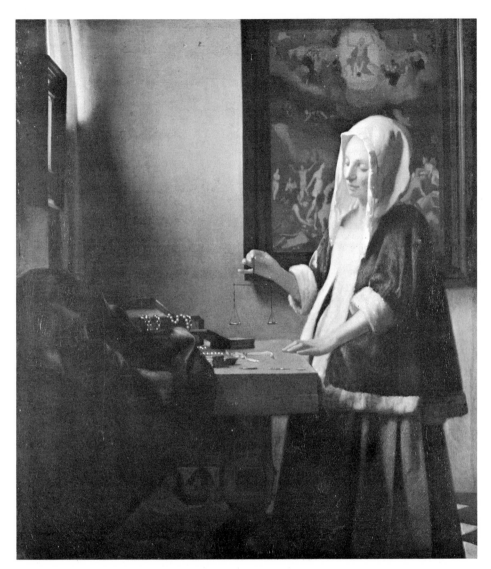

Figure 72. A Woman Weighing Gold (ca. 1657). Jan Vermeer: National Gallery of Art. Washington, D.C. Widener Collection.

and therefore the artist endeavors to create the strongest, purest, most precise embodiment of the meaning that, consciously or unconsciously, he intends to convey.

The carriers of directly perceivable meaning, which mimetic art embeds in its representations of physical objects, reveal their abstractness more conspicuously in successful works of non-mimetic modern art. I will try to illustrate this point by comparing Camille Corot's *Mother and Child on the Beach* (Figure 73) with Henry

Figure 73. Jean Baptiste Camille Corot: Mother and Child on the Beach. John G. Johnson Collection, Philadelphia. Opposite page, center: Figure 73*a*.

Moore's *Two Forms* (Figure 74). In the Corot, just as in the two paintings discussed a moment ago, the basic theme of the work is conveyed by the structural skeleton of the composition (Figure 73*a*). The child, symmetrical and frontal, reposes like a self-contained, independent little monument, whereas the figure of the mother is fitted to a bending and reaching wave shape, express-ing protection and concern. Moore's carving, equally complex and subtle, embodies a very similar theme. The smaller of the two units is compact and self-sufficient like Corot's infant, although it also strains noticeably towards its partner. The larger seems wholly engaged in its leaning over the smaller, dominating it, holding it down, protecting, encompassing, receiving it. One can find parallels to human or otherwise natural situations in this work: the relation of mother and child, spelled out in the Corot, or that of male and female. Such associations rely on the similarity of the inherent patterns of forces. they exemplify the reasons why the work has

something to tell that concerns us; but they are no inherent part of the work itself.

Just as a chemist "isolates" a substance from contaminations that distort his view of its nature and effects, so the work of art purifies significant appearance. It presents abstract themes in their generality, but not reduced to diagrams. The variety of direct experience is reflected in highly complex forms. The work of art is an interplay of vision and thought. The individuality of particular existence and the generality of types are united in one image. Percept and concept, animating and enlightening each other, are revealed as two aspects of one and the same experience.

Figure 74. Moore: Two Forms (1934). Collection, The Museum of Modern Art.

15. *Models for Theory*

The scientist, like the artist, interprets the world around him and within him by making images. The creation of perceptual models, of course, is not the scientist's only occupation. A physicist, a biologist, or a sociologist spends much effort on collecting data, checking their validity, measuring and counting them, and testing his predictions. But all these operations serve only to prepare and confirm his discoveries and his explanations. And to discover and to explain requires perceivable models. "It is by logic that we prove," says Henri Poincaré, "but by intuition that we discover."

Unless an image is organized in forms so simple and so clearly related to each other that the mind can grasp them, it remains an incomprehensible, particular case. Only through the generalities in its appearance is the imaged thing seen as a kind of thing, and thus made understandable. In the arts, elementary and early images showed this most conspicuously. The same is true for early models in science. I shall therefore take examples from situations in which science is young or concerned with problems of very broad scope.

Cosmological shapes

Theories on the nature and origin of the physical world offer convenient examples. They deal with a subject that has occupied humanity from its early beginnings; they must be concerned with the largest forms in existence, and the pertinent imagery must be correspondingly generic. Even a cursory glance at early cosmolo-

gies reveals features that are familiar from our dealings with the arts. Shapes suggested by direct experience interact with the "pure shapes" the mind puts forth in response to that experience. Out of the irresistible need for comprehensible form, mankind sees itself in a world that is flat, although beset with mountains and other secondary items, and which is closed by a circular horizon. This plain base is surmounted by the hemispherical star-spangled dome of the sky and may be seen as surrounded by the circular moat of the Homeric *okeanos*, on whose waters the heavenly bowl perches mysteriously. It is a closed world, suggested by form-seeking perception, and simple, like a child's picture.

I am concerned here with the psychological sequence rather than the chronological one. The psychological order leads from elementary to more complex conceptions, as the mind becomes more differentiated and observation more refined. On the other hand, since the models of thought set out from the complexities of the directly observed world, they also tend to get simpler as the mind becomes more independent. Aristotle knew that a ship gradually sinks below the horizon as it moves away; he knew that during a lunar eclipse the earth casts a circular shadow on the moon and that new constellations of stars become visible as one travels from country to country. In this way, the challenge of refined observation called for the notion of a curved earth, which meant appealing to a model that was even simpler and more elegant than the earlier one, namely, the image of a spherical world, surrounded concentrically by the shell of the heavens. Such divergence from direct perception is not easily accepted. One may resort to intermediary models, trying for a compromise. Anaximander, for example, said "that the earth is cylindrical in shape, and that its depth is a third of its width; its shape is curved, round, similar to the drum of a column: of its flat surfaces we walk on one, and the other is on the opposite side."

Just as in the drawings of children the primary circle often differentiates, after a while, into a group of concentric circles, so the astronomical shell of the heavens becomes a system of concentric shells. Each shell carries one of the planets; the outermost is reserved for the fixed stars and constitutes the boundary of the finite universe. However, as far as the earth itself is concerned, the concentricity of the model remained incomplete for a long time. The older view insisted that there was an upper and a lower world, the one in the light of day inhabited by living mortals, the other

a netherland of darkness, the dwelling-place of devils and the dead. The cognitive dissonance between the perceived environment and the equally perceptual thought model of the universe resolved itself but slowly.

The geometric stability of these early models tempts us to think of them as static shapes. However, all shapes are experienced as patterns of forces and are relevant only as patterns of forces. In practical life, a wall counts not as a geometrical plane but as a boundary that contains, keeps out, and covers; and in a child's drawing the pencil line of a jump rope surrounding the head may be, as we have seen, not an inert shape but a protective container. Man sees in the things around him the actions that brought them about, and that they are able to perform. This dynamic view of the world corresponds to what is known about the objective state of nature. Modern physics goes so far as to assert that material shape is nothing but man's way of seeing the effects of actions of forces.

From the beginnings, the cosmic architecture is viewed as being brought about by action. Cosmogony starts with form emerging from formlessness. The earth, says the Bible, was without form and void, and the early Greek philosophers speak of the prime matter as boundless and liken it to the mobile and flexible elements of water or air, which seem animated by an unshaped life. The word *chaos,* however, means originally, as F.M.Cornford has pointed out, not a primitive disorder but a yawning gap. It thereby refers to an earliest state of orderly shape, namely, the separation of two generative principles. Perhaps this principle, found in the cosmogonies of many cultures, is simply derived from the biological polarity of the sexes; but it may also present itself compellingly when cosmogonies do not involve the notion of a creator separate from the creation and therefore must expect the world itself to have split up at the start into at least two entities, which are both creator and creation. This view of the interaction of opposites may then seize upon the sexual duality as a natural model. In Chinese thought, all existing things are due to the antagonistic cooperation of the Yin and the Yang, traditionally represented as the two intertwining components of the circular emblem. In the Bible, the two primordial forces take the shape of heaven and earth. According to the Babylonian Genesis, "the primeval silt, born of the salt and the sweet waters in the original watery chaos, was deposited along its circumference in a gigantic ring: the horizon." From the horizon ring,

sky and earth grew as two enormous discs, later "forced apart by the wind, which puffed them up into the great bag within which we live, its underside being the earth, its upperside the sky."

In this Babylonian model, the distance between earth and heaven is viewed dynamically as the result of a distension, and the vault of the sky appears as the product of this expanding force. Thus the cosmogony is not only the story of how things came about in the past but remains inherent in the architecture of the universe as its presently visible pattern of forces.

As a rule, the cosmological shapes and actions are personified in mythological stories. However, just as in the arts the narrative subject matter is the vehicle of inherent forces, so is the marriage of Heaven and Earth, brought about by the attractive power of Eros, little more than a symbolization of basic patterns. Inversely, anthropomorphic features are still traceable even when the myths have turned into theories of celestial mechanics. There is an analogy to human yearning in Aristotle's belief that bodies move by an impetus inherent in them. Terrestrial things move in straight lines, either away from the center of the earth, as does fire, or toward it because "a body moves naturally to that place where it rests without constraint," and the spherical shape of the earth comes about dynamically through the pressure of all its parts in the direction of its center.

The heavenly bodies are said to move in circles because the circle is the simplest natural shape and fits the roundness of these bodies themselves. The primacy of circle and sphere is of purely perceptual origin, and so is the notion that the movement of a body conforms to its shape. The idea that the perceptually simplest shape is also naturally the most fundamental one has never been quite abandoned by the human mind. It gives way reluctantly when empirical observation curtails perceptual preference, notably in the dramatic episode of Galileo's refusal to accept Kepler's finding that the planets move in ellipses, with the sun located in one of the foci. This discovery was repugnant to Galileo, for whom the circle was still the only natural movement, whereas rectilinear motion came about through the interference of some foreign agent. The sun stood in the center of a system of perfect circles, and the velocity of planetary movement could not but be constant. To this extent, then, the struggle for scientific progress was a family feud within the perceptual realm: a fight of exact observation against the tend-

ency to simplest shape. Erwin Panofsky, in discussing Galileo's bias, has pointed out that the ellipse, the distorted circle, "was as emphatically rejected by High renaissance art as it was cherished in Mannerism." In painting, he says, it does not occur until Correggio.

Kepler established the priority of rectilinear movement for the terrestrial world and suggested by the example of muscular action in the human body that rotation was brought about by an artifice, indirectly and imperfectly. But it took a later generation to conceive of planetary rotation as the resultant of two rectilinear impulses, an inherent propulsion and an attraction from elsewhere. Newton writes in 1692 to Richard Bentley:

To the last part of your letter, I answer, first that if the earth (without the moon) were placed anywhere with its center in the *orbis magnus* and stood still there without any gravitation or projection, and there at once were infused into it both a gravitating energy toward the sun and a transverse impulse of a just quantity moving it directly in a tangent to the *orbis magnus*, the compounds of this attraction and projection would, according to my notion, cause a circular revolution of the earth about the sun.

Circular shape is so persuasively simple and indivisible to the eye that an ingenious effort was necessary to contradict it in this fashion. But by no means can Newton's conception be described as an emancipation from the senses. All that happened was that an elementary perceptual model had to be replaced with a more complex one. The tugging of two divergent forces from which the curvature results is not only less simple than the older image of a single agent swinging in the round; it also can be seen only indirectly, that is, by its product, and therefore requires the help of mental imagery. The model of, say, a stone tied to a string and swirled around must be applied to a cosmic swirl, which shows no string and therefore no attractive power.

Examples of this kind indicate how misleading it would be to pretend that in science the senses serve only to record data in the manner of a photographic camera and that the processing of the data is left to later and perhaps non-sensory operations. We find instead that direct observation, far from being a mere ragpicker, is an exploration by the form-seeking and form-imposing mind, which needs to understand but cannot unless it casts what it sees into manageable models. The earliest models are those suggested by appearance itself. Here, as I have shown earlier, the sense of sight tries for the

simplest pattern compatible with the given stimulus situation. This interaction between the demands of the object and the tendencies in the observer repeats itself at higher levels of understanding. Now the demands of the object are no longer limited to what strikes the eye but derive from a broader range of experience, to which the percept must conform. What Newton sees in the motions of the planets must agree with all he has seen of kinetic actions.

That we are dealing here indeed with perceptual operations can be illustrated by still another aspect of the same problem area. I mentioned that Aristotle thought natural movement to be sustained by an impetus inherent in the object itself. This was more than a theory about the nature of motion. It was, as we know from Michotte's experiments on the perception of causality, an inseparable aspect of what Aristotle saw. To see an object propelled by its own power is different from seeing it pushed by an external impulse or attracted from the outside. The forces involved in a visible action are a part of the percept itself, not something added later as an explanation, as David Hume thought when he asserted that "all events seem entirely loose and separate" and that they can be seen as being contiguous in time and space, but not as connected. The psychological experiments show that if, for example, a moving object comes to touch another one that is at rest and if thereupon the second object begins to move, this second movement will be seen either as being caused by the impact of the first, or simply released by the signal of the contact. Michotte has described the exact conditions that produce the one rather than the other experience spontaneously, and there can be no question but that the two percepts are fundamentally different. The same is true for the corresponding mental images. When Galileo visualized the planets as rotating not under their own power, but rather as being driven by an initial impulse, perpetuated through inertia, his perceptual image was no longer that of Aristotle. And it was this image of causal event that he described in his theory of inertia. The change that had come about was an instance of what in the psychology of thinking is known as the re-structuring of the problem situation. The pattern of forces seen in the given condition is altered in such a way as to produce a solution of the problem.

A reader may be willing to accept my contention that reasoning about the nature of the physical world takes place within perceptual imagery, but he may be reluctant to admit that the same is true for reasoning about non-sensory subjects. Actually, the kind of highly

abstract pattern I have been discussing is applicable to non-physical configurations as readily as to physical ones, because there again the concern is with patterns of forces, a purpose best served by exactly the same means. In fact, the approach is so similar that only by paying explicit attention to the difference in subject matter does one become aware of the ease with which the mind shifts from the one to the other.

The nonvisual made visible

The image of the sphere may serve as an example. It has been used through the ages to depict physical, biological, and philosophical phenomena. Here again one can observe how such a conception develops from simple beginnings to more and more refined conceptions. Roundness is chosen spontaneously and universally to represent something that has no shape, no definite shape, or all shapes. In this elementary sense, Parmenides represents the wholeness and completeness of the world by a sphere, which serves merely as a container for a homogeneous, indivisible mass of consistent density, unstructured except for its boundary. A first structural differentiation—and here again I discuss psychological, not historical stages—establishes the relation between center and circumference. In its most static version, this relation serves only to illustrate the contrast between the very large and the very small. Thomas Aquinas, for example, compares God, the all-encompassing, with the boundary surface of the sphere, whereas the center point represents the insignificance of the creature. A German mystic of the seventeenth century, Johannes Scheffler, conceives of a dynamic interaction between the two: the circular boundary contracts towards the center when man encloses God within himself, and vice versa, the center expands into the circumference as man dissolves in God's greatness. "When God lay hidden in a maiden's womb," Scheffler writes in one of his couplets, "the point contained the circle."

The dynamic relation between center and boundary expresses itself often in the assumption that the sphere originates by growing from the center, and that the center remains the controlling agent. This is the view of Johannes Kepler, who says that the central point is the origin of the circle and gives birth and form to the circumference. Correspondingly he sees all the mobile powers of the plane-

tary system as concentrated in, and issuing from, the energy of the centrally located sun. An analogous biological model may be found in Aristotle's image of the heart as the central organ of the animal body. The heart is considered the embryonic core from which the rest of the body grows and which continues to function as the central source of all vital energies. This is demonstrated by the vessels that distribute the blood in all directions. Inversely, the sensory messages converge from the circumference of the body toward the center.

The image of the sphere has been used by various Christian thinkers to clarify the concept of the Trinity. The center of the sphere (or circle), its circumference, and the space intervening between the two are sufficiently distinct parts and yet so integrated in the whole that they can depict the unity of the triad. Examples show how the same geometrical form can be structured quite differently depending on the pattern of forces seen in it. In the fifteenth century, for instance, Nicolas Cusanus has the Father, as the generative principle, hold the center, from which the Son issues as a power equal in kind to that of God. The Holy Ghost unifies the two and closes the whole by the circumference. A century or so later, Kepler changes this conception. "The image of the triune God," he writes, "is in the spherical surface, that is to say, the Father is in the center, the Son is in the outer surface, and the Holy Ghost is in the equality of relation between point and circumference." Here again the image implies more than an assignment of static locations. The Father is the source of origin, whose power, transmitted through the Holy Ghost as intermediary, is spread and revealed by the Son in all directions from the spherical boundary. Characteristic of the ease with which the meaning of visual models moves back and forth between the spiritual and the physical is Kepler's view that the image of the Trinity is manifest in the astronomical cosmos. God is personified in the sun, the source of light, motion, and life; the Son appears in the shell of the fixed stars, which reflects the sunlight like a concave mirror; and the Holy Ghost dwells in the space filled with the emanations of the sun and the air of the heavens. As a third example I will cite another Protestant mystic, Jacob Boehme, who also unites his theological and astronomical conceptions in one vision. Here the Son has moved into the center as the concentrated power of the sun; through the Holy Ghost the central power radiates in all directions; and the Father appears as the all-encompassing sphere of the heavens.

Models have limits

As the natural sciences insist increasingly on verifying their conceptions by exact observation, the image of the sphere is limited more and more strictly to physical structures that fit it closely. However, the geometrical shape which dominated the view of nature from the beginning because of the preference of the form-seeking mind for simplicity continues to be applicable to such principal patterns of the physical world as the solar system or the atomic model. This is more than a happy coincidence. If the psychological tendency towards simplest structure is referred back to its physiological base in the nervous system, it can be viewed as an application of the same law of nature which presses for balance, order, and regular shape throughout the physical universe. It is the tendency to a state of minimum tension, expressed most explicitly in the second law of thermodynamics.

The perceptual models of science are only simplified approximations of the actual states of affairs in the physical world. This is in the nature of the relation between the conceptions of the mind and their referents in nature. The ancient image of the concentric spherical system, still present in the cosmology of Dante, who relates the spheres of the planets to the seven liberal arts, and even in that of Copernicus, reappears in our own century in the atomic model of Rutherford and Bohr.

A few quick references may suffice to illustrate the dynamic patterns active in spherical models. I mentioned that even in the days of Galileo the planets were still assumed to rotate around a central earth or sun, in adherence to the perfect shape of the circle. In Newton's reinterpretation, the sun acts as the central attractive power, while the elliptical orbit of planets is viewed as a compromise resulting from a tug of war between the striving of the satellite to pursue its own course and that of the sun to draw it toward the center. In the atomic model, the negative charge of the electrons is balanced by an equal positive charge of the nucleus.

It should be clear that the meaning of visual models in science, precisely as that of form patterns in art, resides entirely in the perceptual forces they convey. At the same time, however, these forces cannot be represented directly by pictures or other physical objects; they can only be evoked by them. A picture of a circle and its central point does not contain the forces that it may evoke

in the image experienced by the observer. No physical object offers to the eye anything beyond shapes and colors, at rest or in motion. To be sure, the shades of darkness and brightness in a painting may produce such forces more effectively than does a simple outline drawing; and the motion added to the image in dance, theater, or film promotes the result even more actively. These are differences in degree, but the basic fact remains that perceptual forces come about in the nervous system, not in the picture as an object of the outer world. Therefore, the essential features of cognitive models exist only in percepts or mental images. But even these dynamic products of the mind are limited in their ability to represent dynamic events. Important aspects of the behavior of forces can be envisaged only approximately. Some of these will now be discussed because they illustrate the higher levels of complexity and subtlety that the human mind attempts to reach.

A process of interaction, for example, does not seem to be directly accessible to the mind. Its results can be apprehended intuitively, or its components can be represented separately by the intellect. The spherical models of the Trinity are frequently offered with the admonition that the three components must be understood not as separate entities but as inherent in each other. They do more than influence each other from fixed positions; and they do not simply generate each other. Rather the central point is supposed to dwell, extended, in the circumference, and the circumference lies contracted in the center, while the space between them is filled with their coexistence in various ratios. This sort of interaction, although met everywhere, can be conceived by the mind only in its separate ingredients or in its final result. Leibniz faced this problem when he saw the individual monad as the mathematical center point in which all the radii converge. Although without spatial extension, the center gathers nevertheless the infinity of sensory messages that arrive radially from everywhere and unfolds them inversely in a world of its own. This plurality in the unity can only be pointed to by human thought but not explicitly represented because an image can do only one thing at a time.

Figure and ground and beyond

Attention to the behavior of forces and the urge to represent them calls for images that can show continuous flow or, at least, contin-

uous extension. This need, however, is resisted by the mind, which starts its account of reality with self-contained, circumscribed shapes. All early imagery relies on the simple distinction between figure and ground: an object, defined and more or less structured, is set off against a separate ground, which is boundless, shapeless, homogeneous, secondary in importance, and often entirely ignored. In the psychology of perception, this elementary level of organization has been studied by Edgar Rubin. Independently, Gustaf Britsch described it for the arts; he formulated the earliest condition of visual thinking as follows: "An intended spot is detached from a nonintended environment by means of a boundary."

Britsch also foresaw the kind of comparison I am proposing here. In the words of Egon Kornmann,

he recognized that the immediate and specific cognition deriving from visual experiences precedes conceptual relations; and he found correspondingly that early cosmologies, e.g., in the pre-Socratics, will be seen in a new light if one understands the visual relations on which these conceptions are based. Thus, the early stage of an intended entity seen as segregated from an unintended environment (= apeiron) corresponds to a different conception of the world than does the stage at which the intended entity can be envisaged as passing without boundary into the unintended environment.

Following Britsch's clue, we find in fact the perceptual figure-ground relation directly reflected in the distinction which the Milesian philosophers, especially Anaximander, saw between a geometrically shaped world, constituted of the four elements, and the boundless, limitless, undefined matter *(apeiron)* creating it and surrounding it. The perceptual notions of shape and boundlessness were considered opposites. Mahnke has pointed out that Parmenides and later Plato still thought of boundlessness as something imperfect and therefore not truly existent.

An unbroken tradition also presents the human mind as a confined spherical entity, receiving messages from, and acting upon, an environment, which is separate and loosely defined. Kepler writes that "the faculties of the soul—the mind, the faculty of ratiocination, and even the sensitive faculty—are a sort of center whereas the motor functions of the soul are the periphery." Among the Romantic thinkers, Friedrich von Hardenberg sees the Self separated from its environment by a spherical boundary, whose external surface is outwardly oriented whereas the internal surface is related to the Self.

In our century, Freud's conception of the Id and the Ego retains essential features of the ancient model. The Id is the central source of blindly radiating energy. Under the impact of the physical environment, the outer sheath of the psyche develops the organs of sensory perception and becomes a protective bark against injuries from the outside. As an intermediary between the environment and the Self, the Ego reacts to the outer world and controls the libidinal aggressiveness of the Id in the interest of self-preservation. None of these conceptions transcends the basic perceptual pattern of figure and ground. Only the more recent biological and psychological approaches of Jacob von Uexküll, Kurt Lewin, and others have begun to view the interaction between organism and environment as processes within a continuum. Parallel developments in the physical sciences will be mentioned presently.

a b

Figure 75

In early stages of visual art an analogous development is apparent (Figure 75). When a child first attempts to draw a head in profile, (Figure 75a), he typically starts out with an unmodified circle as a base, to which he attaches nose, mouth, hair, neck, etc. The result is, as it were, a figure-ground situation seen in section. The circular line of the head serves as ground, on which the appendices sit as separate, self-contained entities. Later this duality fuses into one continuous shape, which contains the various secondary shapes as modifications (Figure 75b). This can be observed in pictures as well as in sculpture. The same refinement can change also the relation of the whole figure to its environment. For a long time, objects are shown in drawings and paintings as detached entities in front of

an empty or independently structured or colored foil, such as the textured gold ground of medieval paintings. Under certain conditions, the duality gives way here again to a continuously modulated pictorial surface. Instead of the neat distinction between foreground and background, the picture space consists, in European post-Renaissance painting, of an unbroken sequence of shape and color values. Britsch, Kornmann, and Schaefer-Simmern have analyzed examples from various styles of art in detail.

Is not the change from corpuscular theory to field theory in physics an example of the same perceptual development? In the corpuscular view, well defined, self-contained objects are seen as "figure" in empty or otherwise qualitatively different space, which serves as "ground." The traditional image of the planetary system is of this nature, and so is the atomic model of Rutherford and Bohr. Such clear-cut distinctions are easy to visualize. Notice now the peculiar blend of discomfort and elation which one experiences when such a system is redefined as a continuous electro-magnetic field, in which the objects or particles may be thought of according to Erwin Schrödinger, as "more or less temporary entities within the wave field whose form and general behavior are nevertheless so clearly and sharply determined by the laws of waves that many processes take place *as if* these temporary entities were substantial permanent beings." The former image is changed in several ways. The dichotomy between empty ground and actively engaged objects has been eliminated. James Clerk Maxwell said of Michael Faraday, the father of field theory:

Faraday, in his mind's eye, saw lines of force traversing all space, where the mathematicians saw centres of force attracting at a distance; Faraday saw a medium where they saw nothing but distance; Faraday sought the seat of the phenomena in real actions going on in the medium, they were satisfied that they had found it in a power of action at a distance impressed on the electric fluids.

Also eliminated is the separation of matter and force. Now, the object is a bundle of energy. And with this fundamental change from state of affairs to dynamic event goes furthermore the suggestion that situations are not unalterable, but subject to change in time.

Great pleasure goes with this animation of a formerly static concept. But the change to a model of higher complexity also arouses apprehension. The neat circumscription of objects—expressed in

drawings by a determined contour line—must be abandoned, and the timeless stability of concepts, cherished by the thinker, no longer has its counterpart in the world these concepts describe.

Infinity and the sphere

There is also the dread of the endless. "I protest against the use of infinite magnitude," exclaimed the mathematician Gauss in the nineteenth century; it is "never permissible in mathematics." Some examples of visual models representing the infinite will be profitable to the purpose of the present chapter because they illustrate the limits of human perception and therefore of human understanding. The mathematician can no more conceive of infinity than can the average person. He deals with it by two approximations. He can start a sequence and propose to have it continue forever. The sequence of positive integers, 1, 2, 3, . . ., is an example. "We cannot include the symbol ∞ in the real number system and at the same time preserve the fundamental rules of arithmetic," caution Courant and Robbins. Or, the mathematician thinks of a container filled with an infinite quantity of items, as did Georg Cantor in his theory of sets. Both ideas derive from perceptual images.

When children wish to depict the radiant sun or a lamp, they draw a group of radii issuing from a central point or disc. The radial lines, limited in length, nevertheless represent limitless extension. Here are lines of force moving in all directions from a definite base. It is one-sided infinity, as it were, with a beginning at one end, just like the sequence of positive integers in arithmetic. The geometrical sunburst pattern is the image by which Plotinus conceived of the action of the spirit. According to his philosophy, God in his uniqueness is related to the multiplicity of intelligible ideas as is the center to the radii, and so is the world soul to the individual souls, and the individual soul to its various activities in the body. Yet Plotinus' spiritual sphere is neither finite like the sphere of the physical universe, nor is it spatially infinite. Thus, although Plotinus treats infinity as a positive feature of existence, the relation between shape and infinity is still unresolved.

According to Mahnke's thorough historical investigation, a source of the twelfth century, the *Book of the Twenty-four Philosophers,* presents for the first time the formula that later became famous through the writings of Cusanus and Giordano Bruno: "God is an

infinite sphere, whose center is everywhere and whose circumference is nowhere." Originally applied to God, the image is used by Cusanus also for the Universe, God's creation, and the Renaissance considers it suitable also for the individual human mind (Marsilio Ficino). Here, then, the image of the finite container makes explicit contact with the notion of the infinite—an anticipation of the step taken by exact mathematics around the turn of our century.

Infinity did appear in the classical philosophy of nature as a positive feature—that is, not just as a shapeless background—in an approach that limited shape to the smallest units of matter. The Atomists—Leucippus, Democritus, Epicurus, and later Lucretius—treated the universe as uniform and infinite, although they conceived of it not as a continuum but as a multitude of corpuscles milling through empty space. In the view of the Atomists, the world had no centre; but they simply rejected centricity as "an idle fancy of fools," as Lucretius puts it. "There can be no centre in infinity." They did not resolve the conflict between the image of the centric world, based on the powerful experience of the Self as the reference point for its environment, and that of endless homogeneity. This problem was faced only with the image of the infinite sphere. Let us remember in passing that two contemporaries of Cusanus, the Italian artists and architects Alberti and Brunelleschi, introduced infinity into painting through the geometrical construction of central perspective. This construction, however, contained the paradox of locating the infinite in a definite point of pictorial space. It represented the infinitely large by the infinitely small, and it made the world converge rather than expand. Only later did painting attempt to convey the experience of endless space, most notably on the ceilings of Baroque buildings.

Cusanus spoke of the center in an endless world not just negatively as absent. He saw it as everywhere and anywhere. He realized that the earth could not be in the middle of the world and that all motion is relative. We can recognize a movement, he said, only by comparison with something stable, such as poles or centers, the relation to which we presuppose in our measurements of motion. He thereby laid the groundwork for the relativism of the twentieth century. Relativism as a concrete procedure calls for a rather complex imagery, namely, the coordination of at least two mutually exclusive systems—one for which an object is in motion and another for which the same object is at rest. Probably this can be visualized only by the alternation of the two images, similar, for example,

to what happens in the reversal of figure and ground or to the co-ordination of the inside and the outside of a building in architecture. It is through this detachment from either frame of reference that the mind attempts to assume the outside position of Einstein's pure absolute.

Is it legitimate to place speculations of the past on an equal footing with modern theories based on exact observation and calculation? It is, for the purposes of this book, since I am not concerned with the trustworthiness of constructs but with their perceptual shape—their *themata,* as the physicist Gerald Holton has called the underlying principles of scientific conceptions. He refers to thought models that derive neither from empirical statements, such as meter readings, nor from analytical ones, reliant on the calculus of logic and mathematics. Holton does not wish to commit himself as to whether these *themata* should be associated "with any of the following conceptions: Platonic, Keplerian or Jungian archetypes or images; myths (in the non-derogatory sense, so rarely used in the English language); synthetic a priori knowledge; intuitive apprehension or Galilei's 'reason'; a realistic or absolutistic or, for that matter, any other philosophy of science." I am treating these *themata* as mental images, and I trust that even persons who like to distinguish modern science in principle from what preceded it, will be struck by the formal resemblances discussed here.

Modern cosmology still oscillates between the two basic images first conceived by the Greeks. In the eighteenth century, such thinkers as Thomas Wright and Immanuel Kant suggested that the solar system is a part of a galaxy and that universal space is filled with more galaxies similar to ours. Thus by empirical generalization they made new contact with the Atomist conception of a homogeneously filled infinite expanse. How similar this approach was to that used in arithmetic progression was explicitly realized by Kant:

We see the first members of a progressive relationship of worlds and systems; and the first part of this infinite progression enables us already to recognize what must be conjectured of the whole. There is no end but an abyss of a real immensity *(ein Abgrund einer wahren Unermesslichkeit),* in presence of which all the capability of human conception sinks exhausted, although it is supported by the aid of the science of number.

The generalization suggested by these thinkers required bold restructuring of direct perceptual evidence, which thereby was

made to fit quite a different image. To see the solar system as woven into the circular band of stars, which appears to surround the earth as the distant Milky Way, and then to see the galaxy as being elliptical and thereby making it comparable to the specks of nebulae such as that of Andromeda, required an extraordinary flexibility of visual imagination. The example also shows again how the removal from primary evidence does not mean removal from perception but rather the shifting from one perceptual model to another.

The image of endless continuity was supplemented with that of a centered universe in order to account for the origin of it all. Although "in an infinite space no point can properly have the privilege to be called the centre," Kant assumed that one area of greatest density had served as the fulcrum, from which nature originated by spreading in all directions of infinite space. Here then we are back at the Plotinic image of radiation from a center of energy—a conception reflected again in the recent theory of the expanding universe which, according to Georges Lemaître, developed from an atomic nucleus. And we cannot but recall the infinite sphere of the Middle Ages, whose center was nowhere and everywhere, when we watch the astronomer Fred Hoyle illustrating, in 1950, the idea of the expanding universe by the analogy of a balloon with a large number of dots on its surface and blown up gradually to infinite size:

The balloon analogy brings out a very important point. It shows we must not imagine that we are situated at the center of the universe, just because we see all the galaxies to be moving away from us. For, whichever dot you care to choose on the surface of the balloon, you will find that the other dots all move away from it. In other words, whichever galaxy you happen to be in, the other galaxies will appear to be receding from you.

Nicolas Cusanus, reading this, would have found himself on familiar territory.

The stretch of imagination

It may be well to conclude this chapter with a remark on the notions of the fourth spatial dimension and so-called "curved space," often mentioned in connection with Einstein's general theory of relativity. Einstein's vision of a finite but boundless world—although by now apparently abandoned in favor of an "open uni-

verse"—deserves to be mentioned as the most refined attempt to reconcile spherical shape and infinity in physics. The fourth spatial dimension, on the other hand, is a purely mathematical construct, a first step in a geometry of the higher dimensions. Whether or not this mathematical extension leads to models that can be visualized has been debated in the literature. The chances are that if it is accessible to mental imagery at all, it will be so by approximation only or, more likely, by its effects or by its projections into three dimensional space. I will not go into this problem.

A different kind of extension beyond the third spatial dimension has been used to make non-Euclidean geometry plausible. Applied to astronomical physics, this approach has led in popular discussion to the mistaken notion that the theory of relativity proposed the existence of a fourth spatial dimension in our universe, a dimension needed to make room for "curved space." This misunderstanding led to the suggestion that modern science had reached the limit beyond which its constructs are closed to visual imagination, not only in practice but in principle.

Perhaps Helmholtz, in one of his *Popular Scientific Lectures,* was the first to illustrate the properties of non-Euclidean space by the analogy of an imaginary population living in a two-dimensional world. If their world were the surface of a sphere, Euclidean geometry would not hold. The shortest connection between two points would not be a straight line; the sum of the angles in a triangle would vary and would always be larger than 180°; the ratio between the radius and the circumference of a circle would also vary, depending on the size of the circle. Now suppose, so the demonstration goes, this whole situation is transposed by one dimension, then we have a three-dimensional world curved in four-dimensional space. At this point, visual imagination capitulates to science fiction, because the proposed step along a mathematical sequence does not simply extend a perceivable dimension quantitatively beyond the range of visual imagination—as in the cases of the infinitely large or small—but makes an assumption that is incompatible in principle with human spatial experience. Helmholtz says that "we find ourselves by reason of our bodily organization quite unable to represent a fourth dimension." Whether or not this is true, is, as I mentioned, under discussion. If it is, however, then probably not for the reason that our three-dimensional brains are incapable of imagining an actually existing four-dimensional world. If such a world existed, our brains could be expected to be four-dimen-

sional also. The analogy with the flatland world seemed to suggest that there could be beings equipped with one dimension less than the space in which their world dwelled, and that consequently they would be unable to conceive of three-dimensional volume. This, however, is nonsense. As soon as we pass from a purely mathematical analogy to a physical one, we must recognize that in order for those hypothetical beings and their world to exist they would have to possess a minimum of thickness; and so would their brains. Physically and mentally they would not be two-dimensional; they would just be cramped.

If a fourth spatial dimension cannot be visualized, it is probably because geometry is concerned with relations that can use perceptual and physical space as a convenient image up to the third dimension, but no further. Beyond that limit, geometrical calculations—just as any other multidimensional calculations, such as factor analysis in psychology—must be content with fragmentary visualization, if any. This also means probably putting up with pieces of understanding rather than obtaining a true grasp of the whole.

No fourth dimension of space, however, is in fact claimed to exist by modern physics. It is, in the words of Arthur Eddington, "a fictitious construction." To return once more to the analogy of the hypothetical two-dimensional world: as long as that world is thought of as indeed curved in three-dimensional space, nothing about its geometry contradicts Euclid's *Elements* in principle, although it does not agree, of course, with what he says about geometry in a flat plane. Something truly new takes place only when those geometrical distortions are found in a world not known to be curved or, in fact, not curved in reality. In such a world, the deviations from Euclid become inhomogeneities of space. The time it takes to traverse a unit of distance may increase with the length of the road; and if one walks long enough in the same direction one may find oneself in the place one started from.

This sort of thing can happen in three-dimensional non-Euclidean space. To call it curved is a figurative way of calling it inhomogeneous; and inhomogeneity is found, according to Einstein, in the three-dimensional space of our universe. He says that "according to the general theory of relativity the geometrical properties of space are not independent but determined by matter;" the geometry

of the universe turns out to be distorted by gravitational fields. A layman cannot tell whether the analogy of an appropriately curved surface world is sufficient to let the mathematician or physicist calculate the effect of the corresponding inhomogeneities in three-dimensional space. What he can tell is that when the metaphor is taken for a literal description of what goes on in the universe, imagination is led astray.

If, then, the modern conception of physical space is not closed to visualization in principle, the question remains whether it is accessible in practice. Non-Euclidean situations do not seem to be forever excluded from sight. In another book I described the perspective of space perception as an example: objects shrink with increasing distance from the observer, yet they are seen also as remaining the same size; motion is seen as accelerating with distance although it is seen as remaining constant at the same time. Contradictory in Euclidean terms, these phenomena fit nevertheless into a reasonably consistent view of the visual world because the inhomogeneity of perceptual space is built into the experience of vision as a constant condition.

Whether the inhomogeneities of physical space can be visualized by an imagination more developed than that of the average person today is hard to tell. H. P. Robertson uses the example of a metal plate unevenly heated; a short metal rule, changed in length by the temperature, would give measurements revealing an inhomogeneous geometry. Morris Kline compares the geodesics created in Einsteinian space by the presence of a mass with those created by the shape of mountains on the surface of the earth. How much such analogies help, practical experience will tell. Perhaps, here again, approximations can be attained. Whatever the answer, it seems safe to say that only what is accessible to perceptual imagination at least in principle, can be expected to be open to human understanding. To be sure, the mind can make useful gains that do not involve comprehension and perhaps need not do so. There are many operations we can perform, many facts we can know, many partial aspects we can visualize quite clearly, but without full understanding. Just as a complex painting or symphony can be put together and grasped, even by its maker, only through acts of partial organization, so every great work of man is probably greater than the mind that made it.

16. Vision in Education

This book has attempted to re-establish the unity of perception and thought. Visual perception, far from being a mere collector of information about particular qualities, objects, and events, turned out to be concerned with the grasping of generalities. By furnishing images of kinds of qualities, kinds of objects, kinds of events, visual perception lays the groundwork of concept formation. The mind, reaching far beyond the stimuli received by the eyes directly and momentarily, operates with the vast range of imagery available through memory and organizes a total lifetime's experience into a system of visual concepts. The thought mechanisms by which the mind manipulates these concepts operate in direct perception, but also in the interaction between direct perception and stored experience, as well as in the imagination of the artist, the scientist, and indeed any person handling problems "in his head."

If these affirmations are valid, they must profoundly influence our view of art and science, and all the rest of cognitive activity located between these poles. Art has been discussed here principally as a fundamental means of orientation, born from man's need to understand himself and the world in which he lives. As I mentioned before, the various other purposes served by art can be shown to depend on this basic cognitive function. Art, then, approaches the means and ends of science very closely, and for the present purpose it is more important to recognize how much they have in common than to insist on what distinguishes them. Some of the differences, however, will come up in the course of this final chapter.

294

What is art for?

Perhaps the arts have been prevented in our time from fulfilling their most important function by being honored too much. They have been lifted out of the context of daily life, exiled by exultation, imprisoned in awe-inspiring treasure-houses. Schools and museums, especially in our own country, have done much to overcome this isolation. They have made works of art more accessible and familiar. But works of art are not the whole of art; they are only its rare peaks. In order to regain the indispensable benefits of art, we need to think of those works as the most evident results of a more universal effort to give visible form to all aspects of life. It is no longer possible to view the hierarchy of art as dominated by the fine arts, the aristocracy of painting and sculpture, while the so-called applied arts, architecture and the other varieties of design, are relegated to the base of the pyramid as impure compromises with utility. The artists of our time have gone a long way in making the old categories inapplicable by replacing the traditional works of the brush and the chisel with objects and arrangements that must merge in the environment of daily life if they are to have any place at all. One more step, and the shaped setting of all human existence becomes the primary concern of art—a setting in which the particular objects of fine art find their particular place.

This broader concept, which the late Ananda K. Coomaraswamy defended so lucidly as "the normal view of art," must be supplemented by a psychological and educational approach that recognizes art as visual form, and visual form as the principal medium of productive thinking. Nothing less will serve to free art from its unproductive isolation.

At the beginning of this book, I referred to the widespread neglect of art at all levels of our educational system. This situation prevails largely because art educators have not stated their case convincingly enough. If one looks through the literature on art education one often finds the value of art taken so much for granted that a few stock phrases are considered sufficient to make the point. There is a tendency to treat the arts as an independent area of study and to assume that intuition and intellect, feeling and reasoning, art and science coexist but do not cooperate. If it is found that high school students know little about art history or cannot tell an etching from a lithograph, or an oil painting from a water color, the consequences to be drawn will depend, I should think, on how impor-

tant this sort of knowledge can be shown to be. If it is claimed that the value of the arts consists in developing good taste, the weight of the argument depends on whether taste is a luxury for those who can afford it or an indispensable condition of life. If art is said to be a part of our culture and therefore necessary to the equipment of every educated person, the responsible educator must ask himself whether all parts of this culture are needed for all and are accessible to all, and whether they are all equally relevant. If we hear that the arts develop and enrich the human personality and cultivate creativity, we need to know whether they do so better than other fields of study and why. The battle against one-sided intellectualism cannot be fought by nourishing a Romantic prejudice against the sciences as agents of mechanization. If the present practice of the sciences does indeed impoverish the human mind, the remedy may have to be sought in the improvement of science education and not in an escape from the sciences to the arts as a refuge. Nor are pedantry, sterility, and mechanization found only in the sciences; they are equally present in the arts.

Once it is recognized that productive thinking in any area of cognition is perceptual thinking, the central function of art in general education will become evident. The most effective training of perceptual thinking can be offered in the art studio. The scientist or philosopher can urge his disciples to beware of mere words and can insist on appropriate and clearly organized models. But he should not have to do this without the help of the artist, who is the expert on how one does organize a visual pattern. The artist knows the variety of forms and techniques available, and he has means of developing the imagination. He is accustomed to visualizing complexity and to conceiving of phenomena and problems in visual terms.

Pictures as propositions

Artists and art teachers put these talents to good use when they act on the implicit assumption that every art work is a statement about something. Every visual pattern — be it that of a painting, a building, an ornament, a chair — can be considered a proposition which, more or less successfully, makes a declaration about the nature of human existence. By no means need such a declaration be conscious. Few artists would be so able to tell in words what

they intend to say, as was, for instance, Van Gogh. Many would refuse to do it, and experience has shown that artists driven by the desire to convey definite messages, such as those of a moral or social nature, are likely to fail. They are in danger of tying their imagery to stereotyped symbols. Correspondingly, insistence on such spelled-out meanings is risky in art education. However, exercises of the kind I described in chapter 7 might be quite helpful. "Abstract" representations of concepts, such as *Past, Present, Future,* could fulfill a function very similar to that of doing a portrait, still life, or landscape. They could set a particular pattern of forces as a target. In order to work out an image that truly represents the student's conception of the subject, he must be resourceful, disciplined, insistent; and this is what is takes to produce art and to make its practice educationally fruitful. The rather theoretical themes used in the experiments can be supplemented with more evocative ones, of the kind used by Paul Klee as titles for his pictures: *From Gliding to Rising; Rejuvenation; Beginning Coolness; Pride; Against the Tide; Searching and Finding; Last Hope; Nasty Music.*

Such exercises can help the student to realize that no standard of right or wrong can derive from purely formal criteria. Harmony, balance, variety, unity, are applicable only when there is something definite to express, be it consciously explicit or not. The handling of shape and color is as much a search for this content and its crystallization as it is an effort to render the content clearly, harmoniously, in a balanced, unified fashion. Exercises of this kind will also suggest to the student that any organized pattern is a carrier of meaning, whether intended or not. Similarly, it follows from this approach that the mere spontaneous outburst, the mere loosening-up and letting-go, is as incomplete a performance artistically as it is humanly. The purely Dionysian orgy, while pleasurable and sometimes needed as a reaction to restraint, calls for its Apollonian counterpart. The outlet of energy aims at the creation of form.

The depicting of natural objects, which has occupied the arts traditionally, is not different in principle from the symbolic representation of concepts. To make a picture of a human figure or a bunch of flowers is to grasp or invent a generic form pattern or structural skeleton. This sort of practice is a powerful aid in establishing the perceptual basis of cognitive functioning. No such training of the mind is accomplished by the mechanical copying of

models, aimed at measurable correctness and employing the sense of sight as a measuring tool. Exact reproductions are useful for practical purposes but are made more reliably by machines, and the skill of estimating measurable quantities correctly is insignificant and better entrusted to instruments. The human brain is not suited for mechanical reproduction. It has developed in biological evolution as a means of cognitive orientation and therefore is geared exclusively to the performance of kinds of action and the creation and recognition of kinds of things.

And yet, the days in which faithful copying was considered the main educational purpose of painting and drawing are not all too far behind us. Early in our own century, a leading art educator, Georg Kerschensteiner, stated that the representation of the human figure could not be a suitable objective of drawing in the public schools because the reproductions of which the children are capable would match appearance and shape only partially and, at best, in generic approximation. "Instruction in drawing, however, can no more be satisfied with mere approximations than can any other field of teaching."

This purely quantitative criterion of what makes a successful image was, of course, derived from the exact sciences as they had developed since the Renaissance. But it is worth remembering that even in the sciences measurable exactness is not an ultimate value in itself but only a means of ascertaining the nature of relevant facts. The degree of exactness required of measurements depends on the nature of the facts to be identified and distinguished. The quantitative evidence of experiments must be carried far enough to show that the results are not due to accident, that is, to the noise inherent in every empirical situation. The measurements used by Kepler to determine the paths of the planets had to be precise enough to distinguish ellipse from circle with certainty. The same was true for the measurements of Ivan Pavlov, who wanted to find out whether dogs could distinguish ellipses from circles. Pavlov refined his data enough to ascertain how subtly the dogs discriminated shape and how similar the shapes had to be in order to make his subjects uneasy. The range of tolerance in scientific and technological measurements is determined by the nature of the task. Exactness beyond need is pedantry, and the final curiosity of the scientist is not satisfied by numbers. When he learns that the human germ cell contains 46 chromosomes, he wants to know why this

is so, and the final answer cannot be a quantity. Both science and art, then, are after qualitative facts, and measurements are means to an end in both.

Standard images and art

If the mechanical copying of nature will not do, how about Johann Pestalozzi's ABC of visual understanding (*Anschauung*), which he placed ahead of the ABC of letters because "conceptual thinking is built on *Anschauung*"? What Pestalozzi had in mind, in those early years of the nineteenth century, deserves our attention:

I must point out that the ABC of *Anschauung* is the essential and the only true means of teaching how to judge the shape of all things correctly. Even so, this principle is totally neglected, up to now, to the extent of being unknown; whereas hundreds of such means are available for the teaching of numbers and language. This lack of instructional means for the study of visual form should not be viewed as a mere gap in the education of human knowledge. It is a gap in the very foundation of all knowledge at a point to which the learning of numbers and language must be definitely subordinated. My ABC of *Anschauung* is designed to remedy this fundamental deficiency of instruction; it will ensure the basis on which the other means of instruction must be founded.

For this admirable purpose, however, Pestalozzi forced the children to draw angles, rectangles, lines, and arches, which, he said, constituted the alphabet of the shape of objects, just as letters are the elements of words. His manner of approach had its adherents throughout the nineteenth century. Peter Schmid made his pupils draw accurate likenesses of basic stereometric bodies, spheres, cylinders, slabs, as building stones of the more complex objects of nature, and as late as 1893, Konrad Lange suggested that the teacher put on the blackboard geometrically simplified line drawings of table, chair, flag, bed, or church, to be copied by the children. This use of geometrical guides in drawing goes at least as far back as Villard de Honnecourt's sketchbook, in which this French architect of the thirteenth century showed how to develop human figures or animals from triangles, rectangles, or star patterns.

There is merit in deriving the shape of an image from its underlying structural skeleton. In fact, artists commonly begin their work by sketching the overall patterns, which serve to hold it together. This procedure, however, must be distinguished, on the one hand, from mere trick techniques for the production of stereotyped draw-

ings, and, on the other, from sets of rigidly prescribed forms, to be copied by the faithful student. This latter approach suggests to the student that there is one standardized and objectively correct shape to each kind of object and that the actual specimens encountered in the world are to be considered mere elaborations of this archetype. It is one thing to recognize the core of psychological and physical truth in this conception, and another to base the strategy of art education on it. For through art man acknowledges the full wealth of particular appearance. Instead of imposing pre-established schemata upon these appearances, he searches them for graspable forms and responds with such forms in reaction to what he sees. The form patterns suggested by a landscape or still life relate, when taken in their uniqueness, only quite indirectly to the standard shapes and meanings of trees or farm houses or artichokes or fishes. The validity such patterns acquire in art is not primarily that of reporting about the subject matter as such but about much more generic patterns of forces reflected by the particular configuration. I mean to say that when van Gogh confronts the figure of a sower with a large, yellow sun, he makes a statement about man and light and labor that takes little more than its terminology from the standard form and character of the objects involved. He would have been hamstrung rather than helped by being required to copy standard figures of sun, man, and tree.

In the arts, then, the student meets the world of visual appearances as symbolic of significant patterns of forces in a manner quite different from the scientific use of sensory information. Sights that are accidental with regard to the objective situation become valid as carriers of meaningful patterns and can be called truthful or false, appropriate or inappropriate by standards not applicable to the statements of science. But art not only exploits the variety of appearances, it also affirms the validity of individual outlook and thereby admits a further dimension of variety. Since the shapes of art do not primarily bear witness to the objective nature of the things for which they stand, they can reflect individual interpretation and invention.

Both art and science are bent on the understanding of the forces that shape existence, and both call for an unselfish dedication to what is. Neither of them can tolerate capricious subjectivity because both are subject to their criteria of truth. Both require precision, order, and discipline because no comprehensible statement can be

made without these. Both accept the sensory world as what the Middle Ages called the *signatura rerum*, the signature of things, but in quite different ways. The medieval physicians believed that yellow flowers cure jaundice and that bloodstone stops hemorrhage; and in a less literal sense modern science still searches the appearance of things for symptoms of their character and virtues. The artist may use those yellows and reds as equally revealing images of radiance or passion; and the arts welcome the multiplicity of world views, the variety of personal and cultural styles, because the diversity of response is as legitimate an aspect of reality as that of the things themselves.

This is why the criteria of exactness in art are quite different from those in science. In a scientific demonstration, the particular appearance of what is shown matters for the validity of the experiment only to the extent to which it is symptomatic of the facts. The shape of containers, the size of dials, the precise color of a substance may be irrelevant. Similarly, the particular proportions, angles, colors of a diagram may not matter. This is because in science the appearances of things are mere indicators, pointing beyond themselves to hidden constellations of forces. The laboratory demonstration and the diagram in the textbook are not scientific statements but only illustrations of such statements. In the arts the image is the statement. It contains and displays the forces about which it reports. Therefore, all of its visual aspects are relevant parts of what is being said. In a still life, the particular colors and shapes of the bottles and their arrangement are the form of the message presented by the artist.

Looking and understanding

The arts tell the student about the significance of direct experience and of his own response. In this sense, they are complementary to the message of science, where direct experience must be transcended and the individual outlook of each observer counts only to the extent to which it contributes to shaping the one common conception of the phenomenon under investigation. When a student of biology or psychology looks at a piece of nature or a sample of behavior, he cannot be satisfied with organizing what he sees into a visual image. He must try to relate this direct image to another one, namely, that of some mechanism operative in the perceived

object or happening. This relation is not often simple because nature was not shaped with the purpose of disclosing its inner workings and functions to human eyes. Nature was not fashioned by a designer. Its visual appearance is only an indirect by-product of its physical being.

The experienced physician, mechanic, or physiologist looking at a wound, an engine, a microscopic preparation, "sees" things the novice does not see. If both, experts and laymen, were asked to make exact copies of what they see, their drawings would be quite different. N. R. Hanson has pointed out that such "seeing" is not simply a matter of tacking different interpretations to one and the same percept, — of requiring visual grist to go into an intellectual mill. The expert and the novice see different things, and different experts see differently also:

To say that Tycho and Kepler, Simplicius and Galileo, Hooke and Newton, Priestley and Lavoisier, Soddy and Einstein, De Broglie and Born, Heisenberg and Bohm all make the same observations but use them differently is too easy. It does not explain controversy in research science. Were there no sense in which they were different observations they could not be used differently.

But how can the same retinal imprint lead to different percepts? What exactly do different observers see differently? First of all, many sights are ambiguous because they are so vague that they can be organized according to various patterns or because they admit more than one clear-cut organization. Every textbook of psychology

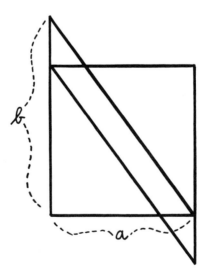

Figure 76

shows reversible images oscillating between two mutually exclusive versions; but they are only the most obvious demonstration of the fact that most visual patterns can be seen in more than one way. Max Wertheimer gives the example of a geometrical problem solved most easily by the restructuring of a figure (Figure 76). The perceptual tendency toward simplest structure favors the view of a square overlaid by an oblique parallelogram; but in order to find the area of square plus parallelogram when lines a and b are given, the figure is better seen as a combination of two overlapping triangles, each with the area $\dfrac{a\,b}{2}$. Here the same visual stimulus yields two different percepts through two different groupings of the elements, one of them better suited to the solution of the problem than the other. If the observer happens to have right-angular triangles on his mind, he is likely to hit on the solution more easily. Better still, if he were shown an animated cartoon with two triangles roaming on empty ground and finally coming to rest in the position of Figure 76, he should have no trouble at all. A congenial context would guide his perception.

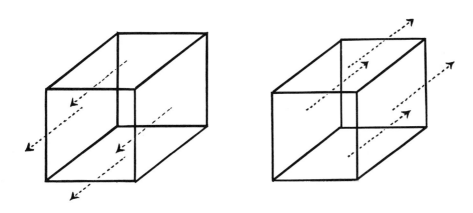

Figure 77

In other instances it is not the grouping of the elements that changes, but the character of the dynamic vectors. The spatial orientation of the reversible cube (Figure 77) depends on the direction in which the diagonal vectors are seen to move. Since these perceptual vectors are given only through the shapes, the same figure can often carry more than one pattern of forces.

In many instances, the desired goal pattern can be directly perceived in the problem situation. The two triangles can be seen in Figure 76. Armed with the image of what to look for, the hunter, the birdwatcher, the mathematician or microscopist recognizes it within the complexity of given shapes. Pertinent here are also the instances in which a percept is supplemented or completed by earlier visual experience. The expert sees a missing part as a gap in an incomplete whole. A footprint in the sand makes us see the foot that is not there. A student who has been told about the continental drift sees the outlines of the African and American continents not as separate, capricious shapes but as fitting together like tongue and groove or male and female. Instead of two masses, he now sees only one, torn apart. The dynamics of the separation of the halves, seen as belonging together like the pieces of a broken pot, are a genuine component of the percept itself, not just an inference.

However, the perceptual solution of a problem does not require that the image on which the crucial thought operation is performed be seen in the problem situation itself. In order to accomplish the heliocentric revolution, it was not necessary for Copernicus, as Hanson assumes, to "see the horizon dipping, or turning away, from our fixed star." For thousands of years, astronomical observations had been related to cosmic models of rotating spheres and shells, and the visual transformations needed to establish this relation between direct observation and "pure shapes" are well within the range of perceptual versatility. Copernicus had to rely on the further image of the relativity of movement, an observation familiar to him from daily experience, and the decisive restructuring consisted in applying the effects of relative motion to the cosmic model, not to what he perceived at sunrise.

Although in such cases the direct observation and the model on which the restructuring is performed are two separate images, they are nevertheless related perceptually. This continuity, which unites all relevant aspects of the phenomenon under investigation is necessary for understanding. Of course, many useful relations can be discovered or learned which connect certain items of experience by mere association. One can stumble on the fact that curare slackens the muscles or learn that the switch of the thermostat changes the temperature, without any conception of the events causing these effects. Much human competence and even some progress derive from the practice of such connections, but since mechanical conditioning lets the mind bypass the relevant facts

it does not involve truly productive thinking and surely cannot serve as a model of it.

Figure 78. Paul Klee: Drawing of the human heart. With permission of the Paul Klee-Stiftung, Kunstmuseum, Bern; and SPADEM, 12 rue Henner, Paris.

How illustrations teach

When the mind operates in the manner of the scientist, it looks for the one correct image hiding among the phenomena of experience. Education has to bridge the gap between the bewildering complexity of primary observation and the relative simplicity of that relevant image. For the purpose of science, education must do precisely what it needs to avoid in the teaching of art, namely, provide a sufficiently simple version of that final image, whenever the student cannot be expected to discern it by himself in the intricate sight of the real thing. Think of a student trying to understand the shape and functioning of the human heart. The heart's twisted chambers, its tangled arteries and veins, the asymmetry of shapes and locations serving symmetrical functions tax the senses of the observer more confusingly than if he tried to unravel the serpents of the Laocoon group. Eventually the student must learn to see the simple principle in this baroque spectacle; he may even want to understand why nature came to fulfill a simple physiological function with so much contortion. But his road to that goal will be needlessly arduous unless he is given a target image as a sort of template. Figure 78 shows a drawing made by Paul Klee to explain to his students the functioning of the human heart. All shape

has been radically reduced to the simplest representation of the basic processes. Volume and pathways have been confined to a two-dimensional plane. The chambers, deprived of their internal subdivision, have become symmetrical. Equally symmetrical are the two circuits, the one sending the blood to the lungs for purification and returning it to the heart, the other picking it up and sending it to work through the body and back to the central pump. Some of Klee's anatomical liberties may be misleading; but he has used the freedom of an artist's pictorial imagination to present the basic essentials of the subject with the simplicity of a child's drawing. Once the student has grasped the principle he can move to closer approximations of the intricate real situation.

In the educational practice, learning through perceptual abstraction must be guided by suitable illustrations. This is often done with great ingenuity. For example, the visual information on the pages of the *Scientific American* is consistently excellent. Some textbooks do equally well. Others let their designers get away with "artistic" embellishments, which serve the misguided self-respect of the commercial artist but confuse the reader. Or again, illustrations may not be geared carefully enough to the particular level of abstraction that fits a student at a given stage of his mental development and of his acquaintance with a given subject matter. Much progress has been made since the medical textbooks of the Middle Ages showed how to apply leeches or treat a bone fracture by depicting doctor and patient in full costume and surrounded with a completely equipped office and dispensary. But the decision of how much to reproduce faithfully and how much to simplify requires educational experience and visual imagination. It must be precisely coordinated with the abstraction level of the teaching. How much detail should a geographical map contain? How much visual complexity can be grasped by the student?

The problem is particularly acute when students are required to make their own drawings. At a level of development at which the free art work of the child still employs relatively simple geometrical shapes, the art teacher may respect his pupils' early stage of visual conception, but in geography class the same children may be compelled, perhaps by the same teacher, to trace the coastlines of the American continent or the irrational windings of rivers — shapes that can be neither perceived nor understood nor remembered. When a college student is asked to copy what he sees under the microscope, he cannot aim, mechanically, for mere accuracy and

neatness. He must decide what matters and what types of relevant shapes are represented in the accidental specimen. Therefore, his drawing cannot possibly be a reproduction; it will be an image of what he sees and understands, more or less actively and intelligently. The discipline of intelligent vision cannot be confined to the art studio; it can succeed only if the visual sense is not blunted and confused in other areas of the curriculum. To try to establish an island of visual literacy in an ocean of blindness is ultimately self-defeating. Visual thinking is indivisible.

The lack of visual training in the sciences and technology on the one hand and the artist's neglect of, or even contempt for, the beautiful and vital task of making the world of facts visible to the enquiring mind, strikes me, by the way, as a much more serious ailment of our civilization than the "cultural divide" to which C. P. Snow drew so much public attention some time ago. He complained that scientists do not read good literature and writers know nothing about science. Perhaps this is so, but the complaint is superficial. It would seem that a person is "well rounded" not simply when he has a bit of everything but when he applies to everything he does the integrated whole of all his mental powers. Snow's suggestion that "the clashing point" of science and art "ought to produce creative chances" seems to ignore the fundamental kinship of the two. A scientist may well be a connoisseur of Wallace Stevens or Samuel Beckett, but his training may have failed nevertheless to let him use, in his own best professional thinking, the perceptual imagination on which those writers rely. And a painter may read books on biology or physics with profit and yet not use his intelligence in his painting. The estrangement is of a much more fundamental nature.

In advocating a more conscious use of perceptual abstraction in teaching, one must keep in mind, however, that abstraction easily leads to detachment if the connection with empirical reality is not maintained. Every thinker is tempted to treat simplified constructs as though they were reality itself. Gerald Holton has vigorously reminded his fellow science teachers that the average lecture demonstration "is of necessity and almost by definition a carefully adjusted, abstracted, simplified, homogenized, 'dry-cleaned' case." It replaces the actual phenomenon with an analogue, for instance, when "a mechanically agitated tray of steel balls . . . becomes the means of discussing a basic phenomenon (e. g. Brownian motion) — without giving the class a glimpse of the actual case itself." The

phenomenon is torn out of context as though it were a complete and independent event and is shown, literally or figuratively, "against a blank background," which eliminates the "grainy or noisy part" of the actual situation. Neither is the student prepared for the bewildering complexity of the live fact, nor does he experience the excitement of the explorer who tries to clear his path and is unsure of the outcome. Even photographs and films of authentic laboratory or natural situations differ importantly from the direct experiences they replace.

Holton's warnings remind us that science, just as art, can only function if it spans the total range from direct, empirical perception to formalized constructs and maintains continuous interchange between them. Severed from their referents, the stylized images, stereotyped concepts, statistical data lead to empty play with shapes, just as the mere exposure to first-hand experience does not assure insight.

Problems of visual aid

The use of so-called visual aids does not provide by itself a sufficiently favorable condition for visual thinking. Lawrence K. Frank has charged that such aids, as the word implies, "are considered as purely subsidiary to the seemingly all-important verbal communication, the traditional spoken or written representations. Usually visual aids are just that—illustrations; for the words are considered the primary mode of communication." The mere presentation, by photograph, drawing, models, or live exhibition, of things to be studied, does not guarantee a thoughtful grasp of the subject. The insistence of modern educators on direct experience was certainly a valuable reaction to the remoteness of traditional teaching. But it is not enough to make the objects of study available for direct inspection. Pictures and films will be aids only if they meet the requirements of visual thinking. The unity of perception and conception, which I have tried to demonstrate, suggests that intelligent understanding takes place within the realm of the image itself, but only if it is shaped in such a way as to interpret the relevant features visually. I have put it elsewhere as follows:

Visual education must be based on the premise that every picture is a statement. The picture does not present the object itself but a set of propositions about the object; or, if you prefer, it presents the object as a set of propositions.

If the picture fails to state the relevant propositions perceptually, it is useless, incomprehensible, confusing, worse than no image at all. In order to do its job, the sight must conform to the rules of visual perception, which tell how shape and color determine what is seen. Great progress has been made in this respect; but much remains to be done. A few practical examples will make the point.

How much do we know about what exactly children and other learners see when they look at a textbook illustration, a film, a television program? The answer is crucial because if the student does not see what he is assumed to see, the very basis of learning is lacking. Have we a right to take for granted that a picture shows what it represents, regardless of what it is like and who is looking? The problem is most easily ignored for photographic material. We feel assured that since the pictures have been taken mechanically, they must be correct; and since they are realistic, they can be trusted to show all the facts; and since every human being has practiced from birth how to look at the world, he can have no trouble with lifelike pictures. Do these assumptions hold true?

In one of the early books on film theory, Béla Balázs tells the story of a Ukrainian gentleman-farmer, who, disowned after the Soviet revolution, lived as the administrator of his estate, hundreds of miles away from the nearest railroad station. For fifteen years he had not been in the city. A highly educated intellectual, he received newspapers, magazines, and books and owned a radio. He was up to date, but he had never seen a film. One day he traveled to Kiev and at that occasion saw his first movie, one of the early Douglas Fairbanks features. Around him in the theatre, children followed the story with ease, having a good time. The country gentleman sat staring at the screen with the utmost concentration, trembling of excitement and effort. "How did you like it?" asked a friend afterwards. "Enormously interesting," he replied, "but what was going on in the picture?" He had been unable to understand.

The story, authentic or not, makes a valid point. There is much evidence that the comprehension of photographic pictures cannot be taken for granted. Joan and Louis Forsdale have collected examples to show that Eskimos or African tribesmen were unable to perceive such pictures when first introduced to them. In extreme cases, a picture presented by the foreign visitor is a flat object,

nothing more. Or a minor detail is the only thing recognized in a longish film. Or a panning shot confuses because it looks as though the houses are moving. Some of these obstacles have been overcome in Western culture; others persist in our own children, unrecognized.

The reactions of African natives reported in one of the studies which the Forsdales cite make it clear that the human mind does not spontaneously accept the rectangular limits of a picture. Visual reality is boundless; therefore when a film showed persons going off the edge of the screen, the audience wanted to know how and why they had disappeared. Interruptions of the continuity of time are equally puzzling. An American film maker found that an Iranian audience did not follow the connection between a close-up and a long shot. In order to make it clear that a large isolated eye or foot belonged to the animal shown a moment before, the camera had to present the complete transition in motion.

Many of our own children learn to accept such breaks of spatial or temporal continuity at an early age, although even they will run into the problem when they face unfamiliar conditions. In a useful study of how well pupils in elementary and secondary schools handle geographic maps, Barbara S. Bartz observed that children sometimes assume a country to end where the map ends. She noted that border lines are often so neat as to give a misleading impression of completeness, and that "bleeding" the picture may do better than the finality suggested by the white margin. The close-up problem can repeat itself when insets are used in maps in order to accommodate a portion of an area for which there is no space on the page otherwise or in order to give a more detailed view of, say, a large city.

Obviously, older children handle this sort of problem better than younger ones, and socio-economic differences also show up clearly. A bright child will do better than a dull one, and some teachers are more skilful than others in training their pupils how to read a map. Teachers must be explicitly aware of the problems that arise because maps differ from the appearance of the ordinary visual world, and they must know the perceptual principles guiding a child's apprehension of visual patterns. The level of abstractness, at which a map is conceived, should be geared, as I suggested earlier, to its purpose and to the user's level of comprehension. As a case in point, Bartz mentions that the graphic scales indicating how

many miles correspond to an inch on the map should be no more detailed than appropriate; a high school child needs more division for finer measurement than does a fifth-grader.

Frequently, visual patterns offer difficulties of comprehension, some of which could be avoided if the pertinent perceptual principles were more consciously observed. Scale differences, for example, should be indicated conspicuously because the notion of relative size militates against the primary evidence that a thing is as large as it appears. Hence the temptation to judge the size of two countries by the absolute areas they occupy on two maps of different scale. (Compare here the incurable calamity of lantern slides, which show giant-sized insects, or miniature portraits as large as wall-sized murals.) Map makers have been aware for centuries of the distortions of size and shape that occur when the spherical surface of the earth is projected on flat paper. Also, when the grid lines are curved, the directions of North and South are not the same for all areas of the map but bend at the top and the bottom.

Avoidable difficulties arise frequently in the use of colors. Basically, colors indicate qualitative differences: Spain is blue, France is green, Italy is yellow. But hues also serve as layer-tints to indicate different elevations. W. H. Nault reports:

We have found, for instance, that children associate hue change (as from green to brown to blue) with change in *quality,* and they associate value change (light to dark) with change in *quantity,* amount or intensity. For example, many children said that light blue areas indicated shallower water and dark blue areas indicated deeper water. But when a purplish or reddish-blue was used to depict the deepest water category, two-thirds of the children did not associate this with a further depth change, but rather guessed at all sorts of qualitative changes — islands, coral reefs, and so on. We found hue a difficult factor to handle in map-making. Children have learned many hue-associations before they ever learn to read maps; red is hot, blue is cold, green is grass, blue is water, etc. Thus, what often happens with maps is that colors are spontaneously misinterpreted.

This sort of problem calls for the help of artists, designers, and psychologists, acquainted with the theoretical and practical handling of perceptual principles.

What holds for maps is equally true for every sort of visual presentation in textbooks, models, charts, films, etc. Careful investigations of what the persons see for whom these images are made are indispensable. It is worth noting in this connection that the manuals on audio-visual materials, which abound in technical detail other-

wise, tend to dispatch these fundamental problems with the perfunc-
tory recommendation that the pictures be neat, natural, and simple.

A single example may illustrate the visual illiteracy, which still
goes largely unnoticed. Jean Piaget, the child psychologist who has
been concerned with perceptual problems all his life, used Figure 79
to test the comprehension of children. Do they understand how a
tap works? When the handle is turned horizontally, the canal is open

Figure 79

and lets the water run through; otherwise it is closed. The child's
performance will largely depend on whether the drawing is recog-
nizable as a tap and whether it presents the relevant aspects correctly.
Is the cross-shaped object in Figure 79a a tap? The pipe, flat rather
than cylindrical, hangs in space. It does not continue on top, nor
does it receive water from anywhere. The hatching does not indicate
liquid filling a hollow and shows little relation to the dark stripe,
meant to be the canal. The canal is in front of the handle rather than
behind it, and the handle is not in front of the pipe. Does Figure 79b
show a vertical handle outside of a pipe or rather a kind of bob,
swallowed by a rectangle or possibly a tube? I am not denying that a
person, immunized and warned by years of exposure to mediocre
textbook illustrations, mail order catalogues, and similar products
of visual ineptness, can figure out the meaning of these drawings,
especially if helped by a verbal explanation. But surely, if a child
passes the test he does so in spite of the drawing, not with the help
of it; and if he fails, he has not shown that he does not understand
the working of a tap. He may simply be unable to extricate himself
from a visual pitfall.

Focus on function

Deficient pictures of this kind can be found at any level of abstract-
ness. The drawings could be much more realistic and still unsuited
to present the relevant features of the physical situation. They fail
not because they are not lifelike or devoid of detail but because
they are ambiguous and misleading. The anatomical drawings of
Leonardo da Vinci are so remarkably successful not only because
he had the artistic ability to draw what he saw but because he saw
every part of the human body as a contraption designed by a fel-
low inventor. He saw every muscle, bone, or tendon as shaped for
its purpose, and represented it as a tool. He used spatial relations
in order to show functional connections. The same holds true, of
course, for his technological drawings.

Emanuel Winternitz has discovered remarkable examples of
Leonardo's concern with analogies or parallels. One of the draw-
ings "shows a diagram of tendons and muscles attached to the
spine. Leonardo does not draw the muscles in their full width, but
represents them by thin cords to show clearly and transparently
their function in stabilizing the vertebral column. In his comments
on the page he compares the spine and its cords to the mast of a
ship and its stays." Leonardo invented a device by which the finger-
holes of wind instruments, too widely spaced to be reachable by
the human hand, can be controlled by wires, and Winternitz sug-
gests that he took this idea from the tendons of the human hand,
which permit remote control of the finger tips.

Leonardo was capable of finding analogies among materially
distant mechanisms because what he saw in objects of any kind
was their "functional value." Karl Duncker, who introduced this
term into psychology, has shown that all productive thinking dis-
cerns between essential principle and accidental embodiment. He
experimented, for example, with the following problem:

Given a human being with an inoperable stomach tumor, and rays which destroy
organic tissue at sufficient intensity, by what procedure can one free him of the
tumor by these rays and at the same time avoid destroying the healthy tissue
which surrounds it?

He gave Figure 80 as a first approximation to the problem. With
the simplicity of a child's drawing the diagram depicts the essenti-
als: the target within the body, reached by rays. At first, the solution

may be sought at a highly abstract level: Use an opening through which the rays can pass without damaging the body! This leads to the next step of searching the anatomy of the body for such an opening. Duncker calls this the approach "from above." One can also proceed "from below," by starting with an inventory of what is given anatomically, in the hope of coming across something that will give the solution. The interaction of both approaches is characteristic of successful thinking, and they correspond, of course, to the two polar levels of learning material mentioned here earlier: the highly abstract presentation of principle and the complexity of the real-life situation.

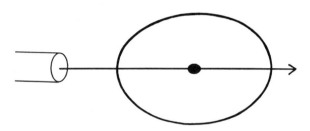

Figure 80

At both levels, however, the attention of the observer must be trained upon the functional value embodied in the object. Duncker shows the foolish mistakes that result when someone vaguely remembers the shape of some useful device, without truly realizing the principle served by that shape. Inventors, on the other hand, are concerned with functional values, as the Leonardo drawings indicated. Designers also must be aware of the difference between principle and embodiment, in order to realize where their imagination has freedom and where it is bound. The designer David Pye has shown convincingly that function never prescribes form, although it circumscribes its range. A wheel cannot be square-shaped but allows innumerable variations of the disk. A wedge can assume a hundred shapes, sizes, proportions, and so can a pin, a rod, a hook, a cup; because a function is a principle that does not call for a particular form but for a type of form.

The burden of it all

What I have said may seem all too theoretical. But it contains prin-
ciples that, if valid, should be constantly on any educator's mind.
It is not enough to pay lip service to the doctrine of visual aids; not
enough to turn on the movie projector, more or less diffidently, to
provide a few minutes of entertainment in the dark. What is needed,
it seems to me, is the systematic training of visual sensitivity as an
indispensable part of any educator's preparation for his profession.
The difference between a picture that makes its point and one that
does not can be discerned by anybody whose natural responses to
perceptual form have been cultivated rather than stifled.

The experimental and theoretical basis for visual education is
being developed in psychology. Practical experience is best pro-
vided by work in the arts. It is not good strategy, however, to label
perceptual sensitivity as artistic or aesthetic, because this means
removing it to a privileged domain, reserved for the talents and
aspirations of the specialist. Visual thinking calls, more broadly,
for the ability to see visual shapes as images of the patterns of forces
that underlie our existence—the functioning of minds, of bodies or
machines, the structure of societies or ideas.

Art works best when it remains unacknowledged. It observes
that shapes and objects and events, by displaying their own nature,
can evoke those deeper and simpler powers in which man recog-
nizes himself. It is one of the rewards we earn for thinking by what
we see.

Notes

Numbers in parentheses refer to corresponding entries in the bibliography.

Chapter 1: Early Stirrings

Schopenhauer (257) book 1, paragraph 10.

Perception torn from thinking, pp. 2–3.

Baumgarten (18). Also chapter 4 of the history of aesthetics in Croce (45).
Liberal and Mechanical Arts: Leonardo (176) p. 12.
Plato on music: *Republic* 530.

The senses mistrusted, pp. 4–6.

The golden calf: Exodus 32.
Primitive thinking: Lévy-Bruhl (181) chaps. 6 and 7.
Taoism: Waley (287) pp. 55, 58.
Parmenides on reasoning: Kirk and Raven (145) fragment 6, p. 271.
Heraclitus: Kirk and Raven (145) fragment 88, p. 189.
Democritus: Kirk and Raven (145) fragment 125, p. 424.

Plato of two minds, pp. 6–8.

Plato on logical operations: Cornford (42), p. 267; *Phaidrus* 265.
Plato on perceiving reality: *Republic* 515.
Plato on anamnesis: *Meno* 81.
Plato on gazing upon the truth: *Phaidrus* 247, *Phaido* 99.
Plato on true vision: *Republic* 508 and 510.

Aristotle from below and from above, pp. 8–12.

Aristotle on systematizing in animals: *Posterior Analytics* 100a.
Aristotle on induction: *Prior Analytics* 68b.
Platonic genera: Cornford (42) p. 269.
Aristotle on perception of the "such:" *Post. An.* 87b.
Syllogism as *petitio principii:* Cohen and Nagel (38) pp. 177–181.
Aristotle on the universal: *On Interpretation* 17a and *Metaphysics* 981a; also *Post. An.* 88a.
Aristotle on thinking in images: *On the Soul* 431a.

Chapter 2: The Intelligence of Perception (i)

Perception circumscribed, pp. 15–16.

Helmholtz: (111) part III, para. 26; also his "Recent Progress in the Theory of Vision" in (112).

Exploring the remote, p. 17.

Piaget: (229) p. 14.
Jonas: (137) p. 147.

The senses vary, pp. 17–19.

Sensory deprivation: Heron (117).

317

Vision is selective, pp. 19–23.

Selective vision: quoted from Arnheim (3) p. 28; (paperback edition, p. 33).
Boethius: quoted after Strunk (268) p. 80.
Leonardo da Vinci: (175) vol. I, p. 250.
Satiation of vision: Pritchard (240); also Arnheim, "Contemplation and Creativity" in (9) pp. 292–301; Woodworth and Schlosberg (309) pp. 270, 559.
Vision in frogs: Lettvin (178), Muntz (204) and Pfeiffer (221).
Visual releasers: Lorenz (185) and Tinbergen (276).

Fixation solves a problem, pp. 23–25.

Mechanism of fixation: Koffka (155) chap. 3, paragraph 5; also Sherrington (263) chap. 7, p. 187.
Köhler on intelligence (153) p. 3.
James on attention: (135) chap. 11, especially p. 438.

Discernment in depth, pp. 26–27.

Early theories of shape perception: Held (110).

Shapes are concepts, pp. 27–29.

Visual concepts: Arnheim (3) chap. 2.

Perception takes time, pp. 29–31.

Stages of gestalt formation: Flavell (67), Hausmann (105), Sander (251), Ehrenfels (60).
Variability of shape perception: Hebb (107) p. 29.

How machines read shape, pp. 31–33.

Pattern recognition by machine: Deutsch (52), Selfridge and Neisser (261), and Uhr (282).

Completing the incomplete, pp. 33–36.

Transparency: Arnheim (3) p. 250; (paperback edition, p. 298).

Chapter 3: The Intelligence of Perception (ii)

Subtracting the context, pp. 37–40.

Helmholtz's theories: Treatise on Physiological Optics (111) vol. 3, § § 26, 33; also his lectures on vision.in (112).

Brightness and shape as such, pp. 40–43.

Brightness constancy: Woodworth and Schlosberg (309) chap. 15.
Perception of distance: Gilinsky (88).
Size constancy: Gibson (86) chap. 9; Koffka (156) chap. 7, p. 305; Ittelson (131).

Three attitudes, pp. 43–45.

Models of interaction: Arnheim (5).

Keeping the context, pp. 46–47.

Badt: (15) p. 101.

The abstraction of shape, pp. 47–51.

Geometrical transformations: Courant (43) p. 42.
Gurwitsch: (98) pp. 165 ff.; Wertheimer on "good continuation" (301).
Kinetic depth-effect: Wallach and O'Connell (289).
Simplicity principle: Arnheim (3) pp. 209 ff. (paperback ed. pp. 252 ff.).
Hogarth: (121) Introduction.

Permanence and change, pp. 52–53.

Windelband: (304) part I: Philosophy of the Greeks, § § 4 and 6.

Chapter 4: Two and Two Together

Relations depend on structure, pp. 54–60.

Association and gestalt: Asch (14) and Köhler (154).
Picasso: Gilot (90) p. 120.
Palladio: the church *Il Redentore* in Venice was consecrated in 1592.
Embedded figures: experiments first performed by Gottschaldt (96) part I.
Pattern vision in birds: Hertz (118).
Chimpanzees: Köhler (153) p. 104.
Michotte: (195) pp. 97, 211.

Pairing affects the partners, pp. 60–65.

Haiku: Henderson (114) pp. 19, 40.
Pairing of paintings: unpublished undergraduate work done at Sarah Lawrence College in 1966.

Metaphor: Arnheim (1).

Levertov: *To the Reader* in (179) p. VII.

Goethe on color: Aphorisms appended to (92) p. 653. Figural after-effect: Köhler and Wallach (152) figs. 2 and 24; perceptual interpretation is mine. Also Ganz (78).

Aristophanes: Plato's *Symposium* 189–193.

Bamboo sticks: Köhler (153) p. 127.

Perception discriminates, pp. 65–66.

Figure and ground: Klüver's experiments with monkeys (150) p. 316.

Children's reactions: to shape and color, Landreth (166) p. 245; to visual patterns, Fantz (65).

Perception compares, pp. 66–69.

Rats and spatial directions: Hebb (108) p. 27.

Lashley: quotation on abstraction (171); Rat experiments with circles (170); quotation on monkey's reaction to colored circles, Lashley and Wade (172) p. 82.

What looks alike?, pp. 69–72.

Chimpanzees and triangles: Hebb (108) p. 29.

Spatial orientation: Arnheim (3) chap. 3; Teuber (271) p. 1612; Landreth (166) p. 243; Ghent (84); Köhler (151) pp. 15–19.

Octopus: cited by Teuber (271).

Mind versus computer, pp. 73–79.

Artificial intelligence: Minsky (198), from which Figs. 10 and 11 are derived with the permission of the author.

Thorndike: (274) and (273)

Simplicity quantified: Hochberg and Mc-Alister (119).

Chapter 5: The Past in the Present

Perceptual readiness: Bruner (28).

Metzger: (192) p. 694.

Forces acting on memory, pp. 81–84.

Memory of form: Woodworth (309), edition of 1938; Koffka (156) pp. 493 ff.

Experiment with broken circle: Hebb and Foord (106).

Map drawings: unpublished experiments by students of Sarah Lawrence College.

Fluid medium: Lewin (183) pp. 160, 196.

Percepts supplemented, pp. 84–87.

Perceptual complement: Michotte et al. (194); Titchener on "tied images" in (277) pp. 75, 87.

Hemianopsia: Koffka (156) p. 146; Teuber (271) pp. 1616 ff.

Piaget: experiments on disappearance (223); also his (225) chap. 1.

To see the inside, pp. 87–88.

Sechehaye: (259) pp. 3 and 25.

Visible gaps, pp. 89–90.

Giacometti: Lord (184) p. 60.

Dreyer: Kracauer (161) p. 90.

Van den Berg: (284) p. 28.

Things-of-action: Werner (294) chap. 2.

Recognition, pp. 90–96.

Chaplin: *The Gold Rush* is from 1925.

Preperception: James (135) pp. 442 ff.

Effect of expectation: James (135) p. 429; Gottschaldt (96) part 2; Bruner and Minturn (29).

Roger Price: (239).

Mantegna: *Judith and Holofernes*, National Gallery of Art, Washington, D.C.

Chapter 6: The Images of Thought

Inner design: Panofsky (214) pp. 32, 46 ff.

What are mental images like?, pp. 98–100.

Aristotle: *On Memory and Reminiscence*, 449b.

John Locke: *An Essay Concerning Human Understanding*, Introd., sect. 8 and book 4, chap. 7, sect. 9.

Holt: (123).

Can one think without images?, pp. 100–102.

Imageless thought: Mandler and Mandler (187) sect. 4.

Woodworth: (311) pp. 74, 106.
Piaget: (227).
Titchener: (278) p. 187.

Particular and generic images, pp. 102–107.

Greek *eidola:* Kirk and Raven (145) p. 422; also Held (110).
Eidetics: Jaensch (133); Riekel's chapter in Saupe (253); also Klüver (149).
Penfield: (219) chap. 3.
Berkeley: *A Treatise Concerning the Principles of Human Knowledge,* Introd., sect. 10 and part 1, sect. 5.
Koffka: (158).
Amodal complements: Michotte et al. (194).
Binet: (21) pp. 138 ff.
Dreams: Hall (101).

Visual hints and flashes, pp. 107–109.

Titchener: (278) pp. 13, 21.

How abstract can an image be?, pp. 109–115.

Galton: (76).
Silberer: (264).
Darwin on expression: (47).
The Blue Rider: Selz (262) chaps. 16, 17.
Ribot: (244).

Chapter 7:
Concepts Take Shape

Abstract gestures, pp. 117–118.

Efron's study of gestures (58).

Experiments with drawings, pp. 120–129.

Some pencil drawings have been retraced in ink, in order to make them show up more clearly in reproduction. This modifies the character of the original strokes somewhat but does not alter the shapes otherwise.

Thought in visible action, pp. 129–134.

The creative process in Picasso's *Guernica:* Arnheim (6).

Chapter 8: Pictures, Symbols, and Signs

Three functions of images, pp. 135–139.

Symbols vs. signs: see, e. g., Langer (168) chap. 3.
Traffic symbols: Krampen (163).
Lorenz on visual releasers: (185).
Sterne's drawing: *Tristram Shandy,* book 6, chap. 40.

Images to suit their functions, pp. 140–144.

Courbet: Hofmann (120) pp. 11 ff.
Magritte: *The Wind and the Song* (1928/29) is in a private collection.
Picasso: *Bull's Head,* done in Paris in 1943.
Krampen, *op. cit.*
Modley: Kepes (143) vol. 6, pp. 108–125.
Trademark design: Doblin (54).

What trademarks can tell, pp. 144–148.

Expression of music: Rigg (246) and Pratt (237).
Schopenhauer on music: *Die Welt als Wille und Vorstellung,* book 3 and chap. 39 of additions; see also Langer (168) chap. 8.
Trademarks: Kamekura (139).

Experience interacting with ideas, pp. 148–150.

Goethe: *Zur Farbenlehre,* chapter on materials for the history of color theory, section on the seventeenth century.
Hegel: *Aesthetik,* part 2, section 1: "Die symbolische Kunstform."
Picasso's *La Vie:* Boeck and Sabartés (23) p. 124.
Fry on Pfister: (74).
Pfister: (222); cf. also Kramer (162).
Freud on daydreams: (72).

Chapter 9:
What Abstraction Is Not

A harmful dichotomy, pp. 154–156.

Locke on abstraction: *An Essay Concern-*

ing *Human Understanding,* book 2, chap. 11, sect. 9.

Pellet: (218) pp. 9, 60.

Hume on Berkeley: *A Treatise of Human Nature,* part 1, sect. 7.

Berkeley on universals: *A Treatise Concerning the Principles of Human Knowledge,* Introd., sect. 15.

Introduction to logic: Cohen (39) pp. 103, 107; also Cohen and Nagel (38) chap. 18, sect. 5.

Abstraction based on generalization?, pp. 157–163.

Locke on generalization: *op. cit.,* book 1, chap. 1, sect. 15, and book 2, chap. 32, sect. 6.

James on dissociation: (135) vol. 1, p. 506.

Inhelder and Piaget: (130) Conclusions, p. 284.

Bergson: (20) chap. 3.

Laporte: (169) p. 117.

Langer on primary abstraction: (167).

Medawar: in Edge (56) p. 8.

Generality comes first, pp. 163–169.

Pavlov: (217) lecture 2, p. 20.

Lashley and Wade: (172) pp. 81 ff.

Piaget: (225) chap. 1, § 6.

Teale on fieldmarks: (270) p. 214.

Boas: in Hymes (129) p. 121.

James on confusion: (135) vol. 1, p. 488.

Gesell and Ilg: (81) chap. 2, p. 18.

Piaget on syncretism: (228) chap. 4, § 1.

Blurred stimuli: Koffka (156) pp. 493–505.

Aquinas: quoted after Gessner (82).

Bouissou: (25) pp. 45, 96.

Priority of generalization: Brown (27) chap. 8.

Sampling versus abstraction, pp. 169–172.

Boethius: quoted after Gessner (82).

Kouwenhoven: (160).

Chapter 10:
What Abstraction Is

Wertheimer: (299); cf. also Asch (12) and (11).

Jonas: (136).

Spinoza: *On the Correction of the Understanding,* § 95.

Asch on personality: (11).

Types and containers, pp. 174–178.

Kretschmer on types: (165).

Galton on composite photographs: (76).

Seiffert: (260).

Hempel and Oppenheim: (113).

Static and dynamic concepts, pp. 178–182.

Locke: *Essay,* book 3, chap. 3, sect. 10.

Galton on averages: (77) p. 62.

Aristotle: *On Memory and Reminiscence,* 450a.

Berkeley on triangles: *Treatise,* Introd., sect. 16.

Poncelet: (234) Introd., p. xiv. The figures are mine.

Concepts as highspots, pp. 182–186.

Prägnanzstufen: Wertheimer (301).

Rausch: (243) pp. 906 ff.

Schopenhauer on water: (257) book 3, § 51.

Ivins on Greek geometry: (132).

Chapter 11:
With Feet on the Ground

Abstraction as withdrawal, pp. 188–191.

Abstraction and empathy: Worringer (313); Arnheim (2).

Goldstein and Scheerer: (94).

Cameron: In Hunt (127) chap. 29, p. 904.

Pikas: (232) p. 39.

The extraction of principle, pp. 191–194.

Valéry: (283).

Wittgenstein (308) p. 219.

Against the grain, pp. 194–199.

Duncker: (55) p. 108.

Goldstein and Scheerer: I have corrected an error in their fig. 18, which contains 5 squares instead of 4.

Nigerian boys: Jahoda (134).

On Goldstein and Scheerer: Brown (27) pp. 287 ff.

In love with classification, pp. 199–202.

Wechsler-Bellevue test: (292).
Locke on abstract maxims: *Essay*, book 1, chap. 1, sect. 27.

In touch with experience, pp. 202–207.

Riessman: (245) p. 73.
Davis: (48) pp. 78 ff.
What the IQ measures: Tyler (281) p. 52.
On the middle classes: Miller and Swanson (197) p. 339.
Two styles of expression: Miller and Swanson, chap. 15, and Goldberg (93).
Torrance: (280) pp. 110 ff.
Riessman: (245) p. 69.
Deutsch: (53) in Passow (215).
Two kinds of student: Arnheim (8) p. 86.
Gifted children: Torrance (280) and Getzels and Jackson (83).

Chapter 12:
Thinking With Pure Shapes

Numbers reflect life, pp. 208–211.

Wertheimer: (298).
Educational Research Council: (57).
On set theory: Deans (49).
Prévert's poem: In (238) p. 243.

Quantities perceived, pp. 211–213.

Piaget: (224) chap. 4.
Heidegger: (109) pp. 70 ff.
Leporello's inventory: "In Italy 640, in Germany 231, 100 in France, in Turkey 91; but in Spain there are already 1003."
Legions of angels: *Matthew* 26:53.

Numbers as visible shapes, pp. 213–217.

On Francesco Sizi: Panofsky (213) p. 11.
Arithmetic in the army: Ginzberg and Bray (91) p. 71.
Marguerite Lehr: In Stern (267).
Illinois Project: Deans (49) p. 57.
Stanford Project: Deans (49) p. 74.
Cuisenaire rods: Cuisenaire and Gattegno (46) and Gattegno (79, 80).

Meaningless shapes make trouble, pp. 217–222.

Stern: (267).
Montessori: (201) chap. 19.
Plato: *Meno*, 82.
Gattegno: (79) p. VIII.
Rousseau: *Confessions*, book 6.

Self-evident geometry, pp. 222–225.

Schopenhauer: (257) book 1, § 15.
Greek geometry: Hankel (103) pp. 205 ff.
Indian proof: Hankel (103) p. 207.
Brecht: *Leben des Galilei*, scene 3: "Das Denken gehört zu den grössten Vergnügungen der menschlichen Rasse."

Chapter 13:
Words in Their Place

Can one think in words?, pp. 227–229.

Sapir: (252) p. 15.
Brown on animal thinking: (27) p. 268.
Wittgenstein (308) part I, # 650.

Words as images, pp. 229–232.

Kant: Kritik der reinen Vernunft, Introd., sect. 4.

Words point to percepts, pp. 232–233.

Asch on the metaphor: (13).
Whorf: (302) p. 146.

Intuitive and intellectual cognition, pp. 233–238.

Synoptic thinking: Klafki (146) p. 36.
Von Haller: (102) vol. 2, p. 130; Hanson (104) p. 69. (I have supplied the word *possint*, which is missing in Hanson's quotation.)
Language: Herder (116).
Cassirer: (34) p. 27; also (35) vol. 3, p. 15.
Whorf: (302) pp. 213, 240.
The myth of the bleating lamb: Arnheim (9) pp. 136–150.

What words do for images, pp. 238–240.

Words as categories: Brown (27) pp. 205 ff. and Wallach (290).
Plato: *Cratylus* 398.

Wittgenstein: (307) p. 7.

The imagery of logical links, pp. 240–242.

Freud: (73) chap. 6, sect. c.
Raphael: *The School of Athens* and *Parnassus* (1508–11) are in the Stanza della Segnatura in the Vatican.
Michotte: (195).

Language overrated, pp. 242–246.

Sapir: (252) p. 15.
Humboldt: quoted after Cassirer (34) p. 9.
Lee: (173) p. 105.
Mauss: (190) p. 125.
Whorf: on faulty thinking (302) p. 135.
Deese: (50).
Sarris: Cited after Werner (294), p. 61.
Langer: (168) chap. 5.
Sapir: on the birth of a concept (252) p. 17.
Lenneberg: (174) p. 334.

The effect of linearity, pp. 246–250.

Langer: (168) chap. 4, p. 80.
Lessing: (177) esp. sect. 16.
G. Chr. Lichtenberg: *Briefe aus England,* letter to Heinrich Christian Boie, dated October 1, 1775.
Camus: *La femme adultère* (31).
Linearity in radio plays: Arnheim (7) chap. 7.
Third Class Carriage: Honoré Daumier's painting, *Un wagon de troisième classe* (c. 1862) is in the Metropolitan Museum of Art in New York.
Dylan Thomas: In (272) p. 65.

Verbal versus pictorial concepts, pp. 251–253.

Sapir: (252) p. 11.
Brown on Titchener: (27) pp. 90 ff.
Deese: (50) p. 649.
Dubuffet: *The Cow with the Subtile Nose* (1954) is in the Museum of Modern Art, New York.

Chapter 14: Art and Thought

Paul Klee: "Ich schaffe *pour ne pas pleurer,* das ist der letzte und erste Grund"(1905). In Grohmann (97) p. 433.

Thinking in children's drawings, pp. 255–260.

Children's drawings: Some of the following material was first published in Arnheim (10) and is used here by permission of George Braziller, New York.
Representational concepts: Cf. Arnheim (3) chap. 4.

Personal problems worked out, pp. 260–263.

European child: This example is taken from an undergraduate term paper of Miss Judith Bernstein.
Naumburg: (209, 210).

Cognitive operations, pp. 263–269.

Interaction: Arnheim (5).
Sapir: (252) p. 123.
Schlauch: (256) p. 147.

Abstract patterns in visual art, pp. 269–273.

Christ at Emmaus: *Luke* 24: 28-31.

Chapter 15: Models for Theory

Poincaré: (233) p. 129.

Cosmological shapes, pp. 274–280.

Homeric ocean: Rüstow (250).
Anaximander: Kirk and Raven (145) p. 134.
Cornford: Munitz (203) p. 26.
Babylonian Genesis: Jacobsen in Munitz (203) p. 11.
Aristotle: Munitz (203) p. 93.
Galileo and circular shape: Panofsky (213) pp. 20 ff.
Newton's letter: In Munitz (203) p. 215.
Michotte: (195).
Hume: *Treatise,* book 1, part 3, sect. 6.

The nonvisual made visible, pp. 280–281.

Image of the sphere: Much of the following material is taken from Mahnke (186).
Scheffler: Angelus Silesius: *Cherubinischer Wandersmann:*

Als Gott verborgen lag in eines Mägdleins Schoss,

Da war es, da der Punkt den Kreis in sich
 beschloss.
(After Mahnke, p. 33.)

Aristotle on the heart: In Mahnke, p. 225.
Kepler on the trinity: Pauli (216) p. 160.

Models have limits, pp. 282–283.

Leibniz: After Mahnke (186) p. 17.

*Figure and ground and beyond, pp.
283–287.*

Rubin: (249).
Britsch: (26) p. 131.
Apeiron: Kirk and Raven (145) p. 108 and
 Mahnke (186) pp. 238 ff.
Kepler on the faculties of the soul: Pauli
 (216) p. 186.
Freud: (71) part 1, chap. 1.
Schrödinger: (258).
Faraday: Newman (212) p. 65.

Infinity and the sphere, pp. 287–290.

Gauss on infinity: after Kline (148) p. 396.
Courant and Robbins: (44) p. 77.
Plotinus: Mahnke (186) p. 67.
Lucretius: *The Nature of the Universe,*
 book 1, sect. 1050.
Cusanus: Mahnke, pp. 76 ff.
Holton on *themata:* (124) p. 99.
Kant: (140) part 1.
Hoyle: (126) after Munitz (203) pp. 423 ff.

*The stretch of imagination, pp. 290–
293.*

Einstein: (61) § 31.
Fourth dimension: Manning (188).
Helmholtz: *On the Origin and Significance
 of Geometrical Axioms,* in (112) p. 227.
Eddington: in Munitz (203) p. 321.
Einstein on the geometry of space: (61)
 § 32.
Non-Euclidean perspective: Arnheim (3)
 chap. 5.

Robertson: Munitz (203) p. 385.
Kline: (148) p. 445.

Chapter 16:
Vision in Education

What is art for? pp. 295–296.

Coomaraswamy: (40, 41).

Pictures as propositions, pp. 296–299.

Kerschensteiner: see Weber (291) p. 56.

Standard images and art, pp. 299–301.

Pestalozzi: (220).
Schmid and Lange: Weber (291) pp. 26 ff.
Villard de Honnecourt: (286).
Signatures: see, e. g., Pauli (216) p. 159.

*Looking and understanding, pp. 301–
305.*

Hanson: (104) p. 19.
Wertheimer: (300).
Continental drift: Hurley (128).

How illustrations teach, pp. 305–308.

Snow: (265).
Holton: (125).

Problems of visual aid, pp. 308–312.

Frank: (69) p. 456.
Pictures as statements: Arnheim (4)
 p. 148.
Balázs: (16) p. 2.
Forsdale: (68).
Map reading: Bartz (17) and Nault (208).

Focus on function, pp. 313–315.

On Leonardo: Winternitz (305, 306).
Functional value: Duncker (55).
Pye: (241) chap. 3.

Bibliography

1. Arnheim, Rudolf. Abstract language and the metaphor. *In* Arnheim (9) pp. 266–284.
2. Arnheim, Rudolf. Abstraction and empathy in retrospect. Confinia Psychiatrica 1967, vol. 10, pp. 1–15.
3. Arnheim, Rudolf. Art and visual perception. Berkeley and Los Angeles: Univ. of California Press, 1964.
4. Arnheim, Rudolf. The myth of the bleating lamb. *In* Arnheim (9) pp. 136–150.
5. Arnheim, Rudolf. Perceptual analysis of a symbol of interaction. *In* Arnheim (9) pp. 222–244.
6. Arnheim, Rudolf. Picasso's *Guernica:* the genesis of a painting. Berkeley and Los Angeles: Univ. of California Press, 1962.
7. Arnheim, Rudolf. Radio. London: Faber and Faber, 1936.
8. Arnheim, Rudolf. Second thoughts of a psychologist. *In* Taylor (269) pp. 77–95.
9. Arnheim, Rudolf. Toward a psychology of art. Berkeley and Los Angeles: Univ. of California Press, 1966.
10. Arnheim, Rudolf. Visual thinking. *In* Kepes (143) vol. 1, pp. 1–15.
11. Asch, Solomon E. Forming impressions of personality. *In* Henle (115) pp. 237–285.
12. Asch, Solomon E. Max Wertheimer's contribution to modern psychology. Social Research 1946, vol. 13, pp. 81–102.
13. Asch, Solomon E. The metaphor: a psychological inquiry. *In* Henle (115) pp. 324–333.
14. Asch, Solomon E. Perceptual conditions of association. *In* Henle (115) pp. 187–200.
15. Badt, Kurt. Die Farbenlehre Van Goghs. Cologne: DuMont Schauberg, 1961.
16. Balázs, Béla. Der Geist des Films. Halle: Knapp, 1930.
17. Bartz, Barbara S. Map design for children. Chicago: Field Enterprises, 1965.
18. Baumgarten, Alexander Gottlieb. Reflections on poetry. Berkeley and Los Angeles: Univ. of California Press, 1954.

19. Bender, Lauretta. A visual-motor gestalt test and its clinical use. Research Monogr. #3. Amer. Orthopsychiatric Ass., 1938.

20. Bergson, Henri. Matière et mémoire. Paris: Presses Universitaires, 1946. (Matter and memory. New York: Macmillan, 1911.)

21. Binet, Alfred. L'étude experimentale de l'intelligence. Paris: Costes, 1921.

22. Boas, Franz. On grammatical categories. In Hymes (129) pp. 121–123.

23. Boeck, Wilhelm and Jaime Sabartés. Picasso. New York: Abrams, 1955.

24. Boring, Edwin G. A history of introspection. Psych. Bull. 1953, vol. 50, pp. 169–189.

25. Bouissou, René. Essay sur l'abstraction et son rôle dans la connaissance. Gap: Jean, 1942.

26. Britsch, Gustaf. Theorie der Kunst. Munich: Bruckmann, 1926.

27. Brown, Roger. Words and things. New York: Free Press, 1958.

28. Bruner, Jerome S. On perceptual readiness. Psych. Review 1957, vol. 64, pp. 123–152.

29. Bruner, Jerome S., and A. L. Minturn. Perceptual identification and perceptual organization. Journ. of general Psych. 1955, vol. 53, pp. 21–28.

30. Bühler, Karl. Tatsachen und Probleme zu einer Psychologie der Denkvorgänge. Archiv für die gesamte Psychologie 1908, vol. 12, pp. 1–92.

31. Camus, Albert. L'exil et le royaume. Paris: Gallimard, 1957. (Exile and the kingdom. New York: Knopf, 1958.)

32. Capelle, Wilhelm. Die Vorsokratiker. Stuttgart: Kröner, 1935.

33. Cassirer, Ernst. The concept of group and the theory of perception. Philos. and Phenom. Research 1944, vol. 5, pp. 1–35.

34. Cassirer, Ernst. Language and myth. New York: Dover, 1946.

35. Cassirer, Ernst. The philosophy of symbolic forms. New Haven: Yale, 1957.

36. Cassirer, Ernst. Substanzbegriff und Funktionsbegriff. Berlin: Cassirer, 1910. (Substance and function. New York: Dover, 1953.)

37. Cobb, Stanley. Borderlands of psychiatry. Cambridge, Mass.: Harvard Univ. Press, 1944.

38. Cohen, Morris R., and Ernest Nagel. An introduction to logic and scientific method. New York: Harcourt Brace, 1934.

39. Cohen, Morris R. A preface to logic. New York: Meridian, 1956.

40. Coomaraswamy, Ananda K. Christian and oriental philosophy of art. New York: Dover, 1957. (First published as: Why exhibit works of art? London: Luzac, 1943.)

41. Coomaraswamy, Ananda K. Figures of speech or figures of thought. London: Luzac, 1946.

42. Cornford, Francis Macdonald. Plato's theory of knowledge. London: Routledge and Kegan Paul, 1935.

43. Courant, Richard. Mathematics in the modern world. Scientific American, Sept. 1964, vol. 211, pp. 41–49.

44. Courant, Richard, and Herbert Robbins. What is mathematics? New York: Oxford Univ. Press, 1951.

45. Croce, Benedetto. Estetica come scienza dell'espressione e linguistica

generale. Bari: Laterza, 1928. (Aesthetic as science of expression and general linguistic. New York: Noonday, 1953.)

46. Cuisenaire, Georges, and Caleb Gattegno. Numbers in color. Mount Vernon, N.Y.: Cuisenaire, 1954.

47. Darwin, Charles. The expression of the emotions in man and animals. London: Watts, 1934.

48. Davis, Allison. Social-class influences upon learning. Cambridge: Harvard Univ. Press, 1962.

49. Deans, Edwina. Elementary school mathematics. Washington: U.S. Department of Health, Education and Welfare, 1963.

50. Deese, James. Meaning and change of meaning. Amer. Psychologist 1967, vol. 22, pp. 641–651.

51. Dennis, Wayne (ed.). Readings in general psychology. New York: Prentice-Hall, 1949.

52. Deutsch, J. A. A system for shape recognition. Psychol. Review 1962, vol. 69, pp. 492–500.

53. Deutsch, Martin. The disadvantaged child and the learning process. In Passow (215) pp. 163–179.

54. Doblin, Jay. Trademark design. Dot Zero #2. New York: Finch, Pruyn and Co., 1966.

55. Duncker, Karl. On problem-solving. Psychol. Monographs 1945, vol. 58, no. 270.

56. Edge, David (ed.). Experiment. London: British Broadcasting Corp., 1964.

57. Educational Research Council of Greater Cleveland. Key topics in mathematics for the primary teacher. Chicago: Science Research Associates, 1961.

58. Efron, David. Gesture and environment. New York: King's Crown Press, 1941.

59. Ehmer, Hermann K. (ed.). Kunstunterricht und Gegenwart. Frankfurt a. M.: Diesterweg, 1967.

60. Ehrenfels, Christian von. Ueber "Gestaltqualitäten." In Weinhandl (293) pp. 11–43.

61. Einstein, Albert. Ueber die spezielle und die allgemeine Relativitätstheorie. Braunschweig: Vieweg, 1922.

62. Eisner, E. W., and D. W. Ecker (eds.). Readings in art education. Waltham, Mass.: Blaisdell, 1966.

63. Ellis, Willis D. (ed.). A source book of gestalt psychology. New York: Harcourt Brace, 1939.

64. Evans, C. R., and A. D. J. Robertson (eds.). Brain physiology and psychology. Berkeley and Los Angeles: Univ. of California Press, 1966.

65. Fantz, Robert L. The origin of form perception. Scientific American, May 1961, pp. 66–72.

66. Field, J. (ed.). Handbook of physiology. Washington: Amer. Physiol. Society, 1959.

67. Flavell, John H. A microgenetic approach to perception and thought. Psychol. Bull. 1957, vol. 54, pp. 197–217.

68. Forsdale, Joan Rosengren, and Louis. Film literacy. Teachers College Record 1966, vol. 67, pp. 608–617.
69. Frank, Lawrence K. Role of the arts in education. *In* Eisner and Ecker (62) pp. 454–459.
70. Freeman, Kathleen. Ancilla to the pre-socratic philosophers. Oxford: Blackwell, 1952.
71. Freud, Sigmund. Abriss der Psychoanalyse. Schriften aus dem Nachlass. London: Imago, 1941. (Outline of psycho-analysis. New York: Norton, 1945.)
72. Freud, Sigmund. Der Dichter und das Phantasieren. Gesammelte Werke, vol. 7. London: Imago, 1940. (Creative writers and day-dreaming. Standard ed. of the complete psychol. works of Sigmund Freud, vol. 9. London: Hogarth Press, 1959.)
73. Freud, Sigmund. Die Traumdeutung. Leipzig and Vienna: Deuticke, 1922. (The interpretation of dreams. London: Allen and Unwin, 1954.)
74. Fry, Roger. The artist and psychoanalysis. London: Hogarth Press, 1924.
75. Fuchs, Wilhelm. Experimentelle Untersuchungen über das simultane Hintereinandersehen auf derselben Sehrichtung. Zeitschrift für Psychologie 1923, vol. 91, pp. 145–235. (English summary *in* Ellis (63) pp. 89–94.)
76. Galton, Francis. Inquiries into human faculty and its development. London: Dent, 1907.
77. Galton, Francis. Natural inheritance. London: Macmillan, 1889.
78. Ganz, Leo. Mechanism of the figural aftereffects. Psychol. Review 1966, vol. 73, pp. 128–150.
79. Gattegno, Caleb. For the teaching of elementary mathematics. Mount Vernon, N.Y.: Cuisenaire, 1963.
80. Gattegno, Caleb. Modern mathematics with numbers in color. Reading, Berks.: Educ. Explorers, 1960.
81. Gesell, Arnold, and Frances L. Ilg. Infant and child in the culture of today. New York: Harper, 1943.
82. Gessner, Jakob. Die Abstraktionslehre in der Scholastik bis Thomas von Aquin. Dissertation at Freiburg Univ., 1930.
83. Getzels, J. W., and P. W. Jackson. Creativity and intelligence. New York: Wiley, 1962.
84. Ghent, Lila. Form and its orientation. Child Development 1964, vol. 35, pp. 1127–1136.
85. Gibson, James J. Constancy and invariance in perception. *In* Kepes (143) vol. 3, pp. 60–70.
86. Gibson, James J. The perception of the visual world. Boston: Houghton Mifflin, 1950.
87. Gibson, James J. The senses considered as perceptual systems. Boston: Houghton Mifflin, 1966.
88. Gilinsky, Alberta. Perceived size and distance in visual space. Psychol. Review 1951, vol. 58, pp. 460–482.
89. Gillispie, Charles Coulston. The edge of objectivity. Princeton: Princeton Univ. Press, 1960.

90. Gilot, Françoise, and Carlton Lake. Life with Picasso. New York: McGraw-Hill, 1964.

91. Ginzberg, Eli, and Douglas W. Bray. The uneducated. New York: Columbia, 1953.

92. Goethe, Johann Wolfgang von. Naturwissenschaftliche Schriften, vol. 2. Leipzig: Insel Verlag, n. d. (Goethe's theory of colors. London: Murray, 1840.)

93. Goldberg, Miriam L. Factors affecting educational attainment in depressed urban areas. In Passow (215) pp. 68–99.

94. Goldstein, Kurt, and Martin Scheerer. Abstract and concrete behavior. Psychol. Monographs 1941, vol. 53, no. 239.

95. Gombrich, E. H. Art and illusion. New York: Pantheon, 1960.

96. Gottschaldt, Kurt. Ueber den Einfluss der Erfahrung auf die Wahrnehmung von Figuren. Psychol. Forschung 1926, vol. 8, pp. 261–317, and 1929, vol. 12, pp. 1–87. (English summary in Ellis (63) pp. 109–135.)

97. Grohmann, Will. Kunst und Architektur zwischen den beiden Kriegen. Frankfurt a.M.: Suhrkamp, 1953.

98. Gurwitsch, Aron. Théorie du champ de la conscience. Bruges: De Brouwer, 1957. (The field of consciousness. Pittsburgh: Duquesne Univ. Press, 1964.)

99. Haber, Ralph Norman. Nature of the effect of set on perception. Psychol. Review 1966, vol. 73, pp. 335–351.

100. Hadamard, Jacques. The psychology of invention in the mathematical field. Princeton: Princeton Univ. Press, 1945.

101. Hall, Calvin S. What people dream about. Scientific Amer., May 1951, vol. 184, pp. 60–63.

102. Haller, Albertus v. Historia stirpium indigenarum Helvetiae inchoata. Berne: Societas Typographica, 1768.

103. Hankel, Hermann. Zur Geschichte der Mathematik in Altertum und Mittelalter. Hildesheim: Olms, 1965.

104. Hanson, Norwood Russell. Patterns of discovery. Cambridge: Cambridge Univ. Press, 1965.

105. Hausmann, Gottfried. Zur Aktualgenese räumlicher Gestalten. Archiv für die gesamte Psychologie 1935, vol. 93, pp. 289–334.

106. Hebb, Donald O., and Esme N. Ford. Errors of visual recognition and the nature of the trace. Journal of Exper. Psych. 1945, vol. 35, pp. 335–348.

107. Hebb, Donald O. The organization of behavior. New York: Wiley, 1949.

108. Hebb, Donald O. A textbook of psychology. Philadelphia: Saunders, 1958.

109. Heidegger, Martin. Holzwege. Frankfurt a.M.: Klostermann, 1950.

110. Held, Richard. Object and effigy. In Kepes (143) vol. 2, pp. 42–54.

111. Helmholtz, Hermann von. Handbuch der physiologischen Optik. Hamburg und Leipzig: Voss, 1896. (Helmholtz's treatise on physiological optics. New York: Dover, 1962.)

112. Helmholtz, Hermann von. Popular scientific lectures. New York: Dover, 1962.

113. Hempel, Carl G., and Paul Oppenheim. Der Typusbegriff im Lichte der neuen Logik. Leiden: Sijthoff, 1936.

114. Henderson, Harold G. An introduction to haiku. Garden City: Doubleday Anchor, 1958.

115. Henle, Mary (ed.). Documents of gestalt psychology. Berkeley and Los Angeles: Univ. of California Press, 1961.

116. Herder, Johann Gottfried von. Ueber den Ursprung der Sprache. Herders Werke, vol. 4. Leipzig and Vienna: Bibliogr. Institut, 1901.

117. Heron, Woodburn. The pathology of boredom. Scient. Amer. January 1957, pp. 52–56.

118. Hertz, Mathilde. Wahrnehmungspsychologische Untersuchungen am Eichelhäher, 1. Zeitschrift für vergleichende Physiologie 1928, vol. 7, pp. 144–194. (English summary in Ellis (63) pp. 238–252.)

119. Hochberg, Julian, and Edward McAlister. A quantitative approach to figural "goodness." Journal of Experim. Psych. 1953, vol. 46, pp. 361–364.

120. Hofmann, Werner. The earthly paradise. New York: Braziller, 1961.

121. Hogarth, William. The analysis of beauty. Oxford: Clarendon, 1955.

122. Holt, John. How children fail. New York: Dell, 1964.

123. Holt, Robert R. Imagery: the return of the ostracized. Amer. Psychologist 1964, vol. 19, pp. 254–264.

124. Holton, Gerald. Presupposition in the construction of theories. In Woolf (312) pp. 77–108.

125. Holton, Gerald. Conveying science by visual presentation. In Kepes (143) vol. 1, pp. 50–77.

126. Hoyle, Fred. The nature of the universe. New York: Harper, 1950.

127. Hunt, J. McV. (ed.). Personality and the behavioral disorders. New York: Ronald, 1944.

128. Hurley, Patrick M. The confirmation of continental drift. Scient. Amer., April 1968, vol. 218, pp. 52–64.

129. Hymes, Dell (ed.). Language in culture and society. New York: Harper, 1964.

130. Inhelder, Bärbel, and Jean Piaget. La genèse des structures logiques élémentaires. Neuchatel: Delachaux & Niestlé, 1959. (The early growth of logic in the child. New York: Harper, 1964.)

131. Ittelson, William H. The constancies in perceptual theory. Psychol. Review 1951, vol. 58, pp. 285–294.

132. Ivins, William M., Jr. Art and geometry. Cambridge: Harvard Press, 1946.

133. Jaensch, Erich R. Ueber den Aufbau der Wahrnehmungswelt und ihre Struktur im Jugendalter. Leipzig: Barth, 1923.

134. Jahoda, Gustav. Assessment of abstract behavior in a non-Western culture. Journal of Abnormal and Social Psych. 1956, vol. 53, pp. 237–243.

135. James, William. The principles of psychology. New York: Dover, 1950.

136. Jonas, Hans. Homo pictor und die Differentia des Menschen. Zeitschrift für philosophische Forschung 1961, vol. 15, pp. 161–176. (English translation in Jonas (138) pp. 157–175.)

137. Jonas, Hans. The nobility of sight. In Jonas (138) pp. 135–152.

138. Jonas, Hans. The phenomenon of life. New York: Dell, 1968.

139. Kamekura, Yusaku. Trademarks and symbols of the world. New York: Reinhold, 1965.

140. Kant, Immanuel. Allgemeine Naturgeschichte und Theorie des Himmels. Sämtliche Werke. vol. 2. Leipzig: Insel, 1912. (Kant's cosmogony, etc. Glasgow: Maclehose, 1900.)

141. Kaufmann, Walter. Hegel. Garden City: Doubleday, 1965.

142. Kellogg, Rita, with Scott O'Dell. The psychology of children's art. San Diego: CRM–Random House, 1967.

143. Kepes, Gyorgy (ed.). Vision and value series: 1. Education of vision; 2. Structure in art and in science; 3. The nature and art of motion; 4. Module, proportion, symmetry, rhythm; 5. The man-made object; 6. Sign, image, symbol. New York: Braziller, 1965/66.

144. Kinder, James S. Audio-visual materials and techniques. New York: Amer. Book Co., 1959.

145. Kirk, G. S., and J. E. Raven. The presocratic philosophers. Cambridge: Univ. Press, 1962.

146. Klafki, Wolfgang. Probleme der Kunsterziehung in der Sicht der allgemeinen Didaktik. *In* Ehmer (59) pp. 27–45.

147. Klee, Paul. Das bildnerische Denken. Basel/Stuttgart: Schwabe, 1964. (The thinking eye. New York: Wittenborn, 1961.)

148. Kline, Morris. Mathematics in western culture. New York: Oxford Univ. Press, 1964.

149. Klüver, Heinrich. Eidetic phenomena. Psychol. Bull. 1932, vol. 29, pp. 181–203.

150. Klüver, Heinrich. Behavior mechanisms in monkeys. Chicago: Chicago Univ. Press, 1933.

151. Köhler, Wolfgang. Dynamics in psychology. New York: Liveright, 1940.

152. Köhler, Wolfgang, and Hans Wallach. Figural after-effects. Proceedings of the Amer. Philos. Soc. 1944, vol. 88, pp. 269–357.

153. Köhler, Wolfgang. The mentality of apes. New York: Harcourt Brace, 1931.

154. Köhler, Wolfgang. On the nature of associations. Proceedings of the Amer. Philos. Soc. 1941, vol. 84, pp. 489–502.

155. Koffka, Kurt. Die Grundlagen der psychischen Entwicklung. Osterwieck: Zickfeldt, 1925. (The growth of the mind. New York: Harcourt Brace, 1931.)

156. Koffka, Kurt. Principles of gestalt psychology. New York: Harcourt Brace, 1935.

157. Koffka, Kurt. Ueber die Untersuchungen an den sogenannten optischen Anschauungsbildern. Psychologische Forschung 1923, vol. 3, pp. 124–167.

158. Koffka, Kurt. Zur Analyse der Vorstellungen und ihrer Gesetze. Leipzig: Quelle & Meyer, 1912.

159. Kornmann, Egon. Grundprinzipien bildnerischer Gestaltung. Ratingen: Henn, 1962.

160. Kouwenhoven, John A. The beer can by the highway. New York: Doubleday, 1961.

161. Kracauer, Siegfried. Theory of film. New York: Oxford Univ. Press, 1960.

162. Kramer, Edith. The problem of quality in art, II: stereotypes. Bul. of Art Therapy, July 1967, vol. 6, pp. 151–171.

163. Krampen, Martin. Signs and symbols in graphic communication. Design Quarterly 1965, no. 62.

164. Krech, David, and Richard S. Crutchfield. Elements of psychology. New York: Knopf, 1958.

165. Kretschmer, Ernst. Körperbau und Charakter. Berlin: Springer, 1921. (Physique and character. London: Kegan Paul, 1926.)

166. Landreth, Catherine. The psychology of early childhood. New York: Knopf, 1960.

167. Langer, Susanne K. Abstraction in art. Journal of Aesthetics and Art Criticism 1964, vol. 22, pp. 379–392.

168. Langer, Susanne K. Philosophy in a new key. Cambridge: Harvard Univ. Press, 1960.

169. Laporte, Jean. Le problème de l'abstraction. Paris: Presses Universitaires, 1940.

170. Lashley, K. S. Experimental analysis of instinctive behavior. Psychol. Review 1938, vol. 45, pp. 445–471.

171. Lashley, K. S. The mechanism of vision: XV. Preliminary studies of the rat's capacity for detail vision. Journal of General Psych. 1938, vol. 18, pp. 123–193.

172. Lashley, K. S., and Marjorie Wade. The Pavlovian theory of generalization. Psychol. Review 1946, vol. 53, pp. 72–87.

173. Lee, Dorothy. Freedom and culture. Englewood Cliffs, N.J.: Prentice-Hall, 1959.

174. Lenneberg, Eric. H. Biological foundations of language. New York: Wiley, 1967.

175. Leonardo da Vinci. The notebooks of Leonardo da Vinci. Edward MacCurdy (ed.). London: Duckworth, 1910.

176. Leonardo da Vinci. Paragone, a comparison of the arts. London: Oxford, 1949.

177. Lessing, Gotthold Ephraim. Laokoon oder Ueber die Grenzen der Malerei und Poesie. Lessings Werke, vol. 5. Leipzig: Göschen, 1887. (Laocoon. Boston: Little Brown, 1910.)

178. Lettvin, J. Y., H. R. Maturana, W. S. McCulloch, and W. H. Pitts. What the frog's eye tells the frog's brain. Proceedings of the Institute of Radio Engineers 1959, vol. 47, pp. 1940–1951. Reprinted in Evans (64) pp. 95–122.

179. Levertov, Denise. The Jacob's ladder. New York: New Directions, 1961.

180. Lévy-Bruhl, Lucien. L'âme primitive. Paris: Alcan, 1927. (The "soul" of the primitive. New York: Macmillan, 1928.)

181. Lévy-Bruhl, Lucien. Les fonctions mentales dans les sociétés inférieures. Paris: Alcan, 1918. (How natives think. New York: Knopf, 1927.)

182. Lewin, Kurt. A dynamic theory of personality. New York: McGraw-Hill, 1935.

183. Lewin, Kurt. Principles of topological psychology. New York: McGraw-Hill, 1936.

184. Lord, James. A Giacometti portrait. New York: Museum of Modern Art, 1965.

185. Lorenz, Konrad Z. The role of Gestalt perception in animal and human behavior. *In* Whyte (303) pp. 157–178.

186. Mahnke, Dietrich. Unendliche Sphäre und Allmittelpunkt. Stuttgart: Frommann, 1966.

187. Mandler, Jean Matter, and George. Thinking: From association to gestalt. New York: Wiley, 1964.

188. Manning, Henry P. The fourth dimension simply explained. New York: Dover, 1960.

189. Marx, Melvin H. (ed.). Psychological theory. New York: Macmillan, 1951.

190. Mauss, Marcel. On language and primitive forms of classification. *In* Hymes (129) pp. 125–127.

191. Merleau-Ponty, Maurice. Phénoménologie de la perception. Paris: Nouvelle Revue Française, 1945. (Phenomenology of perception. New York: Humanities Press, 1962.)

192. Metzger, Wolfgang. Figural-Wahrnehmung. *In* Metzger (193) chapter 18, pp. 693–744.

193. Metzger, Wolfgang (ed.). Handbuch der Psychologie. Goettingen: Hogrefe, 1966.

194. Michotte, A., G. Thinès and G. Crabbé. Les compléments amodaux des structures perceptives. Louvain: Publications Universitaires, 1964.

195. Michotte, A. La perception de la causalité. Louvain: Institut Supérieur de Philosophie, 1946. (The perception of causality. New York: Basic Books, 1963.)

196. Mill, John Stuart. A system of logic, ratiocinative and inductive. London: Longmans, 1965.

197. Miller, Daniel R., and Guy E. Swanson. Inner conflict and defense. New York: Holt, 1960.

198. Minsky, Marvin L. Artificial intelligence. Scient. Amer., September 1966, vol. 215, pp. 246–260.

199. Modley, Rudolf. Graphic symbols for world-wide communication. *In* Kepes (143) vol. 6, pp. 108–125.

200. Mondrian, Piet. Plastic art and pure plastic art. New York: Wittenborn, 1945.

201. Montessori, Maria. The Montessori method. New York: Schocken, 1964.

202. Mühlher, Robert, and Johannes Fischl. Gestalt und Wirklichkeit. Berlin: Duncker & Humblot, 1967.

203. Munitz, Milton K. (ed.). Theories of the universe. New York: Free Press, 1957.

204. Muntz, W. R. A. Vision in frogs. Scient. Amer., March 1964, pp. 111–119.

205. Nash, Harvey. Freud and metaphor. Archives of General Psychiatry 1962, vol. 7, pp. 25–29.

206. Nash, Harvey. Mixed metaphor in personality theory. Jour. of Nervous and Mental Disease 1965, vol. 140, pp. 384–388.

207. Nash, Harvey. The role of metaphor in psychological theory. Behavioral Science 1963, vol. 8, pp. 336–345.

208. Nault, W. H. Children's map reading abilities — a need for improvement.

News Letter of the Geographic Society of Chicago, January 1967, vol. 3, no. 5.

209. Naumburg, Margaret. Dynamically oriented art therapy. New York: Grune & Stratton, 1966.

210. Naumburg, Margaret. Psychoneurotic art. New York: Grune & Stratton, 1953.

211. Neisser, Ulric. Cognitive psychology. New York: Appleton, Century, Crofts, 1967.

212. Newman, James R. James Clerk Maxwell. Scient. Amer., June 1955, pp. 58–71.

213. Panofsky, Erwin. Galileo as a critic of the arts. The Hague: Nijhoff, 1954.

214. Panofsky, Erwin. Idea. Studien der Bibliothek Warburg. Leipzig: Teubner, 1924.

215. Passow, A. Harry (ed.). Education in depressed areas. New York: Teachers College, 1963.

216. Pauli, W. The influence of archetypal ideas on the scientific theories of Kepler. New York: Pantheon, 1954.

217. Pavlov, I. P. Conditioned reflexes. New York: Dover, 1960.

218. Pellet, René. Des premières perceptions du concret à la conception de l'abstrait. Lyon: Bosc & Riou, 1938.

219. Penfield, Wilder, and L. Roberts. Speech and brain mechanisms. Princeton: Princeton Univ. Press, 1959.

220. Pestalozzi, Johann Heinrich. Wie Gertrud ihre Kinder lehrt. Leipzig: Siegismund & Volkening, 1880.

221. Pfeiffer, John. Vision in frogs. Natural History, November 1962, pp. 41–46.

222. Pfister, Oskar. Expressionism in art. New York: Dutton, 1923.

223. Piaget, Jean. The child and modern physics. Scient. Amer., March 1957, pp. 46–51.

224. Piaget, Jean. The child's conception of number. New York: Norton, 1965.

225. Piaget, Jean. La construction du réel chez l'enfant. Paris: Delachaux & Niestlé, 1937. (The construction of reality in the child. New York: Basic Books, 1954.)

226. Piaget, Jean, and Bärbel Inhelder. The early growth of logic in the child. New York: Harper, 1964.

227. Piaget, Jean, and Bärbel Inhelder. L'image mentale chez l'enfant. Paris: Presses Universitaires, 1966.

228. Piaget, Jean. The language and thought of the child. New York: Meridian, 1955.

229. Piaget, Jean. La psychologie de l'intelligence. Paris: Armand Colin, 1947.

230. Piaget, Jean, and Bärbel Inhelder. La représentation de l'espace chez l'enfant. Paris: Presses Universitaires, 1948. (The child's conception of space. London: Routledge, 1956.)

231. Piaget, Jean. La représentation du monde chez l'enfant. Paris: Presses Universitaires, 1947. (The child's conception of the world. Paterson, N.J.: Littlefield Adams, 1960.)

232. Pikas, Anatol. Abstraction and concept formation. Cambridge: Harvard Univ. Press, 1965.

233. Poincaré, Henri. Science and method. New York: Dover, 1952.
234. Poncelet, Jean Victor. Traité des propriétés projectives des figures. Paris: Gauthier-Villars, 1865.
235. Postman, Leo (ed.). Psychology in the making. New York: Knopf, 1962.
236. Postman, Leo. Rewards and punishments in human learning. *In* Postman (235) pp. 331–401.
237. Pratt, Carroll C. Music as the language of emotion. Washington, D.C.: Library of Congress, 1952.
238. Prévert, Jacques. Paroles. Paris: Gallimard, 1949.
239. Price, Roger. Droodles. New York: Simon and Schuster, 1953.
240. Pritchard, R. M. Stabilized images on the retina. Scient. Amer., June 1961, vol. 204, pp. 72–77.
241. Pye, David. The nature of design. London: Studio Vista, 1964.
242. Rapaport, David (ed.). Organization and pathology of thought. New York: Columbia, 1951.
243. Rausch, Edwin. Das Eigenschaftsproblem in der Gestalttheorie der Wahrnehmung. *In* Metzger (193) vol. 1, pp. 866–953.
244. Ribot, Théodule Armand. L'évolution des idées générales. Paris: Alcan, 1926.
245. Riessman, Frank. The culturally deprived child. New York: Harper & Row, 1962.
246. Rigg, Melvin Gillison. The expression of meanings and emotions in music. Philos. Essays in honor of Edgar Arthur Singer, Jr. Philadelphia: Univ. of Pennsylvania Press, 1942.
247. Rogers, Carl R. Some observations on the organization of personality. Amer. Psychologist 1947, vol. 2, pp. 358–368.
248. Rothacker, Erich, and Johannes Thyssen. Intuition und Begriff. Bonn: Bouvier, 1963.
249. Rubin, Edgar. Visuell wahrgenommene Figuren. Copenhagen: Glydendal, 1921.
250. Rüstow, Alexander. Archaisches Weltbild. Psychol. Beiträge 1962, vol. 6, pp. 564–569.
251. Sander, Friedrich. Gestaltpsychologisches zur modernen Kunst. *In* Mühlher and Fischl (202) pp. 245–269.
252. Sapir, Edward. Language. New York: Harcourt Brace, 1921.
253. Saupe, Emil. Einführung in die neuere Psychologie. Osterwieck: Zickfeldt, 1928.
254. Schaefer-Simmern, Henry. The unfolding of artistic activity. Berkeley and Los Angeles: Univ. of California Press, 1948.
255. Schapp, Wilhelm. Phänomenologie der Wahrnehmung. Erlangen: Philos. Akademie, 1925.
256. Schlauch, Margaret. The gift of language. New York: Dover, 1942.
257. Schopenhauer, Arthur. Die Welt als Wille und Vorstellung. Sämtliche Werke, vol. 1. Leipzig: Insel, n.d. (The world as will and representation. New York: Dover, 1966.)
258. Schrödinger, Erwin. What is matter? Scient. Amer., September 1953, pp. 52–57.

259. Sechehaye, Marguerite. Autobiography of a schizophrenic girl. New York: Grune & Stratton, 1951.
260. Seiffert, August. Die kategoriale Stellung des Typus. Meisenheim: Anton Hain, 1953.
261. Selfridge, Oliver, and Ulric Neisser. Pattern recognition by machine. Scient. Amer., August 1960, pp. 60–68.
262. Selz, Peter. German Expressionist painting. Berkeley and Los Angeles: Univ. of California Press, 1957.
263. Sherrington, Charles. Man on his nature. Garden City: Doubleday Anchor, 1953.
264. Silberer, Herbert. Report on a method of eliciting and observing certain symbolic hallucination-phenomena. *In* Rapaport (242) chapter 8.
265. Snow, C. P. The two cultures and the scientific revolution. Cambridge: Cambridge Univ. Press, 1960.
266. Sokal, Robert R. Numerical taxonomy. Scient. Amer., December 1966, vol. 215, pp. 106–116.
267. Stern, Catherine. Children discover arithmetic. New York: Harper, 1949.
268. Strunk, Oliver (ed.). Source readings in music history. New York: Norton, 1950.
269. Taylor, Harold (ed.). Essays in teaching. New York: Harper, 1950.
270. Teale, Edwin Way. Wandering through winter. New York: Dodd, Mead, 1965.
271. Teuber, Hans-Lukas. Perception. *In* Field (66) Neurophysiology III, chapter 65, pp. 1595–1668.
272. Thomas, Dylan. Selected writings of Dylan Thomas. New York: New Directions, 1939.
273. Thorndike, Edward L. Do animals reason? *In* Dennis (51) pp. 289–301.
274. Thorndike, Edward L. Animal intelligence. Psychol. Monographs 1898, no. 8.
275. Thorndike, Edward L. Human learning. New York: Century, 1931.
276. Tinbergen, N. The study of instinct. Oxford: Clarendon, 1951.
277. Titchener, Edward Bradford. A beginner's psychology. New York: Macmillan, 1916.
278. Titchener, Edward Bradford. Lectures on the experimental psychology of the thought-processes. New York: Macmillan, 1926.
279. Tolman, E. C. A stimulus-expectancy need-cathexis psychology. Science 1945, vol. 101, pp. 160–166.
280. Torrance, E. Paul. Education and the creative potential. Minneapolis: Univ. of Minnesota Press, 1963.
281. Tyler, Leona E. Tests and measurements. Englewood Cliffs: Prentice-Hall, 1963.
282. Uhr, Leonard. "Pattern recognition" computers as models for form perception. Psychol. Bull. 1963, vol. 60, pp. 40–73.
283. Valéry, Paul. Introduction à la poétique. Paris: Gallimard, 1938.
284. Van den Berg, J. H. The phenomenological approach to psychiatry. Springfield, Ill.: Thomas, 1955.
285. Verworn, Max. Zur Psychologie der primitiven Kunst. Jena: Fischer, 1917.

286. Villard de Honnecourt. The sketchbook of Villard de Honnecourt. Bloomington: Univ. of Indiana Press, 1959.

287. Waley, Arthur. The way and its power. New York: Grove, 1958.

288. Walkup, Lewis E. Creativity in science through visualization. Perceptual and Motor Skills 1965, vol. 21, pp. 35–41.

289. Wallach, Hans, and D. N. O'Connell. The kinetic depth effect. Jour. of Experim. Psych. 1953, vol. 45, pp. 205–217.

290. Wallach, Michael A. On psychological similarity. Psychol. Review 1958, vol. 65, pp. 103–116.

291. Weber, Gert. Kunsterziehung gestern heute morgen auch. Ravensburg: Maier, 1964.

292. Wechsler, David. The measurement of adult intelligence. Baltimore: Williams & Wilkins, 1941.

293. Weinhandl, Ferdinand (ed.). Gestalthaftes Sehen. Darmstadt: Wissensch. Buchgemeinschaft, 1960.

294. Werner, Heinz. Comparative psychology of mental development. Chicago: Follett, 1948.

295. Wertheimer, Max. Drei Abhandlungen zur Gestalttheorie. Erlangen: Philos. Akademie, 1925.

296. Wertheimer, Max. On discrimination experiments. Psychol. Review 1959, vol. 66, pp. 253–266.

297. Wertheimer, Max. Productive thinking. New York: Harper, 1959.

298. Wertheimer, Max. Ueber das Denken der Naturvölker: Zahlen und Zahlengebilde. In Wertheimer (295) pp. 106–163. (English summary in Ellis (63) pp. 265–273.)

299. Wertheimer, Max. Ueber Gestalttheorie. Erlangen: Philos. Akademie, 1925. (Gestalt theory. Social Research 1944, vol. 11, pp. 78–99.)

300. Wertheimer, Max. Ueber Schlussprozesse im produktiven Denken. In Wertheimer (295) pp. 164–184. (English summary in Ellis (63) pp. 274–282.)

301. Wertheimer, Max. Untersuchungen zur Lehre von der Gestalt, II. Psychol. Forschung 1923, vol. 4, pp. 301–350. (English summary in Ellis (63) pp. 71–88.)

302. Whorf, Benjamin Lee. Language, thought, and reality. Cambridge: M.I.T. Press, 1956.

303. Whyte, Lancelot Law (ed.). Aspects of form. Bloomington: Indiana Univ. Press, 1951.

304. Windelband, Wilhelm. Lehrbuch der Geschichte der Philosophie. Tübingen: Mohr, 1910. (A history of philosophy. New York: Macmillan, 1954.)

305. Winternitz, Emanuel. Anatomy the teacher: on the impact of Leonardo's anatomical research, etc. Proceedings of the Amer. Philos. Soc., August 1967, vol. 111, no. 4, pp. 234–247.

306. Winternitz, Emanuel. Leonardo's invention of key-mechanisms for wind instruments. Raccolta Vinciana, 1964, vol. 20, pp. 69–82.

307. Wittgenstein, Ludwig. Notebooks 1914–1916. Oxford: Oxford Univ. Press, 1961.

308. Wittgenstein, Ludwig. Philosophische Untersuchungen. Frankfurt a.M.:

Suhrkamp, 1967. (Philosophical investigations. Oxford: Blackwell, 1953.)

309. Woodworth, Robert S., and Harold Schlosberg. Experimental psychology. New York: Holt, Rinehart and Winston, 1954.

310. Woodworth, Robert S. Imageless thought. Journal of Philosophy 1906, vol. 3, pp. 701–707.

311. Woodworth, Robert S. Psychological issues. New York: Columbia, 1939.

312. Woolf, Harry (ed.). Science as a cultural force. Baltimore: Johns Hopkins, 1964.

313. Worringer, Wilhelm. Abstraktion und Einfühlung. Munich: Piper, 1911. (Abstraction and empathy. New York: Intern. Univ. Press, 1953.)

Index

339